MARKS OF OPULENCE
The Why, When and Where
of Western Art 1000–1900 AD

Colin Platt

HarperCollins*Publishers*

HarperCollins*Publishers*
77–85 Fulham Palace Road,
Hammersmith, London W6 8JB

www.harpercollins.co.uk

Published by HarperCollins*Publishers* 2004

1 3 5 7 9 8 6 4 2

A catalogue record for this book is
available from the British Library

ISBN 0 00 257100 5

Set in Linotype Granjon by
Rowland Phototypesetting Ltd,
Bury St Edmunds, Suffolk

Printed and bound in Great Britain by
Clays Ltd, St Ives plc

With the greater part of rich people, the chief enjoyment of riches consists in the parade of riches, which in their eye is never so complete as when they appear to possess those decisive marks of opulence which nobody can possess but themselves.

Adam Smith, *An Inquiry into the Nature and Causes of the Wealth of Nations* (1776), Book One, Chapter xi.

Contents

List of Illustrations

List of Illustrations

Houdon, *Comtesse du Cayla* (Copyright The Frick Collection, New York)

Fischer, church-interior at *Rott am Inn*, Bavaria (A. F. Kersting)

Tiepolo, Treppenhaus Ceiling in the Residenz, Wurzburg (A. F. Kersting)

David, *Oath of the Horatii* (akg-images London/Erich Lessing)

Géricault, *The Raft of the Medusa* (Louvre, Paris, France/Bridgeman Art Library)

Courbet, *Burial at Ornans* (Musee d'Orsay, Paris, France/Bridgeman Art Library)

Schinkel: Altes Museum (BPK, Berlin/Ansicht der Treppe des Alten Museums/ Photo: G Murza, Berlin, 1993)

Friedrich, *Winter Landscape* (© The National Gallery, London)

Goya, *The Third of May 1808* (Madrid, Prado © 1990, Photo: Scala, Florence)

Turner, *Rain, Steam and Speed* (© The National Gallery, London)

Rossi: General Staff Headquarters, view from the Hermitage (Hermitage, St. Petersburg, Russia/Bridgeman Art Library)

Ivanov, *Christ's First Appearance to the People* (Moscow, Tretyakov State Gallery © 1990, Photo: Scala, Florence)

Cole, *The Course of Empire: Destruction* (New York Historical Society, New York, USA/Bridgeman Art Library)

Sullivan and Adler: Wainwright Building, St Louis, USA (© Thomas A. Heinz/CORBIS)

McKim: Boston Public Library (EDIFICE © Philippa Lewis)

Puvis de Chavannes, *Physics* (Courtesy of the Trustees of the Boston Public Library)

Mary Stevenson Cassatt, *In the Loge*, 1878, Oil on Canvas 81.28 × 66.04 cm (32 × 26 in) Museum of Fine Arts, Boston The Hayden Collection–Charles Henry Hayden Fund; 10.35 © 2003 Museum of Fine Arts, Boston. All Rights Reserved

Haussman's Paris, Map of Paris during the period of the 'Grandes Travaux' (Bibliotheque Historique de la Ville de Paris, Paris, France/Archives Charmet/Bridgeman Art Library)

Pissarro, *Boulevard Montmartre a Parigi* (St Petersburg, Hermitage Museum © 1990, Photo: Scala, Florence)

Garnier: The Grand Staircase of the Opéra-Garnier (Paris, France/Bridgeman Art Library)

Manet, *Le Déjeuner sur l'herbe*, 1863 (Musee d'Orsay, Paris, France, Bridgeman Art Library)

Seurat, *Un Dimanche à la Grande-Jatte* (Art Institute of Chicago, IL, USA/ Bridgeman Art Library)

Millais, *The North-West Passage* (© Tate, London, 2003)

Werner, *A Billet outside Paris 1871* (BPK, Berlin/Staatliche Museen zu Berlin – PreuBischer Kulturbesitz, Nationalgalerie)

Klimt, *Hope I*, 1903 (National Gallery of Canada, Ottawa)

Gaudi: the Casa Milà, Barcelona (A. F. Kersting)

Corinth, *Cain* (Museum Kunst Palast, Dusseldorf)

Introduction

'The simple truth', wrote Philip Hamerton, 'is that capital is the nurse and governess of the arts, not always a very wise or judicious nurse, but an exceedingly powerful one. And in the relation of money to art, the man who has money will rule the man who has art ... (for) starving men are weak.' (*Thoughts about Art*, 1873) Hamerton was a landscape-painter who had studied both in London and in Paris. However, it was chiefly as a critic and as the founding-editor of *The Portfolio* (1870–94) that he made his contribution to the arts. In 1873, Hamerton had lived through a quarter-century of economic growth: one of the most sustained booms ever recorded. He had seen huge fortunes made, and knew the power of money:

> But [he warned] for capital to support the fine arts, it must be abundant – there must be *superfluity*. The senses will first be gratified to the full before the wants of the intellect awaken. Plenty of good meat and drink is the first desire of the young capitalist; then he must satisfy the ardours of the chase. One or two generations will be happy with these primitive enjoyments of eating and slaying; but a day will come when the descendant and heir of these will awake into life with larger wants. He will take to reading in a book, he will covet the possession of a picture; and unless there are plenty of such men as he in a country, there is but a poor chance there for the fine arts.[1]

In mid-Victorian Britain, it was Hamerton's industrialist contemporaries – many of them the inheritors of successful family businesses – who were the earliest patrons of the Pre-Raphaelites. A generation later, it would be American railroad billionaires and their widows who created the market for French Impressionists. 'You've got a wonderful house – and another in the country', ran a recent double-spread advertisement in a consumer magazine. 'You've got a beautiful car – and a luxury four-wheel-drive. You've got a gorgeous wife – and she says that she loves you. Isn't it time to spoil yourself?'[2] If one man's trophy asset is a *BeoVision Avant*, another's positional good is a Cézanne.

Positional goods are assets, like Cézannes, with a high scarcity value. They appeal especially to super-rich collectors, wanting the reassurance of 'those decisive marks of opulence which nobody can possess but themselves'.[3] But for the fine arts to prosper generally and for new works to be commissioned, the overall economy must be healthy: 'there must [in Hamerton's words] be superfluity'. 'Accept the simplest explanation that fits all the facts at your disposal' is the principle known as *Occam's Razor*. And while economic growth has never been the only condition for investment in the arts, it is (and always has been) the most necessary. Collectors pay high prices when the market is rising; even the best painters need an income to continue. It was Sickert, the English Impressionist, who once told Whistler, 'painting must be for me a profession and not a pastime'. And it was Sickert's contemporary, Stanhope Forbes, who confessed to his mother, just before his fortunes changed: 'The wish to do something that will sell seems to deprive me of all power over brushes and paints.' Forbes's marine masterpiece, *A Fish Sale on a Cornish Beach* (1885), painted in Newlyn the following year, at last brought him the recognition he had craved.

Before that happened, Forbes had depended on the support of well-off parents. And very few aspiring artists, even today, can succeed without an early helping hand. 'Princes and writers', wrote John Capgrave in 1440, 'have always been mutually bound to each

other by a special friendship ... (for) writers are protected by the favour of princes and the memory of princes endures by the labour of writers.' Capgrave (the scholar) wanted a pension from Duke Humphrey (the prince). So he put Humphrey the question: 'Who today would have known of Lucilius [procurator of Sicily and other Roman provinces] if Seneca had not made him famous by his *Letters?*' Equally, however, 'those men of old, who adorned the whole body of philosophy by their studies, did not make progress without the encouragement of princes'. In Duke Humphrey's day, 'it is not the arts that are lacking, as someone says, but the honours given to the arts'. Accordingly, 'Grant us a Pyrrhus and you will give us a Homer. Grant us a Pompey and you will give us a Tullius (Cicero). Grant us a Gaius (Maecenas) and Augustus and you will also give us a Virgil and a Flaccus (Horace).'[4]

There have been patrons of genius in every century: Abbot Desiderius in the eleventh century, St Bernard in the twelfth; Louis IX in the thirteenth century, Jean de Berri in the fourteenth; Philip the Good in the fifteenth century, Julius II in the sixteenth; and so on. Tiny seafaring Portugal has had three of them. Manuel the Fortunate (1495–1521), the first of those, could build what he liked out of the profits of West Africa and the Orient. Then, two centuries later, John V (1707–50) and Joseph I (1750–77) grew rich on the gold of Brazil. From the mid-1690s, word of the new discoveries in the Brazilian Highlands had spread quickly throughout Europe's arts communities. And Western art can show few better examples of what biologists call 'quorum-sensing' than the instant colonizing of Joanine Portugal by foreign artists of all kinds – by the painters Quillard, Duprà and Femine, by the sculptors Giusti and Laprade, by the engravers Debrie and Massar de Rochefort, and by the architects Ludovice and Nasoni, Juvarra, Mardel and Robillon – most of whom returned home just as soon as the gold of Minas Gerais was exhausted.

Brazil's 'vast treasures' included diamonds as well as gold, with sugar, hides, tobacco and mahogany. And the splendours of Portugal's

Rococo architecture under its Braganza kings owed as much to the fortunes of returned colonial merchants and administrators. In London a little later, Charles Burney, author of a four-volume *General History of Music* (1776–89), recognized the creative link between a thriving business community and the arts:

> All the arts seem to have been the companions, if not the produce, of successful commerce; and they will, in general, be found to have pursued the same course ... that is, *like Commerce*, they will be found, upon enquiry, to have appeared first in Italy; then in the Hanseatic towns; next in the [Burgundian] Netherlands; and by transplantation, during the sixteenth century, when commerce became general, to have grown, flourished, matured, and diffused their influence, in every part of Europe.[5]

London, when Burney wrote, had taken the place of Brussels and Amsterdam as the commercial capital of the West. And Burney's artist-contemporaries, in the last quarter of the eighteenth century, included Joshua Reynolds and George Romney, Thomas Gainsborough, George Stubbs and Benjamin West. When they were joined shortly afterwards by William Blake, John Constable and J.M.W. Turner, even the French had to acknowledge the excellence of British art – of Constable as a cloud-painter and of Turner as a colourist – indisputably of world class for the first time.

Commerce and peace go together. In Thomas Jefferson's first inaugural address as President of the United States of America, he called for 'Peace, commerce, and honest friendship with all nations – entangling alliances with none.' And in 1801, nobody knew better the profits of neutrality than Jefferson himself – planter, statesman and architect-connoisseur – presiding over the unprecedented growth of the republic's economy when almost every other Western nation was at war. Erasmus had written movingly in 1517 of 'the wickedness, savagery, and madness of waging war', and had castigated princes 'who are not ashamed to create widespread chaos

simply in order to make some tiny little addition to the territories they rule'.[6] Yet just two centuries later, 'I have loved war too much', confessed Louis XIV (1643–1715) on his deathbed. And during the Sun King's long reign, even building – his other passion – had come second to campaigning; for the two main construction pro-grammes at Louis's enormous palace at Versailles – the first from 1668, the second ten years later – corresponded closely with rare intervals of peace. Charles XI of Sweden (1660–97), a contemporary of the French king, inherited an economy almost destroyed by war and by the military adventures of the Vasas. In the next generation, Sweden would be reduced to penury again as his son, Charles XII, took up arms. But for almost twenty years from 1680 (when Charles XI declared himself absolute) neutrality was the policy of his regime. During that time, Sweden's treasury was replenished and its war-debts were cleared, leaving a sufficiency in Charles's coffers to complete his country mansion at Schloss Drottningholm, near Stockholm, and to start another big Baroque palace in the capital.

'Money', wrote Bernard Shaw in *The Irrational Knot* (1905), 'is indeed the most important thing in the world.' And it is usually the very wealthy who control it. Yet there have been exceptional episodes in the history of Western art when the arts have been governed neither by princes nor connoisseurs, but by the 'tyranny of little choices' of the many. In recession-prone Europe, after the catastrophe of the Black Death (1347–9), few individuals were seri-ously wealthy. However, there has never been a time when more money has been spent on memorial and votive architecture than under the collective sponsorship of the gilds. After the Reformation, when the pains of Purgatory had been forgotten, it was the indi-vidual investment choices of men of modest means that supported the Dutch Golden Age. 'All Dutchmen', noted the English traveller Peter Mundy in 1640, fill their parlours 'with costly pieces (pictures), butchers and bakers not much inferiour in their shoppes ... yea many times black smithes, coblers, etc. will have some picture or other by their Forge and in their stall.' There were more than two

million new paintings on Dutch walls by 1660. 'Their houses are full of them', said John Evelyn.[7]

I end my book at the First World War, when many were asking what constituted art and what, in the last resort, it was for. 'Is that all?', asked the Modernist critic, Roger Fry, in his *Essay in Aesthetics* (1909), quoting a contemporary definition of the art of painting ('by a certain painter, not without some reputation at the present day') as 'the art of imitating solid objects upon a flat surface by means of pigments'.[8] Fry, of course, had much more to say. Yet he was writing at a time when 'the visions of the cinematograph' (Fry) and the 'death of God' (Nietzsche) had caused many of the old certainties to fade. The Fauvists in Paris and the Expressionists in Berlin were all reading Nietzsche at the beginning of the last century. They were as committed as the philosopher to new ways of seeing, but would probably have agreed also with his 'sorrowful' conclusion – reluctantly confessed in *Human, All Too Human* (1878) – that the arts would be the poorer without religion:

> It is not without profound sorrow that one admits to oneself that in their highest flights the artists of all ages have raised to heavenly transfiguration precisely those conceptions which we now recognize as false: they are the glorifiers of the religious and philosophical errors of mankind, and they could not have been so without believing in the absolute truth of these errors. If belief in such truth declines in general ... that species of art can never flourish again which, like the *Divina commedia*, the pictures of Raphael, the frescos of Michelangelo, the Gothic cathedrals, presupposes not only a cosmic but also a metaphysical significance in the objects of art.[9]

Almost the last of the religious artists in the grand classical tradition was the Parisian decorative painter, Pierre Puvis de Chavannes (d.1898). Puvis's simple line and his non-naturalistic colours were strong influences on many Post-Impressionists. Yet, wrote Gauguin in 1901, 'there is a wide world between Puvis and myself ... He

is a Greek while I am a savage, a wolf in the woods without a collar.'[10] Twenty years earlier, Van Gogh had spoken similarly of the 'savageries' in his work: 'so disquieting and irritating as to be a godsend to those (critics) who have fixed preconceived ideas about technique'.[11] Maurice de Vlaminck, the one-time Fauvist wrote: 'I try to paint with my heart and my loins, not bothering with style.'[12] But necessary to modern artists though such primitivism had become, there was nothing naïve or unsophisticated about the avant-garde painters showing their work in London in 1912 at Roger Fry's Second Post-Impressionist Exhibition. 'It is the work [wrote Fry] of highly civilized and modern men trying to find a pictorial language appropriate to the sensibilities of the modern outlook ... They do not seek to imitate form but to create form; not to imitate life, but to find an equivalent for life ... they aim not at illusion, but at reality.'[13]

Stimulated by rising prices, popular interest in the arts had never been higher than in the last decade before the Great War. 'Art has become like caviar', wrote the German critic, Julius Meier-Graefe, in 1904; 'everyone wants to have it, whether they like it or not.' However, 'it is materially impossible [Meier-Graefe warned] to produce pure works of art at prices that will bring them within the means of the masses'.[14] And a substitute had been found in the speculative commissioning of important new works – William Frith's *The Railway Station* in 1862, or Holman Hunt's *The Shadow of Death* eleven years later – for subsequent engraving and mass-sale. Frith had been uncertain about his subject until Louis Flatow, the dealer, took it up. 'I don't think', Frith wrote in his *Autobiography and Reminiscences* (1890), '(that) the station at Paddington can be called picturesque, nor can the clothes of the ordinary traveller be said to offer much attraction to the painter – in short the difficulties of the subject were very great.'[15] Yet such was his painting's enduring appeal that engravings of *The Railway Station* were still hanging on parlour walls two generations later, when Clive Bell wrote:

Few pictures are better known or liked than Frith's *Paddington Station* ... But certain though it is that Frith's masterpiece, or engravings of it, have provided thousands with half-hours of curious and fanciful pleasure, it is not less certain that no one has experienced before it one half-second of aesthetic rapture – and this although the picture contains several pretty passages of colour, and is by no means badly painted ... *Paddington Station* is not a work of art; it is an interesting and amusing document ... But, with the perfection of photographic processes and of the cinematograph, pictures of this sort are becoming otiose ... (they) are grown superfluous; they merely waste the hours of able men who might be more profitably employed in works of a wider beneficence.[16]

Where Frith's world ended and Bell's began is debatable. In the 1890s, William Frith R.A. – 'Chevalier of the Legion of Honour and of the Order of Leopold; Member of the Royal Academy of Belgium, and of the Academies of Stockholm, Vienna, and Antwerp' – could still count on the support of the great majority of academicians in counselling aspiring artists to study 'the great painters of old', while predicting that 'the *bizarre*, French, "impressionist" style of painting recently imported into this country will do incalculable damage to the modern school of English art.'[17] However, when the once-fashionable Berlin Realist, Anton von Werner (1843–1915), looked back in 1913 on his long career, all he could see was waste and failure: his careful art overtaken by the daubs of the Expressionists.[18] Some believe Gustave Courbet's *A Burial at Ornans* (1850) to be the first 'modern' work; others see Manet's *Olympia* and *Le déjeuner sur l'herbe* (both of 1863) to be Modernism's beginning; and there are those again who would prefer to start only with the Cubists. However, what is certain is that the 'incessant work' of a Werner or a Frith – 'The whole of the year 1861, with fewer interruptions than usual, was spent on *The Railway Station*', Frith noted in his journal[19] – was no longer demanded of the successful

modern artist; and money, as a consequence, had lost its power. There is only one nation today – the United States of America – where art convincingly follows money, and where 'superfluity' still makes everything possible. Take, for example, the extraordinary architecture of present-day Chicago. 'Recognisableness', wrote Aldous Huxley in *Art and the Obvious* (1931), 'is an artistic quality which most people find profoundly thrilling.' And sixty years afterwards, Hammond, Beeby and Babka, architects of the Washington Library Center (1991), were to give Chicago's *literati* a cornucopia of such references: from the Library's rusticated base, through its *rundbogenstil* façade, to the huge grenade-like exploding terminals of the pediment.[20]

The *Grand Projet* still lives on in modern architecture. And there are more big country houses being built in Britain today than at any time since the mid-nineteenth century. At Mexico's Guadalajara, Jorge Vergara, a self-made billionaire, has hired the world's most famous architects, including the Deconstructivists Philip Johnson and Daniel Libeskind, to build him a showcase of their works. In Seattle, Bill Gates's huge new mansion is set to become the largest private palace of his 1990s generation: the nearest equivalent, a century on, of George W. Vanderbilt's Biltmore House (1888–95) – prodigal emblem of America's Gilded Age. But as national economies continue to grow, the pre-eminence of the individual patron has been lost. John Pierpont Morgan (1837–1913), second-generation banker and art-collector extraordinary, was wealthier than any of the Vanderbilts. He began serious collecting only in the 1890s, yet was able to amass, before his death, a remarkable hoard of paintings and drawings, manuscripts and incunabula, ivories and enamels, tapestries, maiolica and oriental porcelains, second to none in the West. The like would be impossible today. In 1913, J.P. Morgan's personal fortune, it has been estimated, could have met the entire investment needs of the United States of America for as much as a third of that year. To do the same now would require the combined fortunes of the top sixty super-rich, with Bill Gates ('the

world's richest billionaire by a wide margin') accounting for barely a fortnight.[21]

For better or worse, the individual collector-patron has lost the power to transform an entire culture. We are unlikely, that is, ever to see again another Peter or a Catherine 'the Great'. But the arts too have changed radically since the birth of Modernism. And if I end my 'essay' – the word is Jacob Burckhardt's – with the Fall of the Old Empires and the Academies' dying breath, it is because nothing thereafter has been the same. An essay, I warned my students, must have an argument. And I return repeatedly in this book to money as the driver of high achievement in the arts, and to the transforming power of great riches. However, I have never seen money as the sole begetter of high quality, any more than Burckhardt himself thought the 'genius of the Italian people' (*dem italienischen Volksgeist*) the only explanation of the Renaissance. 'In the wide ocean upon which we venture', Burckhardt began *The Civilization of the Renaissance in Italy* (1860), 'the possible ways and directions are many; and the same studies which have served for this work might easily, in other hands, not only receive a wholly different treatment and application, but lead also to essentially different conclusions.'[22] I take his point entirely; for one very good reason why Burckhardt's *Civilization* has become a classic and is still read today, is the candour of that disavowal of omniscience.

My final paragraph is an apology. In the course of my argument, I have given many important artists too little space or, in some cases, have failed to mention them at all. One missing person is the Copenhagen painter, Vilhelm Hammershi (1864–1916), master of the psychologically-penetrating portrait and quiet interior. Like the Unknown Warrior, he shall stand for all the rest: *in memoriam*.

CHAPTER ONE

A White Mantle of Churches

Rodulfus Glaber (*c*.980–*c*.1046), chronicler of the Millennium and author of *The Five Books of the Histories*, witnessed two millennial years in his lifetime. The first was the Millennium of the Incarnation of Christ (1000); the second, the Millennium of his Passion (1033). While disposed to tell of miracles and portents, of plagues, of famines and other horrors, Glaber's message in neither case was of Apocalypse. Instead he chose to write not of the Coming of Antichrist nor of a Day of Wrath, but of a Church resurgent and victorious:

> Just before the third year after the millennium [Glaber writes
> of 1003], throughout the whole world, but most especially in
> Italy and Gaul, men began to reconstruct churches . . . It was
> as if the whole world were shaking itself free, shrugging off
> the burden of the past, and cladding itself everywhere in a
> white mantle of churches.[1]

Cathedrals, monasteries, and even 'little village chapels', Glaber continues, 'were rebuilt better than before by the faithful'. And of this, as an untypically restless monk who never stayed long in one place, Glaber had considerable experience. He was at Saint-Bénigne at Dijon when, in 1016, Abbot William (990–1031) consecrated the new church he had rebuilt 'to an admirable plan, much wider and longer than before'. And it was to Cluny's Abbot Odilo (994–1048), whose famous boast it was (echoing Caesar's) that he 'had found

Cluny wood and was leaving it marble', that Glaber came to dedicate his *Histories*.

In point of fact, Glaber probably owed his life to Abbot Odilo. For it is thought that he was at Cluny during the three famine years when 'the rain fell so continuously everywhere [that] no season was suitable for the sowing of any crop, and floods prevented the gathering in of the harvest'. *'Heu! proh dolor!'*, Glaber laments, 'Alas! a thing formerly little heard of happened: ravening hunger drove men to devour human flesh!'[2] But then, in the next millennial year, the Almighty intervened and the chronicler's tone again lightens:

> At the millennium of the Lord's Passion [1033], which followed these years of famine and disaster, by divine mercy and good-ness the violent rainstorms ended; the happy face of the sky began to shine and to blow with gentle breezes and by gentle serenity to proclaim the magnanimity of the Creator. The whole surface of the earth was benignly verdant, portending ample produce which altogether banished want.[3]

Glaber died in 1046. And long before that time, 'like a dog returning to its vomit or a pig to wallowing in its mire' (Glaber again), the rich had reverted to type: 'they resorted, even more than had formerly been their wont, to robbery to satisfy their lusts'. However, it was in 1046 also that the Emperor Henry III first intervened in Roman politics. And the new reforming papacy of Leo IX (1049–54) and his successors would bring about triumphantly in a very few years almost everything that Glaber had desired. 'Everything flows and nothing stays', said Heraclitus of Ephesus, the Greek philoso-pher. And of the many changes which Glaber witnessed in his own millennia-crossed lifespan, none were more important than those which were the consequence of vigorous economic growth.

Improving weather and more reliable harvests, technical inno-vations in agriculture, the absence of plague, the retreat of invading armies and the banning of private war – even the supposed efficiency gains of a new feudal order – have all been given credit for this

increase. And certainly the two main exogenous factors in the late-medieval Recession – a deteriorating climate and heavy plague mortalities – were neither of them present at this time. Nevertheless, the scourge of famine would return regularly to Western Europe every three or four years for many centuries yet; while the only agrarian revolution to bring permanent relief to the poor began in the nineteenth century, and not before. 'Peace! Peace! Peace!' had cried the bishops after 1033, their croziers raised to heaven; 'Peace!' had echoed the crowd with arms extended.[4] Yet the Truce of God, thus proclaimed so charismatically in the aftermath of famine, was broken almost as soon as it was made.

That collapse of public order during the millennial decades, causing a widespread flight to lordship in almost every Western society, was instrumental in promoting what some historians have described as a 'feudal revolution'.[5] And if almost every element of that revolution has since been challenged, nobody now disputes that the tax-raising royal governments of the ninth (Carolingian) and twelfth (Capetian) centuries sandwiched between them a long and dismal interlude of *violentia*. At this directionless time, when vendetta ruled, the building of private castles was yet another sympton of mounting lawlessness. Yet Europe's population and its economy kept on growing. In Glaber's Burgundy, the Churches of Saint-Philibert at Tournus, Saint-Bénigne and Cluny were the subject of major rebuildings. To the north and west, Saint-Rémi at Reims, Saint-Martin at Tours, Saint-Hilaire at Poitiers, and Bishop Fulbert's Chartres were all being rebuilt in Glaber's lifetime. In Germany simultaneously, the cathedrals at Augsburg and Strasbourg, Hildesheim, Goslar and Paderborn, Speyer, Trier and Mainz, were either rebuilt completely or substantially extended, as were many of the larger abbey churches.[6]

Building on this scale, which may call for special skills, cannot usually be done without money. And it is no surprise, accordingly, that this building boom coincided precisely with what is now widely recognized as 'the most significant period for the early growth of

the use of coin in Western Europe ... witnessing the real start of a money economy'.[7] In the mid-960s, a prodigious new silver source had been found on the Rammelsberg, just above Goslar in the Harz mountains. Some thirty years later, the mines were in full production and would pay, among other things, for Goslar's new cathedral, built in the 1040s, and for Henry III's enormous Kaiserhaus in that city. Huge contemporary coin hoards, their principal constituent being Adelaide-Otto silver pfennigs from central Germany, have been found in Sweden. And it was the Rammelsberg mines again that furnished the silver for the locally-minted coinages of Russia and Poland, Bohemia and Hungary, Sweden, Denmark and Norway, which would play a major role in Christianization. Furs from the Baltic, wine from the Rhineland, wool and cloth from England and Flanders, were all to be bought with German ingots. But equally important for European rulers everywhere was their growing understanding of how a coinage worked, its symbolism as meaningful as bullion weight. It was Vladimir the Great, Prince of Kiev (977–1015), who brought Christianity to Russia in the late 980s. And a significant function of his new coinage on the remote Christian rim was to spread the propaganda of Church and State. On one face of Vladimir's coins is the political legend 'Vladimir on the throne'; on the reverse is an all-powerful Christ Pantocrator.[8]

On Swedish coins of this date, there is a cross on the reverse; on the coins of contemporary Poland, a church is shown. And Vladimir of Kiev, having set up pagan idols in his pre-conversion days, at once became a builder of Christian churches. He owed his baptism in 988 to an alliance with Byzantium, sealed by his marriage the following year to Anna, sister of the Greek Emperor Basil II ('the Bulgarslayer'). And he dedicated his first Kievan church to the eponymous St Basil (d.379), monastic legislator and Bishop of Caesarea. Neither Vladimir's Church of St Basil nor his Cathedral of the Dormition (Church of the Tithe) have survived. But both are thought to have been based directly on Byzantine originals, and it was Constantinople again which set the style for the new stone

churches of Yaroslav, Vladimir's son. Yaroslav the Wise (1019–55) 'loved religious establishments and was devoted to priests, especially to monks. He applied himself to books, and read them continually day and night.' During Yaroslav's reign, the same chronicler adds, 'the Christian faith was fruitful and multiplied, while the number of monks increased, and new monasteries came into being'. Of Yaroslav's new churches, the most important was the huge multi-aisled and cupola'd Cathedral of St Sophia at Kiev, described by Bishop Hilarion as 'adorned with every beauty, with gold and silver and precious stones and sacred vessels . . . wondrous and glorious to all adjacent countries . . . another like it will not be found in all the land of the North from east to west.'[9] And whereas the bishop's praise was surely generous, for Prince Yaroslav himself was in the audience, Hilarion had already built a cathedral of his own at Rostov east of Novgorod, knew Kiev's many churches (said to number more than 200 before Yaroslav's accession), and could recognize superior quality when he saw it.

Novgorod's Cathedral of St Sophia, built in the mid-century by Yaroslav's son, again had a Byzantine model. Yet there are borrowings here also from Western Romanesque. And it was the contemporary development of long-distance trading systems – to the Baltic (and the West) from Novgorod, to the Black Sea (and Constantinople) from Kiev – that chiefly funded the construction of these great churches. Beneficial to all, such silent revolutions are much more likely to survive than military conquests. 'Blessed be the Lord my strength, which teacheth my hands to war, and my fingers to fight' (*Psalm* 144) ran the legend on a Frankish sword-hilt found in Sweden.[10] But it was Christian wealth rather than force of arms that defeated the Viking gods, and it was towns as much as churches that spread Christ's message. Well before 1200, by which time Novgorod and Kiev were each as large as London, urban centres had multiplied across Russia. And although every new town of this period was market-based, none was just about money. Thus it would be said of Baltic Riga, founded in 1201, that 'the city of

Riga draws the faithful to settle there more because of its freedom than because of the fertility of its surroundings'.[11] And while Riga's situation as the crusading headquarters of the Livonian Knights of the Sword was necessarily unique, there was nothing exceptional about the liberties it shared with almost every market-town in Western Christendom. 'Perhaps the greatest social achievement', writes Susan Reynolds, 'of towns in this period was that they offered a way of life that was attractive. People flocked into them and . . . went on coming.'[12]

It was the steady flow of immigrants, attracted by freedoms denied to them in rural hinterlands, which kept the towns intact through the famines and feuding of the late eleventh century. When Goslar's silver ran out, as it had begun to do already in the 1050s, most towns survived the consequent recession. But aristocracies everywhere had learnt to love good living. And one result of the growing silver shortages of the second half of the eleventh century was to focus attention, both north and south of the Alps, on those regions which were still bullion-rich. It was not by chance alone that German interest in Italy revived sharply from the mid-eleventh century. And it was in Italy, south of Rome, that German knights first encountered Norman mercenaries. 'Accustomed to war', wrote William of Malmesbury (d.1143), half-Norman himself, the Normans 'could hardly live without it'. They are 'a warlike race . . . moved by fierce ambition . . . [and] always ready to make trouble', was the verdict of another Anglo-Norman chronicler, Orderic Vitalis (d.1142), who, after spending most of his life among them at the abbey of Saint-Evroult, knew the Normans as 'the most villainous' of neighbours.[13] Unable to tolerate another's dominance and always spoiling for a fight, Norman adventurers carved up Southern Italy between them. They took Capua in 1058; drove the Byzantines out of Calabria by 1071; the Lombards out of Salerno by 1077; the Arabs out of Sicily by 1090. They became the masters of Malta and Corfu. Silver-rich England, always the North's most tempting prize, made a kingdom for Duke William in 1066.[14]

Windfall fortunes, won and held by force, need legitimizing. And it was through the Church that the Normans laundered their new money. In the Conqueror's England, there was hardly a major church which was not at once rebuilt by its first Norman abbot or reforming bishop. But whereas the scale of this new construction – as at Bishop Walkelin's Winchester – was almost without precedent, and while some of these great churches – in particular, William of St Calais's Durham – could readily bear comparison with the most advanced continental buildings of their day, it was not in England that Norman patronage was most productive. Southern Italy allowed its Norman appropriators to take everything they wanted from a long-established melting-pot of cultures: Latin, Byzantine, and Saracenic. It was in Norman Apulia and Capua, Calabria, Salerno and Sicily – not in Lombardy or in Germany, in England, France or Russia – that the 'Renaissance of the Twelfth Century' first originated.

This Renaissance was not limited to the arts. However, it was in church-building, in particular, that scholar-priests and princes found common ground. And one of their earliest cooperative ventures was at Monte Cassino, in Norman Capua, the sixth-century birthplace of Benedictine **monachism** in the West. It was there, after Richard of Aversa drove the Lombards from Capua in 1058, that Abbot Desiderius, with Richard's help, made Monte Cassino a busy hive of the arts, drawing on every culture of the region. And it was from Desiderius's new church that Abbot Hugh of Cluny (a visitor there in 1083) took some of the ideas – the Byzantine vault and the Saracenic pointed arch – which he would re-use almost immediately in his comprehensive rebuilding of Cluny III. Another eminent Monte Cassino scholar, the Latin poet Alfanus, was raised to Archbishop of Salerno in 1058. And when, two decades later, the Norman Robert Guiscard took Salerno as well, it was Duke Robert's sudden riches which built Archbishop Alfanus a fine new cathedral, equipped with costly mosaics in the best Greek tradition and with great bronze doors (as at Monte Cassino) from Constantinople.[15]

The dedication of Salerno Cathedral in 1084 was one of Gregory VII's last public acts as pope-in-exile. Following his death in 1085, Abbot Desiderius, against his better judgement, accepted office as Victor III. And Desiderius, in turn, was succeeded by Urban II (1088–99), a former prior of Cluny. Each had Norman support. Gregory VII (1073–85) had first enlisted Normans as his principal allies against the Germans; Desiderius, when pope as much as abbot, remained dependent on the support of Norman princes; and Urban II's great Crusade, preached so charismatically at Clermont on 27 November 1095, would probably never have reached Jerusalem without their leadership.

Only five years before, the successful expulsion of Sicily's Arab rulers by Roger 'the Great Count', younger brother of Robert Guiscard, Duke of Apulia, had established a model for Christian renewal in the Mediterranean. And Sicily's enormous wealth, fuelling Crusader hopes of similar booty in the East, was in truth far more real than the legendary golden pavements of Jerusalem. Significantly for the arts, that wealth was almost entirely Mediterranean-based, combining seaborne commerce – the Arab, Byzantine, and (increasingly) North Italian trades – with the export of Sicily's high-quality grains. And the island's new rulers soon found it more convenient to forget – or ignore – their Norman origins. Roger II, crowned King of Sicily and Apulia on 25 December 1130, had been Count of Sicily since 1105 and Duke of Apulia from 1122. At Roger's cosmopolitan court – over which he presided with Byzantine pomp – French and Latin, Greek and Arabic were all in common use. And although, from Roger's death in 1154, the Latinization of Norman Sicily appreciably gathered pace, it would be a long time yet before incoming Latin settlers outnumbered the indigenous Greeks, and almost as long before the last Arab merchant left Palermo.[16] Roger II's two outstanding buildings – the new cathedral at Cefalù and his Palatine Chapel at Palermo – were both begun soon after he was crowned king. And in this exceptional context of cross-fertilizing cultures, whereas each church is of Latin (or

Romanesque) plan, the expensive high-quality mosaics which orna-
ment both buildings are unmistakably Greek, while the pointed
arches of Roger's palace chapel, and its rich stalactite-style ceiling,
are just as obviously of Arab inspiration. That identical mix of Latin,
Greek and Arab, on an even grander scale, again characterized the
new cathedral at Monreale, west of Palermo, built by William II
(1165–89). King William, Ibn Jubayr relates, spoke Arabic. And the
pointed arches of Monreale's nave arcades and cloister, completed
in the 1180s, are at least as Saracenic as those of the Palatine Chapel
of William's grandfather. Similarly, while Monreale's plan is Latin,
its mosaics are Greek. And it was for those mosaics in particular –
political in purpose, spectacular in spread, enormous in cost, Greek
in execution, yet Latin in subject – that William II's huge cathedral
was most admired.[17]

In late twelfth-century English art, some significance attaches
to William II's marriage in 1177 to Joanna of England, Henry
II's daughter. And there are contemporary English wall-painting
schemes, even in remote country churches, which quite clearly have
a Byzantine cast. However, the great majority of English pilgrims
had always travelled to the Holy Land by way of Sicily. And it was
most probably a Greek icon, brought home by one of those, which
furnished the inspiration in *c.*1150 for two high-quality miniatures
('the Byzantine Diptych') in Henry of Blois's *Winchester Psalter*. A
decade or so later, there is even more direct evidence of a migratory
Sicilian art in the Morgan Master's extraordinary contributions to
Bishop Henry's great *Winchester Bible* of 1160–75. And that same
Master's exquisite Palermo-based miniatures would themselves
become the model for the Byzantine-style frescos, contemporary
with Monreale, of the Holy Sepulchre Chapel at Winchester
Cathedral.[18]

Such links are obvious. Nevertheless, the strong Byzantine pres-
ence in Western art – in Germany and France, as well as Italy and
England – was both too early and too general for eastward-looking
Sicily to be its source. A more likely genesis for this characteristically

twelfth-century emphasis in the arts was Abbot Desiderius's re-building of Monte Cassino. When planning his great church, Desiderius had visited Rome in the mid-1060s to buy antiques: 'huge quantities of columns, bases, architraves, and marbles of different colours'. But there had been no native-born mosaicists or *opus sectile* (ornamental marble) paviours at Monte Cassino when work began, and Desiderius had accordingly used imported Greeks to train his younger monks in those forgotten arts 'lest this knowledge be lost again in Italy'. 'Four hundred and fifty years have passed', wrote his friend Archbishop Alfanus, 'during which this kind of art has been excluded from the cities of Italy; [but] something that had been alien to us for a long time has now become our own again.'[19]

That instinctive reaching back into the past for renewal in the arts came to be closely identified with the missionary reforming programme to which Desiderius, as a Gregorian, was committed. While never a fanatic in Gregory VII's cause, Desiderius followed the pope in condemning lay investiture (royal intervention in church appointments) and simoniacal ordination (clerical office obtained by purchase), and came to support the separation of Church and State – of Papacy and Empire, King and Bishop, God and Mammon – which was what the Investiture Contest was all about. In the almost three centuries since Leo III's coronation of Charlemagne as Emperor in the West on 25 December 800, German theocracy had travelled too far. And as Desiderius looked to Rome for his direction in Church reform, so Rome's anti-imperial reforming popes, seeking renewal in building also, took inspiration from Monte Cassino. What resulted was an architecture which, while more antiquarian than scholarly, was archaeologically correct in a way not seen again for three centuries. Rome itself, as Desiderius had discovered, was rich in re-usable antiquities. And when Innocent II (1130–43) began his huge new church at Santa Maria in Trastevere, he was free to plunder Ancient Rome for his materials. Innocent II's grand parade of columns with their antique Ionic capitals, his re-used sculptured brackets on their classically straight entablatures, his archaizing

marble pavements and rich mosaics, would all have been familiar in Early Christian Rome. The model for Santa Maria in Trastevere was no church of its own period but the fifth-century basilica, still standing today, at Santa Maria Maggiore.[20]

In the long papal schism which began with Innocent II's disputed election and ended only with the death of the antipope Anacletus II in January 1138, the pope's most capable lieutenant was Bernard, Abbot of Clairvaux. Bernard was a reformer of quite a different kind, finding his inspiration in the poverty-driven austerities and literal truths of the primitive Church. Yet there was nothing in the least austere about the lavish mosaics and pavements of Santa Maria in Trastevere. And the church Bernard built at his newly acquired abbey of Tre Fontane on Rome's Via Laurentia, exactly contemporary with Innocent's own, was so stripped-down and bare as to be seen as a reproach, inviting unfavourable comparisons. Bernard himself never hid his real feelings. 'What business has gold in the sanctuary?', he asked, in a characteristic borrowing from the feisty Neronian satirist, Persius Flaccus (*fl.*34–62). 'To speak quite openly, avarice, which is nothing but idolatry, is the source of all this . . . for through the sight of extravagant but marvellous vanities, men are more moved to contribute offerings than to pray . . . [and while] eyes feast on gold-mounted reliquaries and purses gape . . . the poor find nothing to sustain them.'[21]

There was room, in point of fact, for a renewal of both kinds, each finding its rationale in the fourth-century Church. Nevertheless, it was Bernard's populist message which caught the tide. 'See', exclaimed Orderic Vitalis, echoing Rodulfus Glaber at the Millennium, 'though evil abounds in the world, the devotion of the faithful in cloisters grows more abundant and bears fruit a hundredfold in the Lord's field. Monasteries are founded everywhere in mountain valleys and plains, observing new rites and wearing different habits; the swarm of cowled monks spreads all over the world.' But while generous in his praise of Bernard's valiant white-monk 'army' – a favourite Bernardine metaphor – Orderic (the black monk) was

perfectly aware as he wrote of a major public-relations disaster in the making. Old-style Benedictines like himself had always worn black.

> Now however, as if to make a show of righteousness, the men of our time [the Cistercians] reject black, which the earlier fathers always adopted as a mark of humility both for the cloaks of the clergy and for the cowls of monks ... they specially favour white in their habit, and thereby seem remarkable and conspicuous to others ... they have built monasteries with their own hands in lonely, wooded places and have thoughtfully provided them with holy names, such as Maison-Dieu, Clairvaux, Bonmont, and L'Aumône and others of like kind ... [so that] many noble warriors and profound philosophers have flocked to them ... [and others] who were parched with thirst have drunk from their spring; many streams have flowed out of it through all parts of France ... through Aquitaine, Brittany, Gascony, and Spain.[22]

'Do as none does and the world marvels' was a proverb (his biographer tells us) often on Bernard's lips and ever in his heart.[23] And there is no doubting that his timing was impeccable. Furthermore, while his message was wrapped persuasively in the age-old language of renewal, Bernard's policies were more radical than they appeared. It was at Cîteaux, wrote Philip of Harvengt in the 1140s, using the familiar reformer's code, that 'the monastic order, formerly dead, was revived; there the old ashes were poked; it was reformed by the grace of novelty, and by zeal it recovered its proper state ... and the rule of Benedict recovered in our times the truth of the letter'.[24] But 'as the body without the spirit is dead, so faith without works is dead also' (*James* 2:26). And those many 'workshops of total sanctity' which so exhilarated Philip would not have survived long – let alone multiplied as they did – had they failed to make their way in the real world. Throughout the Catholic West, and deep into its marches with Muslim Spain and the Slavic East, there

had never been a boom quite like this one. The Cistercians were not the only monks to make a killing.

> O how innumerable a crowd of monks [apostrophized Peter the Venerable, Abbot of Cluny] has by divine grace multiplied above all in our days, has covered almost the entire countryside of Gaul, filled the towns, castles, and fortresses; *however varied in clothing and customs*, the army of the Lord Sabaoth has sworn under one faith and love in the sacraments of the same monastic name.[25]

Peter the Venerable's increasingly *démodé* Cluniacs had long ceased to function as the Lord of Hosts' front-line troops. However, they had already profited hugely from the new reforming emphasis which their long-lived abbots, Odilo (994–1049) and Hugh (1049–1109), had each helped promote in his turn. And what the reforms had begun to bring to them, even before 1100, were large numbers of parish churches, with their tithes and other offerings, formerly treated by lay owners as private property. It was Leo IX's Council of Rome in 1050 which urged the restoration of all lost church revenues to their clergy. And that was immediately the message of Bishop Airard of Nantes in the 1050s, having in mind – he told his hearers – that 'in France more than elsewhere the wicked custom has grown up that ecclesiastical revenues, tithes, and oblations are usurped by others than the ministers of the churches to which they rightly belong, and sustenance is evilly transferred from the clergy to laymen and from the poor to the rich.' Airard's message came too early to win general support; and he was driven from office in 1059 in favour of a pastor of the landowning party. Nevertheless, he had already secured the release before that time of several parish churches, including those of Rodald 'who set an example to others and gave up everything he possessed and left it to me what to do with it, and I gave it all, just as it had been given to me, to St Martin and the monks of Marmoutier'.[26]

That first eleventh-century trickle of church transfers rose to a

flood after the triumph of the reforming party at the Concordat of Worms in 1122 had brought the Investiture Contest decisively to an end. And it is very clear that, as the conscience of lay proprietors increasingly got the better of them, the contemporary rebuilding of parish churches throughout the West owed more to changes of ownership than to population growth, to landowner wealth, to developing ritual, or any other cause. One especially well-documented example of such a rebuilding, where the new church still survives, is an arrangement of the 1170s by which William, son of Ernis, gave the English Cluniacs of Castle Acre three acres in Long Sutton 'in the field called Heoldefen next the road, to build a parish church there. And my wish is that the earlier wooden church of the same vill, in place of which the new church will be built, shall be taken away and the bodies buried in it shall be taken to the new church.'[27] Long Sutton, in the fertile Lincolnshire fens, was a developing market-town, and its church was ambitious from the start. For another century and more, church and town continued to grow in unison, before the Great Pestilence brought calamity and recession.

'Each man [they say] must have a beginning, for the fair lasts but a while.'[28] And for many reforming clergy, both in the twelfth century and the next, that beginning could come only in the towns. In particular, that was true of the regular canons – Augustinians for the most part – who, as priests as well as monks, attracted endowments which almost always took the form of parish churches. Then, in the thirteenth century, it was in the towns again that the friars – Dominicans and Franciscans, Carmelites and Austin Friars – made their homes. Not so the Cistercians, nor other 'hermit-monks', whose statutes from the start had provided that 'none of our monasteries is to be constructed in towns, castles or villages, but in places remote from human intercourse'.[29] Paradoxically that policy, far from removing their abbeys from the natural growth-points of the economy, located them initially on those expanding frontiers of wealth – of clearance and reclamation, of conquest and new settlement – at which major development was still possible. Frontiers are

hostile places. And when, in 1112, a young Burgundian nobleman, Bernard of Fontaines, joined the little community of ascetics settled since 1098 in 'the wilderness known as Cîteaux ... where men rarely penetrated and none but wild things lived', it was weak and on the point of collapse. Yet just as soon as Bernard had absorbed Cîteaux's disciplines, he left it again to found his own community in its image. And it was from Bernard's Clairvaux – with Morimond and Pontigny and Cîteaux itself – that the huge expansion of the Cistercian order almost immediately took place, so that just forty years later, on Bernard's death, there would be well over 350 abbeys in a mighty monastic family which even its rivals acknowledged to be 'a model for all monks, a mirror for the diligent, [and] a spur to the indolent' of all convictions.[30]

'That was the golden age of Clairvaux', wrote William of St Thierry, re-telling the story of Abbot Bernard's first two decades, when 'men of virtue, once rich in goods and honour and glorying now in the poverty of Christ, established the Church of God in their own blood, in toil and hardship, in hunger and thirst, in cold and exposure, in persecution and insults, in difficulties and in death, preparing the Clairvaux of today, which enjoys sufficiency and peace.'[31] But Bernard's first 'little huddle of huts' at Clairvaux, 'strangled and overshadowed by its thickly wooded hills', was quickly filled to bursting by the many who hurried there to join him. And the standard Cistercian abbey of the order's main expansion period – with 'no statues or pictures', with 'windows of clear glass', and with 'no bell-towers of stone' (provided the statutes) – would have had much more in common with the new Clairvaux II after 1135, when the saint at last agreed to its rebuilding. 'Should you wish to picture Clairvaux', begins a famous description of Bernard's second abbey, 'imagine two hills and between them a narrow valley, which widens out as it approaches the monastery. The abbey covers the half of one hillside and the whole of the other. With one rich in vineyards, the other in crops, they do double duty, gladdening the heart and serving our necessities, one shelving flank

providing food, the other drink.' Characteristically, though, it was not in his account of Clairvaux's buildings – as a Cluniac might have done – that the Cistercian author came to life, but in his transparent delight in the tumbling waters of the Aube and in the 'smiling face of the earth'.[32] It was another Cistercian writer, Gilbert of Swineshead, who described the site of his own English abbey as 'a secret, cultivated, well-watered, and fertile place and a wooded valley [which] resounds in springtime with the sweet song of birds, so that it can revive the dead spirit, remove the aversions of the dainty soul, [and] soften the hardness of the undevout mind'. And it was a third, Walter Daniel, who found Paradise (no less) in the wooded hills and dashing streams of Aelred's Rievaulx.[33]

Of Abbot Aelred, Walter wrote: 'This man turned Rievaulx into a veritable stronghold for the comfort and support of the weak . . . an abode of peace and piety where God and neighbour might be loved in fullest measure.' To Rievaulx, 'monks in want of brotherly understanding and compassion came flocking from foreign countries and the farther ends of the earth'; and no restless 'rolling-stone' was turned away. Yet Rievaulx's lush meadows, like those of its Yorkshire sister-house at Fountains, had only lately been 'a place of horror and vast solitude . . . thick set with thorns, and fit rather to be the lair of wild beasts than the home of human beings'. And the gentle Aelred, abbot from 1147, was as much successful manager as caring father. Before his death in 1166, Aelred had more than doubled Rievaulx's size in 'monks, lay-brothers, hired men, farms, lands and chattels', leaving it well equipped to support an even greater company than the already huge throng of 140 choir-monks and 500 lay-brethren and servants which had packed the church on feast-days 'like bees into a hive, unable to move forward for very numbers'.[34]

Aelred was a Cistercian of the second generation. And by his death, many white-monk houses had ceased to live by the austere code of their founders. One sharp contemporary verdict on what the Cistercians had become – especially worth attending because

delivered by an admirer and reported by an abbot of their own order – is that of Wulfric of Haselbury Plucknett, a well-regarded Somerset recluse. Wulfric, said Abbot John of Ford, his biographer:

> clasped all Cistercians in a close embrace, like sons of his own body, or rather of Christ Jesus. He lauded the Order to the skies and never hesitated to direct to it those who came to consult him about reforming their lives. There was only one matter, according to this friend and champion of our Order, in which the Cistercians displeased God: when it came to lands made over to them, they exercised their rights too freely and, more intent on law than on justice, seemed insufficiently mindful of their duty to those men committed to their lordship.[35]

However, the problem for the Cistercians, as for the other rural orders of the twelfth-century reform – the Carthusians and Tironensians, the Gilbertines, Premonstratensians and Grandmontines – was that both in the quality of their recruitment and in the largesse of their friends, support was very rapidly falling off. To meet their continuing building commitments – and Aelred's hugely expanded Rievaulx was only one of many white-monk houses already rebuilt almost entirely before 1200 – Cistercian abbots everywhere had begun accepting those very properties, from feudalized lands to parish churches and their tithes, which their predecessors had on principle rejected.[36] Those earlier abbots had invariably made sure that their houses were sufficiently endowed. And few Cistercian communities ever ran much risk of the wretched poverty felt, for example, by the hermit-monks of Grandmont, struggling to maintain themselves on a mountain-top so 'stern and cold, infertile and rocky, misty and exposed to the winds' that even 'the water is colder and worse than in other places, for it produces sickness instead of health'.[37] Yet from the mid-century already, the very success of the Cistercians had begun to cost them dear, losing them the respect and loyalty of just those powerful men and women for whom the

soldierly discipline of Abbot Bernard's troops had always been their principal attraction.

Bernard had communed easily with princes. However, the West's most affluent patrons – bishops as well as dynasts – were beginning to find other homes for their money. One major beneficiary would be the Friars Mendicant, who arrived with the new century. But before that fresh distraction, the rebuilding of Europe's cathedrals had entered a new phase, driven at least in part by popular piety. 'We have begun the construction of a larger church [at Aix-en-Provence]', promised Archbishop Rostan de Fos's encyclical of 1070, addressed to all the faithful of the diocese, 'in which you and other visitors will have space enough to stand ... We ask each of you to give what he can, so as to receive from God and us a full remission of his sins ... [then] for everything you give, you will receive a hundredfold from the Lord in the day of Judgement.'[38] And it was pilgrims again, drawn to Chartres Cathedral by the Virgin's shrine, who had contributed to its rebuilding after the great fire of 1020. At Chartres, the chief attraction was an ancient image of the Virgin 'about to bring forth', with the Tunic she was wearing at childbirth. And there were already some lone voices – among them that of Guibert, Abbot of Nogent – who spoke out eloquently against the folly of such cults.[39] Yet there is no mistaking the furious passion of those Chartres citizens who, as their new cathedral neared completion in 1145, 'in silence and with humility ... [and] not without discipline and tears', dragged waggon-loads of stone and wood to aid the works. 'Powerful princes of the world', wrote Abbot Haimon of that same scene, 'men brought up in honour and wealth, nobles, men and women, have bent their proud and haughty necks to the harness of carts, and, like beasts of burden, have dragged to the abode of Christ these waggons loaded with wines, grains, oil, stone, wood, and all that is necessary for the wants of life or for the construction of the church'.[40] But already Haimon's emphasis was on the high birth of his devout penitents, and it was from the rich that the works received their funding. Thus when, on 10 June 1194,

Chartres Cathedral burnt down again, what made another start feasible was not the Sisyphean labours of the city's ardent poor but the solid wealth of its *prudhommes* and their friends.[41]

Cathedral-building is almost always long-term. And those great twelfth-century programmes at Laon and Notre-Dame de Paris, at Norwich and Canterbury, at Zamora and Salamanca, at Tournai, Worms and Mainz, all took generations to complete. Cologne Cathedral, the most ambitious yet, although begun at a fine pace in 1248, was not finished until the late nineteenth century. However, the mere fact that so many ambitious projects were launched at the same time says much for the health of the economy. Rhineland Cologne, always a minting capital, was at the centre of a revival which, after more than a century of bullion shortages, took off again in 1168 with the chance discovery of an important new silver source at Christiansdorf (later Freiberg), in Meissen. In less than twenty years from that first opening of Freiberg's seams, the circulation throughout the West of hundreds of millions of silver pfennigs had transformed its trading economy.[42]

For cathedral-building bishops everywhere, the fact that this new wealth was largely created in the towns gave them whatever assurances they still needed. With population on the increase and labour cheap and plentiful, the ideal context had been established for daring programmes of new works characterized by leap-frogging ambition. Silver-rich Cologne remained for generations the most insanely ambitious project of them all. However, a seductive target had been set. And Cologne's challenge, taken up first in 1386 by Gian Galeazzo Visconti, tyrant of Milan, was then accepted by the canons of Seville. It was one of those canons who, in 1401–2, made the famous boast: 'We shall build a cathedral so fine that none shall be its equal ... so great and of such a kind that those who see it completed will think that we were mad.'[43]

And that, in just a century, is what they did.

CHAPTER TWO

Commercial Revolution

Europe's commercial revolution is now sometimes seen as beginning at the Millennium, with that 'birth of the market' and 'transformation of town/country relations' which Guy Bois has located within a few years of 970.[1] However, most historians would date it later, and all agree that it was in the long thirteenth century – from the 1150s (or a little earlier) to the 1340s (or a little later) – that genuine surpluses built up, to result in the huge cathedrals of today. Cologne was only one of many Western cities which grew spectacularly in the twelfth century, adding two new circuits of defences; Rheims, at least doubling its size, was another. Both then began cathedrals – Rheims in 1211, Cologne in 1248 – on a scale so vast that nobody could have known how they would end. 'Spend and God shall send', the cathedral-builders told each other; 'God loves a glad giver', they advised their friends. But prayer was not the only funding strategy they employed. Abbot Suger, in the previous century, had shown the way. Before beginning on the rebuilding of his abbey church at Saint-Denis, Suger's first priority had been to set about the recovery of his rents. Only after that, he reported, 'having put the situation to rights, I had my hands free to proceed with construction'. Even so, he had been concerned about the future: '[but] when later on our investments became more substantial, we never found ourselves running short, and an actual abundance of resources caused us to admit: "Everything that comes in sufficient quantities

comes from God".'[2] Yet in 1148, when Suger told his story, a more reliable source of funding was the rising rent-roll of his abbey, having all the wealth of Paris on its doorstep.

With the economy speeding up and money no longer tight, one circumstance especially favoured large-scale building. 'Thou shalt not lend upon usury', ran the ancient teaching of the Church, whether 'usury of money, usury of victuals, [or] usury of any thing that is lent upon usury' (*Deuteronomy* 23: 19). And while frequently disregarded from the thirteenth century if not earlier, that doctrine remained unchanged throughout the Middle Ages, holding back the evolution of money markets. It was not, for example, until late in the seventeenth century that London developed fully the sophisticated banking and commercial systems which helped make it into Europe's largest city. And before that time, the unresolved problem of the urban rich was where – if not in land or treasure – to keep their money. In compensation, towns before the plague were good places to live: they were free, well-protected, and expanding quickly. But where fully a third of Europe's cultivable land-space was already alienated to the Church, and where most of the remainder was locked away in the protected family holdings of the nobility, what was left sold only at a premium. Confident in their own abilities and anticipating little profit from the fields outside their walls, the comfortably-off citizens of Chartres, Bourges and Rheims, of Beauvais, Tours and Amiens, were the more easily persuaded to put their money into building when almost every other option was circumscribed.

Where they began was on the rebuilding of their cathedrals. But with the arrival of the friars, from early in the thirteenth century, another popular receptacle for surplus profits opened up. It was in 1210 that Francis of Assisi's Regula Prima was first approved at Rome, and as late as 1216 that Dominic of Caleruega's Order of Friars Preachers was formally recognized by Pope Honorius III. Yet so well targeted were the Mendicants, closely focused on the towns, that Matthew Paris (a Benedictine of St Albans) would say about them by the mid-century:

Brothers of many orders swarmed, now Preachers [Domini-
cans], now Minors [Franciscans], now Cruciferi [Crutched
Friars], now Carmelites ... The Preachers indeed and the
Minors at first led a life of poverty and the utmost sanctity,
devoting themselves wholly to preaching, hearing confessions,
divine services in church, reading and study. Embracing pov-
erty voluntarily for God, they abandoned many revenues, keep-
ing nothing for themselves for the morrow by way of victuals.
But within a few years they were stocking up carefully and
erecting extremely fine buildings.[3]

Writing in 1250, Matthew Paris had seen the friars triumph over
his own brethren too many times. And what he neglects to mention
is that it was not always – nor even usually – the friars themselves
who had chosen to build with such magnificence. Both the Domini-
cans and the Franciscans – the two senior orders – had insisted
from the start on simple life-styles. 'Our brothers shall have modest
and humble houses', runs a Dominican constitution of 1228, 'so that
the walls of houses without an upper room shall not exceed twelve
feet in height, and of those with an upper room twenty feet, the
church thirty feet; and their roofs should not be vaulted in stone,
except perhaps over choir and sacristy.'[4] And when, in 1260, Bona-
venture (the 'Seraphic Doctor') brought the Franciscans back to
unity after the divisions which had followed their founder's death,
his new statutes insisted that no churches of the order should have
bell-towers of their own; that expensive vaults (as with the Domini-
cans) should be limited to the presbytery; that the only stained-glass
imagery should be in the great east window over the high altar;
and that 'since exquisite craftsmanship and superfluity are directly
contrary to poverty, we order that such exquisite craftsmanship,
whether in pictures, sculpture, windows, columns and suchlike, and
any superfluity in length, width or height above what is fitting to
the requirements of the place, be more strictly avoided'.[5]
Such 'superfluities' had indeed characterized a great number of

Franciscan churches, not least the huge basilica at Assisi itself which Brother Elias began building, soon after Francis's death in 1226, in clear contravention of the saint's explicit wishes. Yet it was over-eager patrons, in almost every case, who had commissioned them. 'King Louis', wrote Jean de Joinville in his hagiographic history of Louis IX of France (1226–70), 'loved all people who devoted them-selves to the service of God by taking on the religious habit; none of these ever came to him without his giving them what they needed for a living.' And while it was the Franciscans and the Dominicans who profited most from that largesse, Louis bought land also for the Carmelites on the Seine near Charenton, 'where he built them a monastery and supplied it, at his own expense, with vestments, chalices, and such other things as are essential for the service of our Saviour'; he provided a site and built a church for the Austin Friars 'outside the Porte Montmartre'; and he gave the Friars of the Holy Cross (Crutched Friars) a house 'in the street once known as the Carrefour du Temple, but now called the rue Sainte-Croix'. In this way, boasts Joinville, 'the good King Louis surrounded the city of Paris with people vowed to the service of religion'.[6]

'They have already encircled the city', sang Rutebeuf, the jon-gleur, taking the opposite view; 'God keep Paris from harm/and preserve her from false religion.'[7] And it was undoubtedly the case that Louis IX's too obvious advocacy of the friars in their long mid-century dispute with the secular masters of the University cost him much support in his own capital. 'There were times', Joinville admits, 'when [even] some of those who were most in his confidence found fault with the king for spending so lavishly on what seemed to them over-generous benefactions'.[8] Yet the friars, whether as preachers to urban audiences or as buriers of the dead, were in no danger of losing their appeal. It was in Louis's own Sainte-Chapelle – built at huge cost in the 1240s to house his most precious relic, the Crown of Thorns – that the king and his family heard the friars preach on many occasions. And high on the list of Louis's favourite preachers was that same Bonaventure, once himself a famous teacher

in the Paris schools, who restored order to the Franciscans in 1260. Over a quarter of Bonaventure's sermons while minister-general are known to have been delivered on return visits to Paris, when the king was very often in his audience. They satisfied an addiction as powerful in Louis IX as the passion of Henry III, his English brother-in-law, for hearing masses.[9]

With Louis's monumental reliquary rising before him as a challenge, Henry III was at least as determined to build a shrine of his own of similarly exemplary magnificence. Begun in 1246, when work on the Sainte-Chapelle (consecrated in 1248) was still in progress, Henry's abbey church at Westminster replaced the demolished pre-Conquest church of King Edward the Confessor, whose canonization in 1161 had made him the focus of a developing cult to which Henry was personally devoted. No materials were too expensive nor spaces too grand for a work of such intense royal piety. Yet Henry was impatient to see it finished: 'Because the king wishes that the works of the church of Westminster should be greatly speeded up (*multum expedirentur*)', orders Henry III's testy writ of 30 October 1252, 'Henry, the master of the said works, is directed to have all the marble work raised this winter that can be done without danger.'[10] The cost of this one project was enormous; Westminster alone (of all Henry's many building enterprises) absorbed the equivalent of more than a year of the royal revenues, and contributed significantly to the popular unrest which culminated in the Baronial Revolt of 1263–5. Yet as Louis IX had told his critics: 'I would rather have such excessive sums as I spend devoted to almsgiving for the love of God than used in empty ostentation and the vanities of this world.'[11] And where 'magnificence' in every gesture was routinely demanded of a king, there was little to be gained by royal parsimony. A generation later, in typical Mendicant-speak, the Dominican Federico Franconi would invoke a pagan Greek philosopher to justify the pious works of Louis's nephew Charles II, King of Sicily (1285–1309):

According to Aristotle, *Ethics* 4, it is the part of the magnificent man to go to great expense and to make donations, and especially in connection with God and the building of temples. Thus our lord King Charles acted as befits a magnificent man and went to great expense and made gifts to knights, counts, and the like ... How great were the gifts he made to clerics and religious! Indeed, too, how many were the churches and monasteries, how many were the convents that he built and endowed![12]

Magnificence was as desirable in the government of cities also, for as the Florentine patrician, Pagolantonio Soderini, would later explain to his fellow disputants in Francesco Guicciardini's political *Dialogue* of the 1520s: 'Although cities were founded principally to protect those who took refuge in them and to provide them with the commodities of everyday life, nevertheless their rulers are also responsible for making them magnificent and illustrious, so their inhabitants can acquire reputation and fame among other nations for being generous, intelligent, virtuous and prudent.'[13] But public works, in the last resort, are usually funded by private wealth. And probably the most significant contribution the friars ever made to the self-esteem of Europe's cities was to give wealth-creation recognition in the Church. It was to Aristotle again, only recently become accessible in translations of their own making, that Mendicant scholars turned for a less condemnatory view of personal profit – deemed, until then, to be no better than exploitation – which began with the defence of private property. Aristotle, in his own day, had seen nothing wrong with private property. And for the Aristotelian Dominican, Thomas Aquinas, not only was personal wealth no sin, but the rich stood a better chance of being virtuous: thus 'exterior riches are *necessary* for the good of virtue, since through them we sustain ourselves and can help others'.[14] Contemporaneously, it was the Franciscan master Guibert of Tournai, teaching alongside Aquinas (the 'Angelic Doctor') in the Paris schools, who assured

the class of merchants that 'gold and silver make neither good men nor bad men: the use of them is good, and the abuse of them is bad': in effect, that there is nothing sinful in buying and selling provided always that the motives are not base.[15] And while some of the friars' other rationalizations of money-making – of interest ('usury') as an acceptable charge for venture capital, and of a fair (or 'just') price as being whatever the market would bear – were more problematic, they were nevertheless entirely successful in promoting Christ the Good Merchant (Bonus Negotiator) as a commerce-friendly figure, on a level with Christ the Lawyer (Advocatus) or Christ the Lord (Dominus).

Taking the sin out of commerce was never more necessary than in this century of growth, when profits were accumulating all the time. And what made that growth significant – for the arts as for all else – was that a substantial proportion of it was real. The poor have few protectors. And when Pisa first expanded from its original walled core of just 30 hectares to the 114 hectares of 1162, and then again to the 185 defended hectares of 1300, it was less to enclose the shantytowns of migrant workers than to shelter the spreading suburbs of the rich.[16] Florence, over the same period, grew by almost eight times: from 80 to 620 hectares. And while Genoa, the wealthiest of the Lombard cities, always stayed much more compact, the huge increase in trading volumes which the Genoese experienced through the thirteenth century in particular – well beyond even their considerable population growth of some 230 per cent – is the clearest possible demonstration of rising affluence.[17]

What Genoa and other Mediterranean cities enjoyed throughout the long thirteenth century was a consistently favourable trading balance with the commodity-starved but silver-rich nations of the North. Italian luxury goods – silks and linen, worked leather and fine woollens, armour and weapons, precious stones and spices – were all exchanged for northern silver. And although the bulk of the accumulated bullion was then passed on immediately to Naples and southern Italy, to North Africa, Asia Minor and the Near East,

much also stuck to the fingers of Lombard middlemen. In direct response to that abundance, Italian interest rates fell sharply, from a typical 20 per cent at the beginning of the century to less than half that figure before its end, bringing the cost of a commercial loan in Genoa down as low as 7 per cent, in Venice to 8 per cent, in Florence to 10. And while personal loans were more expensive and usury (even as Mendicant casuistry had redefined it) was still condemned by the Church, every circumstance now favoured the entrepreneur.[18]

With bills of exchange in regular use and with book money increasingly substituting for real, the first to benefit were the citizen-bankers of northern Italy. They challenged one another like young bulls. 'The noble city called Venice', wrote Martin da Canale, its thirteenth-century chronicler, is 'the most beautiful and delightful in the world'; the Piazza San Marco is 'the most beautiful square in the whole world, and on the east side is the most beautiful church in the world, the church of the lord Saint Mark'. And when, on the eve of the Black Death, Agnolo di Tura ('called the Fat') recorded the completion in 1346 of the great piazza, or *Campo*, at Siena, he was equally confident in awarding it the crown as 'the most beautiful square, with the most beautiful and abundant fountain and the most handsome and noble houses and workshops around it of any square in Italy'. Chief among the newest and grandest of those 'handsome and noble houses' was Siena's enormous Palazzo Pubblico, for which the clinching argument had been that 'it is a matter of honour for each city that its rulers and officials should occupy beautiful and honourable buildings, both for the sake of the commune itself and because strangers often go to visit them on business; this is a matter of great importance for the prestige of the city.'[19] And what then came to be exhibited in Siena's heart of government – the Sala de' Nove (Chamber of the Nine) – was Ambrogio Lorenzetti's huge fresco cycle of *The Effects of Good and Bad Government in Town and Country*, among the most impressive didactic paintings ever made.

Both Ambrogio and his brother Pietro (also a major painter) are believed to have died in the Black Death. And another casualty of that catastrophe was the projected extension, finally agreed as late as 1339, of Siena's already big thirteenth-century cathedral. A huge new nave was to have been built on the line of the existing south transept, enormously increasing the floor area. But construction had begun to falter even before the plague reached Siena in the spring of 1348, and the entire enterprise was abandoned soon afterwards. As a display of citizen hubris roused to fever pitch, Siena's failed Nuovo Duomo would be difficult to match. Yet it has a parallel in the new cathedral proposed at Beauvais a century earlier, following the fire of 1225: 'the tallest structure ever built in northern Europe and certainly the most ambitious cathedral project of the High Gothic era'.[20] Bishop Miles's Beauvais Cathedral, like the Nuovo Duomo at Siena, was never finished. There was a major collapse of the upper choir in 1284, the great crossing tower (only recently completed) fell in 1573, and the long nave of the original plan was never built. But if pushing technology to its limits may sometimes end in tears, it was a luxury that the newly affluent could well afford. John de Cella, Abbot of St Albans (1195–1214), headed one of the wealthiest of the English black-monk houses. He won the praise of his monks for his rebuilding ('in every detail faultlessly') of their 'new and splendid' dormitory and 'very beautiful' refectory. Yet it was Abbot John also who made the grievous error of entrusting his most prestigious project, the rebuilding of the western show-front of his substantial abbey church, to Master Hugh de Goldcliff – 'a deceitful and unreliable man, but a craftsman of great reputation'. Then

> It came about by the treacherous advice of the said Hugh that carved work, unnecessary, trifling, and beyond measure costly, was added; and before the middle of the work had risen as high as the water-table, the abbot was tired of it and began to weary and to be alarmed, and the work languished. And as

the walls were left uncovered during the rainy season the stones, which were very soft, broke into little bits, and the wall, like the fallen and ruinous stonework, with its columns, bases and capitals, slipped and fell by its own weight; so that the wreck of images and flowers was a cause of smiles and laughter to those that saw it.[21]

The *schadenfreude* of John de Cella's critics would certainly have been shared by Abbot Samson of Bury (1182–1211), in whom even his biographer saw something of the night. Abbot Samson, Jocelin of Brakelond tells us, 'was a serious-minded man and was never idle ... [But] as the wise man [Horace] said, no one "is entirely perfect" – and neither was Abbot Samson.' Always more manager than spiritual father of his community, Samson 'appeared to prefer the active to the contemplative life, in that he praised good obedientiaries (office-holders) more highly than good cloister monks, and rarely commended anyone solely for his knowledge of literature unless he also knew about secular matters.'[22] Those secular matters, to Abbot Samson's mind, included the keeping of meticulous accounts. And the highly professional accounting practices of which Abbot Samson and his generation were the undoubted pioneers, helped extract the maximum profit from the land. Soon after his election, it was on Abbot Samson's command that

> A complete survey was made, in each hundred, of letes, suits, hidages, foddercorn, renders of hens, and other customs, rents, and payments, which had always been largely concealed by the tenants. Everything was written down, so that within four years of his election, no one could cheat him of a penny of the abbacy rents, and this despite the fact that no documents relating to the administration of the abbey had been handed on to him from his predecessors ... This was the book he called his 'Kalendar'. It also contained details of every debt he had paid off. He looked in this book nearly every day, as though it were a mirror reflecting his own integrity.[23]

It was under Abbot Samson's sharp-eyed management that the great court at Bury echoed once again 'to the sound of pickaxes and stonemasons' tools'. And effective financial controls, from that time forward, would greatly ease the lot of the rebuilders. When Canterbury Cathedral's choir was rebuilt after the fire of 1174, it owed at least some of its new glory to pilgrims' offerings at the shrine of Archbishop Thomas Becket, murdered there just four years before. However, the greater part of the required funding, both of this and later works, was always less piety-driven than rental-led. While frequently in debt to Sienese bankers among others, the cathedral's monk-custodians – the third richest monastic community (after Westminster and Glastonbury) in the kingdom – never stopped building at any time.[24]

Canterbury's monks could handle debt more securely, and over a much longer term, because they were able to calculate very exactly what was owing to them. One of the cathedral-priory's earliest rentals, dating to about 1200, brings together in one place all the information its obedientiaries might need for the resolution of future disputes. Not only, that is, did it record the names, rents, and payment-dates of the priory's Canterbury tenants, but it gave locations and measurements also, beginning with the Northgate tenement of Roger fitzHamel's sister, who paid sixpence at Michaelmas for 'land lying behind our almonry wall; its breadth to the north 26 feet, length from the street towards the west 110 feet'.[25] Nobody until that time had kept records of such precision. Yet so fast-developing was the economy, and so urgent was the need for new mechanisms of control, that within less than a generation of those first monastic rentals, almost every major landowner would keep the same.

It is the survival of such records that makes possible for the first time convincing estimates of growth in this century. Thus the estates of Christ Church Canterbury are thought to have almost doubled their net worth through the long thirteenth century; Westminster Abbey's assets grew by more than twice in the same period; the

monks of Battle and the bishops of Ely nearly trebled their receipts; and the income of the bishops of Worcester rose by four.[26] Even allowing for inflation, such levels of growth are exceptional. And while it was the grander projects of the already rich which inevitably attracted the first funding, some residue trickled down to the localities. In the majority of English parishes, the rector was also a major landowner. And in clear recognition of the continuing affluence of his class, the chancels of many parish churches – widely acknowledged by that date to be the rector's personal charge – were rebuilt on the most generous of scales. Not only were the new chancels of late thirteenth- and early fourteenth-century England much larger than before, they were also conspicuously better furnished – with canopied piscina, triple sedilia and priest's door in the south wall; carved reredos behind the altar; founder's tomb and Easter Sepulchre to the north. In the post-Plague recession after 1349, such rectorial investment fell off sharply. And when, after a gap of half a century or more, building began again in many parishes, it was the parishioners' nave rather than the rector's chancel which claimed the rebuilders' first attention, dread of Purgatory (not surplus wealth) being the spur.[27]

There was little, however, even just before the plague, to stop the rich growing exponentially richer. For while it is probably true that population growth was slowing before 1300, and although serious subsistence crises may already have developed as early as the 1260s in some regions, it was never the rich who paid the price.[28] As the supply of labour went on growing, its cost fell still further; as the demand for land rose, so rents rose also; as husbandry intensified on overcrowded plots, tithable yields continued to increase. Some have seen Europe's widespread famines of 1315–17 as the critical divide, when population advance turned into a retreat. And for Jacques Le Goff, 'the combination of poor technological equipment and a social structure which paralysed economic growth meant that the medieval West was a world on the brink ... constantly threatened by the risk that its subsistence might become uncertain

... only just in a state of equilibrium'.[29] But try telling that to a Sienese banker or to some wealthy prelate from the North. And many historians now take the view that it was the onset of the Black Death in 1347–9 – not overcrowding nor soil exhaustion, not a deteriorating climate nor a commerce-averse Church – which ended medieval Europe's golden age. 'France', concludes James Goldsmith, 'did not face a serious economic or demographic crisis in the half-century prior to the Black Death. France was not trapped in a Malthusian-Ricardian dilemma in which population increase outstripped food production. France was not overpopulated in terms of its economic structures and there was no shortage of land.'[30] In practice, every circumstance still combined in the last half-century before the Pestilence to deliver yet more riches to the fortunate.

In the meantime, many had come to take prosperity for granted. There was never a time, for example, when skilled craftsmen lacked employment on the increasingly ambitious building pro-grammes – three churches in two centuries – of the wealthy canons of Guisborough, in northern Yorkshire. Masons settled permanently in Guisborough township, they raised families to succeed them, were buried in the church's shadow and left money to the priory's fabric-fund in their wills.[31] And while religious communities of every allegiance, confident in their rent-rolls, frequently took on greater projects than was prudent, very few came to grief as a result. Other wealthy Yorkshire houses where new construction never stopped included the near-neighbours, Cluniac Pontefract and Benedictine Selby. Both had contracted huge building debts before the end of the thirteenth century, as had the normally affluent canons of Augustinian Dunstable, forced to cut their commons to make ends meet:

> We decided [Dunstable's chronicler relates] that one portion of conventual dishes of every kind should be set before two brothers. Of the other economies made at that time [1294], as regards the number of dishes in the convent, as regards the almonry, the reception of guests, and the management of the

household, you will find the particulars entered in the old book of obits [of this priory].[32]

Yet not one of these communities ever ran much risk of failure. And it was their still substantial wealth, over two centuries later, that made them such tempting targets for suppression.

What boosted building confidence – probably more in these pre-plague generations than at any other time – was an economic climate in which even the most feckless noble landowner could do no wrong. Few would ever match the hands-on farming skills of Walter de Burgo, custodian from 1236 of Henry III's southern manors, who raised their value – through intelligent investment in marling, seed and stock – by as much as 70 per cent in just four years.[33] However, agricultural regimes on England's great demesnes would continue to improve throughout the thirteenth century, assisted by the circulation of such contemporary manuals of good practice as the *Seneschaucy* and Walter of Henley's *Husbandry*. And every Western property-holder, great and small, obtained at least some benefit from the flow of German silver which had begun to run again more freely after the new discoveries at Freiberg in 1168, irrigating every economy through which it passed. Most particularly, all employers throughout this period shared easy long-term access to cheap labour. And not only were wages falling in proportion to landowner wealth, but new levels of skill were developing in many crafts and trades as greater specialization was driven by overcrowding. Good craftsmen are rare at any time. But much rarer is the situation where high skills and low rewards coincide with unfettered wealth-creation at patron level. When, from the 1250s or even earlier, this began to happen in the West, what resulted was affordable quality in every category of the arts, unleashing ingenuity and invention.

Of the extremes of that invention – always expensive and occasionally perverse – there is no better example than the multiple shafts and complex tracery of a big 'Decorated' cathedral like Exeter, in south-west England, rebuilt almost entirely between 1270 and

1340 at a time of unprecedented landowner prosperity. Walter Stapeldon (1307–27), twice Treasurer of England and the refurnisher of Exeter's choir, was probably the wealthiest of the five bishops who oversaw these works during the seven decades they took to complete. However, it is to Bishop Peter Quinel (1280–91) that the costly sixteen-shafted 'Exeter pillar' is usually attributed; and it was Quinel's pillar that set the standard for all that followed. Two centuries before, at Anglo-Norman Durham, single drum columns had supported the arcades; at Transitional Canterbury, after the fire of 1174, paired 'Roman' pillars were chosen for the renewal of the choir; the builders of Early English Salisbury, not otherwise shy of decoration, believed four-shafted piers ornate enough; and even Henry III, never one to spare expense, had settled on piers of just eight shafts for Westminster Abbey. Quinel doubled that number to sixteen.

Exeter Cathedral is provincial work, over-ornate and alarmingly top-heavy. More refined in every way was the king's new choir at Westminster, in the Court Style of Louis IX's Sainte-Chapelle. Other characteristically tall and slender churches in the French *rayonnant* tradition had included Suger's Saint-Denis (rebuilt from 1231), with Beauvais and Amiens, Tours and Troyes, Clermont-Ferrand, Saint-Thibault and Carcassonne; in Germany, Cologne and Strausbourg; in Spain, Toledo and Leon. Such huge devotional spaces required furnishings of similar quality. And Walter Stapeldon's enormous throne at Exeter – 'the most exquisite piece of woodwork of its date in England and perhaps in Europe'[34] – was a typical response to that challenge. But with no lack of cash-rich patrons, excellence spread out in all directions. Medieval England is not generally remembered for its art. Yet it was in these decades in particular that English wood-carvers and stonemasons were at their most inventive; that English tilers and potters worked at a standard never afterwards repeated; that English brasses and memorial sculptures were at their liveliest and most original; and that English Court Style painters, as in the Thornton Parva and Westminster retables

or the De Lisle and Queen Mary psalters, were the equal of any in the West.[35] Of the many English glazing schemes also commissioned in this period, none was more important than the glazing in 1305–40 of York Minster's new *rayonnant* nave. Last to be completed were the cathedral's three west windows. And so close were these in style and subject-matter to the best French paintings of their period that their makers were almost certainly Paris-trained.[36]

English miniature-painters are known to have worked in Paris in the early fourteenth century. And some would have learnt their art in the thriving atelier of Jean Pucelle (d.1334), illuminateur to Philip the Fair and his successors. Pucelle, in his turn, had learnt from the Italians, while the Italians themselves, including the great Sienese panel-painter Duccio di Buoninsegna (*fl.*1278–1318), who was an important influence on Pucelle, took as much from the North as they gave back. For all, the common factor was extravagant commissions. Thus Duccio's big *Maestà*, which took three years to paint, was commissioned in 1308 for the high altar at Siena Cathedral: the most prestigious location in the city. And the ingenuity and high invention of Pucelle and his assistants would have fallen far short of what they actually achieved had their virtuosity not been stimulated by the connoisseurship of Capetian kings and of the Valois who, from 1328, succeeded them.

Those increasingly sophisticated rulers of pre-plague France had owed their schooling in public patronage to Louis IX. And what St Louis did for the arts in thirteenth-century France had its closest parallel in the German empire of Frederick II Hohenstaufen. Frederick, as Holy Roman Emperor (1220–50), had only nominal suzerainty over Italy north of Apulia. He was never in total control of his German lands. Accordingly, it was in Frederick's southern Italian kingdom, which he held absolutely from 1208, that he spent the greater part of his reign, creating a Court in Sicily and Apulia as brilliant as any that had surrounded the Norman 'Great Count', Roger I Guiscard, and his heirs. Apostrophized as *Immutator Mundi* (Transformer of the World), Frederick never lacked his admirers.

He was a new David – claimed Henry of Avranches, one of the more extravagant of those – a new Charlemagne, a Caesar, or a Robert Guiscard; he was intellectually on a par with Plato and Cicero, Ptolemy, Euclid and Pythagoras.[37] The Franciscan Salimbene, in contrast, stressed the downside of his rule, where 'all these parties and schisms [between Guelf and Ghibelline] and divisions and maledictions in Tuscany as in Lombardy, in Romagna as in the March of Ancona, in the March of Treviso as in the whole of Italy, were caused by Frederick, formerly called emperor.'[38] Yet like him or not, there was no denying the force of the Emperor Frederick's example, whether in the revival of antique scholarship or in the arts. 'O fortunate Emperor', exclaimed another of his circle, 'truly I believe that if ever there could be a man who, by virtue of knowledge, could transcend death itself, you would be that one!'[39] And indeed Frederick, the classical scholar, was one of the first Western rulers to pay intelligent tribute to Antiquity in his buildings. There were Roman-style busts on Frederick's great triumphal arch at Capua; at Castel del Monte, his Apulian hunting-lodge, the pediment of the big portal, supported by attached pilasters with neo-Corinthian capitals, is also Roman. Such overt imperial symbolism was hardly new. However, the Holy Roman Emperor was ruler also in the North, and what resulted at Castel del Monte – and probably at all of Frederick's buildings, very few of which survive – was an eclectic mixture of the authentically Antique with northern Gothic and Apulian Romanesque.

It was the same merging of traditions in the sculptures of the Pisani (Nicola and Giovanni) and in the paintings of Duccio and Giotto, Simone Martini and Lorenzetti, which first breathed life into the Italian Renaissance. Nicola Pisano (*fl.* 1259–78) was an Apulian. And it was probably his familiarity with the Roman-derived work of the artists of Frederick's Court that enabled him to bring a new understanding of classical sculpture to his adopted city, using it to good effect in the five pictorial panels of his pulpit for the Baptistery at Pisa. Another major influence on Pisano's work

was Gothic figure-carving, which he would have seen in portable form on the Via Francigena (the busy trade route south to Rome), even if – as seems likely – he never set foot in the North. Both Rome and the Gothic North were influential also on Giovanni Pisano, Nicola's son: 'not only equal but in some matters superior to his father', wrote Giorgio Vasari (d.1574), architect and prosopographer of the Renaissance. And what most appealed to Vasari in the Pisani's work was a new realism and truth to Nature lost (he believed) from Late Antiquity until their rediscovery by the Florentine painter Giotto di Bondone (1267–1337) 'who alone, by God's favour, rescued and restored the art [of good painting], even though he was born among incompetent artists'. It was Giotto, the barefoot country-boy of Vasari's sometimes fanciful narrative, who soon after being brought to Florence by the established painter Cimabue 'not only captured his master's own style but also began to draw so ably from life that he made a decisive break with the crude traditional Byzantine style and brought to life the great art of painting as we know it today, introducing the technique of drawing accurately from life, which had been neglected for more than two hundred years'. And it was just that break with tradition, earning Nicola and Giovanni a chapter of their own in Vasari's *Lives of the Most Eminent Italian Architects, Painters, and Sculptors* (1550), that he saw also in the sculptures of the two Pisani, who 'very largely shed the old Byzantine style with its clumsiness and bad proportions and displayed better invention in their scenes and gave their figures more attractive attitudes'.[40] What Vasari did not say was that much of that 'better invention' was not Italian at all, but had been learnt from the Gothic masters of the North.

Strikingly, for 'invention' has not always commanded such support among the rich, there was no lack of commissions for the new art. Giotto, in Vasari's long account of his career, was pressed to work in Florence (repeatedly), in Assisi and Pisa, in Rome and Avignon (home of the exiled popes), in Padua and Verona, Ferrara and Ravenna, Lucca, Naples, Gaeta, Rimini and Milan.

And, characteristically, it was not just among cardinals and princes that he found his patrons, but in a wealthy Paduan banker like Enrico Scrovegni, heir to one of the greatest private fortunes ever put together in the West, whose commissioning of Giotto's masterpiece, the Arena Chapel frescos, is thought to have been intended as an act of expiation for the notorious usury of the super-rich Reginaldo, Enrico's father.[41]

Generous funding also followed the Pisani. Nicola's Pisan Baptistery pulpit had been much admired. And five years later, in 1265, an almost identical (but larger) pulpit was commissioned for Siena Cathedral, with seven pictorial panels in place of five. Then, shortly after the Siena pulpit was completed, it was again the Pisani's workshop – largely Giovanni's by this time – that was commissioned to make a civic fountain for Perugia, long a stronghold of the Guelfs, which had found itself at last on the winning side. It was following Charles of Anjou's decisive victory over Conradin's Ghibelline forces at Tagliacozzo in 1268 that the Perugians entered a new era of exceptional self-confidence and prosperity. One expression of that new confidence was the founding of a university; another, the completion of the long and costly aqueduct which would eventually debouch into Perugia's Fontana Maggiore. Deliberately linking the two events, the Pisani's sculptured fountain carries allegories of Philosophy and the Liberal Arts; there are political reminders – the eagles of the Empire, the griffon of Perugia, and the lion of the Guelfs; there are saints, kings and prophets; there is Eulistes (legendary founder of Perugia) and Melchizedek (Priest of the Most High God), with, between them, the two egregious civic dignitaries in office at the time: Matteo da Correggio, *podestà* of Perugia in 1278, and Ermanno da Sassoferrato, *capitano del popolo*. 'And as Giovanni [Pisano] considered he had executed the work very well indeed, he put his name to it.'[42]

It was the unremitting feuding of Guelf and Ghibelline, still continuing in the 1280s, which caused Brunetto Latini to write: 'War and hatred have so multiplied among the Italians that in

every town there is division and enmity between the two parties of citizens.'[43] But what perpetuated those enmities was never as much vendetta, however politically inspired, as the tensions of a society in which only money mattered – and mattered more because it was abundant. On the steps of the Virgin's throne in Simone Martini's *Maestà*, painted in 1315 for the Great Council Chamber at Siena, there are verses which read: 'The angelic flowers, the rose and lily/ with which the heavenly fields are decked/do not delight me more than righteous counsel./But some I see who for their own estate/ despise me and deceive my land'.[44] Yet it was precisely that pursuit of individual fortunes that had made the Sienese wealthy; and Simone Martini painted largely for the rich. Simone's *Maestà* in Siena's Palazzo Pubblico was once thickly gold-encrusted; his *St Louis of Toulouse* (1317), painted for the Angevin Robert the Wise of Sicily, was embellished further with gold and precious stones; his *Annunciation* (1333) for Siena Cathedral has a 'chocolate-chip' richness which contrasts absolutely with the 'plain vanilla' of the Giottos at Assisi.

There are frescos by Simone also in the double basilica at Assisi, where his sumptuous *St Martin Cycle*, in the Montefiore Chapel of the Lower Church, recalls the particular devotion of an Italian cardinal, Gentile da Montefiore, for a Gallo-Roman bishop, Martin of Tours (d.397), whose following was principally in France. And while plainly influenced by Giotto's art, Simone's St Martin frescos have a distinctly Northern flavour, owing more to a contemporary Court Style miniaturist like Jean Pucelle. The distinguishing characteristics of that style were a bold use of brilliant colour (including much gold) and the repeated tiny brush-strokes of the illuminator. But such techniques are expensive, even on a manuscript's much smaller scale. And when re-used in the 1320s on Simone's frescos at Assisi, they could only have been realized with funding so unlimited that cost was no longer a consideration.

The times were certainly ripe for that expenditure. For in the long history of Western patronage there have been comparatively few such episodes of immoderate private wealth – industrializing

America at the time of John D. Rockefeller, Cornelius Vanderbilt, and J.P. Morgan was another – and none which have lasted quite as long. Then, towards the end of the 1340s, came the reckoning. 'After great heat cometh cold', warned a proverb of those years, 'let no man cast his cloak away.'[45] After the smiling summers, the drenching rains; after plenty, dearth; after centuries of remission, the return of Plague; and after boom, recession. 'Even in Arcadia, I (Death) am . . . *Et in Arcadia ego.*'

CHAPTER THREE

Recession and Renaissance

'Civilization both in the East and the West was visited by a destructive plague', wrote Ibn Khaldun of the first onset of the Black Death, 'which devastated nations and caused populations to vanish. It swallowed up many of the good things of civilization and wiped them out . . . The entire inhabited world changed.'[1] He was right, of course. Yet he could not have known, as a contemporary witness of the Great Pestilence, just how long-lasting those changes would prove to be. Reduced by at least a third in 1347–50, Europe's populations either stabilized at that level for the next 150 years or fell still further. And while some of that reduction was arguably inevitable – a necessary purge following centuries of growth, bringing people and resources back in balance – what followed was a recovery so sluggish and so unequal as to put a blight on the economy for generations. Downsizing a labour force is effective only if what is left provides a springboard for future growth. Yet there was to be little growth of any kind before the 1480s at earliest. And the real tragedy of the Black Death, in the *longue durée*, was Western society's lamentable failure to rebuild.

That failure was more complete in some localities than in others. Norway, at one extreme, lost 64 per cent of its pre-plague population between 1348 and 1500; whereas England, over the same period, lost nearer 50 per cent, and others went down by just a third. These are estimates only, of which the accuracy has often been disputed.

But even if wrong in detail, what the figures clearly show are conspicuously low replacement rates across the population as a whole, frequently barely adequate for survival. The most successful urbanized economies of the first half of the fifteenth century were Burgundian Flanders and Republican Florence. Both were especially attractive to skilled immigrants and, in part as a result, became the leading contemporary capitals of the arts. Yet the population of the Flemish cities, for all the magnetism of their wealth, continued to drift downwards through much of the fifteenth century, with no recovery of any substance before the end of it. And in Florence likewise, whereas population losses had bottomed out by the 1420s, there was then no upward movement for half a century at least, so that there were still markedly fewer Florentines in 1500 than there had been in 1347.

A severe and exceptionally long-lasting demographic collapse was thus the shared experience of almost all late-medieval communities in the West. And very little of what happened after the Black Death makes sense without reference to the pestilence. However, bubonic plague was just one element of a general retreat which, while certainly triggered by the Black Death in 1347–50, very rapidly developed its own momentum. That first outbreak of the disease had killed huge numbers, with some death-counts rising as high as 80 per cent even in remote rural communities. While increasingly an urban phenomenon, killer plagues then returned repeatedly for over three centuries before vanishing unaccountably in the 1700s. Yet plague was never the only – nor even the principal – population curb in the Western towns and cities it most afflicted. In late-medieval Europe, it was less bacteria that frustrated growth than full employment.

In practice, plague survivors were in great demand in every sort of occupation, and the jobs-for-all bonanza of the Black Death's aftermath was self-perpetuating. Working women, in what is some-times seen as their original 'Golden Age', were free at last to choose when to stop work and start a family. And in opting to marry later,

only then setting up households of their own, they also cut the numbers of their children. Europe has many cultures, and neither the marriage patterns nor the household formation systems of North and South were then – or have ever been – the same. But whereas Mediterranean brides continued to find their partners before the age of twenty-one, post-plague northerners usually waited until their mid-twenties to make a match, and not infrequently stayed single out of choice. Where women married late and were prone to die in childbirth, where infant mortality was chronically high, where breast-feeding postponed conception for two years or more, and where life expectations, already low before the plague, fell still further, populations soon stopped growing. In short, the key demographic variable after the Black Death was arguably not mortality but nuptiality.

'People are not poor because they have large families', wrote a student of household systems in modern India. 'Quite the contrary, they have large families because they are poor.'[2] And, in contrast, it was the relative affluence of individual plague survivors – and particularly, in this context, of independent farmers and their wives – which enabled them to settle for smaller *nuclear* families with fewer children. Traditional *extended* family systems, while still very much alive in the Third World today, were dying out in north-west Europe by 1400. And those comfortably-off English yeomen and their womenfolk who built the solid oak-framed farmhouses of the fifteenth-century Kentish Weald, were never in the business of offering accommodation to all and sundry. In their big open halls – relics of a life-style once entirely led in common – the uncles and aunts, nephews and nieces, grandparents, in-laws and cousins far and near, came together only, as it were, for Sunday lunches.

It was thus high levels of employment and good wages in the West which enabled that critical threshold to be crossed between a 'situation where people cannot afford not to have children [and] one where they cannot afford to have many of them.'[3] And paradoxical though it may sound, it was this new post-plague prosperity

that, by discouraging large families, helped put off demographic recovery. Another token of private affluence, of which the outcome was the same, was the single-person household of the unmarried working woman or merry widow. In Florence in 1427, one in four adult women were widows, and many had doubtless chosen to remain in that condition, coming to view the death of older spouses as liberation: 'as if a heavy yoke of servitude (*un grave giogo di servitu*) had been lifted from their backs', observed Lodovico Dolce in the next century.[4]

Ensnared by Mamma's cooking, Florence's affluent bachelors had been reluctant to leave home before their early thirties, or even later. And fathers who had married tardily were another obvious reason why European city populations, even before the plague, had always found it difficult to replace themselves. Traditionally, the gap had been filled by immigration from rural areas. But whereas new recruitment remained steady in the half-century following the Black Death, as the smaller and more marginal settlements lost out to the towns, that pool was drying up by 1400. Newly prosperous peasant families, with too much land at their disposal and too little labour of their own, remained (and kept their children) in their localities. For if the populations of big cities risked extinction in post-plague times, so too – and often more so – did village communities. The Tuscan city of Pistoia was a near-neighbour and dependency of Florence. And Pistoia's *contado* (rural territory) had been haemorrhaging population since the late thirteenth century, losing more than 70 per cent of its pre-plague maximum by 1400. That figure conceals huge differences between well-situated lowland villages, which continued to keep up numbers, and remote hill-top communities already in the advanced stages of disbanding. Nevertheless the fact remains that Pistoia the city – regular plague-trap though it was – held its strength marginally better than the *contado*. When surveyed in 1415, Pistoia's population had fallen from around 11,000 shortly before the Black Death to just below 4000, or a loss of some 65 per cent.[5]

'Death was everywhere' in post-plague rural Normandy, of which fully half the population had disappeared by 1380.[6] In Castile likewise, in the wake of 'the Great Death', settlement desertions gathered pace as bubonic plague returned again in 1363–4, in 1374, in 1380, in 1393–4, in 1399 and 1400.[7] But while Castile shed many villages in the Black Death's aftermath, Normandy lost rather few. And here it was the weather, rather than plague, that made the difference. The hot dry summers and mild wet winters of temperate Europe's high-medieval warm epoch had begun to break up shortly after 1250. And what followed was a much lengthier cooling phase, starting with the great sea-storms and coastal inundations of the late thirteenth century and persisting through the rest of the Middle Ages. Characterized by wild temperature swings from cold to hot again, with their associated floods and droughts, it damaged most particularly those outlying farming communities which, in two centuries of increasing overcrowding before the Great Pestilence, had pushed out settlement into the more marginal territories on the hillsides, in the marshlands, and through the forests. Too hostile to allow survival, Castile's parched and barren uplands were among the first to be deserted, as were the thin-soiled hill-top settlements of Mediterranean Pistoia, and the eroded slopes of Bray in the otherwise lush green pastures of Atlantic Normandy.

Imposed rather than created, plague and a deteriorating climate were the two principal *exogenous* factors in the Great Recession of the 'long' fifteenth century. No Western European economy was unaffected by them. Yet it was the *endogenous* factors – made by man himself – which were more likely to touch the arts directly. Chief among these was the weakness of money systems: a combination of politically-driven debasements (almost always to finance a war) and of chronic silver shortages in the West. Precisely because such crises were man-made, their incidence and fall-out could differ spectacularly between neighbours. Weak currencies and bullion famines were everywhere the norm in fifteenth-century Europe. But in Spain, whereas Aragon maintained a strong currency, Castile's

was one of the weakest; and while bullion in Aragon was in short supply, Castile's location on the trade routes north from Africa kept gold flowing through the markets of Seville.[8]

For prince and people alike, Philip the Good concluded in 1433, *'ung des principaulx poins de toutes bonnes policies . . . es davoir monnoye ferme et durable, tant d'or comme d'argent'*.[9] And it is perfectly true that a weak currency – the very reverse of *une monnaye ferme et durable* – was especially damaging to the receipts of great land-owners, dependent on long-term leases and sluggish rents. Inflation, on the other hand, suited rent-payers very well, leaving fifteenth-century governments with the dilemma that if they devalued, the aristocracy rebelled, while every attempt to strengthen the currency was certain to be resisted by their tenants. In the event, it was the nobility who cried loudest, swinging the balance in favour of strong money. And the regular savage debasements which alone had enabled Philip VI of France to pay his troops in the opening cam-paigns of the Hundred Years War, were already largely over by 1360. For the next 350 years, interrupted only by such short-term wartime debasements as those of 1417–22 and 1427–9, France pur-sued the strong money policy, supported by taxation, which best suited its tax-exempt nobility. Yet the attractions of a stratagem which – explained Guillaume le Soterel (treasurer general of Navarre) – allowed the prince to 'strike coin as feeble as he likes to have the means to pay his troops to defend him and his people and his land', were too powerful to resist in a crisis.[10] And nowhere was this more obvious than in post-Black Death Castile, where four 'spectacularly awful' debasements – starting in 1354, 1386, 1429 and 1463 – each paid for a war but cost the *maravedi*, or Castilian money of account, as much as 95 per cent of its value.[11]

In contrast, the post-plague Low Countries under their Bur-gundian dukes – Philip the Bold (1384–1404), John the Fearless (1404–19), Philip the Good (1419–67) and Charles the Bold (1467–77) – became a model of firm government and strong money. Yet precipitous debasement would return, if only briefly, at the start of

46

Habsburg rule in the 1480s: again to pay for mercenaries. Nor had it been possible for the dukes, vastly wealthy though they were, to survive unscathed through the deeply disruptive bullion famines of the fifteenth century. The accompanying hiatus in Europe's money supply imposed constraints of every kind on the economy. It had begun with the mid-fourteenth-century exhaustion and closure of the Central European silver mines, aggravated by hoarding and accumulations of plate, and by the steady drain of bullion towards the East. Severe by 1400, the famine was most complete in 1440–65, when so catastrophic were the silver shortages that every mint was empty and hardly a new coin was struck. Surrounded by a countryside in deep recession, mid-century Brussels (home of the Burgundian court) was one of only four Brabantine cities to ride the storm successfully, the others being Malines (the legal centre), Louvain (for its new university), and Antwerp (for its capture of the English cloth trade). Even so, for almost a generation from 1437 the Brabantine mint at Brussels struck no new silver coins, closing completely (i.e. for gold as well as silver) for rather more than half of that long period.[12]

Defaulting rulers, among them Edward IV of England, contributed to the crisis which, from the late 1450s, had enveloped even Florence, damaging the Medici and causing the collapse of several major banking families (the Baldesi, the Partini, the Banchi and their like) in the late autumn of 1464. 'It is the greatest calamity that has happened in this city since 1339 [the bankruptcy of the Bardi and Peruzzi]', reported Angelo Acciaiuoli, himself a banker, that December. However, Florence's crisis proved short-lived, and of more general significance to the economies of the West was the all but total disappearance – 'throughout the universe', thought the councillors of Barcelona in 1447 – of an official silver coinage, along with the small change (petty currency or 'black' money) of everyday transactions in street and marketplace.[13] Disadvantaged already by uncompetitive pricing and by the deflationary pressures of the Burgundians' pursuit of hard money, the once famous Brabantine

draperies, with their long-established German and French outlets, had only just survived the growing competition of English imports. Then, in the mid-fifteenth century, two decades of currency starvation wiped them out.[14]

A flexible economy – and Brabantine Malines had one of those – can survive just about anything. But whereas the weavers of Malines moved successfully into dyeing and leather-processing, gunfounding, furriery, embroidery and carpet-making, the more normal case was that of Flemish Ypres, unable to diversify or to make the required transition from the high-cost quality draperies of the traditional Low Countries industry to the cheaper cloths which alone could compete with English imports. There had been some 1500 looms at Ypres in 1311; by 1502, that number had fallen to just a hundred, while population had retreated by two-thirds.[15] Flanders' loss was England's gain, with English cloth exports rising by as much as two and a half times between Edward IV's debasements of 1464–5 and the early 1500s. However, England too had suffered devastating currency shortages in the mid-century. And the subsequent continent-wide success of English cloth – swamping the European markets in what would be likened thirty years later to 'an immense inundation of the sea' – was at least in part the product of a 1450s rationalization of the export trade, concentrating capital in fewer hands as those without access either to cash or to credit went out of business.[16]

'I thank God and ever shall', wrote John Barton (d.1491) of Holme, merchant of the Staple of Calais, ''tis the sheepe hath payed for all.' And for a rich man like himself, obtaining credit held few terrors even in the worst of times, nor would he have been excluded, as lesser men might be, from those complex barter arrangements – exchanging wool for alum, cloth for wine or iron – which were all that the mid-century currency shortages allowed. By making the rich still richer, the post-plague bullion famine thus added another element to the already serious distortion of family inheritance histories created by exceptionally high mortalities and low birth-rates.

If the generations are too compressed and wealth cascades too rapidly, and if a failure to reproduce, or the sudden death of heirs, brings unanticipated enrichment to distant kin, high levels of consumerism may result. In late-medieval Europe, such extraordinary windfall riches – a major factor, even then, in the funding of the arts – bore no more relation to the real health of the economy than the inflated lottery takings of today.

In those circumstances exactly, it was the deaths in quick succession of no fewer than six better-qualified heirs that catapulted John Hopton on 7 February 1430 into the spreading estates which enabled him to take a leading role in the rebuilding of his parish church at Blythburgh.[17] And it was other swiftly acquired fortunes which made great church-rebuilders also of John Barton of Holme, of John Tame of Fairford, of John Baret of Bury, of Thomas Spring of Lavenham, and of the Cloptons (John especially) of Long Melford. These small-town English clothiers, protected from competition by the Low Countries slump, could expect to sell everything they produced. Nothing could prevent them getting richer. However, even in those Flemish cities which lost out most to English exports, there had been opportunities enough under Burgundian rule for the accumulation of considerable private fortunes. Mid-century Ghent – its looms fallen silent and its weavers out of work – was among the more prominent casualties of the recession. Yet just two decades earlier, a wealthy Ghent couple had nevertheless found the means to commission a high-quality painted altarpiece from the best artists of the day, pensioners of Philip the Good. Hubert and Jan van Eyck's luminous polyptych, the *Adoration of the Lamb* (1432), was painted for the personal chantry at St John's (now Ghent Cathedral) of Joos Vijd and Elizabeth Borluut. It was a 'stupendous' painting: huge and vastly detailed.[18] And of course it was enormously expensive.

Other big commercial fortunes in the post-plague North included those of William Canynges, shipowning philanthropist of Bristol, and Jacques Coeur, merchant-financier of Bourges. Each would

support an ambitious building programme – a cathedral-like preaching nave for St Mary Redcliffe (Bristol); a fabulous townhouse in Bourges – in which there is not the slightest evidence of economy. Likewise vast preaching naves, spectacular prodigy gatehouses, and big town halls characterized the more successful of the late-medieval German towns where, for example, by the early 1500s the taxable worth of some thirty-seven burghers of Nuremberg and fifty-three of Augsburg – each assessed at more than 10,000 Rhenish florins – would have ranked them among the top 1 per cent of Florentine taxpayers a century earlier.[19] Meanwhile in Florence itself the number and scale of individual private fortunes continued growing. And it was the steadily increasing disposable wealth of Florence's better-off citizenry which underpinned its continuing eminence in the arts.

By far the richest man in Florence in 1427 (the year of the great *catasto* or tax assessment) was Palla Strozzi. However, Palla's son, Gianfrancesco, was to be among those brought down in the major banking debacle of 1464. And if even the greatest Florentine fortunes were thus so vulnerable to collapse, long-term investment in the arts in general – and in large-scale palace-building in particular – might have seemed in normal circumstances unlikely. In practice, the opposite was the case. New fortunes, unlike old, invite display; and Florence was awash with new money. By the 1490s another Strozzi, Filippo, had grown individually so rich that he was worth more than twice as much in real terms as the great Palla. It was Filippo who began building the huge Strozzi Palace, far exceeding his own family's needs, which he then left unfinished on his death. Furthermore, Filippo and his contemporaries, as well as being distinctly richer than their early fifteenth-century counterparts, belonged also to a much larger group. There had been nobody in Florence in 1427 to equal Palla Strozzi. Just a century later, there were no fewer than eighty Florentine citizens at least as rich as Palla, of whom eight enjoyed fortunes twice as large.[20]

For many of these, public patronage of the arts was acceptably part of the price of Florentine citizenship. Pride in their city was motivation enough. However, a more general occasion for investment in the arts was provided by after-death soul-care. Palla Strozzi's many works of public piety, for which he expected (and received) recognition, included the commissioning in 1423 of Gentile da Fabriano's splendid and hugely popular *Adoration of the Magi* altarpiece for the fashionable church of Sta Trinità. Likewise big donor figures feature prominently in the foreground of Masaccio's almost contemporary *Holy Trinity* (1425–7) at Sta Maria Novella, where Domenico Lenzi and his wife kneel in adoration of the Crucified Christ, of God the Father, the Virgin Mary and St John. It was of this highly original work, admired more by other painters than by the art-loving public of the day, that Vasari later wrote: 'the most beautiful thing, apart from the figures, is the barrel-vaulted ceiling drawn in perspective and divided into square compartments containing rosettes foreshortened and made to recede so skilfully that the surface looks as if it is indented'.[21] And it is true that neither Masaccio's mastery of perspective nor his intuitive understanding of classical architecture had any parallel in Florentine painting of his time. Yet there is a more traditional moral message in Masaccio's *Trinity*. Below his two donor figures is a skeleton on a sarcophagus, painted with as much care as the rest of the fresco and accompanied by the ancient warning legend: '*Io fuga quelche voi sete* ... I was once what ye are now; and what I am now, so shall ye be.'

Almost identical *memento mori* texts occur on twelfth-century tomb-slabs. They are used again on pre-plague morality paintings of *The Three Living and the Three Dead*, where the Dead confront the Living at a crossroads, and have no necessary association with the pestilence. In contrast, the cadaver-bearing 'transi' tomb – always more common north of the Alps than in Mediterranean lands such as Italy – gained broad acceptance as a funerary convention only in the fifteenth century, when at least some of the cadaver's realism and much of its immediate impact were unquestionably owed to

the everyday experience of the dying and the dead shared by sculptor and public alike. Even so, it was less contemporaries' morbid preoccupation with sudden death which inspired the style than their abiding dread of the punishments of Purgatory. At the turn of the century when the transi tomb began – most influentially with the cadaver effigy of Cardinal Jean de Lagrange (d.1402) at Avignon – the naked and corrupt figure of a great prince of the Church served chiefly to demonstrate humility: 'Miserable one [runs the cardinal's inscription], why are you so proud? You are only ash, and you will revert, as we have done, to a fetid cadaver, food and titbits for worms and ashes.' However, as the style spread to laymen, other purposes were added: to attract attention, to awaken pity, and to elicit prayer.[22] At John Barton's rebuilt church at Holme by Newark, there is the customary inscription in the big east window over the altar, calling on the devout to 'pray for the soul of John Barton . . . builder of this church, who died 1491'. Identical *orate pro anima* (pray for the soul of . . .) texts are repeated all over Europe in similar contexts. Yet on Barton's canopied monument – paired effigies above, single cadaver below – the appeal is both more personal and more affecting: 'Pity me, you at least my friends, for the hand of the Lord has touched me.'

Barton's words were original, but his concerns were not. And never have prayers for the dead been invoked more assiduously than in the century leading up to the Reformation. Purgatory – where the shriven soul is comprehensively cleansed by fire and ice – was already an ancient concept when accepted as Church doctrine at the Council of Lyons in 1274. However, what had not been made so clear until that time was the clergy's power of intervention. How long a soul must remain in Purgatory – 'some longer and some shorter' – would depend, the Church taught, not just on 'whether they have done good on Earth before they died' but also on 'whether they have friends on Earth to help'.[23] And in the formal recognition of prayer's supreme role in speeding release from torments so dreadful 'that all the creatures in the world would not know how to

describe their pains', the first elements of a bargain were spelled out. 'It is for the rich to pay, the poor to pray', dictated the popular contemporary jingle. That implicit contract, once accepted by the wealthy, brought a flood of new investment to the arts.

'For Jesus love pray for me', urged John Tame (Barton's contemporary) on his own founder's monument at Fairford Church. 'I may not pray, now pray ye, with a *pater noster* and an *ave*, that my paynys relessid may be.'[24] And by 1500, when John Tame died, provision for personal soul-care – the earliest form of health insurance – had become so everyday that it would routinely absorb up to a third of a testator's estate. John Tame was a rich clothier, and he built a big church. However, when the even wealthier nobility took out policies of their own, what resulted were huge factories of prayer. One of the greatest of these was the Burgundian tomb-church at Champmol, near Dijon, newly founded in 1378 by Philip the Bold (d.1404) for a double-sized community of Carthusians. The Champmol Charterhouse has gone. But among the fine sculptures preserved on its destruction is Claus Sluter's highly original monument to Philip the Bold himself, where the duke's recumbent effigy, hands raised in prayer, has hooded mourners processing round the tomb-chest.

As Adam Smith once wrote: 'With the greater part of rich people, the chief enjoyment of riches consists in the parade of riches, which in their eye is never so complete as when they appear to possess those decisive marks of opulence which nobody can possess but themselves.' (*Wealth of Nations*). And Philip of Burgundy's sculptors – Jean de Marville, Claus Sluter and Claus de Werve in succession – were indeed the best that money could buy, while his monks were the most highly regarded. When other religious orders, condemned for lax observance and widely blamed for God's wrath, were held in low esteem, the more ascetic Carthusians continued to attract patronage from those so rich that they could afford the high costs of the very best quality intercession. Carthusians were expensive. Rejecting the life in common, they lived out their silent lives in

spacious private cells set about a great cloister, and only their little-used churches were ever small. Nevertheless, for all their expense, as many as seven of the nine English Charterhouses were to be of post-1340 foundation, including big double houses at London (1371) and Sheen (1414): the first owing its scale to great City fortunes sometimes dubiously acquired, the second to the free-flowing conscience-money of Lancastrian kings, troubled by the murder of an archbishop. 'Five hundred poor I have in yearly pay', boasts Henry V on the brink of Agincourt, 'who twice a day their wither'd hands hold up toward Heaven, to pardon blood.' (*Henry V*, iv:i:294–6). And while the prayers of the destitute had particular worth, to those were now added the even weightier prayer barrages of Henry's forty Carthusian monks at Sheen, next to his new manor-house, and of another sixty Bridgettine nuns at Syon Abbey (1415) across the river, storming Heaven together.

If soul-masses were indeed, as many supposed, 'highest in merit and of most power to draw down the mercy of God', there was no absolute limit to their numbers. What resulted was serious inflation. Whereas the endowment of between 1500 and 5000 soul-masses was considered usual – if by normal standards excessive – in the mid-fourteenth-century nobility of Bordelais, Bernard d'Ecoussans left provision for 25,000 masses for himself and another 10,000 for his forebears, Jean de Grailly bought 50,000, and Bernard Ezi doubled that number.[25] Prayer barrages of this density were clearly burdensome to heirs, as were the other works often associated with such programmes. It took, for example, very nearly half a century to wind up the personal soul-trust of Richard Beauchamp, Earl of Warwick (d.1439). And among the causes of this delay, hugely damaging to Richard's heirs, was the commissioning in 1451 of a tomb and effigy of superlative quality – 'to cast and make a man armed, of fine latten garnished with certain ornaments, viz. with sword and dagger; with a garter; with a helme and crest under his head, and at his feet a bear musled, and a griffon, perfectly made of the finest latten' – to be housed in a splendid new chapel dedicated

to the purpose and attached to the family's collegiate chantry at Warwick Church.

While the Beauchamp investment was heavy enough, it could scarcely compare with that of many of the royal families of late-medieval Europe, or even of the greater princes of the Church. Exclusive Carthusians were again the first choice of Juan II of Castile to be custodians of the royal dead at Miraflores (Burgos), where an over-sized church began rising in 1442, to be ready at last by the mid-1480s to receive the sumptuous tombs of Juan II and Isabella of Portugal and of the Infante Alfonso their son, commissioned by Isabella of Spain (Alfonso's sister) from the workshops of Gil de Siloé. A generation earlier, João I (the Great) of Portugal had made similar provision for his new dynasty. Mindful of the Virgin's help in granting him a decisive victory over the Castilians at Aljubarrota in 1385, João (after some hesitation) chose a Marian order – Dominicans on this occasion – to tend the family tomb-church at Batalha, north of Lisbon. And there he still lies, in the most enormous state, next to Philippa of Lancaster, his English queen.[26]

Philippa was the eldest daughter of John of Gaunt, son of one king (Edward III), uncle of another (Richard II), and father of a third (Henry IV). Her half-sister (by the duke's second marriage to Constance of Castile) was Catherine, queen of Castile; and one of her half-brothers (by Gaunt's third wife, Catherine Swynford) was the great priest-statesman Henry Beaufort (d.1447), 'Cardinal of England', Bishop of Winchester, and international diplomatist. In circles such as these, national frontiers had little meaning in the arts. Thus the architecture of Portuguese Batalha, in its primary phase, shows clear English influence, being an early demonstration of the close bond between the nations first established at the Treaty of Windsor in 1386. And when, in the 1430s, Cardinal Beaufort spent many months in the Low Countries on diplomatic missions to the Burgundians, he took the opportunity to have his portrait painted by Philip the Good's most favoured artist, Jan van Eyck.[27]

Beaufort was an old man when the painting was done, and he may already have been pondering his death-plan. Certainly, over the next ten years he took every known precaution to guarantee the comfort of his soul. While plainly confident of his ability to translate the wealth of this world into high-ranking ease in the next, Beaufort nevertheless made provision for an instant barrage of 10,000 soul-masses on his death. He endowed perpetual chantries at three great cathedrals (Lincoln, Canterbury and Winchester); made major contributions, similarly recompensed by prayer, to Henry VI's mammoth educational charities at Eton and King's College (Cambridge); and invested heavily in the rebuilding of the ancient hospital of St Cross (Winchester) as an almshouse or refuge 'of noble poverty'. Even after these and much else, the residue of Beaufort's estate was still substantial. All was to be spent – the cardinal instructed his executors – in such ways especially 'as they should believe to be of the greatest possible advantage to the safety of my soul'.[28]

It was this single-minded concentration on the soul's repose which, whatever the announced purpose of the work in hand, inspired the great majority of fifteenth-century *Grands Projets*. Thus it was Archbishop Chichele's clearly expressed desire in 1438 that the 'poor and indigent scholars' of his new Oxford college at All Souls should

> not so much ply therein the various sciences and faculties, as with all devotion pray for the souls of glorious memory of Henry V, lately King of England and France . . . of the lord Thomas, Duke of Clarence [Henry's brother], and other lords and lieges of the realm of England whom the havoc of that warfare between the two said realms has drenched with the bowl of bitter death.

And it was in this century, in particular, that the funding of universities attracted the attention of propertied but heirless bishops whose concern to improve the quality of diocesan clergy ranked second

after the protection of their souls. 'There never was a prelate so good to us as you have been', wrote the grateful scholars of Oxford to Richard Beauchamp, Bishop of Salisbury (1450–81), shortly before his death: 'You promised us the sun, and you have given us the moon also.' Yet Bishop Beauchamp, in point of fact, was among the less substantial of their benefactors.[29]

Fifteenth-century Europe, half-empty and bullion-starved, was both socially and economically disadvantaged. Yet so general was the belief in the cleansing power of prayer that there has never been another time in the entire history of the Church when so much funding has been directed to just one end. Furthermore, if the costly death-styles of the wealthy had established a new climate for exceptionally generous investment in the arts, so also had the life-styles of those 'great ones' of the century – usually the same – whose chosen mode of government was to dazzle and overawe by exhibitions of conspicuous waste. Henry Beaufort, the 'Rich Cardinal', was dynast as well as priest. And for him as for his siblings (the sons and daughters of John of Gaunt) 'dispendiousness' and 'great giving' – the distinguishing marks of the *generosus* – were the inescapable accompaniments of high rank. 'One morning, on a solemn feast', relates Vespasiano da Bisticci (Florentine bookseller and gossip), taking his story from Antonio dei Pazzi, a fellow citizen, 'the cardinal assembled a great company for which two rooms were prepared, hung with the richest cloth and arranged all round to hold silver ornaments, one of them being full of cups of silver, and the other with cups gilded or golden. Afterwards Pazzi was taken into a very sumptuous chamber, and seven strong boxes full of English articles of price were exhibited to him.'[30] Almost nothing now remains of a collection so extraordinary that even a Florentine banker was impressed. However, among the many treasures known to have stuck to the old cardinal's fingers in his last acquisitive decade was the Royal Gold Cup of Charles VI of France, made in Paris for Jean de Berri in the late 1380s and subsequently presented to his nephew, the young king. Now in the British Museum, the

cup is decorated on bowl and cover with fine enamel miniatures of the life, miracles and martyrdom of St Agnes. Yet for all its religious imagery, this precious vessel was (and long remained) a secular object, made chiefly for display and probably always intended for 'great giving'.[31]

On Charles VI's death in 1422 when by the terms of the Treaty of Troyes (1420) the infant Henry VI of England assumed his throne, the cup had come into the possession of Beaufort's nephew, John of Lancaster, Duke of Bedford and Regent of France. And Bedford himself was a patron in the grand manner, both collector and acknowledged connoisseur. As would-be promoter of the fragile union of France and England brought about by Henry V's marriage to Catherine of Valois (daughter of Charles VI), Bedford had frequent cause for political giving. However, his collecting instincts were not exclusively pragmatic. And the possession of objects of great value has always found much favour with the rich. One who caught the habit early was Francesco Gonzaga (1444–83), cardinal at the age of seventeen, whose particular private passion was for carved and engraved gemstones, both cameos and intaglios, many of them recovered from ancient sites. The cardinal's other special interest was in books. While no great scholar himself, Gonzaga was the patron of leading contemporary humanists. And almost a quarter of his large collection was given over to the classical texts to which his friends among the literati had introduced him. As inventoried on Gonzaga's death in 1483, his books included the poetry of Terence and Virgil, Horace and Ovid; the oratory of Cicero; the ethics of Aristotle; the histories of Sallust, Livy and Plutarch; the comedies of Plautus, the satires of Juvenal, the tragedies of Seneca the Younger, and many more. In his own tongue, Gonzaga read the poetry of Dante and Petrarch, the short stories of Boccaccio, and the marvels of the explorer Marco Polo. In the cardinal's library, the largest single category – 66 books in total – was made up of works of religion. Nevertheless, the contrast overall with the even greater collections of another clerical bibliophile, Guillaume d'Estouteville,

Cardinal Bishop of Ostia, was very striking. Cardinal d'Estouteville died the same year. But the Frenchman was no humanist. And while his library was extensive, his reading was chiefly limited to theology and patristics, to contemporary devotional writings, and to the law.[32]

To be or not a humanist was never a stark choice for European intellectuals of North and South. In France, as early as the 1410s, Jean de Montreuil, Charles VI's learned chancellor, was a collector of classical texts, a reader of Petrarch, and an admirer of Leonardo Bruni, the humanist scholar, who was later himself Chancellor of Florence (1427–44). And when Poggio Bracciolini, subsequently Chancellor of Florence in his turn, came to England in 1429 to comb monastic libraries for antique texts, he was welcomed there by Cardinal Beaufort among others. Yet what Poggio encountered could hardly have been more remote from his experience. 'The past is a foreign country', L.P. Hartley once declared, 'they do things differently there.' And equally unbridgeable in Poggio's generation was the gulf between Mediterranean and Northern life-styles. On returning to Italy, Vespasiano tells us, Poggio 'had many witty stories to tell of adventures he had encountered in England and Germany when he went thither', among them a favourite tale of a four-hour English banquet during which 'he had been forced to rise and bathe his eyes with cold water to prevent him from falling asleep'. Poggio – 'the foe of all deceit and pretence' – was also wickedly dismissive of Northern scholars. But one of the things Poggio reported, and which was confirmed by other travellers, had particular resonance for the arts. 'The nobles of England', Poggio wrote, 'deem it disgraceful to reside in cities and prefer to live in country retirement. They reckon a man's nobility by the size of his landed estate. They spend their time over agriculture, and traffic in wool and sheep.'[33] In contrast, Florentine noblemen preferred the urban life, while it was in the big-city populations of north and central Italy that the artists of the Renaissance found their patrons.

Some seventy years later, the Venetian author of *A Relation of*

England (*c.*1500) would again observe that 'there are scarcely any towns of importance in the kingdom', the exceptions being London, Bristol and York. Few Englishmen, furthermore, with the exception of the clergy, 'are addicted to the study of letters', even though 'they have great advantages for study, there being two general Universities in the kingdom, Oxford and Cambridge, in which are many colleges founded for the maintenance of poor scholars'. Yet neither their rustic predilections nor the poverty of their scholarship prevented the English from being 'great lovers of themselves, and of everything belonging to them; they think that there are no other men than themselves, and no other world but England'. And with English cloth just then commanding a higher premium than ever before, their self-esteem was not without cause. 'The riches of England', the Venetian continued, 'are greater than those of any other country in Europe . . . This is owing, in the first place, to the great fertility of the soil . . . Next, the sale of their valuable tin brings in a large sum of money to the kingdom; but still more do they derive from their extraordinary abundance of wool, which bears such a high price and reputation throughout Europe.'[34] Where sheep paid for all, it was less a horror of the new which excluded the Renaissance from the North than the sufficient quality of the life-styles already practised there.

That quality was the more welcome for following the long contraction which Professor R.S. Lopez was the first to identify as 'the economic depression of the Renaissance'.[35] Every part of Europe was affected by it. Fertile, mild of climate, and well-situated for the London market, Kent is still commonly known as England's 'Garden'. Yet even in this most favoured location of middle-income yeoman farmers, new housing-starts fell off appreciably in the mid-fifteenth century, to recover again only in the 1470s.[36] Nor can it be doubted that a currency crisis so prolonged and so severe as simultaneously to threaten Medici solvency and close the Flemish mints must have brought many larger projects to an end. That the crisis was less punishing to the arts than to the economy in general

was owed to a combination of special circumstances: to mortalities so unremitting as to destroy individual families and bring fortunes together, to paranoid investment in soul-care provision, and to a culture of 'magnificence' and free-spending. Another contributory circumstance was civil war.

One prominent casualty of the depression was the Malatesta principality of Rimini. And there, towards the end of 1461, with his city half-empty and nothing left to tax, Sigismondo Malatesta found himself unable to keep the literati in his household or pay his artists. Even work on his half-finished tomb-church of San Francesco – Alberti's Tempio Malatestiano at Rimini – would have to stop, and the only remedy left to him was war.[37] On this occasion, Sigismondo's enemy was Pius II, whose hired captain in the field was the Malatesta's next-door neighbour at Urbino. And two years later, it would be Federigo da Montefeltro's decisive victory over Sigismondo and his mercenaries that almost trebled Urbino's territory, raising its lord – already the most famous condottiere of his day – to the wealth and magnificence of a prince. Duke Federigo (1420–82), a 'Mars in the field, a Minerva in his administration', typifies the century's virtues and its vices. But what his history makes quite clear is that there was no way for a fifteenth-century nobleman, however sophisticated his education or spreading his estates, to prosper on good government alone. Federigo was a poor man when he came by chance into his inheritance. It was the vendetta, essentially, that made him wealthy. With as much blood on his hands as any Mafia godfather, Federigo's ambition to rebuild his Urbino palace was status-driven: 'to make in our city of Urbino a beautiful residence worthy of the rank and fame of our ancestors and our own status'.

Where Federigo differed from most other captains of his day was in his schooling. He had begun his education at the Mantuan academy of the great humanist teacher Vittorino Rambaldoni da Feltre (d.1446). And his favourite reading in later life remained the usual humanist texts, with a particular professional preference for

the histories of Livy and for the *De Bello Gallico* of Julius Caesar. 'In arms, his first profession', recollected Vespasiano, who had sold him many books, 'he was the most active leader of his time, combining strength with the most consummate prudence, and triumphing less by his sword than by his wit.'[38] And in truth, the bookseller reasoned, 'it is difficult for a leader [today] to excel in arms unless he be, like the Duke, a man of letters, seeing that the past is a mirror of the present'. More followed:

> As to architecture it may be said that no one of his age, high or low, knew it so thoroughly. We may see in the buildings he [Federigo] constructed, the grand style and the due measurement and proportion, especially in his palace, which has no superior among the buildings of the time, none so well considered, or so full of fine things ... As to sculpture he had great knowledge ... employing the first masters of the time. To hear him talk of sculpture you would deem it was his own art. He was [also] much interested in painting, and because he could not find in Italy painters in oil to suit his taste he sent to Flanders and brought thence a master [Joos van Gent] who did at Urbino many very stately pictures, especially in Federigo's study, where were represented philosophers, poets, and doctors of the Church, rendered with wondrous art. He painted from life a portrait of the Duke which only wanted breath.[39]

That portrait was long thought to have been the formal double-portrait of Federigo da Montefeltro and Guidobaldo, his infant son, now more usually attributed to Pedro Berruguete, the Castilian. And the long-term presence at Federigo's court of two such major foreign artists, while saying something also about their own crisis times at home, is tribute enough already to the range and intelligence of the duke's patronage. But the portrait has other intentions. Its first and most obvious emphasis is on the duke's worldly success

and magnificence. Duke Federigo displays his chivalric honours: the Garter of England and the Ermine of Naples. The great book he is holding is bound in the distinctive scarlet livery of what he had always intended from the first to be 'the finest library since ancient times . . . bought without regard of cost'. A richly dressed Guidobaldo, at his father's knee, holds the sceptre of government and promises the continuity in the Montefeltro dynasty which is the second major message of the painting. That continuity had not been easily achieved. Federigo himself had been born illegitimate. He had succeeded his murdered half-brother at Urbino chiefly because the much younger Oddantonio had no son. Then two of Federigo's own natural sons – the talented Buonconte and probably Bernardino also – had died of the plague; while the pale and delicate Guidobaldo of the Urbino double-portrait was the cradle-sick last child of what was otherwise a quiverful of daughters.

Berruguete's painting is not overtly religious. It lacks even the usual close attendance of a saint. Yet we are told that 'as to works of alms and piety he [Federigo] was most observant. He distributed in his house every day a good quantity of bread and wine without fail, and he gave freely to learned men and gentlefolk, to holy places, and to poor folk ashamed of their case.'[40] Federigo's charity, we may assume, had some design. There is another and larger painting at Urbino, more certainly by Joos van Gent, in which the duke is shown with members of his circle as witnesses of Our Lord at the Last Supper. *The Communion of the Apostles* (1473–4) is the central panel of a big and costly altarpiece, partly paid for by the duke but commissioned for their chantry by one of the wealthier confraternities of Urbino. Its purpose, unequivocally, was commemoration. Not many years before, Niccolò della Tuccia, similarly portrayed with the *Madonna of Mercy* (1458) at Viterbo, had sought to justify his presence in that company. He was there, Niccolò explained, 'not out of pride or vainglory, but only in case any of my successors wishes to see me, he can remember me better thus, *and my soul may be commended to him*'.[41] In Renaissance Italy, as throughout the

Gothic North, neither the banker nor the soldier, the priest nor the scholar could ever entirely set aside their apprehensions. Art has never known a greater stimulus than fears of Purgatory.

Expectations Raised and Dashed

'Money is like muck', wrote Francis Bacon (1561–1626), 'not good except it be spread.' And in his own lifetime there was much more of it about. In complete contrast to the severe and prolonged bullion famines of the late fourteenth and fifteenth centuries, Central European silver production had enormously increased. The formerly rich but long abandoned silver sources at Goslar, Freiberg and Kutná Hora had been made accessible again by more up-to-date technologies. And the new silver mines at Schneeberg (Saxony) and Schwaz (the Tirol) had come into full production by the 1470s, to be closely followed in the next generation by those at Annaberg (Saxony) and Joachimsthal (Bohemia).[1] In 1542, in the first known formulation of the quantity theory of money (according to which price levels are determined by the money supply), Sigismund of Poland's counsellors reported: 'This year the unmeasurable increase of the coinage has raised the value of the gulden very much and will raise it still further, if nothing is done ... When now the gulden (which is a measure and standard of everything bought and sold) rises and becomes dearer, it follows that everything brought from abroad and grown at home must become dearer too.'[2] 'As for the reason [for these price rises]', wrote Peter Kmtia, Palatine of Cracow, that same year, 'nobody is so foolish as not to see that the multitude of coins is to blame, which is in no relation to either the gulden or the things to be bought, as it used to be in former times.'[3]

In his own terms, Kmtia's analysis was perfectly correct: there was too much silver in circulation, forcing up the face value of the Polish gold gulden and causing prices to rise out of control. However, the population of the West was recovering swiftly also, and a superabundance of bullion – additionally swollen from the 1520s by Spanish-American gold and silver – was not the only explanation of the 'price revolution' which saw European prices, after their long stagnation, rise between three and four times in just one century. George Hakewill (d.1649), the English scholar and divine, saw this clearly. Writing in the 1620s, Hakewill recognized that it had not been 'the plenty of coin' alone which had caused the upward drift of prices but 'the multitude of men' – for 'either of which asunder, but much more both together, must need be a means of raising the prices of all things'.[4] 'That the number of our people is multiplied', wrote William Lambarde in the 1590s, 'is both demonstrable to the eye and evident in reason'. And whereas Lambarde's list of likely causes included the broods of married clergy – 'which was not wont to be' – he could also point more plausibly to the fact that 'we have not, God be thanked, been touched [in England] with any extreme mortality, either by sword or sickness, that might abate the overgrown number of us.'[5]

Just as everybody by the 1590s had a view on overcrowding, so the contemporary price inflation produced a literature of its own, explanations ranging from usury (the old enemy) to enclosure (the new), from harvest failures and civil commotion to state monopolies and excessive government spending. Fashion also took its share of the blame. Poland's youths, Bishop Tarlo had complained during the currency scare of 1542, 'cannot go comfortably and smoothly without foreign merchandise as nourishment and clothing'.[6] And seven years later, it was Sir Thomas Smith's lament that 'there is no man [in England] can be contented now with any gloves than is made in France or in Spain; nor kersey, but it must be made of Flanders dye; nor cloth, but French or frizado; nor owche, brooch, nor aglet, but of Venice making or Milan; nor dagger, sword, nor

girdle, or knife, but of Spanish making or some outward country; no, not as much as a spur, but that is fetched [bought] at the Milaners [milliners].'[7]

Complaints of this kind are often heard, and are not usually given much credence. However, Sir Thomas – 'physician, mathematician, astronomer, architect, historian, and orator' – was no ordinary Colonel Blimp. And as one of the promoters of Edwardian England's recovery from the chaos of Henry VIII's Great Debasement, he was exceptionally well placed to appraise for himself the consequences of over-rapid growth. As to how it all began, historians today have yet to agree on fundamentals – 'the price revolution was a phenomenon of [population-led] bullion velocity rather than of bullion imports' (Harry Miskimin); 'the price rises in England were not caused by the influx of precious metals but by . . . the upsurge of credit and the rise of banking and of the inland bill of exchange' (Eric Kerridge); 'the price revolution evidently began in Spain . . . [and was] a monetary phenomenon after all' (Douglas Fisher).[8] However, the fact remains that, after the long price stability of the late fourteenth and fifteenth centuries, prices continued to rise through every decade of the next; that economies were growing and that their growth was real; and that it was not just prices which rose but profits also.

Much emphasis has been placed on the inflationary effect of large-scale imports of Spanish-American bullion. And it is undoubtedly true that inflation in Spain from the 1520s forced up price levels in other nations also. But the turn-around of the West's economy had begun much earlier. And it was in the late 1460s and 1470s, when silver returned and the mints re-opened, that rents and other revenues became collectable again and that the purses of the rich were replenished. It was not American gold that enabled Ludovico il Moro (d.1505), the Sforza ruler of Milan, to attract Donato Bramante from Urbino and Leonardo da Vinci from Florence, but a strong revival of Lombard industry and commerce. In Florence, it was the recovery of banking profits from the 1470s that allowed

Lorenzo de' Medici (the Magnificent) and his fellow bankers to commission work of the highest quality from Andrea del Verrocchio and Sandro Botticelli, Filippino Lippi and Domenico Ghirlandaio. And what supported Andrea Mantegna at Mantua, Francesco del Cossa at Ferrara, and Piero della Francesca at Urbino, was always less the old-style profits of war of their respective Gonzaga marquesses and Este and Montefeltro dukes, than a very visible escalation of landed wealth. Baldassare Castiglione's hugely influential dialogue, *Il Cortegiano* (The Courtier), while first drafted at Urbino in 1508, took many more years to complete. And his cherished recollections of life in Duke Guidobaldo's palace – 'the very Mansion place of mirth and joy' – no doubt improved in the telling. But Castiglione (like Sir Thomas Smith) was an expert witness: a professional courtier all his life. And his final judgement, in consequence, carries weight. 'There was then to bee heard', Castiglione remembered of those long evenings of lively talk, 'pleasant communications and merie conceites, and in everie mans countenance a man might perceive painted a loving jocundnesse . . . And I beleeve it was never so tasted in other place, what manner a thing the sweete conversation is that is occasioned of an amiable and loving company, as it was once there.'[9]

In April 1528, when his book was at last published, Castiglione was in Spain at the Court of Charles V, where he was Clement VII's papal nuncio. Less than a year later, he was dead. However, there had been manuscript versions of *Il Cortegiano* in circulation for at least ten years before his death, and Castiglione's book was an immediate success. Charles V (Holy Roman Emperor) and Francis I (King of France) each received a presentation copy from the author, as did Pope Clement VII (Castiglione's employer) and Isabella d'Este (his patron). Other recipients of complimentary copies included Eleonora Gonzaga (Duchess of Urbino), Federico Gonzaga (Marquis of Mantua), Aloysia Gonzaga Castiglione (the writer's mother), and Ippolita Fioramonda (Marchioness of Scaldasole). Thomas Cromwell (the English statesman) is known to have possessed a copy as

early as 1530; in the following year, Rosso Fiorentino (the Mannerist painter) had another; in 1545, a third was on its way to Peru.[10] Translated first into Spanish (1534), then French (1537), then English (1561) and finally German (1565), nothing better demonstrates the aspiration, widely-shared across the West, for a life-style characterized by good talk and sensitive to the arts on the perceived model of Guidobaldo's Urbino. It was Victor Hugo who once said: 'Jesus wept; Voltaire smiled. Of that divine tear and of that human smile the sweetness of present civilization is composed.'[11] He spoke in 1878 at a commemoration of the centenary of Voltaire's death. But almost four centuries earlier, in Castiglione's time, that synergy was already present at Urbino.

Jesus wept for Lazarus. In 1528, he had greater cause for weeping in his Church. Castiglione, the pope's envoy, took Clement VII's initial blame for the Sack of Rome on 6 May 1527. But there were many, even then, who saw the looting of Rome's treasures by Charles V's unpaid troops as a visitation of God's wrath on Clement himself and on the venality and chronic nepotism of his Court. A decade before, the growing secularization of the papacy in the pursuit of dynastic ends had been a major cause of Martin Luther's disaffection when, on 31 October 1517, he nailed his ninety-five theses to the church door at Wittenberg, thereby launching the German Reformation. His target in that year had been the Medici pope, Leo X (1513–21), second son of Lorenzo the Magnificent. But already in 1509 it was the della Rovere warrior-pope Julius II (1503–13), nephew of Sixtus IV (1471–84), whom Erasmus had pilloried (but prudently failed to name) as 'the deadliest enemy of the Church', along with those earlier 'impious pontiffs' – Innocent VIII (1484–92), Alexander VI (1492–1503), and Sixtus himself – 'who allow Christ to be forgotten through their silence, fetter him with their mercenary laws, misrepresent him with their forced interpretations of his teaching, and slay him with their noxious way of life!'[11] 'They that will be rich [Paul advised Timothy] fall into temptation and a snare . . . For the love of money is the root of all

evil: which while some coveted after, they have erred from the faith, and pierced themselves through with many sorrows.' (*1 Timothy* 6:9–10)

It was Clement VII who reaped the whirlwind that the nepotistic Sixtus and his successors had rashly sown. Yet what must have struck most visitors to Rome, both before and after its Sack, was the ceaseless activity of its building sites. Sound money had returned during Sixtus's long pontificate. What followed was urban renewal. It was to Sixtus IV that Rome owed the Via Sistina and the Ponte Sisto; to Alexander VI, the Via Alexandrina; to Julius II, the Via Giulia; to Leo X, the Via Leonina; and to Clement VII, the Via Clementia. In the 1530s and 1540s, following the Sack, it was Clement's successor, Paul III (1534–49), who more than restored the ruined city with new buildings. But while this renewal undoubtedly gained momentum from the economic reforms which Sixtus IV put in place, it was never entirely the work of the popes. Sixtus's reforms are now most often remembered for the institutionalization of the sale of papal offices which helped create an army of Roman sinecurists and placed a heavy charge on future revenues. Yet he had greater success in the short term. Along with much else, Sixtus freed his cardinals and officials, by protecting their heirs, to use the receipts from their church benefices for private building. Thus it was that Alessandro Farnese (Paul III), while still a cardinal, began building his enormous family palace, the Palazzo Farnese, on the Via Giulia. Then after election to the papacy in 1534, Paul nearly doubled the building's size, spending almost a quarter of a million ducats on it before his death. Yet this was only one of the many new palaces and villas of Renaissance Rome, built by laymen as well as priests, both in the city itself and its Campagna.[12]

Paul III borrowed heavily to finance his many works. And it was largely with borrowed money that successive builder-popes – Pius IV (1559–65), Gregory XIII (1572–85), Sixtus V (1585–90), and Paul V (1605–21) – carried out their programmes of embellishment and renewal. They would have done so with more confidence

because their credit was good, because their revenues were rising steadily, and – perhaps most of all – because the bulk of their new money, in contrast to earlier times, came directly from taxation of the Papal State.[13] Even so, it would take over a century – and more than a million and a half gold ducats – to complete their flagship project, the new St Peter's, which became one of the heaviest crosses they had to bear. Begun during the pontificate of Julius II – 'a patron of genius and a lover of all good art' (Vasari) – under the direction of Donato Bramante, this huge enterprise drained the papal finances and absorbed the energies of other famous partnerships: Antonio da Sangallo (d.1546) with Paul III; Michelangelo Buonarroti (d.1564) with Julius III; Giacomo della Porta (d.1602) with Gregory XIII and Sixtus V; and – following consecration – Gianlorenzo Bernini (d.1680) with Urban VIII (the bronze *baldacchino*) and Alexander VII (the Piazza).

On 18 April 1506, when the foundation stone was laid, both Julius and his architect were over sixty. Understandably, they were men in a hurry. It was Julius's intention that receipts from the sale of papal indulgences should finance the work, there being long-established precedents for such action. However, another anticipated source of funding was rising revenues from the Papal State, the full recovery of which became the principal objective of Julius II's high-profile military campaigns. 'Here even decrepit old men', grumbled Erasmus in 1509, 'can be seen showing the vigour of youths in their prime, undaunted by the cost, unwearied by hardship, not a whit deterred though they turn law, religion, peace, and all humanity completely upside down.'[14] But Erasmus wrote in private to Thomas More, his English friend. And neither Julius (on the field of battle) nor Erasmus (in his study) knew the damage he was doing to the Church. 'I laid a hen's egg', reflected Erasmus after the event. 'Luther hatched a bird of quite a different species.' The incubator was Luther's horror of indulgences.

There were many, from the first, who felt as he did. Within two years of publication in 1518, Luther's polemical sermon on

indulgences and pardons (*Von Ablass und Gnade*) ran into no fewer than twenty German editions. And already by the mid-1520s, there were great numbers of evangelical tracts in circulation in Germany, for many of which Rome itself – so-called 'Whore of Babylon', 'Seven-headed Dragon', 'Gathering of Antichrist', 'Synagogue of Satin' – was the enemy.[15] That wild frenzy of pamphleteering – the *Flugschriften* of Luther's followers – was a specifically German phenomenon. Yet it could not have happened, even in print-alert Germany, if economic recession had still gripped the West. In the event, it was those circumstances exactly which favoured the Roman papacy – new technologies (including printing), the return of sound money, easy access to cheap credit, and the beginnings of world expansion – that almost immediately split the Church.

Those were the circumstances also that encouraged movement in the arts, introducing the Renaissance to the North: to France under Louis XII (1498–1515) and Francis I (1515–47); to Germany and the Low Countries under Maximilian I (1493–1519) and Charles V (1519–56); to England under Henry VII (1485–1509) and Henry VIII (1509–47). It was the Urbino-born painter Raphael, Julius II's talented protégé, whose fame (Vasari tells us) 'spread as far as France and Flanders, and [also] influenced the work of Albrecht Dürer, the marvellous German painter and master of fine copper engravings'. Leonardo da Vinci, invited to France by Francis I, died there in 1519. And while Francis was less successful in attracting Michelangelo to the North, having no better luck with the Venetian painter Titian, he remained nevertheless an assiduous collector of their art, being among those contemporary potentates – Charles V, Holy Roman Emperor, and Suleiman the Magnificent, Sultan of Turkey, were others – who severally made Michelangelo 'very honourable offers, simply to avail themselves of his great talents'.[16]

From 1529, when he began rebuilding Fontainebleau, Francis I assembled the cream of his collections in that huge palace. 'All that he could find of excellence,' recorded the architect-engraver Jacques Androuet Du Cerceau (d.1585), 'was for his Fontainebleau, of which

he was so fond that whenever he went there he would say that he was going home.'[17] And one of the king's most cherished possessions was Leonardo's remarkable portrait of Mona Lisa, wife of Francesco del Giocondo, of which Vasari wrote:

> If one wanted to see how faithfully art can imitate nature, one could readily perceive it from this head; for here Leonardo subtly reproduced every living detail. The eyes had their natural lustre and moistness . . . The eyebrows were completely natural, growing thickly in one place and lightly in another and following the pores of the skin . . . The mouth, joined to the flesh-tints of the face by the red of the lips, appeared to be living flesh rather than paint . . . There was a smile so pleasing that it seemed divine rather than human; and those who saw it were amazed to find that it was as alive as the original . . . Altogether this picture was painted in a manner to make the most confident artist – no matter who – despair and lose heart.[18]

That final parenthesis has been repeated ever since to explain a paradigm shift in Western art from the truth-to-nature realism of Leonardo and his contemporaries to the exaggerated gestures, long-bodied human figures, vivid contrasting colours, and extremes of light and shade of the Roman Mannerist painters of the next generation. But giants though the great masters of the High Renaissance undoubtedly were, setting new standards of unattainable perfection, the almost immediate rejection by their pupils of regularity in the arts – in sculpture and in architecture, as much as in painting – had more to do with aspiration than despair.

Following the Sack of Rome, it was in the North that many Mannerists found a welcome. Thus it was that Rosso Fiorentino, the *bravura* painter, who had been working in Rome in 1527 when assaulted and robbed by German troops, accepted the French king's invitation to come to Fontainebleau in 1530–1, where he was appointed 'superintendent of all the buildings, pictures and other

ornaments of that place'. And it was at Fontainebleau most memorably, in the frescos and stucco ornament of the Galerie François Ier, that Rosso achieved his finest work. Certainly, Vasari was in no doubt that Rosso gained much more than he lost from his Northern exile, for 'although in Rome and in Florence his labours were not pleasing enough to those who could reward them, he did, however, find someone to give him recognition for them in France, and with such results that the glory he won could have quenched the thirst of every degree of ambition that could fill the breast of any craftsman whatsoever'.[19]

Rosso's death in 1540 greatly saddened the king, for 'it seemed that he had lost the most outstanding craftsman of the day'. And it was no less distressing to the artist's friends and fellow craftsmen 'who, through him, have learned how much may be acquired from a prince by one who has all-round competence and is well-mannered and gentle in all his actions, as he was'.[20] Rosso's close associate at Fontainebleau, and his successor in the superintendency, was Francesco Primaticcio (d.1570), known especially for his artistry in stucco work. And both Primaticcio (as superintendent) and Rosso (as fellow Florentine) would have known Benvenuto Cellini (1500–71) – master goldsmith, would-be sculptor, and inveterate braggadocio – who similarly knew the warmth of Francis's patronage. It was 'the French king', Cellini later wrote in explanation of his own genius, 'who set me on the path of sculpture'. And while rather little of Cellini's *Autobiography* is the plain unvarnished truth, Francis's enthusiasm for his work is clear enough. Early in 1542, not long after entering the king's service, Cellini had been instructed to make proposals for a great new fountain at Fontainebleau, 'with the most elaborate adornment I could devise'. Then some six weeks later, when he showed his model to the king, so delighted was Francis that he clapped Cellini on the shoulder, crying: '*Mon ami*, I don't know which is the greater, the pleasure of a prince at having found a man after his own heart, or the pleasure of an artist at having found a prince ready to provide him with all he needs to express his great creative ideas.'[21]

Pride of place in Cellini's fountain was to have been given to a colossal figure of the God Mars ('unique in valour'), otherwise Francis himself. But war with Charles V's Empire – Francis's most expensive yet – had just begun again. And work on the fountain was only part-complete when Cellini's return to Italy in 1545, followed two years later by his patron's death, robbed the sculptor of 'the glory of my great work, the reward of all my labours, and of everything I had left behind me [in Paris]'.[22] In reality, Cellini's colossus – as tall as a three-storey building and greater (the sculptor boasted) than anything in Antiquity – would probably never have been finished. Yet Francis (Cellini claimed) had believed in the scheme sufficiently to order his treasurers to 'provide all I needed *no matter what it cost*'. And whether or not that was the truth, the image of 'patron of genius and lover of all good art' was as important to Francis I's design for a centralizing monarchy in France as to Julius II's ambitions for a new Jerusalem in Rome.

Sale of offices was a strategy they shared. 'When the king orders the construction of a private or public building', the Venetian ambassador reported home in 1535, 'officers are appointed to supervise it who are paid a pension and are chosen among the families of office-holding noblemen. These offices still exist and that is why so many buildings are started and never completed.' And some eleven years later, the evil practice was still continuing, for 'offices are infinite in number and increase daily ... half of which would suffice'.[23] Most to blame for this venality were the king's continual wars, each promoting another crisis in state funding. Yet population was again rising in many parts of France. And so strong was the French economy on Francis's accession in 1515 that not even the inherited war in Italy, with its humiliating *dénouement* in the king's defeat and capture at Pavia in 1525, could seriously dent the riches of a kingdom justly famed for its 'beauty, fertility, fecundity and abundance of all excellent things, as if it were the heart, the cream or the yolk of the egg'.[24]

That abundance was still largely agricultural. But where growth

took off most vigorously was in the towns. Lyons, after Paris, was France's fastest growing city. And it was in the furnaces of Lyons that Girolamo Cardano – the Milanese physician and mathematician – saw English coal for the first time: 'stones that can be ignited and that burn . . . [to] produce a very intense fire . . . exceptionally useful in the processing of iron'.[25] In 1552, when he made that journey north, Cardano found Paris less to his liking: 'although the largest city in France, [it] is a rather filthy place, filled with stench and poisoned air.' However, of a third French city, Rouen, he had little but praise, preferring it even to Milan: 'It is well situated, it has fine architecture, and its inhabitants are handsome. It lies among hills and fertile fields, along a navigable river with beautiful islands . . . The town itself has a stone bridge and stately houses and impressive churches. The spires of the cathedral are of extraordinary height and magnificence – I don't know if there are any more beautiful in Europe . . . It would seem that only Rome is even better situated and still more imposing and beautiful.'[26]

It was to banking especially that Lyons owed its wealth. Rouen's prosperity was maritime-based. In both cases, growth was concentrated in the first half of the sixteenth century and followed many decades of recession. Fortunes were improving in the countryside also, where the crown, like other landowners, profited from higher prices and rising rents. Yet important though his demesne revenues (*finances ordinaires*) always were to the king, it was from taxation (*finances extraordinaires*) that he stood most to gain – from his sales taxes (*aides*), his salt tax (*gabelle*), and his land tax (*taille*), of which the last was very much the most important. Already at the start of Francis I's reign in 1515, the *taille* accounted for almost half the royal revenues; it had doubled in yield before his death. And the great advantage to Francis of this high-yielding direct levy – the envy of other monarchs – was that it gave him immediate access to vast resources.[27] Thus it was the ready availability of Francis I's revenues from the *taille*, in particular, that enabled him to fund his habit of uninhibited spending on the arts – on Chambord and the

RIGHT When commissioned in 1880 to make the
great bronze doors of the *Musée des Arts Décoratifs*
in Paris, Auguste Rodin (b.1840) at last received the
state support he needed to create his acknowledged
masterpiece: a huge and complex scheme which was
to include many of the sculptor's best-known figures
and which came to be known (after Dante's *Inferno*)
as *The Gates of Hell*.

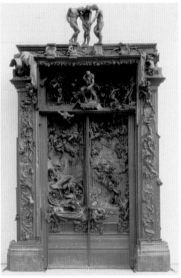

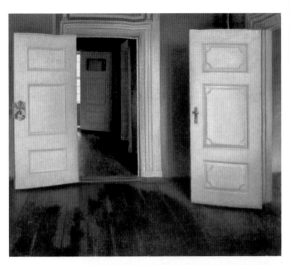

LEFT *White Doors* (1905), by
Vilhelm Hammershøi (1864–1916),
is one of the tranquil interiors,
many of them views of his own
apartment in Copenhagen, which
brought this unjustly neglected
Danish painter international
recognition during his lifetime.

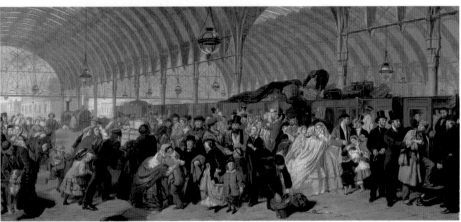

William Frith's *The Railway Station* (1862) was the most acclaimed of his modern life
panoramas. Yet it was to be of this same painting that Clive Bell wrote just five years after
the artist's death: '*Paddington Station* is not a work of art; it is an interesting and amusing
document ... (but) with the perfection of photographic processes and of the cinematograph,
pictures of this sort ... are grown superfluous'(*The Aesthetic Hypothesis*, 1914).

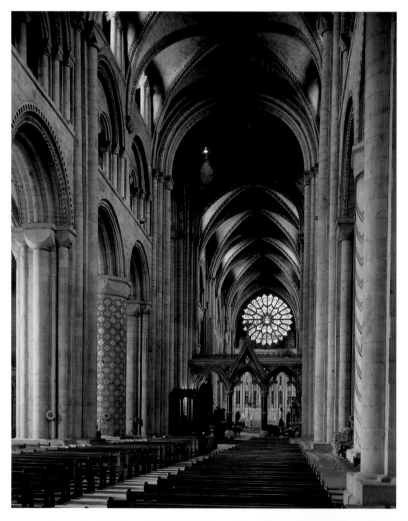

ABOVE Begun by William of St Calais (d.1096) and continued by Ranulf Flambard (d.1128), Durham Cathedral was conceived and built on the triumphalist scale that the Norman bishops' windfall fortunes could support.

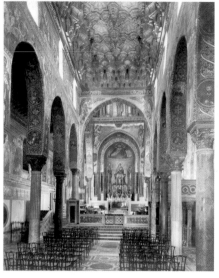

RIGHT Byzantine mosaics, a Saracenic ceiling, and the re-used antique columns at Roger II's Palatine Chapel (*Cappella Palatina*) at Palermo reflect the wealth and cosmopolitan interests of Sicily's Norman rulers before the progressive Latinisation of their kingdom.

Jeremiah, reeling back in alarm, receives a doom-laden prophesy from the hand of God in this lively initial by the Leaping Figures Master in Henry of Blois's great *Winchester Bible*. It was at the *scriptorium* in Winchester, under the discriminating patronage of the well-travelled Bishop Henry, that different traditions came together – from Sicily (the Morgan Master) and Spain (the Genesis Master) – in a project of unrivalled ambition.

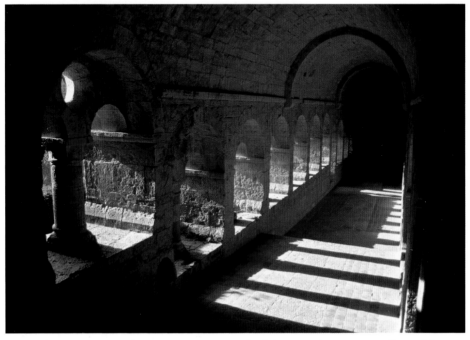

Bernardine austerity, in finger-wagging reproach of the excessive ornamentalism of the older-established Cluniacs, characterises this severely plain cloister at the Abbey of Thoronet (Provence), one of the earlier Cistercian foundations.

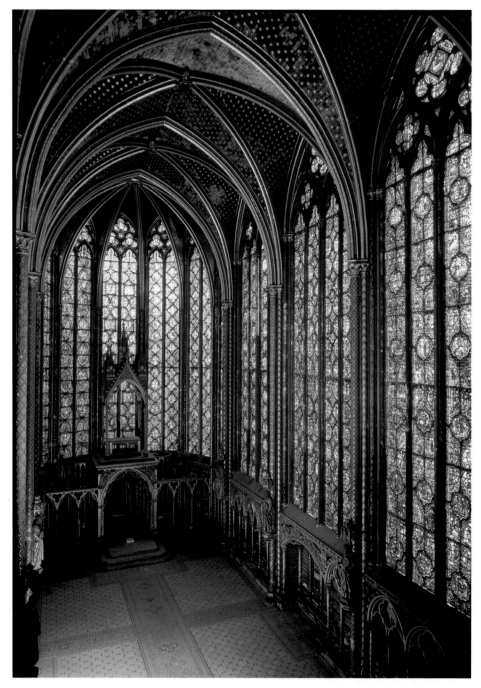

Louis IX's Sainte-Chapelle (Paris), built at huge cost in 1239–48, doubled as his reliquary church and palace chapel. Constructed on two levels, the upper chapel (shown here) communicated directly with the royal apartments. Much of the stained glass – but not the painting – is original.

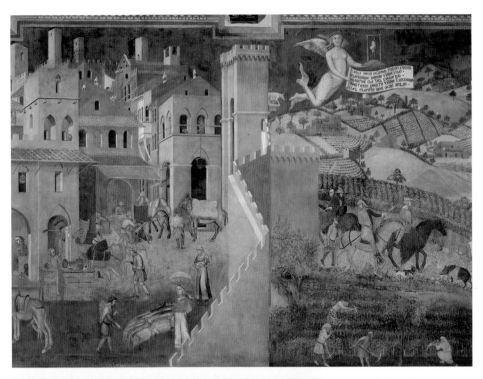

ABOVE Painted in 1338–9 for the *Sala dei Nove* in Siena's *Palazzo Publico*, Ambrogio Lorenzetti's *Effects of Good Government on Town and Country* was accompanied by two other similar allegories on the consequences of good and bad government.

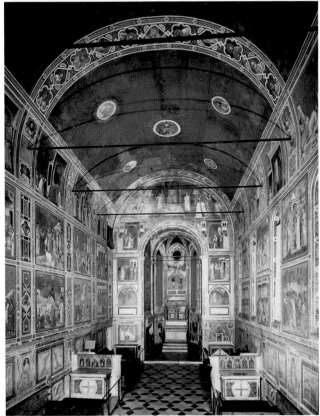

LEFT Giotto's Arena Chapel frescos (1304–5) were commissioned by Enrico Scrovegni, a wealthy Paduan banker. Praised for their pioneering naturalism, they include an *Annunciation*, a *Last Judgement*, a *Life of the Virgin* and other cycles.

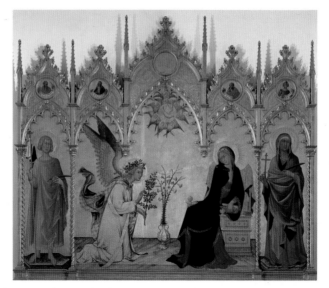

The use of rich materials – gold, silver and precious stones – on important devotional works such as Simone Martini's *Annunciation Altarpiece* (1333) at Siena Cathedral coincided with a period of great civic prosperity and exceptional private wealth, brought to a sudden end by the Black Death.

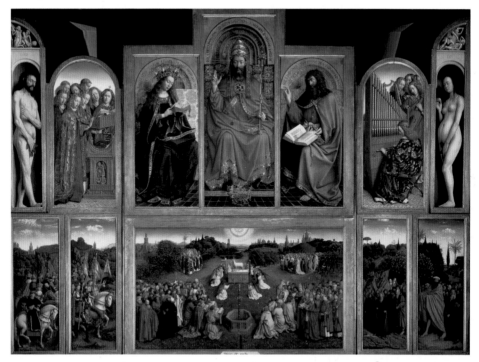

An inscription on the frame of the *Ghent Altarpiece*, dedicated on 6 May 1432, identifies its two painters, Hubert ('than whom no greater was found') and Jan ('his brother, second in art'). When opened up fully (as here) on important feast-days, a big *Adoration of the Lamb* is revealed as the centrepiece; when closed, there are donor-portraits of Joos Vijd and Elizabeth Borluut on the doors.

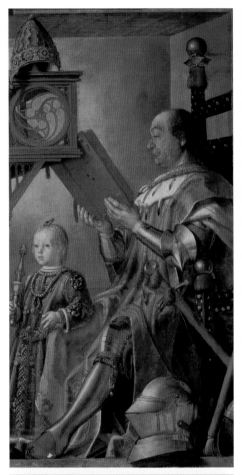

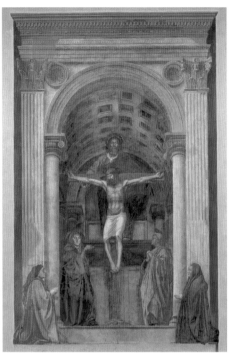

ABOVE LEFT Pedro Berruguete, the Spanish painter, was among the foreign artists attracted to Urbino in the 1470s by the enlightened patronage of Federigo da Montefeltro (d.1482), the successful warlord.

ABOVE RIGHT Masaccio's precociously classical *Holy Trinity* (1425–7) is a key work of the Florentine Renaissance. The young painter's fellow-citizens included the sculptor Donatello (1386–1466), who taught him volume, and the engineer Brunelleschi (1377–1446), from whom he learnt linear perspective.

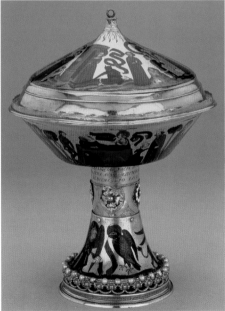

LEFT Made originally for Jean de Berri, the great connoisseur-collector, the Royal Gold Cup is the only identifiable survival of the huge hoard of plate and other precious objects accumulated by John Duke of Bedford (d.1435), Regent of France.

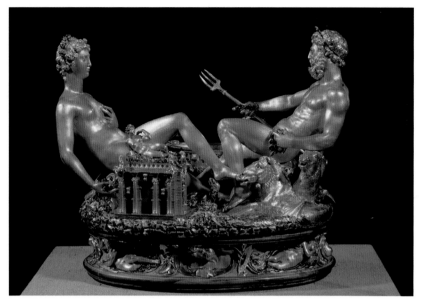

Benvenuto Cellini, the Florentine goldsmith and sculptor, worked in France between 1540 and 1545 in the service of Francis I. His *Salt of Francis I* (1540–3), which pleased the king mightily, is his most important surviving work, his larger projects being too expensive to complete.

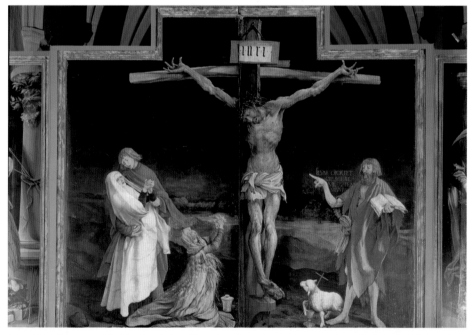

Matthias Grünewald's big *Isenheim Altarpiece* (1515) centres on a *Crucifixion* of such stark and brutal realism that it could only have been made by an artist intimate with death. On Christ's left, St John Baptist points the moral: 'He that believeth on the Son hath everlasting life: and he that believeth not the Son shall not see life; but the wrath of God abideth on him.' (John iii:36)

New Louvre, on the Château de Madrid and Fontainebleau, and on the massive art collections that they housed.

Nobody took more seriously the challenge of such buildings than Henry VIII, King of England, an addicted builder and collector in his own right. Henry, like Francis, was the patron of foreign artists, among them most famously Hans Holbein the Younger (d.1543), the Augsburg-born religious painter and Court portraitist. Other decorative artists and architectural advisers who worked for Henry VIII included Giovanni da Maiano, Benedetto da Rovezzano, Toto del Nunziata, John of Padua, Girolamo da Treviso (a pupil of Raphael), and Nicholas Bellin of Modena (who had worked with Rosso and Primaticcio at Fontainebleau), along with a whole army of French and 'Doche' (German and Flemish) master craftsmen – painters and bricklayers, plasterers, glaziers and carpenters.[28] So divergent were these talents and so capricious the hand that guided them, that much that Henry accomplished during the course of his long reign was both clumsily conceived and backward-looking.[29] Yet it was in 1538 – the same year that he began Nonsuch, his riposte to Fontainebleau – that Henry launched a coastal defence system which, while characteristically *retardataire*, would nevertheless result before his death in the construction of some of the most geometrically perfect artillery fortresses ever built.

Henry's new palace at Nonsuch, the most 'curious' of all his works, was in part a celebration of the birth of Prince Edward on 12 October 1537. And it was for dynastic reasons also that Henry continued spending heavily on his coastal defences long after the invasion threat had passed. 'Let fortunate Cornwall rejoice that Edward is now her Duke', ran the legend on Henry's fortress at St Mawes – an elegant device of intersecting circles – which was one of the last that he built; 'may Edward resemble his father in fame and deeds'. And that promise seemed wholly realized when Girolamo Cardano met Edward VI in 1552, to find 'everyone's fondest hopes' still pinned on the young king – 'a wonderful boy . . . as fluent in French and Latin as in his native tongue . . . trained

in logic and extremely intelligent . . . interested in public affairs . . . [yet] a free spirit, like his father'.[30] Those who knew Edward better could see the puppet he had become; and not everybody would have agreed the following year that his death was 'a grievous loss to England and indeed to the world'. But the careful tutoring of Renaissance princes had a long history already. And contemporary praise of Edward's intellect – the boy spoke Latin 'as beautifully and fluently as myself', observed Cardano, astonished – would have applied at least equally to his father. It was in 1499, when still a lad, that Henry (b.1491) met Erasmus for the first time. And so welcoming was the prince, as were English humanists of all persuasions – among them William Grocyn (the Greek scholar), Thomas Linacre (the physician), John Colet (the theologian), and Thomas More (the statesman and political philosopher) – that the great scholar hurried back to England on Henry's accession in 1509, hoping for preferment at his Court. Erasmus got little for his trouble in the event. But his expectations were not unreasonable, for there was never to be a more promising conjunction in the history of art and scholarship than the almost simultaneous accession of three intelligent, rich, and highly competitive young monarchs – of Henry VIII of England (1509), of Francis I of France (1515), and of Charles I and V of Spain (1516) and the Holy Roman Empire (1519).

Their competition continued strenuously for thirty years. However, as religious conflict grew and war absorbed more energy, there would be less and less money to go around. It was the coming together of Charles V and Francis I at the Truce of Nice (18 June 1538) and Treaty of Toledo (1 February 1539) that persuaded Henry VIII – the odd-man-out on both occasions – to begin the ruinously expensive fort-building programme which, before its end, had absorbed much of his government's rich receipts from the plunder of the dissolved religious houses. Then it was the kaleidoscopic realignments of 1542–6 that encouraged new military adventures on land and sea, each more costly than the last, causing Henry calamitously to debase his coinage and driving Francis ever deeper into debt. Another

reason for the Great Debasement of 1544–51, pushing English prices up more rapidly than in any other decade of the century, was a growing shortage of specie.[31] And for Francis too, having no silver mines of his own, bullion famines were an unavoidable affliction. Charles V in contrast, while as free-spending as the others, enjoyed regular access throughout his reign to gold and silver.

Charles's treasure came from two principal sources: Spanish America and the mines of Central Europe. In addition, Charles since early youth had controlled some of the most important commercial capitals of the West. It was not until 1516, on the death of Ferdinand I, that the united kingdoms of the Catholic Monarchs, Ferdinand of Aragon and Isabella of Castile (d.1504), descended to Juana 'the Mad' (d.1555), their daughter, and to Charles of Spain, their grandson: 'Castile, León, Aragon, the two Sicilies, Jerusalem, Navarre, Granada, Toledo, Valencia, Galicia, the Mallorcas, Seville, Sardinia, Córdoba, Corsica, Murcia, Jaén, the Algarve, Algeciras, Gibraltar, the Canary islands, the Indies, islands and terra firma of the Ocean Sea'.[32] And although it is probably true that, while Juana lived, Charles could never feel entirely safe in those possessions, the rich Burgundian Netherlands had come to him already in 1506 on the death of his father, Philip 'the Handsome'; with the result that when, in 1519, he won the imperial crown as well, 'the foundations of the greatness of Charles (were) such and so mighty, that adding that dignity Imperial, there was great hope that he might reduce into one monarchy all Italy and a great part of Christendom (also)'.[33]

Those hopes faded quickly in the Reformation. Nevertheless, the dream of a Christian Empire under Habsburg rule was close to realization when the Emperor Maximilian I died on 12 January 1519; and Charles owed his vast imperium to his grandfather. It was Maximilian's first marriage to Mary of Burgundy (d.1482), sole heiress of the last Burgundian, Charles the Bold (d.1477), that had brought the prize of Flanders to the Habsburgs. And it was Maximilian again who, as early as 1489, began negotiations for the eventual marriage, some seven years later, of his son, the Archduke

Philip, to the Infanta Juana of Spain. Then, from 1512, Maximilian made pioneering use of South German print technology (in particular the combination of letterpress with woodcuts) for dynastic propaganda, laying the groundwork for a Habsburg ascendancy. Chief among the woodcut artists who worked on Maximilian's great pictorial celebration, the Triumphal Arch (1518), was Albrecht Dürer (1471–1528), son of a Nuremberg goldsmith, godson of a printer, and apprentice to Michael Wolgemut, the book-illustrator. The humanist poet, Willibald Pirckheimer (1470–1530), was Dürer's boyhood companion and lifelong friend. With Maximilian's support, it was in their talented generation that the arts were raised in Germany to a pitch of all-round excellence rarely seen before or equalled since. There were the humanist scholars: Jacob Wimpfeling and Conrad Celtis, Ulrich von Hutten, Johann Reuchlin, and Willibald Pirckheimer himself. There were the sculptors: Tilmann Reimenschneider, Veit Stoss, and Hermann and Peter Vischer. And there were the painters, engravers and woodcut-illustrators who, in addition to Dürer, included Matthias Grünewald and Hans Baldung Grien, Hans Burgkmair the Elder and Hans Holbein the Younger, Lucas Cranach the Elder, Jorg Ratgeb and Albrecht Altdorfer.

Funding this extraordinary flowering in South German art and scholarship was economic growth so rapid, uncontainable, and socially disruptive as to result almost immediately in the brutal mayhem of the German Peasant War of 1525–6 in which Jorg Ratgeb was executed, Tilmann Reimenschneider was tortured, and Matthias Grünewald was driven into exile. Yet only six years before, when Charles of Spain (bankrolled by the Fuggers of Augsburg) was elected emperor, it was not just the union of two great kingdoms that had held such promise for the future, but the increasingly successful exploitation of new technologies. 'Let anybody but consider', reflected Francis Bacon, barely a century later, 'the immense difference between men's lives in the most polished Countries of Europe, and in any wild and barbarous region of the New Indies'. It was neither greater fertility nor a better climate that had created

those huge disparities, but the ingenuity of Europe's 'arts' and new inventions

> which are nowhere more conspicuous than in those three which were unknown to the Ancients; namely, Printing, Gunpowder, and the Compass. For these three have changed the appearance and state of the whole World; first in Literature, then in Warfare, and lastly in Navigation: and innumerable changes have been thence derived, so that no Empire, Sect, or Star, appears to have exercised a greater power and influence on human affairs than these Mechanical discoveries.[34]

Bacon published his *Novum Organum* in 1620. And it was in that year too that Alessandro Tassoni reached the same conclusion in his *Comparison between Ancient and Modern Ingenuity*: 'What did the Greeks and Romans ever invent that can be compared with the printing press? . . . What glory is owed to him who taught the Portuguese to navigate to an unknown pole, from one horizon to another? . . . What invention so tremendous was ever imagined that could match that of our artilleries?'[35] While each of these inventions long pre-dated Charles's reign, it was their simultaneous exploitation by three robustly competing monarchs that opened the door at last to new beginnings.

There was room for a fresh start in commerce and finance also, laying the ghost of illicit usury for once and always. The young Charles had been brought up at Margaret of Austria's Court in the commercially sophisticated Southern Netherlands. And he was to use the model of Antwerp's credit market, as developed in the high-value exchanges of the English textile trade, to extend the sale of state-guaranteed, interest-bearing bonds, raising unprecedented sums to pay his troops. So popular were Charles's *renten* and the *juros* (from '*juro*': 'I swear') of his Spanish kingdom, that interest rates fell sharply throughout his huge dominions. And it would be Antwerp itself – the new banking capital of the North and its most important entrepôt for the 'rich' trades in spices and sugar,

metalwork and textiles (wool and linen) – that would gain the most advantage from these developments. Antwerp, still growing at the time, was Dürer's base in 1520–1 for the negotiation of a renewal of his Habsburg pension. And the illustrated diary Dürer kept of that Netherlands interlude depicts a comfortable society at ease with itself and fully recovered from the slump. It was at Antwerp that Dürer was fêted 'like some great lord' by his fellow artists of the city's Gild of Painters; that he met Lucas van Leyden (d.1533), the Dutch engraver he most admired; and that he marvelled at the rich and costly furnishings of the big urban churches of Our Lady and St Michael, prompting the crisp comment that 'at Antwerp they spare no cost on such things, for there is money enough'.[36]

Prosperity was returning likewise to Bruges ('a noble and beautiful town') and Ghent ('a fine and remarkable town'), both prominent casualties of the recession. And it was in those cities that Dürer was able to see for himself the work of the great fifteenth-century Flemish Masters: of Jan van Eyck (d.1441), Rogier van der Weyden (d.1464), and Hugo van der Goes (d.1482).[37] Like any northern painter of his day, Dürer (trained in the same skills) was well able to appreciate the high quality of that work, empathizing intuitively with the self-imposed archaism of the great majority of Netherlands artists, including the conservative Bruges-based master, Gerard David (d.1523). Even cosmopolitan Antwerp – the home of wealthy expatriate communities of French and English merchants, of Portuguese and Spaniards, of Italians, Scandinavians and Germans – was little more successful in persuading its major artists, whether the reluctant Quentin Massys (d.1530) or the more willing Jan Gossaert (d.1532), to adopt Italian fashions as their own. In part, it was their painterly instincts that kept Matthias Grünewald (the German) or Quentin Massys (the Netherlander) making altarpieces in the manner of Jan van Eyck. However, economic growth had revived the demand everywhere for religious and other paintings, and the conservatism of northern artists, reinforced by long apprenticeships, was driven at least as much by market forces.

It is less surprising, in such a context, that the strange surrealist fantasies of Hieronymus Bosch (*c.*1450–1516), the least modern of Brabantine painters, should have continued to find a market long after his death, winning a place in the most celebrated collections. Francis I, a lifelong enthusiast for Italian art, nevertheless owned a set of Boschian tapestries in 1542 which included a reproduction of *The Garden of Earthly Delights*. And rich churchmen and noblemen, for a generation and more, competed to buy the master's works. But the real collectors of Bosch's paintings were the Habsburgs. It was Charles V's father, Philip the Handsome, who commissioned a *Last Judgement* from Hieronymus Bosch in 1504. And it was probably from Philip, her Habsburg son-in-law, that Isabella of Castile obtained the three Bosch paintings listed among her possessions in 1505. Ten years later, Margaret of Austria, Maximilian's daughter and Charles V's aunt, owned at least one Bosch painting. And much later again, it was Philip II who (with Alva's help) became the keenest Bosch collector of them all.[38]

In the 1560s, shortly before the Duke of Alva's repressive policies drove the Dutch into revolt and froze art in the rebel provinces for a generation, Lodovico Guicciardini (nephew of the great historian Francesco, and himself an Antwerp resident) made the bold claim that *almost all* Netherlands artists ('painters, architects and sculptors') had been to Italy, 'some in order to learn, others to see works of ancient art and to make the acquaintance of people who excel in their profession'. But unreserved Italomania, while already well entrenched in the works of such sought-after Antwerp Mannerists as the Floris brothers, Cornelis (the architect-sculptor) and Frans (the painter), was still relatively new in the mid-sixteenth-century North. And the grand diaspora of Italian fashions which Lodovico thought he witnessed – 'to England, all over Germany, and particularly through Denmark, Sweden, Norway, Poland and other northern countries, including even Russia, not mentioning those who go to France, Spain and Portugal'[39] – never happened in the earlier, more prosperous decades of Habsburg rule.

'Plenty has made me poor', mourned Narcissus to his reflection: 'My love's myself – my riches beggar me.'[40] And having too much of everything was the tragedy of Charles V as well, exhausted by the vastness of his empire. Charles kept a splendid Court. For almost forty years, as conjoint king and emperor, his admiration for classical Antiquity was unalloyed. He was the generous patron of humanist scholars, a dedicated collector of objets d'art (especially jewellery), and a connoisseur of excellence in painting. But he was seldom in one place for very long. Exceptionally, Charles was seven years in Spain from 1522. Even so, it was only towards the end of that time that he began – and left unfinished – the great Renaissance palace at the Alhambra, in Granada, which was the closest he ever got to heroic architecture. And while more prepared to sit for Titian – 'the invincible emperor was so pleased by Titian's work that, once they had met, he would never be painted by anyone else' (Vasari) – it was Titian (a reluctant traveller) who had to answer Charles's impatient summonses to Augsburg or Milan, then having to wait until after the emperor's death for his reward.[41]

Titian's second journey to Augsburg, made in 1550–1, was to paint Prince Philip. And it was to Philip (Charles's only legitimate son) and Ferdinand (his younger brother) that the king-emperor resigned his titles some four years later. Addressing a hand-picked audience in the castle hall at Brussels on 25 October 1555, Charles spoke of a lifetime in the saddle. He had been twice to Africa and twice to England; four times to France, six times to Spain, and nine times to Germany. He had risked everything for Christendom, yet had failed to win the peace which was his only desire for all his subjects. Now there was nothing he wanted more than to entrust Spain to Philip and the Empire to Ferdinand, for he was tired 'even to death.'[42]

Charles died not long afterwards, on 21 September 1558, in retirement with the Hieronymites of Yuste. And it was in April the next year, closely following the Peace of Cateau-Cambrésis (2 April 1559),

that Louis Le Roy, the French humanist philosopher, published his *Oratio de Pace & Concordia*, addressed to Charles's successor, Philip II, and to Henry II of France. 'The history of the ancient empires', Le Roy warns the two monarchs, 'proves that kings who have used vast resources for conquest have perished, and that immoderate power breeds crime. History is a vast tide controlled by Fortune as by the moon. In this ebb and flow, one man cannot establish empire over the whole world.' Le Roy congratulates the signatories of the recent treaty, for 'thanks to you, O kings, the peace we prayed for has come'. But his message is essentially sombre. The century's earlier promise has been dissipated:

> Think how far Christendom once extended and how many lands are now lost to the victorious Turk, who holds North Africa and the Balkans, and has besieged Vienna. Meanwhile, as though in answer to Mohammedan prayers, Europe is soaked in her own blood. What blindness there is in this! If you will not listen to me, hear the voice of our common mother Europe. Says she: 'I bore you, mighty Princes, to be my protectors ... Yet now I scarcely retain a trace of my former grandeur, I who in the past hundred years have made so many discoveries, even of things unknown to the ancients – new seas, new lands, new species of men, new constellations; with Spanish help I have found and conquered what amounts to a new world. But great as these things are, the moment the thought of war arises, the better arts of life fall silent, and I am wrapped in flame and rent asunder. Save me from more of this: honour the arts of peace, letters and industry; and you will be rewarded by the grateful memory of mankind.'[43]

Worse was to follow. On 1 March 1562, less than three years after Mother Europe had appealed to her princes to end discord between them 'for all time', the massacre of Huguenots at Vassy, in Normandy, provoked the first French War of Religion. 'We have

suffered enough in our (own) generation', Le Roy had complained, 'which seems to have been born to offer posterity a legend of disasters.' Yet it was the next generation that suffered still more, driving the arts into protracted hibernation.

Religious Wars and Catholic Renewal

Charles V's hybrid empire was the most successful composite monarchy since Charlemagne. And one of its many benefits was to bring the sophisticated court cultures of the Habsburg core states – in particular Austria and Flanders – within reach of peripheral elites. But multi-nationalism also had its disadvantages. 'Men must either be caressed or else annihilated', warned Machiavelli in *The Prince* (1513), examining the subject of 'Mixed Monarchies'. And having seen for himself the French invasions of Northern Italy, he was well aware that 'when dominions are acquired in a province differing in language, laws, and customs, the difficulties to be overcome are [especially] great, and it requires good fortune as well as great industry to retain them'. A new ruler, Machiavelli recommended, should reside in those dominions, for 'being on the spot, disorders can be seen as they arise and can quickly be remedied, but living at a distance, they are only heard of when they get beyond remedy'.[1] And that, from 1517, was precisely what Charles did, moving his Court out of Flanders into Spain. But growing Protestant dissent and the cares of empire removed him increasingly from his Spanish dominions, and old rivalries returned to haunt them in his absence. Aragon, in particular, felt the chill. 'They (the Castilians) want to be so absolute', wrote the Catalan Cristòfol Despuig in 1557, 'and put so high a value on their own achievements and so low a value on everyone else's, that they give the impression

that they alone are descended from heaven, and the rest of mankind are mud.'[2]

Just four years later, it was to Madrid, a little provincial town in Central Castile, that Philip II (1556–98) translated his much-travelled Court, arriving there from the Low Countries by way of Toledo. 'We greatly miss Flanders', complained one of Philip's courtiers, 'and though His Majesty pretends otherwise, I suspect he feels the way all of us do . . . It's hardly necessary to say that the cleanliness there and the filth here are two quite different things.'[3] However, the bullion of Spanish America had made Castile rich, and Philip had no option but to settle there. 'It is here [in Madrid]', wrote Jehan Lhermite much later, 'that His Catholic Majesty normally resides, and where all his councils have their permanent residence also; for this reason the city is considered to be the Royal Court of the Kings of Spain.'[4] But Philip's initial choice of Madrid as his administrative capital, rebuilding the Alcázar (royal citadel) for that purpose, had less to do with its central location than with proximity to his favourite country palaces. It was at those – in the remodelling of the royal apartments and gardens at El Pardo, Valsaín and Aranjuez – that Philip first demonstrated the obsession with detail which was to characterize the rest of his reign. 'The paths have to be broad like what you see here', he noted in 1562 against his sketch of the new gardens at Valsaín. 'What needs to be planted', he ordered for Aranjuez the next year, 'is what is listed here, and I would like most of it done this winter'.[5] Seeking to shield the king from such minutiae, Philip's secretary for works once accompanied a list of minor alterations with the apology: 'I am sorry to fatigue Your Majesty with such trifling matters'. 'They do not fatigue me, they delight me!', came the reply.[6]

It was still not clear in the 1560s that Philip would stay permanently in Spain, much less retain Madrid as his capital. Those decisions were forced upon him by events. However, he had learnt the purpose of superior architecture in his travelling years, and saw himself from the beginning as a modernizer. Thus the king's Pardo

Palace, just north of Madrid, was re-roofed almost immediately 'in the Flanders style'; its apartments were redecorated in the Italian fashion; its gardens were re-modelled by a 'Dutchman'.[7] Not content with the locally available talent, Philip had already persuaded Juan Bautista de Toledo (d.1567), then working in Naples and formerly Michelangelo's chief assistant at St Peter's, to return to Spain as his architect. The office was a new one, not hitherto held at Court; and Juan Bautista was no workaday builder. His long Roman apprentice-ship had schooled him thoroughly in classicism; he was a mathema-tician and a literate engineer. Predictably, the king's advocacy of utility and of moral worth in building was fully shared by the architect of his choice.

Nowhere were the ideals of moral purpose and utility better served than in Juan Bautista's designs, later realized by his pupil, Juan de Herrera, for the great Hieronymite monastery and royal palace of San Lorenzo at El Escorial. The original purpose of the Escorial was to provide a mausoleum for Charles V and his empress, Isabella of Portugal (d.1539), 'it being the just and decent thing that their bodies be honourably entombed and that commemoration and memorials be established and continuous prayers and sacrifices be said for their souls'.[8] And that function alone would have required a degree of solemnity. But when Philip famously reminded Juan de Herrera that what he most desired in building was 'simplicity of form, severity in the whole, nobility without arrogance, majesty without ostentation', he spoke as much of Christian kingship as of architecture.[9] The Escorial ranks so high in the history of Spain because it is the architectural embodiment of Philip II's Catholic Majesty and of the dogma of the Counter-Reformation.

It was Charles V, before his death, who had unleashed Arch-bishop Valdés on the small Protestant communities of Valladolid and Seville, putative 'creators of sedition, upheaval, riots and disturb-ance in the state'. And when, in 1562, work on the Escorial began, Protestantism in Spain had already been effectively eliminated. But whereas the *autos-da-fé* of his Inquisitor-General saved Philip's

kingdom for Catholicism, intellectual freedom was gravely damaged in the fire. 'We are in times', wrote a Jesuit, 'when women are told to stick to their beads and not bother about other devotions'.[10] And among those who suffered proscription in those censorious years was the great monastic reformer and contemplative, St Teresa of Ávila (1515–82). Still more roughly treated was Teresa's follower and fellow-mystic, St John of the Cross (1542–91), imprisoned by his Carmelite brethren at Toledo. Yet both reached a wider audience in their spiritual writings; while it was at Toledo again that the more enlightened higher clergy of Castile's ecclesiastical capital furnished the patrons for the innovatory work of the Cretan-born painter and visionary, Domenikos Theotocopoulos (1541–1614), otherwise known as El Greco.

Philip II's notorious rejection of El Greco's *Martyrdom of St Maurice and the Theban Legion*, commissioned in 1580 for the eponymous reliquary chapel in the Escorial, has frequently been seen as further proof of the poverty of his taste. In reality, it resulted from no more than the same literal-minded orthodoxy that would cause him to disapprove of Federico Zuccaro's *Adoration of the Shepherds* (1588) for its depiction of a basket of eggs, 'for it seemed inappropriate that a shepherd coming in haste from his flock at midnight could have gathered so many eggs, if he did not keep hens'.[11] Iconographically flawed, Zuccaro's big painting was considered unsuitable for its intended inclusion in the grand altarpiece of the Escorial's basilica. And El Greco's *Martyrdom of St Maurice* was likewise removed to another place, condemned for 'errors' which included nudity in the legionaries, the portrayal of the saint's companions as Philip's real-life generals, and the painter's failure to focus principally on the martyrdom of St Maurice himself.[12] 'No image shall be set up which is suggestive of false doctrine', the Council of Trent had decreed in 1563, 'or which may furnish an occasion of dangerous error to the uneducated'.[13] And while that initial ruling later required further glossing, Cardinal Carlo Borromeo (one of its original drafters) had only recently spelled out more deliberately, in his

Instructiones Fabricae et Supellectilis Ecclesiasticae (1577), what his fellow Tridentine doctors had left unsaid:

> Only such [images] as conform to scriptural truth, traditions, ecclesiastical histories, custom and usage of our mother the Church may be painted. Likewise, nothing false ought to be introduced in the painting or carving of holy images, neither anything that is uncertain, apocryphal, and superstitious; nothing [of that sort], only that which is in agreement with custom. Similarly whatever is profane, base or obscene, dishonest or provocative, whatever is merely curious and does not incite to piety, or that which can offend the minds and eyes of the faithful, all this should be avoided. Just as the likeness of the saint whose image is to be portrayed should as far as possible be accurate, in work [of this kind] care must be taken that the likeness of no other person, either living or dead, be deliberately depicted . . . [for] in all these matters, attention should be paid to represent them in agreement with historical truth, church practice, and the rules decreed by the Fathers.[14]

Whether knowingly or not, El Greco had chosen to ignore the rules, with the result that his *St Maurice* 'did not please His Majesty, which is not surprising for it pleases few, although there are those who say it is great art'.[15]

Philip never commissioned another painting from El Greco. But while the prominence given to nudity in El Greco's much later *Laocoön* (*c.*1610) would have shocked the king still more, prudery was not the first thing on his mind. There can be few sixteenth-century paintings as overtly erotic as the *Figures in a Landscape* which Titian sent to Spain in *c.*1560 for hanging in the royal apartments at El Pardo.[16] But the 'Pardo Venus' and Philip's other mythological paintings – his so-called *poesie* – belonged to the first phase of private palace refurbishment. And almost all his later building programmes were public and religious, requiring an art that was both decorous and correct. Prominent in Philip II's huge and swiftly growing

collection of religious paintings, of which there would be well over a thousand at the Escorial before his death, was the big *Last Supper* in the Hieronymites' refectory – 'fourteen feet long and a work of exceptional beauty' – which had been shipped to the king in Spain shortly before Vasari visited Titian's workshop in 1566. And it was on that same Venetian visit that Vasari saw Titian's still unfinished *Martyrdom of St Lawrence*, ordered in 1564 for the Escorial's basilica and delivered three years later. More Titians followed: an *Adoration of the Kings* and a *St John the Baptist* for the basilica, an *Agony in the Garden* and a *St Jerome in Penitence* for the chapter-house, a *Madonna and Child* for the sacristy. And to these would be added other prized Titians from the royal collections: Mary of Hungary's *Noli me tangere* of 1553. Charles V's *Holy Trinity* (1551–4), which had followed him to Yuste, and Prince Philip's own *St Margaret*, painted for him by Titian in 1552 before his elevation to the kingship.[17]

One of the other big unfinished paintings which Vasari saw in Titian's workshop was 'a picture showing the nude figure of a young woman bowing before the goddess Minerva . . . and in the distance a stretch of sea with Neptune in his chariot in the centre.' And this, when eventually dispatched to Philip in 1575 for hanging in his private oratory at the Alcázar, had been re-fashioned by the old painter (who died the next year) into a work of Counter-Reformation propaganda. In Titian's *Religion Succoured by Spain* – begun some decades before as a specially commissioned mythological painting for Alfonso d'Este (d.1534), Duke of Ferrara – Minerva has been transformed into Catholic Spain (*The Church Militant and Triumphant*); the Goddess's kneeling supplicant has become Mary Magdalene (*Faith Fallen through Sin*); snakes (*Heresy*) populate the trees behind; while a turbaned figure (*The Vanquished Turk*) rides the distant waves in commemoration of Don John of Austria's naval victory at Lepanto.[18] Titian's triumphal imagery celebrates Philip II's role in the Catholic counter-attack which had gathered momentum under his leadership after Trent. But the real world that same year

was very different. Philip's Catholic Kingdom, unable to pay its debts, went bankrupt in 1575; France, his northern neighbour, had sunk again into what was already its fifth War of Religion; Alva's repressions had failed in their purpose, and the Revolt of the Netherlands had begun.

'Obscure and terrible is the destiny of God!', wrote the Huguenot poet, Jean de la Taille, in 1562, only three years after the Peace of Cateau-Cambrésis. 'Better for us had he (Henry II) never at the price of his life made that dismal peace.'[19] And indeed it was Henry's sudden death – of head-wounds received at a celebratory tournament soon after the Peace – which delivered France to three decades of political intrigue and religious dissent, as crippling to the arts as to all else. While always less committed to art patronage than Francis I before him, Henry II had continued his father's projects at Fontainebleau and the Louvre, and was himself a connoisseur of fine building. It was in Henry's reign that another major decorative artist, the Bologna-trained Niccolò dell' Abbate (d.1571), joined Francesco Primaticcio in the rebuilding of Fontainebleau; that the court painter, Francois Clouet (d.1572), made many of his best portraits; that Pierre Lescot (d.1578), in collaboration with the sculptor Jean Goujon (d.1568), built the Square Court at the Louvre; and that Philibert de l'Orme (d.1570) – 'beside whom he (Lescot) seems no more than a talented amateur'[20] – completed Diane de Poitiers's classical château at Anet. Philibert de l'Orme's architectural writings and much of his best work belong to the next decade, when he came back into favour with Henry's widow. And Catherine de' Medici was the patron also of Germain Pilon (d.1590), the most innovative sculptor of Renaissance France. Nevertheless, the suddenness of Henry's death and the factious politics of his three sons – Francis II (1559–60), Charles IX (1560–74) and Henry III (1574–89) – added significantly to the instability of a generation, grown accustomed to violent change, which had never known the Church undivided. That uneasy 'generation of the 1530s' included the essayist, Michel de Montaigne (1533–92). And it was as early as

1570, while still in middle-age, that Montaigne retired to the relative safety of his country estate 'to rest myself from wars', to prepare for a good death, and to contemplate the calamities of his era. 'Instability', Montaigne observed, 'is the worst thing I find in our state'. Yet change, he allowed, was in practice inevitable, for 'the world runs all on wheels . . . [and even] constancy itself is nothing but a dance in slower time.'[21]

Montaigne used many words to describe that 'dance'; it was a *fluxion, mutation, agitation* or *remuement*, a *declinaison, decadence*, and *corruption*.[22] And the *instabilité* Montaigne recognized in the politics of his day was undoubtedly a factor in French art. There would be other Western nations, most notably Rudolf II's German Empire, where Mannerism survived even longer. Yet in France itself, the style's exaggerations and distortions, its restlessness, irrationality and wild caprice, were particularly well suited to a generation in flux, inspiring an anti-classical architecture so theatrical, grandiose and perversely over-ornamented that it seldom stood much chance of being built. Significantly, it is in Henry III's costly but ephemeral 'magnificences' – those elaborately staged diversions, combining music and declamation, with which the last Valois king entertained his spendthrift Court – that modern opera has its roots. Nor was it by chance alone that the reign's most famous architect, Jacques Androuet du Cerceau the Elder (d.1584), made his reputation rather for the elaborated and 'improved' façades of his *Les plus excellents Bastiments de France* (1576–9) than for the two colossal châteaux at Verneuil and Charleval – 'in the highest degree fantastic'[23] – which he began but which others had to finish.

With France crippled by civil war, Spain in worsening financial crisis, and the great emporium at Antwerp entering terminal decline following the Sacks of 1576 and 1585, professional artists in search of patrons had to look elsewhere, turning instead to the Bohemian Court of the Emperor Rudolf II (1576–1612). 'Nowadays', wrote the Haarlem painter and biographer Karel van Mander in 1604, 'whoever so desires has only to go to Prague (if he can), to the

greatest art patron in the world at the present time, the Roman Emperor Rudolf the Second; there he may see at the Imperial residence, and elsewhere in the collections of other great art-lovers, a remarkable number of outstanding and precious, curious, unusual, and priceless works.'[24] In the wake of the Peace of Augsburg of 1555, two generations of religious compromise had made the Germans rich. But a more powerful contemporary influence on the quality of German art was Rudolf's decision on his accession to move the imperial capital to Prague, together with his own developing passion for hands-on patronage. Van Mander ('the Dutch Vasari') tells a revealing story of Rudolf's relations with the émigré Antwerp Mannerist, Bartholomeus Spranger (1546–1611), whose travels had ended in Prague:

> From then on [Van Mander writes of the 1580s] the Emperor did not want Spranger to work at home any more as before, but in the chamber that His Majesty was wont to use for relaxation; thus Spranger began to work in the presence of the Emperor, to the great pleasure and satisfaction of His Majesty . . . and that is how it has come about that one has been able to obtain few or any of his works, for he kept no journeymen and he only worked if he felt like it . . . (and) merely applied himself to satisfying and pleasing his Emperor by working in his chamber, where His Majesty was often present – and that lasted about seventeen years.[25]

At once beneficiary and victim of Rudolf's eccentric vision, Spranger chose subjects close to his patron's heart in mythology, astrology, and the occult. And it was the lively intellectual curiosity of Rudolf's emancipated Court which promoted – along with much else in humanist literature and learning – the highly original work of the Milanese Mannerist, Giuseppe Arcimboldo (d.1593), whose portrait of the Emperor Rudolf as the Etruscan god Vertumnus picks out his sovereign's features in fruit and flowers.[26] But whereas Arcimboldo's composite portraits are fantastic, their individual elements are exact.

And when another of Rudolf's exiled artists, the former Antwerp painter Georg Hoefnagel (d.1600), travelled widely through Europe to draw from life 'whatever was unfamiliar to see – agriculture, wine-presses, waterworks, customs, betrothals, marriages, dances, festivities, and innumerable things of this sort', he was no more than following in the train of that greatest of Antwerp masters, Pieter Bruegel the Elder (d.1569), so faithful in his reproduction of the Alpine scenery through which he passed that 'it was said that he had swallowed the rocks and mountains while in the Alps, spewing them forth on canvas and panels upon his return'.[27]

Always the professional, Bruegel painted anything that sold. And with the talk at Antwerp dinner-tables dwelling frequently on country manners, Bruegel went 'often to join the peasants at their festivities and weddings', learning to represent 'very naturally the peasant's silly mien in dancing, walking, standing, and other actions'.[28] By taking refuge in such safe subjects as a *Peasant Wedding* or a *Peasant Dance*, Bruegel and his fellow gildsmen began the long haul of rebuilding a market ruined by the fanaticism of Protestant reformers for whom every religious image was an idol. But while the artists' loss was greater than most, everybody – Catholic as well as Protestant – knew the pain. 'Since everyone [in Germany]', wrote Cardinal Morone in 1536, 'is allowed to believe what he wishes, not only in areas where the princes are contaminated but also in those where they are Catholic, the people are so confused that they do not know which opinion they should adhere to'.[29] Two generations later they still lacked a firm lead, for it would be said of the Emperor Rudolf – neither Lutheran nor Catholic by his own admission – that he had 'abandoned God entirely' by 1606, for 'he will neither hear nor speak of Him, nor suffer any sign of Him (in his presence)'.[30]

Classical mythology and erotic imagery, necromancy and astrology, history and dynastic propaganda, took the place in Rudolfine Germany of the perennial religious subjects of Philip's Spain. And what resulted in the North was a confusion of different messages

at precisely the time when the Tridentine reformers in Spain and the Catholic South were setting a new agenda for the arts. There is a fresh sense of purpose, for example, in Tintoretto's great religious canvases for the Scuola di San Rocco (Venice) which is almost entirely absent from the same painter's treatment of mythological subjects for the Emperor Rudolf II.[31] But whereas Tintoretto (1518–94) was ill-at-ease in classical myth, his fellow Venetian, Veronese (1528–88), was more at home there. And even in Catholic Venice – in Trent's backyard – it was less religious renewal which brought new vigour to art patronage than the contemporary boom in the Republic's economy. Circumstances undoubtedly favoured the Venetians. The Peace of Augsburg (1555) and decline of Antwerp (from 1567) had delivered South Germany's markets to Venetian traders; Cateau-Cambrésis (1559), while good for little else, had taken the French armies out of Italy; Turkish expansion (especially threatening to Venetian interests in the Levant) had been temporarily halted by Lepanto in 1571; and the Revolt of the Netherlands, as well as destroying Flanders as a competitor, had so drained Spain of bullion to pay Philip's troops as to mortgage the cargoes of his annual treasure-fleets before they landed. With population growing rapidly, with inflation low, with money cheap and profits high. Venice entered a long boom which even the great plague of 1575–7, the Italian banking crisis of the 1580s (caused by Spain's default), and the widespread harvest failures of the early 1590s failed to dent. No project, however costly, appeared impossible.

Most memorable of the new additions to Venice's sixteenth-century building stock were the churches of Andrea Palladio (1508–80): his monastery of San Giorgio Maggiore, filling an entire island, and the Church of the Redentore, on the neighbouring Giudecca, begun with civic funding in 1577 as a thank-offering for release from the plague. It was for Palladio's new refectory at San Giorgio Maggiore that Veronese painted his huge *Marriage Feast at Cana* in 1562–3; while Tintoretto's big *Crucifixion* of 1565 was similarly commissioned to fill an important space in the newly-completed

meeting-house of the wealthy charitable fellowship of San Rocco. Much investment was taking place contemporaneously on the Venetian mainland (terraferma), where state-assisted reclamation of the marshlands of the Veneto was creating a new context for country living. It was chiefly for peace and quiet, as Palladio once explained, that 'the antic sages used often to make a habit of retiring to such (country) places where, visited by accomplished friends and kin, possessing houses, gardens, fountains and similar pleasure-giving places, and above all their culture, they could easily achieve whatever happiness one can achieve here below'.[32] But whereas rural serenity was an attraction for Palladio's Venetian patrons too, they could also see the merit of spreading investment risk through the purchase of country estates. The profits of reclamation, once its capital costs had been absorbed, could be considerable. Thus the Paduan polymath Alvise Cornaro (improving landowner, pioneer reclaimer and hydraulic engineer) was to claim with good cause that large areas of former swamp in the Veneto, 'once not worth two *ducati* a field, are now [in the 1570s] worth more than a hundred'.[33] The Republic's tax yield had risen in proportion.

Among Cornaro's interests was villa architecture. And the simplicity and lack of parade which he believed most suited to the working farmhouses of the Veneto was to be reflected in Palladio's earliest villas. Simplicity was a principle Palladio never wholly set aside, later explaining the colossal rusticated columns of his Villa Sarego (1569) as 'put together of undressed stones, in the way in which a villa, suited better by unspoilt and simple than by dainty things, in any case seems to require'. But his wealthy clients in the Venetian patriciate demanded more of him. No villa front, Palladio wrote in his *Quattro Libri* of 1570, should be without a pediment, for 'pediments give emphasis to the entrance and render the building grand and magnificent, as well as making the front more eminent than the other parts of the house; in addition, the pediment is highly suitable for the emblem or arms of the patron since they can be set in the centre of the façade.'[34] At La Rotonda (1568–9) near Vicenza

– the least functional but best remembered of all Palladio's villas – there is an identical pedimented portico on each façade.

Palladio himself found some difficulty in categorizing La Rotonda: 'Because of its closeness to the town, I did not think that it was suitable to put the drawing in amongst the villas, for one could even say that it lies in the town itself.'[35] Yet so successfully had urban life-styles penetrated the country that such distinctions, in practice, meant less and less. Ten years earlier, the Villa Barbaro (1557–8) at Maser was in every way equipped for 'holy agriculture'. But it was also the summer palace of two rich Venetian noblemen – Daniele (a successful cleric) and Marcantonio (the scholar-official) – escaping the heat and tumult of the city. And it was next to a working farmyard that Veronese's illusionistic frescos of gods and goddesses, ruins, landscapes, and country pursuits, helped re-create for the brothers and their guests the wit and urbane intelligence of the city.

Veronese's Arcadian frescos, painted at the Villa Barbaro in the early 1560s, show a society at peace, experiencing the rewards of the Pax Veneziana. But that peace, while denied to other traditional centres of art patronage in France and Flanders, was not confined to Venice. Both Rome and Milan – prominent victims in each case of the *Calamità d'Italia* of the 1520s – were on the road to recovery by 1560. And it was access to new funding that enabled the religious reformers of Counter-Reformation Italy to give substance to their theories on church architecture. Rome's *restauratio* had only recently resumed in the papacy of Pius IV (1559–65), whose cardinal-nephew and chief secretary, the Tridentine reformer Carlo Borromeo, was closely associated with the re-planning of the city (the Via Pia), with the improvement of its fortifications (the Castel San' Angelo and city walls), and with the extension of the papal quarters in the Vatican (the Villa Pia and Belvedere Court). Borromeo left Rome on his uncle's death, to take up full-time residence in Milan. And it was there that the cardinal and his clergy launched typically Tridentine reforming programmes, clearing the churches of the

archdiocese of redundant altars, suspect images and surplus monu-
ments. Borromeo's *Instructiones*, treating architecture as well as
images, were drafted as guidance to his fellow-reformers. And what
they demonstrate is the precarious balance in all church-building
quarters between Classical Antiquity (the scholar's choice) and the
model of the Primitive Church. On 'The Design of a Church',
Borromeo wrote in 1577:

> The bishop will have to consult a competent architect to select
> the form wisely in accordance with the nature of the site and
> the dimensions of the building. Nevertheless, the cruciform
> plan is preferable for such an edifice, since it can be traced
> back almost to apostolic times, as is plainly seen in the buildings
> of the major holy basilicas of Rome. As far as round edifices
> are concerned, this type of plan was used for pagan temples
> and is less customary among Christian people . . . But where,
> on the advice of the architect, the site requires another form
> of building in preference to the oblong form, a church of such
> a construction may be made, according to the mode prescribed,
> as long as it conforms to the judgement of the bishop.[36]

If Borromeo chose his words carefully, it was because, in that same
year, he was himself to commission a new circular church, modelled
on the pagan Pantheon in Rome.

Borromeo's San Sebastiano in Milan, like the contemporary *Il
Redentore* in Venice, was a plague church. Its architect, the Bolognese
Pellegrino (1527–96), also known as Tibaldi, had arrived in Milan
in 1564 at the cardinal's invitation, remaining there until Borromeo's
death. And one of Tibaldi's earlier commissions in Milan had been
a new church for the Jesuits, begun in 1569 only a year after the
Society's mother-church (*Il Gesù*) in Rome. These two big Jesuit
churches, both of Antique plan, launched a programme of new
building of Tridentine inspiration for the popular preaching orders
of the Reform. None of those new orders – Ignatius Loyola's Society
of Jesus and Philip Neri's Oratorians being the most important –

had at first desired churches of any splendour. However, the urging of wealthy patrons changed their minds for them. It was thus less the Jesuits themselves than the enormously rich Cardinal Alessandro Farnese, the chief contributor to Il Gesù, who determined the scale of their church. Farnese's architect, Giacomo Barozzi da Vignola (1507–73), had already worked for him on the family palace at Caprarola. And when commissioned again for Il Gesù, Vignola took instruction from the cardinal for a big preaching space: 'there is to be a single nave, not a nave and aisles, and there are to be chapels on both sides'.[37] Some ten years later, there were many 'new Churches a-building' when Gregory Martin (the English recusant) visited Rome: 'first that of the Jesuites very large and fayre, by the Cardinal Farnese uncle to the prince of Parma: which being but halfe built had forthwith Masses, and preaching, and confessions, etc.; bycause they wil leese no time, whiles the rest is a-building: and thou wouldest have thought this halfe part (alone) to have been a very goodly Church.'[38]

Among the larger churches already 'a-building' when Gregory Martin came to Rome was the Chiesa Nuova (Sta Maria in Vallicella) of the Oratorians. And work would soon begin on S. Andrea della Valle (for the Theatines), on Sta Maria della Scala (for the Carmelites), on S. Carlo alle Quattro Fontane (for the Discalced Trinitarians), and many others. That intense building activity, peaking especially in Sixtus V's papacy, would not have been possible without peace in Italy. And it was with the help of the Papal State's much increased tax yields – some four times larger in real terms than they had been in 1500[39] – that Sixtus V (1585–90) made Rome's *renovatio* his principal mission, 'to the greater glory of God and the Church'. In just five years, Rome's depopulated eastern quarter, still sheltered by the wall of Aurelian (271–5), was re-developed with star-shaped piazzas and long straight streets, ending spectacularly in obelisks. Sixtus demolished and rebuilt the Lateran Palace; he re-housed the Vatican Library; he found the means and the architect, in Giacomo della Porta (1533–1602), to complete St Peter's dome; and he

re-made the ancient aqueduct, the Acqua Alessandrina, naming it the Acqua Felice after himself. Born Felice Peretti to a peasant family in Ancona, Sixtus had been kept waiting for the supreme office long enough, being already in his mid-sixties when elected. And so impatient was he to proceed with his grand rebuilding schemes that he gave the greater part of the new projects to a single court architect, Domenico Fontana (1543–1607), in whom he had absolute trust. With so much building activity concentrated in that one short papacy, originality was sacrificed to speed.[40] Nevertheless, Rome in the next decade was to become a magnet for the arts: Caravaggio, noted Karel van Mander in 1604, 'is doing extraordinary things in Rome'. And what had attracted artists of Caravaggio's quality to the papal capital in the 1590s – Caravaggio himself before 1592, Annibale Carracci three years later – was the generous and enlightened patronage of Rome's nobility and higher clergy, grown rich on rising rents, for 'the Ecclesiastical State is more peaceful today than (ever) formerly, and the authority of its prince is greater than it has ever been (before)'.[41]

That report by Giovanni Botero, a former secretary of Borromeo, dates to 1595. And it was in the 1590s also that Henry IV of France (1589–1610) extracted his people from the cruel civil wars which had blighted his kingdom for an entire generation. 'The nobility indignantly complain', wrote Nicolaus Barnaud, the Huguenot, as early as 1581, 'that most of their number have been ruined in the service of His Majesty (Henry III), as evidence of which one sees today nothing but châteaux and seigneuries up for sale or rent or under mortgage'.[42] But it was the peasants of Périgord, the victims equally of Huguenots and Catholic Leaguers, who had had more than enough by the mid-nineties:

> The *plat pays* has been completely ruined by a vast horde of bandits. The poor farmers, who time after time have suffered from the quartering of the soldiery upon them by one side or the other, have been reduced to famine. Their wives and

daughters have been raped and their livestock stolen. They have had to leave their lands untilled and die of starvation, while numbers of them languish in prison for failure to meet the enormous *tailles* and subsidies both parties have levied upon them.[43]

Recognizing *'le besoing extresme que mon peuple avoit de repos'*, Henry IV's response was not suppression but appeasement.

In appeasing the peasant rebels – known to themselves as the *Tard-Avisés* (latecomers) and to their enemies as the *Croquants* (country bumpkins) – Henry at last found the formula in 1594 to bring religious conflict to an end. 'It is no trifle', said Jean Nicolay (president of the Chambre des Comptes of Paris), addressing Henry the next year, 'for a great prince such as you, in the face of the revolt of an infinite number of cities and the virtually universal uprising of your subjects, to have in so short a space of time . . . regained the heart of so many people'.[44] And after more than three decades of sectarian bitterness, deliberately fomented by Catholic Spain, appeasement had never made more sense. It was on 15 April 1598 that Henry IV published the Edict of Nantes, granting freedom of worship and equal political rights to the Huguenots. Then at the Peace of Vervins, agreed in May that same year, the Franco-Spanish war was settled, while the concession of practical autonomy to the Spanish Netherlands, within days of that treaty, was to pave the way in the longer term for the Twelve Years' Truce of 1609–21, bringing peace to the Low Countries as well.

Philip II's death on 13 September 1598 removed any remaining threat of an immediate resumption of the Spanish war. And with the civil war ended also, Henry IV was free to concentrate, with the duc de Sully's help, on turning round the wrecked economy of his kingdom. 'When Sully came to the managing of the revenues (in 1598)', reported Sir George Carew, ambassador to Henry's Court in the 1600s, 'he found all things out of order, full of robbery of officers, full of confusion, no treasure, no munition, no furniture

for the king's houses and the crown indebted three hundred million (*livres*)'.[45] Yet so successful were Sully's policies, and so naturally resilient was the French economy once peace had been restored, that Henry was able to start almost at once on a remodelling of his capital – much as Sixtus had re-planned Rome – as a symbol of national unity and renewal. Before his death by assassination in 1610, Henry had built the Pont Neuf and laid out the triangular Place Dauphine which adjoined it; he had developed the Place Royale (now the Place des Vosges); and he had launched an ambitious scheme for the Place de France – a huge semi-circular open space with radiating streets, each named after a province of his kingdom.[46]

Henry's interest in town-planning, shared by his minister Sully at Henrichemont, was of course political.[47] But it was also a pragmatic response to the growing power of a middle class which, almost alone in the late Religious Wars, had profited from the abundance of Spanish silver and price inflation. It had been the wealthy office-holders (*noblesse de robe*) and successful tradespeople (*commerçants*) of those unhappy years who had either bought out the old nobility (*noblesse d'épée*) or married into it. And it was among such professionals, in particular, that Henry found his buyers for the house-plots in the Place Dauphine and Place Royale. While comfortable and of good quality, their terrace-houses were not large. And one inevitable casualty of the emergent life-style of Europe's bourgeoisie was the traditional hospitality of the rural *generosus*. 'I am readie to entertaine all', wrote the Englishman, William Cornwallis, in 1600, 'but to keepe open house untill I shall be compelled to shut up my doores, must be pardoned me. I have a purse and a life, and all that I am for some fewe; but they are indeed but a fewe.'[48]

Freed accordingly from the obligation to practise noble waste, the rich citizens of northern capitals – of Paris, of London, of Prague or Amsterdam – spent their surplus profits increasingly on home comforts. And while the resulting revolution in domestic furnishings was led (as always) from the top, demand rose rapidly at every

level. Before the end of the seventeenth century, even the cramped terrace-houses of London's aspiring middle class 'must be broke into dining room, bedchamber and closet, which the lady is content with being small, and so furnish't rich ... with cabinetts, china, sconces &c., meer trifles ... whereby all the grandure proper to quality is layd aside'.[49]

It was Roger North, a London lawyer turned country squire, who wrote thus *Of Building* in 1698. And well before his time, the typical art consumer of the early-modern West was a middle-ranking professional like himself. Increasing commercialization, from the 1550s if not before, had resulted in a much wider spread of wealth. Art too had become the creature of market forces.

CHAPTER SIX

Markets and Collectors

Nobody now questions the role of market forces in the art of the Dutch Golden Age. Unchallenged in world trade, Holland became so prosperous in the first half of the seventeenth century that commercialization 'for the first time in Europe', Michael North suggests, 'also affected art, as market forces proved to be more powerful than patronage'.[1] And while, in truth, market forces have had a much longer history in Western art – not least in the Southern Netherlands under their successive Burgundian and Habsburg rulers – the size and vigour of the Dutch art market after the Truce of 1609 would be hard to parallel at any earlier time, as would its wholesale appropriation by the middle classes. A projection, for example, from the probate inventories of Delft, suggests that there may have been as many as 2.67 million paintings in Dutch households by 1660. And that already enormous number would continue to rise steadily until the century's end, only then showing any evidence of saturation.[2] Artists learnt to work quickly to meet this huge demand, adopting new techniques to speed production. Thus the prolific Leiden artist, Jan van Goyen (1596–1656), a pioneer of tonal painting, is believed to have completed many of his landscapes (including some of the best) in little more than a day. While the 5000 or more portraits of the fashionable Delft painter, Michiel van Miereveld (1567–1641), would have required from him an output of at least two a week through the greater part of a long working life.[3]

Only a small percentage of that work could have been of superior quality, most paintings fetching very little money. Genre paintings of peasant festivals and domestic interiors were the cheapest; next came the smaller landscapes and the less elaborate still lifes; and most expensive were the individually commissioned portraits and the 'histories' (history paintings), of which the majority, even so, could be purchased for 'less than the price of an elegant mirror and much less than an oak buffet'.[4] Yet a market so robust as to encourage painting on this scale had room at the top for excellence as well. Jan Vermeer (1632–75), the Delft genre painter, ranks second only to Rembrandt van Rijn (1606–69) in the pantheon of the Dutch Golden Age. But while held in high regard by his contemporaries and twice headman (*hooftman*) of Delft's Guild of St Luke, Vermeer's productivity was low and his output exceptionally small. Just how, in such a context, a painter of Vermeer's talents could have afforded to work so slowly is a comment on Dutch affluence overall. Certainly, Vermeer had the support of at least one rich specialist collector, Pieter Claesz van Ruijven of Delft; and there were other wealthy admirers of his work.[5] But Vermeer himself was not poor. His father, Reynier Jansz Vermeer (d.1652), had been an art-dealer and innkeeper with big premises on Delft's market square, both of which businesses Jan inherited. And his mother-in-law, Maria Thins, was an independently wealthy widow, assessed for the family levy of 1674 in the top five per cent of Delft's taxpayers.[6] An established dealer as well as a painter, Vermeer belonged to the wealthiest sector of Delft's craft community, along with the engravers, the booksellers and the pottery-owners – all substantially better off than the glassmakers, furniture-painters and craftsmen-potters of the same city.[7] In practice, Vermeer could paint what he liked.

That freedom disappeared in the slump of the early 1670s when 'not only was (Vermeer) unable to sell any of his art but also, to his great detriment, was left sitting with the paintings of other masters that he was dealing in'.[8] And when Vermeer died soon afterwards, he was penniless. Yet until Louis XIV's invasion of

Holland on 12 June 1672, the rise of the Dutch had seemed unstoppable. Commercial freightage in the sixteenth century had brought prosperity to Holland. The Dutch were the bulk carriers of Europe's economic recovery and expansion. However, it was their capture of the 'rich trades' in the 1590s – in sugar and spices, fine cloth and metalwork – that made the Dutch exceptionally wealthy. Those trades, based in the Southern Netherlands and supported by one of the most proficient banking systems ever known, had been with Spain, with India, and with the Levant. And it was Antwerp's sudden collapse, following the 'Spanish Fury' of 1576 and Parma's second Sack of 1585, that delivered them unexpectedly to the Dutch. Amsterdam and Utrecht, Haarlem and Leiden, Rotterdam, Delft and The Hague, were each to receive exiled bankers from Antwerp, with merchants and artists, technicians and skilled craftsmen of every kind. And what followed was a boom of unprecedented proportions, of which Amsterdam was the principal beneficiary. Of this 'greatest and most powerful merchant city in all Europe', boasted Melchior Fokkens in 1662, 'truly it is a wondrous thing that it may be said that from a child and scarce e'er grown in its youth, Amsterdam has become a man, so that our neighbours and foreigners are struck with wonder that in so few years Amsterdam has grown to such glorious riches.'[9]

Raised to great wealth in just one generation, the many rich householders of mid-century Amsterdam behaved little differently from any other community of nouveaux riches.

> The houses [of the Herengracht] are full of priceless ornaments, so that they seem more like royal palaces than the houses of merchants . . . the rooms hung with valuable tapestries or gold- or silver-stamped leather worth many thousands of guilders . . . You will also find in these houses valuable household furnishings like paintings and oriental ornaments and decorations, so that the value of all these things is truly inestimable – but perhaps fifty or even a hundred thousand.[10]

In knowing the price of everything, Melchior Fokkens was a man of his times. But while there was much that was brash and vulgar in the society he described, there was also a high level of connoisseurship. Paintings, seen as investment, had never been more accessible to collectors, nor more attractively priced. For whereas some of sacked Antwerp's better painters had gone east to Rudolf's Prague, and others, including the great Baroque master, Peter Paul Rubens (1577–1640), would later return to the city, attracted by Habsburg court patronage, many more had fetched up in the Northern Netherlands, to settle and raise their families in Holland's cities. David Vinckboons (1576–1630), the genre painter, Esaias van de Velde (1591–1630), the landscape artist, and Frans Hals (1582–1666), the portraitist, were all the sons of southern immigrants. And when exiled painters like Gillis van Coninxloo (1544–1607) and Roelandt Savery (1576–1639) came back from Rudolf's Empire, it was not to their Flemish homeland that they chose to return, but to the rich consumer cities of the Republic.

One of Amsterdam's better-documented art collectors was Herman Becker, a successful Baltic trader and merchant banker. Becker lived in a big house on the Keisersgracht. And it was there that he kept the 231 paintings which, after his death, were sold at auction on 28 March 1679. Becker, who had lent money to Rembrandt among others, had fourteen of the master's paintings in his collection. He had also bought – or acquired as pledges – works by Jan Lievens (1607–74) and Philips Koninck (1619–88), Ferdinand Bol (1616–80) and Cornelis van Poelenburgh (1595–1667), Gabriel Metsu (1629–67) and Adriaen Brouwer (1605–38), Hendrick Goltzius (1558–1617), Cornelis van Haarlem (1562–1638) and Jan de Bray (1627–97). Becker's tastes were eclectic. He owned a number of Italian paintings, both mythologies and devotional works, and 'a large landscape' by the Franco-Italian painter, Claude Lorrain (1600–82). He also had a portrait by Hans Holbein and a *Flight into Egypt* by Albrecht Dürer, with three paintings by the Antwerp master, Rubens. Yet the focus of his collection was on contemporary

Dutch art, where he shared with the majority of art investors of his day a preference for portraits and landscapes, genre paintings and still lifes, chosen less for their message than their artistry – 'a landscape and building with figures by Jan Weenix the Elder', 'a landscape by Philips Koninck', 'a man's face by Rembrandt', 'a wedding in the style of Bruegel', 'a picture of tobacco smokers', 'a still life of a silver lamp by Simon Luttickhuijsen', 'a vase of flowers by Hendrick Schoock', and so on.[11] Subjects like these, just a century before, would usually have carried a warning of some kind – against cupidity, for example, in a scene of money-changers, or debauchery in the case of a peasant wedding. However, Amsterdam's sober collectors saw no need for moral lessons, being equally averse to the allegories and myths which had once challenged the wit of the humanist courtiers and higher clergy of the Renaissance. Devotional works, in the run-up to the Reformation, had commanded more than 90 per cent of the European art market. By 1700 that proportion was reversed, and only 10 per cent of Dutch paintings were religious.[12]

Rembrandt, it was once said, loved only three things: 'freedom, painting, and money'.[13] However, for a painter of his ability in bourgeois Amsterdam, even those were to prove incompatible. Dutch art critics of the period, among them the biographer Karel van Mander (d.1606), had rated 'histories' the highest form of art. But when Rembrandt made his fortune, in the affluent 1630s, it was chiefly as a fashionable portraitist. He painted religious histories also, including five *Passion* paintings and other works for Prince Frederik Hendrik, the Stadtholder (1625–47). But while Rembrandt's *Belshazzar's Feast* (1635) and *The Blinding of Samson* (1636), with their furious poses and Caravaggesque extremes of light and shade, are images of great power, they were patently less well suited to an audience of city merchants than to the Stadtholder's court circle at The Hague. Rembrandt's huge *Night Watch* of 1642, more correctly known as *The Militia Company of Captain Frans Banning Cocq and Lieutenant Willem van Ruytenburch*, is now one of the

most celebrated of his paintings. Yet in showing Captain Cocq's militiamen not – as was the convention – in solemn assembly, but in the apparent pandemonium of a muster, the painter and his subjects drew apart. What his paymasters probably anticipated was a full-face collective portrait in the manner of Nicolaes Pickenoy's *The Company of Captain Jan Claesz Vlooswijck*, painted that same year in Amsterdam.[14] What he gave them contained elements of parody.

Rembrandt's originality was a major reason why his work ceased to be fashionable in his own city. And while there were always rich collectors ready to invest in his art, his chronic extravagance and refusal to conform caused mounting problems with debt. What Rembrandt lacked – and what Rubens, in contrast, was never without – was the proactive encouragement of a Court. Rembrandt's brief flirtation with court patronage, concentrated mainly in 1632, had ended almost as soon as it began. Unlike many of his contemporaries, Rembrandt never went to Italy. Yet the style Prince Frederik Hendrik favoured for the great new programmes of refurbishment he launched in the mid-thirties at the Noordeinde palace in The Hague, at the Binnenhof and Rijswijk, at Honselaersdijk, Buren and Breda, was International Baroque, which in Holland until then was little known. It was in 1634 that the Prince appointed a Frenchman, Jacques de la Vallée (son of Marie de' Medici's superintendent at the Luxembourg), as his architect. And already in that year, as Sir William Brereton complained, 'the ladies and gentlemen here (in The Hague) are all Frenchified in French fashion'.[15] Italy was the dominant influence in painting. Rubens, before returning to Antwerp in 1608–9, had spent eight years in Italy. And of the other major artists commissioned by the Stadtholder, Gerrit van Honthorst (d.1656), Cornelis van Poelenburgh (d.1667) and Anthony van Dyck (d.1641) had all worked in Italy, where they had come under the spell of Annibale Carracci and Caravaggio, the two leading painters of Rome's Renewal. Thus Honthorst's early paintings, before he turned to portraiture, were strongly-lit histories in the

style of Caravaggio; Poelenburgh became a painter of Arcadian landscapes-with-ruins in the Italian manner; van Dyck formed his style in a series of Baroque portraits of Genoese noblemen; and the early heroic images of Rubens himself owed much to the inspiration of Carracci. Such art had little appeal for the investors of Amsterdam. And where it found its market was at Europe's major Courts, led by some of the greatest royal collectors ever known: Frederik Hendrik, Prince of Orange; Isabella and Albert, joint Governors of the Spanish Netherlands; Marie de' Medici, Queen Consort of France; Christian IV of Denmark; Charles I of England; and Philip IV of Spain – than whom 'no one in the world understood more about (painting)'[16] – the patron of Velázquez (1599–1660) and Zurbarán (1598–1664). Rubens worked for them all.

Rubens was in Spain in 1628–9, on a mission that combined diplomacy with art. And it was in Madrid that he met and kept the company of Diego Velázquez, being probably the cause of the younger painter's decision to obtain leave to go to Italy in the summer of 1629, 'to perfect his art' and 'to learn things pertaining to his profession'.[17] Six years earlier, when Velázquez came to Court under the sponsorship of the royal favourite (*valido*) and chief minister, Gaspar de Guzmán, Count-Duke of Olivares, there had still been talk in Madrid of the opening of a new *Siglo de Oro* (Golden Century). And an extraordinary flowering of art and literature would indeed take place during the reign of Philip IV (1621–65), paradoxically coinciding with recession. The severity of that recession and its role in Spain's 'decline' have since been much debated. More a growing 'dependence' on foreign goods and capital than a universal collapse, the slump barely touched the prosperous northern provinces of Asturias, Galicia and Catalonia. Nevertheless, contemporaries were in no doubt that the crisis deepened daily, nor that it was the once-privileged Castile, at the kingdom's core, that bore the brunt of it.[18] In 1631, within a decade of Philip's accession, Miguel Caxa de Leruela's *Restoration of the former abundance of*

Spain included this summary recital of Spanish ills: 'The war which this crown maintains in Flanders; overseas commitments; the sloth of Spaniards through the abuse of *censos* (mortgage rents), *juros* (bonds) and entails; the entry of foreign merchandise; the infinite number of monasteries; the excessive weight of taxes; and the copper currency . . .'[19] Only plague and harvest failure – the exogenous factors – are missing from a list which, equally well today, might be the opening of a modern analysis of Spain's Golden Century decline.

The gathering recession was hastened in Castile by a population collapse more complete and long-lasting than in any other region: the result of subsistence crises and plague mortalities. Settlement desertion in Castile's parched and hostile uplands had begun even before the plague returned in 1596–1602, while the drain of men and matériel to Flanders and the Americas had continued with barely a pause. It was in the Netherlands, in particular, that the Habsburgs met their Nemesis. But equally serious for Spain's monarchy – at war again with Holland after the Twelve Years' Truce expired in 1621 – was its diminishing bullion stock: because of debt repayments; because of piracy at sea; because of the direct export of New Spain's silver to the Philippines to pay for eastern luxuries; and because of a growing disposition in the colonists themselves to retain more bullion for their own building and defence. Great building enterprises were rare in Philip's Spain; at best, they were 'rather undistinguished'.[20] In contrast, throughout Spanish America there were 'so many towns built to *our design*, so many rich buildings of stone and mortar, so many stones worked with the skill and art of Europe' that Bernabé Cobo, a Jesuit missionary for many years, could reasonably conclude in 1653 that Spain's hold on the Americas was irreversible.[21]

For Father Cobo and his fellow colonists, 'our design' was rarely anything but classical and Vitruvian. Back in 1526, Gonzalo Fernández de Oviedo had observed already of Santo Domingo, in Hispaniola, that 'because it was founded in our time, it was laid

out with rule and compass with all the streets of the same size, in which regard they are far ahead of other towns [in Spain] that I have seen.'[22] And there was much that Spain itself might have learnt from its viceroyalties concerning the architecture of social control. Madrid, in particular, was a missed opportunity, for in spite of the city's massive growth of some 1000 per cent during its first hundred years as Spain's capital, there was very little attempt to impose Vitruvian principles on that expansion, only the huge rectangular space of the terraced and colonnaded Plaza Mayor, built by Juan Gómez de Mora for Philip III in 1617–19, in any way approaching the great city-planning initiatives of Henry IV's Paris or papal Rome. The problem invariably was money. In 1607, when Philip III was forced to suspend debt repayments and renegotiate the kingdom's loans, Spain went bankrupt for a second time. Then such were the continuing military and bond commitments of Philip IV's government that there would be four further suspensions in 1627, 1647, 1652 and 1662: while for months on end, at Philip's threadbare Court, 'even bread cannot be had in the royal household . . . for the king has not a *real*'.[23]

'You are Great, Philip', famously quipped his one-time publicist, the embittered poet Francisco de Quevedo (d.1645), 'only in the same way as a hole, in that the more that is taken away from you, the greater you become.'[24] And it is true that little ever went right politically for *Felipe el Grande* after the triumphs of his *annus mirabilis* of 1625, when the siege of Genoa was lifted, when the Dutch surrendered Bahía (in Brazil) and the fortress of Breda (in Brabant), and when the English withdrew defeated from Cadiz. Especially demoralizing to Castilians long accustomed to easy wealth was the universal loss of confidence in Spain's economy and in its debased and largely worthless copper currency. 'Concerning the state of this kingdom', reported Sir Arthur Hopton, the English ambassador, in 1641, 'I could never have imagined to have seen it as it now is, for their people begin to fail, and those that remain, by a continuance of bad success [in the wars], and by their heavy burdens [of tax],

are quite out of heart ... The king's revenues being paid in brass money will be lessened a third part being reduced to silver. They begin already to lay hands on the silver vessels of particular men, which, together with that in the churches, is all the stock of silver in the kingdom ... Justice is quite extinguished here ... (and) this monarchy is in great danger to be ruined'.[25]

Both Quevedo and Hopton believed Philip's minister, Olivares, to be chiefly to blame for the unprincipled extravagance of his Court. It was Olivares who had first called Philip 'the Great', thus exposing him to comparisons with those other fabled heroes of Spain's Expansion: Ferdinand the Catholic ('king of kings'), the Emperor Charles V ('victorious in his wars'), and Philip II ('who governed the world with his pen').[26] In setting the stage for the 'Planet King' (another Olivares title), the new palace at the Buen Retiro, just outside Madrid, was very much a part of that image-building process: of the monarchy's *reputación*. Begun in 1630 and finished under Olivares's tireless direction in just three years, the Buen Retiro was conceived as a distraction. It would also provide Philip with 'a seemly place of retreat (from the Alcazar in Madrid) for such occasions as may present themselves, where perhaps he may be able to get away from business, without having to suffer the usual discomforts and costs of travel'.[27] What resulted was a palace as eloquent of Philip's policies as the Escorial had been of his grandfather's. 'Certainly the building is extremely sumptuous', wrote Fulvio Telvi in 1636, 'although more so within than without, (making) a greater impression than its external appearance would suggest.'[28] And many others would likewise comment on the too-evident contradiction, at this huge royal 'chicken coop', between its opulent interior furnishings and low-cost shell.

As Hopton reported it, the Buen Retiro was furnished 'almost all by presents, for the Count of Olivares hath made the work his own, by which means it hath not wanted friends'.[29] However, Olivares was a collector of books rather than of art. And the main responsibility for the 800 or more paintings that would hang at the

Buen Retiro rested with Philip himself. The Hall of Realms, in particular, as the principal state apartment of Philip's palace, became a showcase of Golden Age painting. Of the Hall's twelve triumphal battle scenes, the most remarkable were the *Recapture of Bahía*, by Juan Bautista Maino (the king's Dominican drawing master), and the *Surrender of Breda* and *Defence of Cadiz*, by Diego Velázquez and Francisco de Zurbarán respectively. There were ten big *Labours of Hercules*, also by Zurbarán, and five royal equestrian portraits by Velázquez and his assistants: of the king's parents (Philip III and Margarita of Austria), of Philip IV himself and of Isabella of Bourbon (his queen), and of Baltasar Carlos (their young son).[30] Philip IV's example was infectious. In 1638, Velázquez was to paint a large equestrian portrait of the Count-Duke of Olivares, in celebration of his recapture of the frontier fortress of Fuenterrabía from the French. And there were other wealthy Madrid noblemen who, by that time, had caught the collecting frenzy from the king:

> They [wrote Hopton to an English collector friend in 1638] are now become more judicious in and more affectioned unto the Art of Painting, than they have been, or than the world imagines. And the king within this 12 month had gotten an incredible number of ancient and of the best modern hands ... and in this town is not a piece worth anything but the king takes and pays very well for them, and in his imitation the Admirante [Medina de Rioseco, Admiral of Castile], Don Luis de Haro [Olivares's successor as royal *valido*], and many others are making collections.[31]

It was Luis de Haro's son Gaspar (d.1687) – a notorious rake but soon to be an even greater art collector than his father – who commissioned Velázquez to paint the huge reclining *Venus and Cupid* (also known as the 'Rokeby Venus') which has since become one of the most cherished erotic images of all time.[32] And while Philip and his aristocracy, bereft of capital, did little large-scale building in these decades, there was never a moment, even during

periods of grave recession, when they stopped collecting paintings altogether. It was in 1661, just before his fourth and final bankruptcy, that Philip IV negotiated his most expensive purchase ever when he bought Raphael's *Christ on the Road to Calvary* from the monks of Santa Maria del Spasimo, in Sicily, in return for a large annual pension. And he was still buying Italian masters in the year before his death, when among his many acquisitions from the late Marquis of Serra's choice collection were Lorenzo Lotto's *Messer Marsilio and his Wife*, Parmigianino's *Count of San Secondo*, Annibale Carracci's *Venus and Adonis*, and Guido Reni's *Atalanta and Hippomenes*, along with more than thirty other works.[33]

Philip IV's connoisseurship, and the long exposure of his nobility to paintings of the highest quality, created a lively market in Spain and its dependencies for the work of native-born painters. The most important of these, after Velázquez and Zurbarán, were José de Ribera (d.1652), who lived most of his life in Naples, and the younger religious painter, Bartolomé Murillo (d.1682), Zurbarán's successor in Seville. Zurbarán's Seville, the gateway to New Spain, had risen to great prosperity during the Twelve Years' Truce with Holland. And it was in that thriving city that artists of all descriptions – writers as well as painters – had gathered at the house of Francisco Pacheco (d.1644), the teacher and subsequently father-in-law of Velázquez. Those who met in Pacheco's salon included the novelist Miguel de Cervantes (d.1616), author of *Don Quixote*, the dramatist Lope de Vega (d.1635), and the young nobleman, Gaspar de Guzmán, Count of Olivares, already alert to the political advantages of art patronage. It would be under Olivares's protection that Pacheco's two star pupils, Diego Velázquez and Alonso Cano (1601–67), 'the Spanish Michelangelo', came to Court. And it was in debates at Pacheco's table, as at the other literary meeting-places of Philip's troubled realm, that the colourful history and threatened collapse of his ramshackle empire furnished a rich vein for the novelists, poets and playwrights of Spain's literary Golden Age, from Cervantes to Calderon de la Barca (d.1681). Especially easy targets were the

Castilian nobility, too preoccupied with *honor*, and too ready to embark on over-ambitious projects of huge expense and questionable utility. It would be Olivares's boast that the building of the Buen Retiro had cost Philip almost nothing: 'not even five hundred ducats'. Yet the Buen Retiro's true annual cost, much of it borne by Madrid's taxpayers, was fifty times that much, and that was for just one of Philip's palaces. In 1637, under growing pressure from his critics, Olivares defended his exceptional expenditure on court entertainments in that year, when the war against the French was going badly. Such fiestas, the chief minister argued, were a political necessity, 'so that our friend Cardinal Richelieu should know that there is still money (in Spain) both for spending and for the chastising of his king (Louis XIII)'.[34]

The Count-Duke of Olivares (1587–1645) and Cardinal Richelieu (1585–1642) were almost twins. They shared a near-identical lifespan and coincided in high office, and each was as power-hungry as the other. 'Now everything is mine', Olivares reportedly told the Duke of Uceda (son of Lerma, Philip III's *valido*) in 1621 – 'yes, everything without exception'; Richelieu, complained a critic, 'is everything, does everything, has everything'.[35] Yet while both chief ministers were mighty builders and both were great collectors, especially of books, the two were temperamentally far apart: 'one (Olivares) extravagant, inflated, and perhaps quintessentially baroque; the other (Richelieu) cool, laconic, tightly controlled'.[36] They differed also in the amount of money they had to spend. France, to Richelieu's credit, was a conspicuously late entrant to the Thirty Years War. And Richelieu was always able, both before and after declaring war on Spain on 19 May 1635, to find the funds for building – for Marie de' Medici at the Luxembourg, for Louis XIII at Fontainebleau and the Louvre, for the re-planning of Paris, and for the reconstruction (at his own expense) of the Sorbonne. The cardinal's guiding principles, throughout his long ascendancy, were reason, precision and good order. To that end, he founded the Académie Francaise in 1635; he poured money into the Sorbonne ('a superb palace of

theology and a mausoleum for his ashes'); and he hired Jacques Lemercier (1585–1654) who had trained in Rome and was the leading classical architect of his generation.

Lemercier's many commissions for the cardinal included a new market town at Richelieu, on the family estates, as geometrical in plan as any virgin-sited city in Spanish America. He was the architect of the Sorbonne, and built the huge new residences – the Palais Cardinal (in Paris) and the château at Richelieu (in Poitou) – which were to house and display the cardinal's exemplary art collections: an inspiration to others to do the same.[37] In addition to books, Richelieu was a collector of antique statuary, largely bought for him in Italy; he had plate, gems and crystal worth enormous sums, and tapestries and other furnishings of great splendour. His paintings, while valued at less than a quarter of his jewellery and plate, were nevertheless of the very highest quality. Of those, Leonardo da Vinci's *Virgin and Child with St Anne* and Paolo Veronese's *Supper at Emmaus* are now considered the most important. However, Richelieu also owned major works by Rubens and van Dyck, along with fine contemporary paintings by the best French artists – Simon Vouet (d.1649), Nicolas Poussin (d.1665), Philippe de Champaigne (d.1674), Claude Lorrain (d.1682), and Charles Lebrun (d.1690) – and with an enviable collection of the most sought-after Italian masters: Titian and Guido Reni, the Carracci and Caravaggio, Pietro Perugino, Lorenzo Costa and Mantegna.[38]

It was for the Cabinet de la Chambre du Roi at Richelieu that Nicolas Poussin painted his *Triumph of Pan* (1636), one of three large bacchanals commissioned by the cardinal to accompany the five High Renaissance allegories – by Costa, Mantegna and Perugino – which his agents had bought on the recent dispersal of the great Mantuan collections of the Gonzagas. Poussin's *Triumph of Pan* is a complex painting, brilliantly coloured and hard-edged, with a confident archaism which could only have been realized by a painter who, like Poussin, had been many years resident in Rome. Italy was still unmistakably the dominant influence in French art. Claude

Lorrain, the landscape painter, spent most of his life in Rome; Simon Vouet lived and worked in that city before returning to France in 1627 at Louis XIII's invitation; Charles Lebrun (Louis XIV's leading painter) trained there under Poussin in 1642–6; and while there is no firm evidence that Georges de la Tour (d.1652) ever studied in Rome, the strongly-lit nocturnal scenes for which he is most remembered are unmistakably Caravaggesque in inspiration. In contrast, François Mansart (1598–1666), the most original of French architects, never went to Italy. And it was probably for that reason that he failed to win commissions from France's Rome-alert nobility, who were attracted instead to the more academic and less innovative Lemercier. In the event, where Mansart found his patrons was in the wealthy parvenus of Paris, for one of whom, the financier René de Longueil, he built the highly ornamental château at Maisons-Lafitte (1642–6), which is one of the few surviving examples of his work. Mansart's paymaster at Maisons was sufficiently rich to encourage him to build what he liked. However, the architect's capricious inventiveness and his notoriously abrasive temper cost him the more prestigious commissions. When employed in 1645 by the Regent and Queen Mother, Anne of Austria, to build her a new convent at Val-de-Grâce in Paris, Mansart lasted in that post for only a year before being replaced by the steadier talent of Lemercier.[39]

Anne of Austria, ruling France on behalf of the infant Louis XIV, had chosen Richelieu's right-hand man and former Italian agent, Cardinal Jules Mazarin (1602–61), as her chief minister. Born in Rome, Giulio Mazarini had made a career in the service of the Barberini Pope Urban VIII (1623–44) – notorious nepotist, addicted builder, and connoisseur. Urban and his Barberini relatives were early patrons of Rome's leading Baroque masters, Gianlorenzo Bernini (1598–1680), the sculptor and architect, and Pietro da Cortona (1596–1669), the painter. And Cardinal Mazarin, once in office, would try without result to bring both artists to Paris. He had more success with Pietro da Cortona's ablest pupil, Giovanni Francesco Romanelli (1610–62), who, in two visits to the city in

1645–7 and 1655–7, created the interiors at the Palais Mazarin and the Louvre which would be used as a model by Charles Lebrun for the grand state apartments at Versailles.

Hardly less influential in preserving the link with Italy was the cardinal's personal collection. Mazarin was an 'eager but prudent collector'. In his long experience of Urban's Court at Rome, he had learnt the connoisseurship that enabled him to assemble one of the century's great collections, strong in early masters like Titian and Correggio, but especially rich in the Roman painters of his youth: Pietro da Cortona, Domenichino (d.1641), and Guido Reni. One of Mazarin's most expensive purchases, in the wake of the dispersal of Charles I's huge collection, was Titian's erotic masterpiece, the Pardo *Venus* – originally painted for Philip II, then given by Philip IV to the young Prince Charles, and sold to the regicide, Colonel Hutchinson, shortly after the king's execution. It was before that extraordinary painting, so the story goes, that Mazarin paused on a final perambulation of his gallery: 'All this must be left behind (*Il faut quitter tout cela*)', the dying cardinal lamented: 'Look at this beautiful painting by Correggio and also at the *Venus* of Titian [the Pardo *Venus*] and at that incomparable *Deluge* of Antonio Carracci. Farewell dear pictures that I have loved so well and which have cost me so much. I will never see (you) again where I am going.'[40]

In the Commonwealth Sale of Charles I's paintings, in which the best bargains had gone immediately to early bidders, the cardinal's prudence finally deserted him. Colonel Hutchinson's Pardo *Venus*, bought in 1649 for £600, was sold just four years later to Mazarin's London agent, Antoine de Bordeaux, for eight times that sum; and there were other instances of profiteering just as gross. However, Charles I himself, from soon after his accession, had already paid substantial prices for his paintings. The 'greatest amateur of paintings among the princes of the world' (as Rubens called him) had been prepared, where necessary, to risk his kingdom's solvency for art. Charles I's greatest collecting coup, won against the competition of Cardinal Richelieu among others, was his purchase from Duke

Vincenzo of Mantua in 1627 of many of the more highly-prized Gonzaga paintings, including two Raphaels, 'the twelve Emperors of Titian, a large picture of Andrea del Sarto, a picture of Michelangelo di Caravaggio; (and) other pictures of Titian, Correggio, Giulio Romano, Tintoretto and Guido Reni, all of the greatest beauty. In short, so wonderful and glorious a collection that the like will never again be met with'.[41] While Daniel Nys, writer of that description and negotiator of the deal, had every reason to put the best construction on his bargain, the £15,000 agreed for the Gonzaga purchase was no great price to pay for an enviable exchange that at once put the spotlight on Charles of England as a world-class collector and connoisseur. Its timing, however, was most unfortunate. After two decades of peace, Charles's kingdom was at war, with every penny committed to the costly fiasco of the Duke of Buckingham's expedition to the Isle de Rhé. 'I pray you let me know', demanded the king's London banker, Filippo Burlamachi, in October 1627, 'where the money shall be found to pay this great sum . . . It will utterly put me out of any possibility to do any thing in these propositions which are to be necessary for My Lord Duke's relief'.[42] But Buckingham's forces were in trouble even before the deal was struck, and it was the royal paintings that got the money, not his pikes.

Named in Parliament as 'the cause of all our miseries', Buckingham (still planning a second expedition to relieve the Huguenots at La Rochelle) was assassinated by John Felton, a naval lieutenant, on 23 August 1628. And prominent among the reasons for the duke's unpopularity was his too-conspicuous expenditure – on 'costly furniture, sumptuous feasting and magnificent building, the visible evidences of the express exhausting of the state'.[43] 'As to conditions in this Court', wrote Rubens to Olivares on 22 July 1629, 'the first thing to be noted is that all the leading nobles live on a sumptuous scale and spend money lavishly, so that the majority of them are hopelessly in debt.'[44] They took their example from the monarchy. Charles I's second major purchase from the Gonzaga collection –

again for a sum so enormous as seriously to embarrass his Lord Treasurer – had included the nine huge canvases of Mantegna's *Triumph of Julius Caesar*. It was another coup of great resonance in the growing world of connoisseurship. But even before Mantegna's acclaimed masterpieces could be shipped to England, London's reputation as an art capital was assured. The general peace of 1604, negotiated by James I (1603–25) soon after he became king, had at last made the Continent accessible to 'the people of Great Britain who (of all other famous and glorious Nations separated from the main Continent of the world) are by so much the more interested to become Travellers'.[45] It was Thomas Howard (d. 1646), Earl of Arundel, known throughout Italy for his free-spending collecting forays, who was the first to be offered the Gonzaga paintings. And by the time Rubens came to London in 1629, he found 'none of the crudeness which one might expect from a place so remote from Italian elegance'. 'The Earl of Arundel', he continued, 'possesses a countless number of ancient statues and Greek and Latin inscriptions . . . And I must admit that when it comes to fine pictures by the hands of first-class masters, I have never seen such a large number in one place as in the royal palace (at Whitehall), and in the gallery of the late Duke of Buckingham (at York House).'[46]

Rubens's mission to London in 1629–30 was to negotiate the truce which would clear the way for the Anglo-Spanish Treaty of Madrid (5 November 1630). He was well received by the king, who had declared himself eager to know 'a person of such merit'. And it was for Charles that Rubens painted his big allegory of *Peace and War*, in which Peace (an ample matron) feeds Wealth (the infant Plutus), supported by emblems of prosperity. It was on that same lengthy London visit that Charles I commissioned Rubens, for the unprecedented fee of £3000, to paint a grand *Apotheosis of James I* for the ceiling of Inigo Jones's newly-completed Banqueting House at Whitehall. Rubens's *Apotheosis* – reinforced, like his allegory, by images of wealth – was a political statement, affirming the Stuarts' right to rule. However, it was also a celebration of James's role as

peace-broker, which, while a failure on the Continent, had kept his Anglo-Scottish kingdom untouched by the wars through a critical two decades of wealth creation. It was the under-taxed and over-privileged sons and daughters of James's fortunate aristocracy who, from early in Charles's reign, sat for the celebrated Antwerp portraitist, Sir Anthony van Dyck (d.1641), back in London again from 1632. Emblematic of their class were the Lords John and Bernard Stuart, sons of the Duke of Lennox and cousins of the king, who were painted by van Dyck in 1638 when on the point of departure for the Continent. van Dyck shows the teenage travellers in the peacock finery of Charles's Court, foppishly posed and richly dressed. Both subsequently perished in the Civil War.

On van Dyck's first London visit, in 1620–1, he had painted a portrait of Lord Arundel. He had also worked for Buckingham on a large Baroque canvas of *The Continence of Scipio*, which was to hang in the hall at York House. It was in the art-filled galleries of the two courtier-collectors that van Dyck studied the work of the great Venetian masters, in particular of Titian and Veronese. And by the time he returned to London a decade later, he had spent six years in Italy – in Genoa and Rome – painting portraits of the nobility and refining the style which, in his *Charles I on Horseback* (1637–8), echoed Titian's pioneering *Charles V at the Battle of Mühlberg* (1548), the source also of Velázquez's equestrian portraits at the Buen Retiro. van Dyck, as 'Principal Painter in Ordinary to their Majesties Charles and Henrietta Maria', painted the king and his family many times. But whereas Charles I, like Philip IV, could usually find the funds to feed his art-collecting habit, he was no better able than Philip of Spain to engage in building projects of any substance. It was not for Charles and Henrietta Maria but for James and Anne of Denmark that Inigo Jones (d.1652) built the Queen's House at Greenwich; Jones's Banqueting House at Whitehall was commissioned (and largely paid for) by the king's father. In contrast, Charles's own cherished project for a new palace at Whitehall came to nothing. Whitehall, as Charles and Inigo Jones

envisaged it, was to have been an entirely new complex of strictly classical design: a flagship of calm and order on London's fringe. And both were well aware of the potential benefit to the Crown of such an architecture of social control. Thus it was Jones (a better architect than historian) who later wrote, in his posthumously published *Stone-Heng Restored* (1655), of a legendary race of Roman Britons (builders of Stonehenge) equipped with a 'knowledge of Arts, to build stately Temples, Palaces, public Buildings, to be eloquent in foreign languages, and by their habits and attire attain the qualities of a civil and well ordered people' – a race untroubled, so Jones believed, by civil conflict of any kind, and perfectly suited by temperament and education to the velvet touch and sparing rod of Divine Monarchy.[47]

'Britanocles, the glory of the western world', as King Charles was represented in William D'Avenant's masque *Britannia Triumphans*, has left little lasting trace in public works. And it is a measure, perhaps, of where the money went instead that among the few completed elements of Charles I's projected palace was a theatre. Inigo Jones was the builder of the Cockpit Playhouse at Whitehall. He was also the stage designer of William D'Avenant's masque, as he had been already of many similar entertainments at the Courts of King Charles and James I. Expensive and ephemeral though these masques were seen to be, they had usually incorporated a message of social harmony, elevating order (royal government) over chaos. *Britannia Triumphans* opens with a street perspective, showing 'English houses of the old and newer forms'. It was not the first such image of planned urban order in one of Inigo Jones's stage designs, for he had been creating regular street perspectives in the Italian manner since Ben Jonson's *Vision of Delight* (1617), or even earlier.[48] Nevertheless, by the time *Britannia Triumphans* was published in 1637, Jones had put theory into practice at Covent Garden. It had been on his first Italian journey, in the opening years of the century – the second was with Lord Arundel in 1613–15 – that Jones originally found the model for his much later Covent Garden

in the great arcaded piazza which Bernardo Buontalenti (d.1608), the Florentine polymath, was building for the Grand Duke of Tuscany at Livorno. Duke Ferdinando's Livorno piazza was to be the inspiration of Henry IV's Place Royale, in Paris; it was probably the model also for Philip III's Plaza Mayor, in Madrid; in the 1630s, it remained the source of Inigo Jones's designs for Francis Russell (d.1641), Earl of Bedford, at Covent Garden. In all four cities – at Livorno and Paris, Madrid and London – symmetrical arcaded terraces and paved open spaces provided the context for well-regulated urban life-styles: warrantors of good order and control.

Never had good order been more urgently desired. In 1631, when a start was first made on Covent Garden, much of Europe had been at war for thirteen years. The Thirty Years War began with a Protestant atrocity, the Defenestration of Prague (23 May 1618), when the Catholic Regents, Martinitz and Slawata, were thrown to their deaths from a window. It ended, almost a generation later, at the Peace of Westphalia (24 October 1648), just weeks before Charles's execution. 'Some nations', wrote the English preacher Edmund Calamy in 1641, 'are chastised with the sword, others with famine, others with the man-destroying plague. But poor Germany hath been sorely whipped with all these three iron whips at the same time ... (and) is now become a Golgotha, a place of dead men's skulls; and an Aceldama, a field of blood'.[49] Great collections were broken up in the mayhem. First to go was the Palatine Library at Heidelberg, packed off to Rome shortly after the defeat of the Calvinist Elector Frederick V (d.1632) at the Battle of the White Mountain in 1620. Then the formerly rich collector, Christian IV of Denmark (1588–1648), drawn into the war on the Protestant side, was driven out of Germany in 1629: defeated, discredited, and in debt. In what was almost the last outrage of what had become a cruel war, the siege of Prague by the Swedes and their capture of the Hradschin Palace in July 1648 was followed immediately by the removal to Stockholm of the still impressive remains of the huge collections of Rudolf II. 'Take good care', Christina of Sweden

(1632–54) had told her generals, 'to send me the library and the works of art that are there (in Prague): for you know that they are the only things for which I care.'[50] And it was Queen Christina's ruthless kleptomania, infecting her Court, that caused Stockholm to rise in a very few years from nowhere to high prominence in the arts.

Connoisseurship in painting had come to rank as highly in the intellectual armoury of the nobleman as excellence in conversation and in writing. And why the Swedish queen and her aristocracy should have coveted such works of art had almost everything to do with reigning fashions. Inevitably, however, the great majority of Christina's trophies (especially those from Prague) were the works of German artists, whereas the painters she much preferred were the Italians. 'Apart from thirty or forty original Italians', Christina once confessed, 'I care nothing for any of the others. There are some by Alberto Dürer and other German masters whose names I do not know, and anyone else would think very highly of them, but I swear that I would give away the whole lot for a couple of Raphaels'.[51] Caught up in the fiscal chaos of the mid-century crisis and deeply engaged in their wars, many prominent art collectors had begun to think the same; for when paintings of good quality usually went for little money, only the greatest Italian masters held their value. In the autumn of 1649, when the Commonwealth Sale began, Charles's finest Gonzaga paintings – his Mantuan Raphael and his two Correggio *Allegories* – were still thought to be worth substantial sums. However, the prices of the late king's northern paintings had tumbled sharply. In 1649, a Hans von Aachen might be had in London for just £3; a Rembrandt for £4; a Paul van Somer for £5; a Quentin Massys and a Lucas Cranach for £6 each; while a pair of Dürer portraits – one of them the great *Self Portrait* of 1498 – were put on sale for just £100.[52]

The two Dürer portraits, bought by the Spanish ambassador (who had offered even less), were consigned in due course to Madrid. And the valuations placed on paintings, in those mid-century crisis

years, compared most unfavourably with the prices asked for almost any other collectible among the late king's 'goods', from antique sculptures to fine textiles, jewellery to plate, crystal to ivories, tapestries to oriental carpets, many of which sold quickly and over-estimate. Thus a silver-gilt 'Galley of Cristall standing upon 4 wheeles (and) garnished with pearles and rubies', valued by the trustees at £100, sold almost immediately on 23 October 1649 for £30 over the asking price. A few days later, 'fowre large fine Turkey Carpetts of the best sort . . . valued together at £44' were sold for £46. Priced originally at £109, 'seaven peeces of very fine Tapestry Hangings of Hercules' sold for ten pounds more on 7 November to John Boulton of Foster Lane, a London goldsmith.[53] Boulton, buying for a syndicate ('dividend') of city investors, spent almost £4000 at the Commonwealth Sale, purchasing embroidered hangings and curtains, tapestries, canopies and cloths of state, carpets and cushions, tables, cabinets and musical instruments, with cups and other precious objects of crystal, agate and silver. However, with the exception of a van Dyck equestrian portrait of the late King Charles, for which he paid £46 on 22 November 1649, and of five antique sculptures – a Hercules and a Claudius, a Nero, a Venus, and an 'olde' Faustina (wife of Marcus Aurelius, the Roman emperor) – which he bought three years later on 22 December 1652, Boulton's interest in the arts was very limited.[54] By that time too, the art market was at last moving upwards.

The reason why sales had started so slowly was that many of the great collectors had stayed away, shocked by Charles's execution and unwilling to deal openly with regicides. One result was deep uncertainty about prices. Almost alone in London as a major purchaser of Charles's art, Alonso de Cárdenas – buying for Luis de Haro, Philip IV's chief minister – made the most of it. It was in December 1649, shortly after the sale began, that Ambassador Cárdenas told his patron that Raphael's *Holy Family* (the great prize of the collection) was believed so expensive that 'no one talks of buying it'. Yet he himself would buy that painting some four years

later, characteristically bidding down its price. 'I can now tell Your Excellency, much to my pleasure', he wrote to Haro on 11 August 1653, 'that, thanks to God, I have also purchased the large painting by Raphael of Our Lady, her Child, St John and St Anne . . . that was valued at 8000 escudos (£2000), which I have had for 4000 escudos, which is half . . . This picture is esteemed as the best in all Europe, and here (in London) it is renowned among the painters as the finest painting in the world.'[55] Cárdenas had good reason to be satisfied with his bargain, for Cardinal Mazarin and other rich collectors had recently joined the hunt, and prices were going through the roof. It was not Mazarin but the Paris-based German banker, Everhard Jabach (d.1695), who bought Charles's remaining Titians and his only genuine Leonardo; who bid for his Guido Renis and his finest Caravaggios; and who was to pay more than three times the initial asking price for Correggio's *Allegory of Virtue*.[56]

One important art collector not represented at the sale was Queen Christina of Sweden; another was Leopold William, Archduke of Austria and Governor-General of the Spanish Netherlands from 1647. But Christina was still gorged on the recent loot of Prague. And Leopold William, located in Brussels to which many royalists had fled, was exceptionally well placed to pick up cheaply the collections of the late king's friends, among them those of Buckingham and Hamilton. It was in 1651 that much of Buckingham's former collection was sent to Prague, to fill the empty spaces on its walls. And when David Teniers the Younger (1610–90), appointed court painter in that year, made the first of his many paintings of the Archduke's Brussels gallery, it was chiefly Hamilton's Italian pictures that he showed there. 'I am much in love with pictures', the soldier Hamilton had claimed in 1636, launching a two-year collecting frenzy in the South. Yet there is little real evidence that he knew anything about art, and it was Charles's connoisseurship that he tracked.

Connoisseurship was the subject of David Teniers's gallery picture, where the painter himself, as curator and cataloguer of Leopold

William's art, holds up Annibale Carracci's easily recognizable *Lamentation* for learned commentary by the Archduke and his guest.[57] Significantly, Leopold William's crowded gallery contained none of the scholarly bric-à-brac and miscellaneous curiosities of the many would-be encyclopedic collections of its time. Instead, with the exception of a few antique busts and other sculptures, it was packed from floor to ceiling with the great Italian masterpieces which Leopold William (their next custodian after Hamilton) would subsequently declare – on bequeathing them to his nephew, the Emperor Leopold I (1658–1705) – to be 'the finest and most beloved part of my belongings'. Leopold William, profiting from the wars, had bought many of his favourite pictures at bargain prices. And other trend-setting collectors, once peace was restored, became equally focused on fine paintings. Prestigious and socially desirable yet intellectually challenging, unique and unrepeatable yet irresistibly affordable, high-quality pictures rose swiftly in Court-led regard, causing painting itself to be raised unequivocally – with architecture and sculpture, literature and music – to the pantheon of the five major arts.[58]

CHAPTER SEVEN

Bernini's Century

When the Haarlem painter, Karel van Mander, wrote of the 'beautiful or excellent things which seem to surpass Nature, such as particularly excellent works of art', his meaning was German and Netherlandish painting. And just as Vasari had 'presented to the people Michelangelo and many others during their lifetime and made their names praiseworthy and illustriously famous', it was van Mander's intention in 1604 that the individual life-histories of his *Schilder-boeck* should extend that same recognition to northern artists.[1] By the mid-1650s, when Cardinal Jules Mazarin was buying his van Dycks, something of the sort had already happened. Even so, painting's 'triumph' as a major art form was only just beginning. And it was that *uomo universale*, Gianlorenzo Bernini (1598–1680) – sculptor first, architect second, and painter only third – who dominated European art for five decades and more: 'not only the best sculptor and architect of his century but, to put it simply, the greatest man as well'.[2]

'You are made for Rome and Rome is made for you', Urban VIII (1623–44) once told Bernini. And Urban – poet, humanist, and lover of art – knew very well what he was talking about. During Urban's long pontificate, Rome in general, and the pope's Barberini relatives in particular, never ceased to benefit from his patronage. However, it was Rome's comparative immunity from the Thirty Years War that contributed most substantially to the

'embarrassment of riches' which – in Urban VIII's Rome, as in Republican Amsterdam – helped bring into the market an entirely new class of art-consumer. 'It is serious, lamentable, indeed intolerable to everybody, to see works destined for the decoration of Sacred Temples or the splendour of noble palaces, exhibited in shops or in the streets like cheap goods for sale', complained the painters of the Accademia di San Luca.[3] Yet it was the art dealers and stall-holders of Rome's Piazza Navona who were often the first to find work for the aspiring painters, sculptors, and other decorative artists attracted to the city by its cardinal-connoisseurs and spending popes. One such economic immigrant had been Caravaggio from Milan, working for some years as a journeyman-painter before Cardinal Francesco Del Monte took him up. Then, soon after Caravaggio's arrival, the established Bolognese fresco-painter, Annibale Carracci, had accepted an invitation in 1595 to work in Rome on the palace of Cardinal Odoardo Farnese. Ten years later, in 1605, the Naples-based sculptor Pietro Bernini (father of Gianlorenzo) found employment in Rome under Pope Paul V (1605–21), beginning his family's long association with the Borghese.

It was for Paul V's wealthy cardinal-nephew, Scipione Borghese, that the young Gianlorenzo Bernini carved the mythological groups – his *Rape of Proserpine* (1621–2) and *Apollo and Daphne* (1622–5) – which established his pre-eminence as a sculptor. 'In its design, in the proportions, in the expression of the heads, in the exquisiteness of all the parts, and in the fineness of its workmanship, it (the *Daphne*) surpasses anything imaginable', wrote Filippo Baldinucci (d.1697), his biographer.[4] And Bernini continued to find favour under Urban VIII, who would use nobody else for major projects. Bernini's spectacular altar canopy – his bronze *Baldacchino* (1624–33) – was commissioned for the newly consecrated St Peter's. He was also the sculptor of Pope Urban's huge sepulchral monument: 'that great miracle of art that Bernini made in marble and bronze . . . (having) qualities so original that if anyone came to Rome solely to see it, he could be sure of expending well his time, effort, and his

expense'.[5] When, after a decade of exclusion during the next (Pamphili) papacy, Bernini was again given work at St Peter's by the Chigi pope, Alexander VII (1655–67), he brought order and regularity to the Piazza di S. Pietro with his embracing semicircular colonnades. In the interval, the mid-century recession had hit Rome also, and the papal city's great renewal was almost over.

War, the old enemy, was to blame. 'Things in Rome have greatly changed under the present papacy', the French painter Nicolas Poussin wrote in 1645, soon after the election of Innocent X (1644–55); 'and we (artists) no longer enjoy any special favour at court'. 'It is impossible', explained the decorative artist Giovanni Francesco Romanelli (d.1662), following Cardinal Francesco Barberini into exile in France, 'for one who has until now lived under the noble patronage of Your Eminence and has received so many favours, to live far from Your Eminence'.[6] Some years would pass before Pietro da Cortona (d.1669), another protégé of the Barberini, got work from the new pope, while Bernini himself (who had considered leaving Rome) lost major commissions to the sculptor Algardi (d.1654) and the architect Borromini (d.1667), both of whom he had previously overshadowed. Neither Cortona nor Bernini, the two outstanding talents of their day, could be permanently excluded from Pamphili patronage, for 'the only way to avoid executing his (Bernini's) works', admitted Innocent X, 'is not to see them'. It was Innocent – 'a prince [wrote Baldinucci] of the clearest intelligence and of the loftiest thoughts' – who himself chose Bernini's design for the Fountain of the Four Rivers in the Piazza Navona. And it was Pietro da Cortona – once Urban VIII's choice for the much-admired Triumph of Divine Providence ceiling in the Gran Salone of the Palazzo Barberini – who would be commissioned again to paint a big *Story of Aeneas* (alleged ancestor of Innocent) on the gallery ceiling at the Palazzo Pamphili, as rebuilt for the pope and his relatives.

With those two exceptions, both family-related and in the Piazza Navona Innocent X built little. Europe was in recession, and the

papacy was very short of money. Urban VIII's overt nepotism and cost-no-object patronage had drained his treasury. Yet more damaging than either had been the late pope's fruitless attempts at mediation in the Thirty Years War, to be followed almost immediately by humiliating defeat in the ruinously expensive War of Castro (1641–4). That minor local war in the Papal State, begun and fought almost entirely in the Barberini family interest, would help double the papal debt by Urban's death, and no Roman pontiff for the remainder of the century could claim to be free of money worries. Among those who complained most bitterly of institutional poverty was Alexander VII, Innocent X's successor. Yet it was that same Alexander, so-called '*papa di grande edificazione*', who was to summon Bernini at the very beginning of his papacy to encourage him 'to embark upon great things in order to carry out the vast plans that he had conceived for the greater embellishment of God's temple (St Peter's), the glorification of the papacy, and the decoration of Rome'.[7] Alexander's timing could hardly have been more unfortunate. 'This pope has long paid particular attention to beautifying the city and repairing the roads', wrote the Venetian ambassador in 1661, 'and truly in this labour he has far surpassed his predecessors ... (but) Rome is getting more and more buildings and fewer and fewer inhabitants (every day).' Then, in the shadow of Alexander's death, 'one very striking reason for the waste of so much treasure', suggested another Venetian envoy in 1668, 'has been the putting up of buildings [including the porticos at St Peter's] which have destroyed rather than added to this city'.[8] Bernini's colonnades, in point of fact, have stood the test of time. And it was less the folly of its popes that cost Rome the leadership of Western art than ineluctable movements in world trade.

In 1623, when Urban VIII was elected pope and the rest of Europe was at war, Rome still had some claim to be called the 'capital of the world'. Yet Italy's traditional lead in banking, industry and commerce came seriously under threat in the next generation, and its title to economic primacy was history. It was the Atlantic

economies – France, the Netherlands, and England – that had moved ahead instead, permanently re-shaping the commercial geography of the West. First to fall victim to them were Spain's fledgling industries, unable to match northern prices. Then Italy also began losing market share, even in those industries (silks, velvets and damasks, ceramics, metalwork and glass) which had always been its province, and with once exclusive trading partners like the Levant.[9] In the arts, the re-drawing of Europe's map came more slowly. Italy's comfortably-off middle classes – the lawyers of Naples, the doctors of Bologna, the merchants of Genoa and Venice – were all collectors now, with both the means and the motivation to support the work of such major provincial artists as Giovanni Carbone (d.1683) in Genoa, Luca Giordano (d.1705) in Naples, Carlo Cignani (d.1719) in Bologna, Sebastiano Ricci (d.1730) and Canaletto (d.1768) in Venice, and many more.[10] When peace at last returned, Germany's wealthy collector-princes and England's Grand Tour *milordi* made Italy a new focus of pilgrimage in the arts, importing its finest muralists from Venice, Rome and Naples to paint their big processional staircases and grand saloons. But whereas French connoisseur-collectors, following Mazarin in the mid-century, continued to buy Italian paintings for some while yet, it was already clear by 1665 – when a reluctant Bernini (under pressure from the pope) left Rome for Paris – where the real money in art patronage now belonged. 'Let no one speak to me of anything small', Bernini stoutly warned Louis XIV (1643–1715), when presenting his new designs for the Louvre. 'As far as money is concerned, there need be no restriction', came the reply.[11]

Bernini was lionized in Paris: 'He was talked about so much everywhere that it was said that during this period there was no *mode* in Paris but Bernini.'[12] Yet the only major product of his stay was a 'noble likeness of the king' (his famous portrait bust of Louis). And while his proposals for the Louvre extension were much admired by some – 'I would have given my skin for Bernini's design', wrote Christopher Wren, who was in Paris at the time[13] –

they would be set aside almost as soon as they were made. Bernini left Paris on 20 October 1665. Only the week before, he had been taken by Paul Fréart de Chantelou, his official minder and interpreter, to see the great collection of pictures recently formed by Armand-Jean du Plessis, Duc de Richelieu (the Cardinal's heir). Bernini, reported Chantelou, found Richelieu's gallery 'just how a collection should be, with nothing in it but the best'. But what Bernini meant by 'the best' were the duke's Titians and his Carraccis, and almost everything else in Richelieu's collection was Italian. In Paris, Chantelou had told him, there were some 'ten or a dozen' such new collections, for 'during the last fifteen or twenty years no expense had been spared (by Parisian collectors) to obtain works in Rome, Venice and other parts of Italy'.[14] But the high fashion for Italian paintings was nearing its end. And so firmly had national feeling gained a hold by 1700, that new purchases of Italian works had almost ceased.[15]

The same thing was happening to architecture. Bernini's design for a Roman Baroque Louvre, while at first attracting Louis XIV's enthusiastic support, was unashamedly Italian, paying only token regard to what was there. Simultaneously, the belief was gaining ground among French *cognoscenti* of the day that Rome's 'grand manner' architects had nothing left to teach, thereby forfeiting their monopoly of the Antique. It would be said in Paris, for example, of Carlo Rainaldi's Louvre proposals (solicited at the same time as Bernini's) that they were *'fort bizarres et n'avaient aucun goût de la belle et simple architecture'*.[16] And there was a growing preference in France for what its own architects could provide: scholarly purity, simplicity, and Frenchness. In view of an upbringing surrounded (Bernini thought) by 'petty and fiddling designs', the king's sureness of taste was 'astonishing, if not miraculous'.[17] But permanence more than beauty is what public architecture is about, and Louis XIV's major buildings were political. 'Nothing', Colbert (Louis's minister) had advised him in 1663, 'better indicates the greatness and spirit of princes than buildings; and all posterity measures them by the

standard of these superb buildings that they have erected during their lives'.[18] Two years later, the first of Louis XIV's politically-driven projects was the completion of the Louvre, where his eventual choice of architect was not the famous foreigner Bernini (favourite of the pope) but a native-born Vitruvian, Claude Perrault (d.1688), editor of *The Ten Books of Architecture*. Colossal but gesture-free – as Bernini's scheme was not – Perrault's great Louvre Colonnade of 1667–74 introduced a new 'French' order alongside those of Rome, and launched Louis's 'Architecture of Absolutism'.

Nowhere was that architecture developed more systematically than at Louis XIV's huge out-of-town palace at Versailles. Built originally as a royal hunting-box in the forests west of Paris, Versailles was already a firm favourite with the young king in 1665 when Bernini was taken there that summer to see the sights. What Bernini saw on that occasion were the 1620s façades (already plainly out-of-date) of Louis XIII's country lodge – 'mixtures of brick, stone, blue tile and gold (that) make it look like a rich livery'[19] – shortly to be encased in Louis Le Vau's great 'Envelope' and preserved today in Versailles's Cour de Marbre. Whereas the great Bernini was accustomed, Baldinucci tells us, 'to praise the good . . . and if there was nothing to praise, to invent ways of speaking without committing himself', he evidently found it hard to be polite. Of one thing, though, he was certain. 'This palace is well proportioned', the old Italian said, '(and) everything is good that has good proportion . . . In palaces of this kind, solidity is not the first consideration, and for that reason it succeeds well.'[20] But while Bernini was right about a hunting-box, he was wrong about a palace. And everybody there present must have known it.

'When we build, let us think that we build for ever', wrote John Ruskin in *The Seven Lamps of Architecture* (1849). And Versailles, as Louis XIV rebuilt it with due emphasis on permanence, was to be the architectural embodiment of Bourbon monarchy. Its two major building campaigns, under Louis Le Vau (from 1668) and Jules Hardouin-Mansart (from 1678), coincided with the greatest of

Louis's triumphs. The Peace of Aix-la-Chapelle, signed on 2 May 1668, had brought the Franco-Spanish War of Devolution (1667–8) to a victorious end, resulting in substantial territorial gains in the Southern Netherlands. Then, almost exactly ten years later, on 10 August 1678, the Peace of Nijmegen with Holland could likewise be construed as a victory for France, ending a long commercial war which had begun six years earlier with Louis XIV's successful crossing of the Rhine (12 June 1672). It was after the War of Devolution that Louis was first called 'Great'. Then, after his Rhine crossing, 'Louis has only to appear and your walls collapse', boasted the French court dramatist Corneille. That legend continued to grow: Louis as the Sun God in Versailles's *Bassin d'Apollon*, Louis as *Imperator Francorum* (Emperor of the Franks), Louis as Constantine ('the unconquered sun'), Louis as *'monarque de l'univers'*, and so on.[21] Much later, the old king on his deathbed would regret those early victories, too easily won in his youth. 'I have loved war too much', Louis warned his infant heir, 'do not imitate me in this respect, or in my expenditure, which was too great.'[22] Love of *gloire* had brought him close to ruin in the Wars of the League of Augsburg (1688–97) and of the Spanish Succession (1702–13). But so too had the 'monstrous and incurable luxury' of Versailles.

In 1661, when Louis first proclaimed his personal rule, the future had looked very different. In those days, the king recalled, 'everything was calm everywhere (and) peace was established with my neighbours, probably for as long as I myself might wish.'[23] He had also had the benefit of the financial wizardry of Colbert, appointed Surintendant des Finances that same autumn. Like most statesmen of his day, Jean-Baptiste Colbert (d.1683) was a mercantilist. He believed in national self-sufficiency and was committed to the three principles which he himself defined as: 'increasing the money in public commerce by attracting it from the countries from which it comes, keeping it within the realm and preventing it from leaving, and giving men the means to make a profit from it'.[24] At first, those

policies had proved entirely successful in excluding foreign imports
and encouraging manufacturing industry throughout France. Yet
they were to lead in just a decade to war with the Dutch Republic,
for which preparations had already started in 1670 when Colbert
delivered his magisterial *Mémoire au Roi sur les finances*. Colbert could
look back as he wrote on nine years of 'great abundance', during
which the royal revenues had more than trebled 'and all expendi-
tures which were beneficial and advantageous to the state were
made with grandeur and magnificence'.[25] In 1664, along with his
other tasks, Colbert had been given the superintendency of Louis's
building programmes. And it was in those bountiful years of relative
peace and strong financial surpluses that there developed in France
'a school of architecture [Wren thought] the best probably at this
day in Europe'.[26] By 1670, in contrast, royal spending had grown
to such extraordinary heights that it exceeded tax receipts even in
peacetime. In the event of war with Holland, Colbert warned, every
category of state expenditure would need careful auditing, not
excluding the king's cherished project at Versailles.

> For buildings, if your Majesty is willing to settle upon a fixed
> sum for Versailles, *to which he will stick closely without going
> beyond it for any reason whatever*, we shall be able to continue
> work on the Louvre, to begin the Arch of Triumph [celebrating
> the Peace of Aix], the Pyramid, the Observatory, the manufac-
> ture of the Gobelins [for the king's tapestries and other furnish-
> ings], and generally all Your Majesty's other projects.[27]

New buildings and industrial enterprises on this enormous scale
both challenged local craftsmen and offered inspiration to foreign
visitors. It was in 1665, with Bernini in Paris and Louis's kingdom
still at peace, that Christopher Wren, the English astronomer
and amateur architect, had gone to see the Louvre almost daily.
There, under Colbert's close direction, 'no less than a thousand
hands are constantly employ'd in the works; some laying mighty
foundations ... others in carving, inlaying of marbles, plaistering,

painting, gilding, etc.' But of equal interest to Wren were the many 'incomparable villas' of the Paris region, commissioned by its rich financiers and state officials. Of his two clear favourites, one was François Mansart's innovatory Maisons-Lafitte, built for René de Longueil in the 1640s; the other was Louis Le Vau's enormous château at Vaux-le-Vicomte, completed in 1661 for Nicolas Fouquet (Colbert's predecessor as *Surintendant*) just weeks before that minister's disgrace.[28] It was at Vaux-le-Vicomte that Colbert found the architect, Louis Le Vau (d.1670), the landscape gardener, André Le Nôtre (d.1700), and the decorative painter, Charles Lebrun (d.1690), to create the king's great palace at Versailles. Significantly, all three of those artists were French by birth, and only one of them had ever trained in Italy. While working in Rome under Nicolas Poussin in the mid-1640s, Charles Lebrun had come under the influence of the Roman fresco-painters Pietro da Cortona and Giovanni Romanelli (who was also in Paris in 1645–7 and 1655–7). Yet he was to develop independently a more sober style of his own – 'a Baroque tamed by the French classical spirit'.[29]

It was Colbert and Lebrun together, as Vice-Protector and Director respectively of the reorganized Académie Royale de Peinture et de Sculpture, who sponsored the growth in France of an 'academic' art: venerating the Antique, capable of being taught on rational principles, and governed by logic, form and rule. Versailles was created in that mould. The palace's long garden front (by Louis Le Vau and Jules Hardouin-Mansart) set aside Baroque in favour of High Renaissance revivalism. Rusticated at the base, it had a straight Mediterranean skyline and a strictly regular façade, broken only by Ionic columns and pilasters. While colossal in scale, Le Vau's architecture was conservative. It had neither the steep-pitched northern roofs of the same architect's Vaux-le-Vicomte nor the unselfconscious swagger (*vanteria*) of Bernini's Rome. Consequently, where Versailles set new standards for palace-building in the West was not in its stretched façades but in the formal splendour of its setting – the geometric gardens by Le Nôtre – and in the spectacular decor

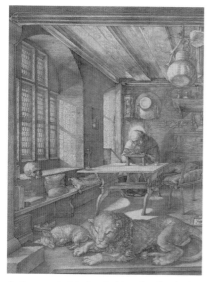

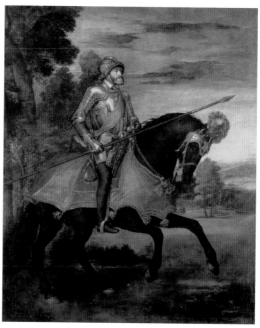

St Jerome in his Study (the theological way to salvation) is one of Dürer's three *Master Engravings* of 1514, the others being *Knight, Death and the Devil* (the moral way) and *Melencolia I* (the intellectual way).

Titian travelled to Augsburg in 1548 to paint this big equestrian portrait of Charles V ('who would never be painted by anyone else'), commemorating the Emperor's victory over the Protestants at Mühlberg.

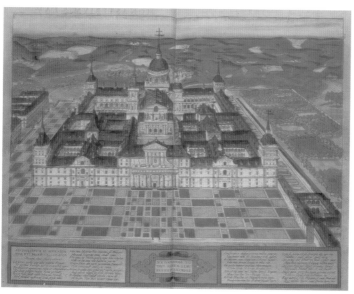

Philip II's convent-palace at El Escorial (1563–84) is often seen as the architectural embodiment of the Counter-Reformation, with which its 'simplicity of form' and 'severity in the whole' were in tune. It also reflects the growing understanding of Ancient Rome which contemporary scholarship had made accessible to all artists – sculptors and painters, as well as architects.

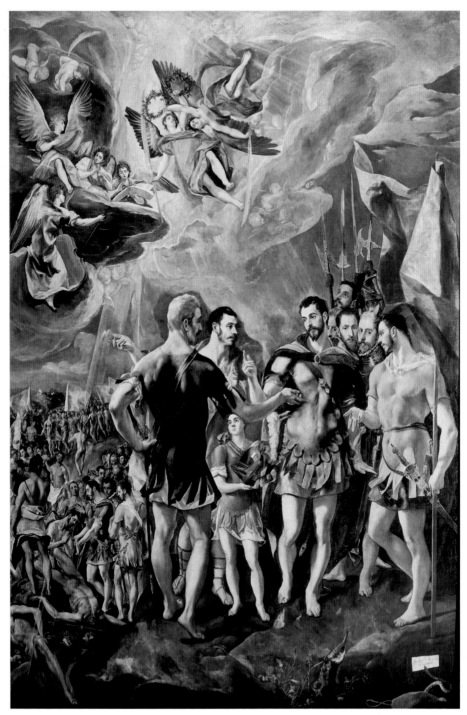

El Greco, originally from Crete, had worked in Venice and Rome before coming to Spain in 1576–7. His *Martyrdom of St Maurice and the Theban Legion* (1580–3) was only his second royal commission. When the painting was rejected by Philip II and his advisers on theological and moral grounds, El Greco found more understanding patrons among the higher clergy of Toledo, where he settled.

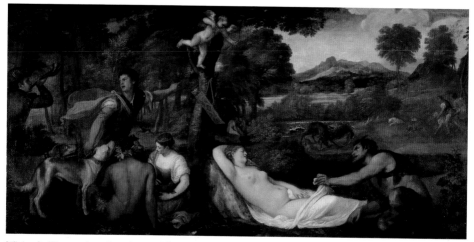

Titian's *Figures in a Landscape* (the 'Pardo Venus') was one of several Arcadian paintings sent from Venice in c.1560 to hang in Philip II's country palaces at El Pardo, Valsaín, and Aranjuez. Overtly erotic, Philip's *poesie* were private paintings never intended for public display, in contrast to the religious works which he began commissioning shortly afterwards for the Escorial.

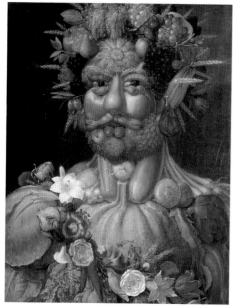

Guiseppe Arcimboldo's *Rudolf II as Vertumnus* (c.1591) is a play on a poem by the irreverent Latin love-poet, Sextus Propertius, here glorifying the Habsburg Emperor Rudolf II (1576–1612) in a naturalistic allegory which would have appealed to the intellectual Emperor and his circle.

Veronese's illusionistic frescos (1561) at the Barbaro brothers' villa at Maser depict the rural pursuits of wealthy Venetians, 'retiring [wrote Palladio] to such places where … they could easily achieve whatever happiness one can achieve here below'.

Palladio's Church of San Giorgio Maggiore (Venice) is one of the better known of his buildings. While completed some two decades after Palladio's death, this grand west front (1599–1610), with its two overlapping facades, is nevertheless typical of his Mannerist invention.

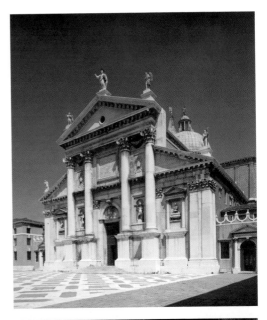

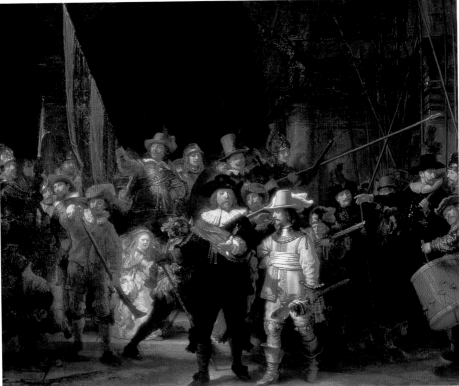

Rembrandt spent most of 1642 on this enormous group portrait of *The Militia Company of Captain Frans Banning Cocq and Lieutenant Willem van Ruytenburch*. While bound to some extent by the terms of his commission, Rembrandt gave his *Night Watch* an individual twist by painting Captain Cocq's Company in the chaotic act of muster, thus elevating the work from portraiture to history – from a lesser to a higher plane of art.

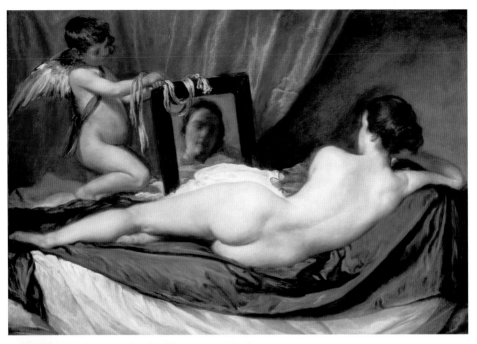

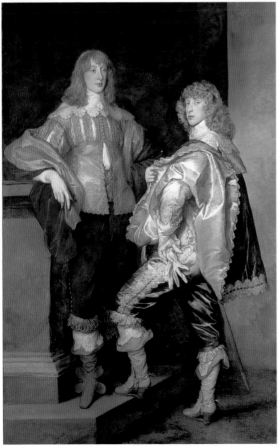

ABOVE It was probably while visiting Italy in 1649–51 that Velázquez painted his *Venus and Cupid* (the Rokeby Venus) privately for Gaspar de Haro, the womanising Marquis de Eliche. Velázquez's *Venus* was the first and last such image in Spanish art before *The Naked Maja* (c.1801) of Francisco de Goya.

LEFT Sir Anthony Van Dyck's *Lord John and Lord Bernard Stuart* (1638) was painted towards the end of his third and longest London period (1635–9), when the court portraitist was about to marry into the high-spending aristocracy to which these two young peacocks belonged.

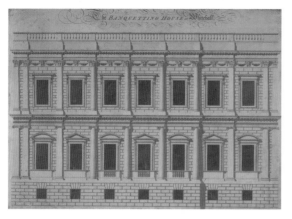

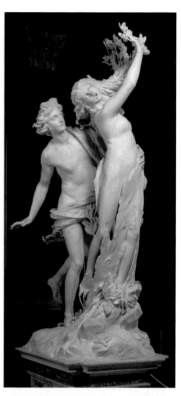

ABOVE Inigo Jones's Banqueting House (1619–22), seen here in Sir John Soane's prize-winning elevation of 1772, is today the only surviving building of James I's over-ambitious dynastic scheme for a new classical palace in Whitehall.

RIGHT Bernini's *Apollo and Daphne* (1622–5) – an early work – was nevertheless one of the finest sculptural groups he ever made.

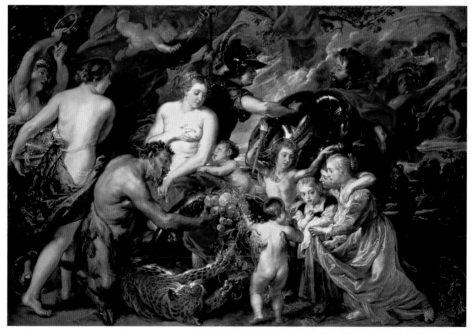

Rubens, 'born to please and delight in all that he says and does', painted his *Peace and War* for Charles I in 1629–30, while in London to negotiate an end to the Anglo-Spanish War. In this large and crowded allegory, *Minerva* (Wisdom) holds back *Mars* (War), while *Pax* (Peace) feeds *Plutus* (Wealth) from her left breast.

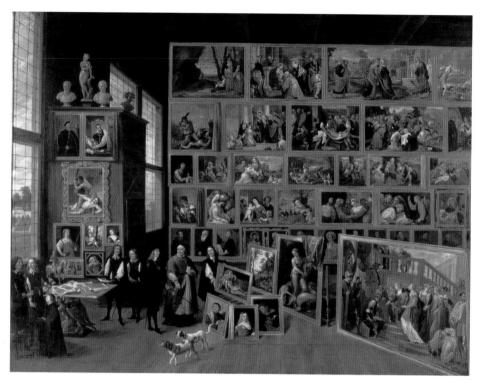

David Teniers the Younger, curator of Archduke Leopold William's collection of art, painted at least eight views of his patron's gallery. In this earliest record, made in 1651, many of the paintings are still extant, including Raphael's *St Margaret of Antioch* (on the floor, partly draped) and Titian's *Diana and Actaeon* (top right), now in London. The painting held up by Teniers for inspection is a Carracci *Lamentation*, to be found today (like the Raphael) in Vienna.

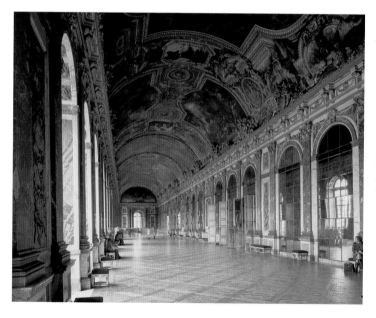

Charles Lebrun, *premier peintre du roi* from 1662, worked with Hardouin-Mansart on the *Galerie des Glaces* (1679–84), the most admired of Louis XIV's many state apartments at Versailles.

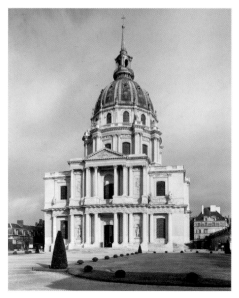

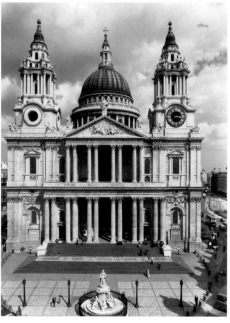

Jules Hardouin-Mansart's great *Dôme* (1677–91) at Louis XIV's *Hôtel des Invalides* paved the way to French Neoclassicism, of which it became a primary source.

Completed in his lifetime, Sir Christopher Wren's Baroque cathedral replaced the medieval St Paul's Cathedral destroyed in the Great Fire of London of 1666.

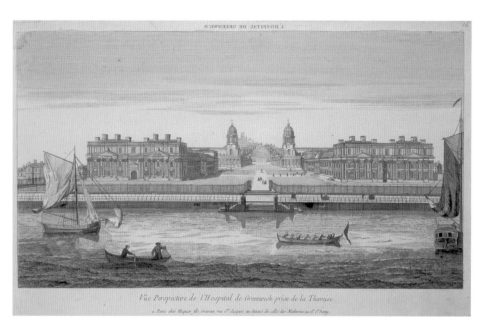

It was in the sumptuous Baroque spread of the Royal Naval Hospital at Greenwich (1695–1716), planned from the start with 'fixt intention for Magnificence', that Wren showed himself at his most successful and creative, untroubled by meddling clergy and city fathers.

and extravagant silver furnishings of its Grands Appartements (by Lebrun and Hardouin-Mansart), in particular of the Galerie des Glaces. 'All that concerns the interior of apartments', commented the Swedish architect, Nicodemus Tessin 'the Younger' (d.1728), 'is improved upon daily in France and it is there (especially) that they achieve such great success.' Tessin, writing in 1694, was shortly to start work on the royal palace in Stockholm, and needed to know from his Paris correspondent 'what is to be found in the most distinguished town houses and more particularly in the State Apartment(s) at Versailles'.[30]

If Swedish court architecture looked to France for its example, it owed that bias chiefly to Tessin's father. Soon after his appointment in 1649 as royal architect to Queen Christina, Nicodemus Tessin 'the Elder' (d.1681) had left her Court on an extended study tour which had taken him to France and Holland, Germany and Italy. He had returned a Baroque enthusiast, and was to model his Drottningholm Palace, begun during the Regency in 1662, on Louis le Vau's just-completed Vaux-le-Vicomte. However, in 1662, after half-a-century of campaigning, the Swedish monarchy was weak both in manpower and in money: 'in the last stages of impotence', Louis XIV was advised a decade later.[31] And Drottningholm took more than twenty years to build. In 1680, a new era opened when Charles XI (1660–97) declared himself absolute. And it was under Sweden's thrifty 'King Greycloak', a firm believer in neutrality, that Drottningholm was finished, that the royal treasury was replenished, and that the national debt was reduced by three-quarters. 'Through this sovereign's unwearied, wise and economical government', wrote the diarist Nils Reuterholm, 'Sweden achieved an internal strength and an external prestige such as she had never had before.'[32] And while little of that prosperity would survive the rash adventurism of his son, Charles XII (1697–1718), sufficient funds were in place in the year of Charles's death for a start to be made on Stockholm's Baroque palace: a Baltic re-working of Versailles.

It was later that same year that the War of the League of

Augsburg was brought to an end in a series of territorial exchanges – many of them potentially explosive – between France and Holland, England, Spain and Austria. With commercial confidence restored following the Treaty and Peace of Ryswick of September-October 1697, building could begin again almost at once. Thus it was in the lull between two wars that Louis XIV pressed ahead with the extravagant Dôme (chapel) of the Invalides which, by the time it was consecrated in 1706, had drained the royal exchequer for many years: 'as for that great and beautiful Dôme that has cost so much', grumbled Louis's military engineer, Sébastien le Prestre de Vauban (d.1707), 'one can only say that it is no more necessary for the Invalides [a veterans' hospital] than a fifth wheel on a waggon'.[33] Vauban himself had been the architect of the king's *barrière de fer*, one of the most sophisticated (and expensive) systems of frontier fortifications ever built. But he had also planned new towns – as at Neuf-Brisach, on the Rhine – and would certainly have found more to interest him in the places royales, each of which focused on a statue of the king, with which Louis XIV was beautifying Paris. In 1685, work had started on the Maréchal de La Feuillade's Place des Victoires, of which Jules Hardouin-Mansart was the designer. And it was Hardouin–Mansart again who planned the Place Louis-le-Grand (now the Place Vendôme), which was to have been Louis XIV's personal contribution to his capital. Postponed, along with the Invalides and other costly projects, during the Nine Years' War, work resumed on the Place Louis-le-Grand only after Ryswick in 1697, when the king himself had lost interest. In the meantime, however, a giant equestrian statue of Louis (later destroyed at the Revolution) had been commissioned from the workshop of François Girardon (d.1715), the leading classical sculptor of his generation. Girardon had worked with Lebrun and Le Nôtre on the palace and gardens at Versailles, where his life-sized statuary group, *Apollo tended by the Nymphs* (1666–75), was one of many patriotic tributes to the Sun King. He was a dedicated academician, and a tireless collector of the small-scale bronzes, reductions from the

Antique, which had given French artists access, as Colbert had intended, to '*tout ce qu'il y a de beau en Italie*'.[34] Predictably, Girardon rejected every Baroque parallel for his statue of Louis 'the Great', favouring instead the second-century Roman monument of the Emperor Marcus Aurelius (161–80): the model chosen also by the Prussian sculptor-architect, Andreas Schlüter (d.1714), for his near-contemporary equestrian statue of Frederick William, the Great Elector, at Charlottenburg.

Whether inspired chiefly by academic classicism or by the *vanteria* of Bernini, there was scarcely a major capital in the late seventeenth-century West untouched by the grand vision of Baroque. London carries that mark more than most. Early in 1666, Christopher Wren (1632–1723) had returned from Paris, after several months of study of French architecture. And it was later that same year that the Great Fire of London of 2–6 September consumed a large part of the old city. Within days of the Fire, Wren (along with other would-be planners, including the diarist John Evelyn) was to present a grand design to Charles II (1660–85) for a complete rebuilding of his capital. And while that initiative came to nothing – wrecked by 'the obstinate Averseness of a great Part of the Citizens to alter their old Ground and Foundations'[35] – Wren's appointment soon afterwards as Surveyor General of the King's Works gave him overall responsibility for the rebuilding of St Paul's Cathedral and for as many as fifty-one city churches. Apart from Oxford's Sheldon-ian Theatre (1662–3) and some lesser Cambridge works, Wren had built little of any consequence before being entrusted in 1669 with the Surveyorship. Nevertheless, his sound mathematical training and sure eye for a bold effect enabled him to combine, in his post-fire London churches, the best elements of Renaissance Rome (from Bramante to Borromini) with the scholarly French classicism of Lemercier, Le Vau and the Mansarts. Wren's highly original city churches – from the multi-storeyed classical steeple of St Mary-le-Bow (1670–77) to the ingeniously-engineered dome of St Stephen Walbrook (1672–87) – have usually been seen as his best work.

However, it is for his mighty St Paul's Cathedral – part Bramante, part Hardouin-Mansart, but mostly Wren himself – that the Surveyor General is now principally remembered. Exceptionally for the initiator of so vast a project, Wren lived to see St Paul's finished in 1711. He was to be buried there twelve years later in the crypt of the great cathedral he had designed and built himself, commemorated by the famous epitaph: *Lector, si monumentum requiris, Circumspice* (Reader, if you seek a monument, look about you).

St Paul's, in point of fact, was not Wren's finest monument. It had been the product of too many compromises, forced on an inexperienced architect by the gathering political storm of the last Stuart years, by growing xenophobia and the collapse of English commerce during the Nine Years War, and by the conservatism (even hostility) of the cathedral clergy. In contrast, when given Queen Mary's project for a Royal Naval Hospital at Greenwich, Wren could proceed with Bernini-like panache. Greenwich, begun in 1695 with 'fixt intention for Magnificence', would be Wren's High Baroque masterpiece: the model for such enormous private palaces as Sir John Vanbrugh's Blenheim (1705–24: for John Churchill, Duke of Marlborough) and Castle Howard (1699–1712: for Charles Howard, Earl of Carlisle). Almost every characteristic of those vast and spreading monuments was imported. True, it was an Englishman who did the frescoes in the Painted Hall at Greenwich, as on the ceiling of the Great Hall at Blenheim. But Sir James Thornhill (d.1734), appointed History Painter to George I in 1718, had learnt his swagger from an Italian, Antonio Verrio (d.1707), and his scholarship from a Frenchman, the Versailles-born muralist, Louis Laguerre (d.1721), who had worked in Paris for Charles Lebrun as a young man. It was Laguerre who painted Churchill's victories for his Marlborough House, in London. And whereas the English – and Marlborough in particular – were to challenge the Sun King's grand designs for Universal Monarchy, his palaces stayed on everybody's lips. There is an entry in John Evelyn's diary which records in waspish detail the Versailles-style furnishings of the

Whitehall apartment of Louise Renée de Kéroualle, Duchess of Portsmouth, Charles II's mistress. Evelyn had been present at Louise's *levée* on 4 October 1683, when the duchess was 'in her morning loose garment, her maides Combing her, newly out of her bed: his Majestie & the Gallants standing about her':

> But that which ingag'd my curiositie was the rich & splendid furniture of this woman's Appartment, now twice or thrice puld downe & rebuilt to satisfy her prodigal & expensive pleasures . . . Here I saw the new fabrique of French [Gobelins] Tapissry, for designe, tendernesse of worke, & incomparable imitation of the best paintings beyond any thing I had ever beheld; some pieces had Versailles, St Germans & other Palaces of the French King, with Huntings, figures & Landscips, Exotique fowle & all to the life rarely don: then for Japon Cabinets, Skreenes, Pendule Clocks, huge Vasas of wrought plate, Tables, Stands, Chimny furniture, Sconces, branches, Braseras &c they were all of massive silver, & without number.[36]

French cultural hegemony, while Evelyn wrote, was already giving cause for concern. In Thomas Shadwell's bawdy comedy *The Humorists*, opening in London in 1671, Crazy – 'one that is in Pox, in Debt, and all the Misfortunes that can be' – launches the play with a characteristic tirade against the French: 'A curse on these French Cheats, they begin to be as rife amongst us as their Countrey Disease [the pox], and do almost as much mischief too: No corner [of London] without French Taylors, Weavers, Milliners, Strong-Water-Men, Perfumers and Surgeons'.[37] And it is in Shadwell's play *The Miser* (1672) – his own re-writing of Molière's *L'Avare* (1668) – that the poet memorably denounces 'France that on fashions does strict Laws impose/The Universal Monarchy for Cloaths'.[38] Yet the English were no more able than either the Germans or the Dutch to resist the siren call of Paris fashion. Within a week of 'surfeiting' on the Whitehall excesses of Louise de Kéroualle, John Evelyn was back again in London on 10 October 1683, recording

with satisfaction – and not a breath of criticism – a visit he had just paid to the 'stately & ample Palace' of Ralph Lord Montagu (twice ambassador to France), newly built behind a forecourt 'after the French pavilion way', like the *grand hôtel particulier* of a Paris nobleman. Large-scale frescoes, suddenly in great demand, were commanding a high price. And the ex-ambassador's initial choice of muralist for the Great Stair and Grand Saloon of Montagu House was the successful Neapolitan painter-of-fortune, Antonio Verrio, who was shortly to succeed the more talented royal portraitist, Sir Peter Lely (d.1680), as 'Chief and First Painter' to Charles II. It was Verrio's extravagant mythologies that Evelyn saw that day in Bloomsbury, believing them to 'exceed any thing he has yet don, both for designe, Colouring, & exuberance of Invention, comparable certainely to the greatest of the old Masters, or what they so celebrate at Rome.'[39] But painting in the 'grand manner' – the gusto grande of Bernini's Rome – was already starting to look old-fashioned to London's francophile connoisseurs. And when Verrio's still-new frescoes were destroyed soon afterwards in the fire of 1686, Montagu turned to Frenchmen for his art. Thus a 'Monsieur Puget' would be Montagu's architect for his Bloomsbury *grand hôtel*, and perhaps also for Boughton House (Northamptonshire), his country seat; his decorative artists included the landscape-painter Jacques Rousseau (d.1693), the flower painter Baptiste Monnoyer (d.1699), and the history painters James Parmentier (d.1730) and Louis Cheron (d.1725); his interior designer was the exiled Huguenot, Daniel Marot (d.1752) – also the decorator of Christopher Wren's new range for William and Mary at Hampton Court – who had earlier worked for the Prince of Orange at Het Loo.[40]

Marot and his uncles, the cabinet-makers Pierre and Adrian Golle, had fled Paris for The Hague after Louis XIV's Revocation of the Edict of Nantes (18 October 1685). Before that time, they had been co-workers in Paris of André-Charles Boulle (d.1732), the great *ébéniste du roi*, who was to give his name to a deliberately lavish school of palace furniture-making, characterized by elaborate

marquetries of tortoiseshell and brass and by pictorial gilt-bronze mounts featuring scenes from classical mythology. It was skills of this high excellence, developed specifically for Louis's palaces and brought to perfection at Colbert's Manufacture royale des meubles de la Couronne (the Gobelins), that migrated across Europe with the Huguenots. And while it was the king's unending wars, rather than this new Protestant diaspora, that were chiefly responsible for the *fin de siècle* recession into which France slipped, his subjects were fully conscious of their loss. Shortly after the Peace of Utrecht (March-April 1713) had brought an overdue end to the second trans-continental war in their own generation, Louis's emissaries in London wrote frankly to their king:

> It is principally since the time of the Prince of Orange's reign that our trade with the English has decayed. The privileges and favours he accorded our Protestants who withdrew to England in great number and who carried there our manufactories of silk, hats, hardware, paper, linen, and several other commodities, have broken the usage in England of all similar imported goods which they formerly obtained from us ... Since the two wars the English have established manufactories similar to ours for hats, paper, silk fabrics, linen cloth, fine hardware, gold and silver thread, window glass, glass tableware, soap, and several other products. This has diminished our exports to England and has changed the balance of trade ...[41]

In a country as rich and populous as Louis XIV's France, the departure of even as many as 200,000 Protestants might have mattered less had it not been for the superior quality of the emigrants. As it was, the Huguenots who fled Lyon (a major banking centre) before 1699 'were rich and cut a good figure in trade and carried away with them a considerable amount of wealth'. And of the 281 Protestants and their families who left Nîmes (famous for its silks and woollens) in 1685, no fewer than forty were noblemen, thirty-two were merchants, seven were lawyers and five were doctors, one

was a schoolmaster and another a bookseller, whereas only forty-five were artisans.[42] Other nations stood to profit from France's loss. Thus many of the wealthier departing Huguenots sought refuge first in Holland, where they were welcomed by Dutch cities – Amsterdam and Utrecht, Haarlem and The Hague – that had fallen on hard times during the Franco-Dutch War of the 1670s. And a good number of those – including Daniel Marot himself, the gold-smith Pierre Platel (d.1719), and the family of the great silversmith, Paul de Lamerie (d.1751) – were to move on again to London after the Glorious Revolution of 1688 had made England a safer haven for their religion. Within weeks of James II's flight and of the accession of William III (1689–1702), the new king was promising the migrating Huguenots the same welcome in England that he had already offered them in Holland:

> All French Protestants [he guaranteed on 25 April 1689] that shall seek their refuge in our Kingdom shall not only have our Royal protection for themselves, families and estates, but we will also do our endeavour in all reasonable ways and means so to support, aid and assist them in their several trades and ways of livelihood as that their living in this realm may be comfortable and easy to them.[43]

Meanwhile, other Protestant princes had acted equally promptly. Just days after Louis's Revocation of the Edict of Nantes, Frederick William, the Great Elector (1640–88), had issued his own counter-vailing Edict of Potsdam, promising the Huguenots 'a free and safe retreat in all the lands and provinces beneath our sway'. And it was in response to that invitation, with its offers of practical assistance both on the journey and on arrival, that some 20,000 Huguenots left France for Brandenburg-Prussia in the first year alone, re-populating its empty cities and frozen plains. Prussia, at this time, was to be one of the principal beneficiaries of *Peuplierungspolitik*: the resettlement policy of Germany's princes after the devastations of the Thirty Years War. And in the next century in particular,

under Frederick the Great (1740–86), Huguenot army officers and financiers, industrialists and farmers, *commerçants* and craftsmen of every kind were to make a major contribution to the emergence of Hohenzollern Prussia as a great power. Furthermore, their concentration in Berlin – almost half the population of which was Huguenot by 1700 – reinforced the existing Gallomania of the Prussian Court and pointed the way to a new Frenchness in German art, in the style known as 'Frederician Rococo'. But that was yet to come. And when High Baroque took off in Germany in the Great Elector's time, it was both Rome-related and southern-based.

Baroque's first appearance in Central Europe had been in Prague, at the huge Valdstejn Palace (1624–34) of Albrecht von Waldstein, Duke of Friedland, the Czech-born military commander and entrepreneur. But few of Waldstein's fellow generals could match his talent for wartime profiteering. And even after the Peace of Westphalia in 1648, there followed a further two decades of reconstruction before the Czech aristocracy could begin building again. One of the more impressive of their new townhouses was the huge Cernín Palace (1669–92), designed by Francesco Caratti ('in the Roman style') for Count Humprecht Hermann Cernín, a wealthy Prague nobleman and Grand Tour traveller. And it was in Prague again that the new French-style classicism reached Central Europe in the archiepiscopal palace of Count Johann Friedrich von Waldstein, designed and built in the late 1670s by the Dijon-born architect, Jean-Baptiste Mathey (d.1695). However, building elsewhere in the Habsburg Empire had been kept to a minimum throughout that time by continuing doubts about the future. In the event, it was the elimination of the Turkish invasion threat in 1683 that opened the way to new building.

So total was Kara Mustapha's defeat at Kahlenberg on 12 September 1683 that the Siege of Vienna was raised immediately and much of Ottoman-held Hungary was recovered within months. Then, as confidence flooded back, the market opened up for Austria's architects. Some of those – including Jakob Prandtauer

(d.1726), the rebuilder of Melk Abbey – had never left home. And in Prandtauer's case, it was Melk's soaring rent-rolls that enabled Abbot Berthold Dietmayr to launch in 1702 a comprehensive rebuilding of his abbey. Prandtauer would then use his Melk experience in subsequent church rebuildings: at Christkindl and Dürnstein, Sonntagberg, St Florian and St Pölten. And it was this pent-up demand for new buildings of every kind, released at last in post-Kahlenberg Austria, that attracted the exiles from Italy. Johann Bernhard Fischer von Erlach (d.1723) and Johann Lukas von Hildebrandt (d.1745) had both been pupils of the Roman Baroque architect Carlo Fontana (d.1714), formerly assistant to Cortona and Bernini. And they found no shortage of commissions on their return. In Vienna itself, Fischer's Karlskirche (1716–37: for the Emperor Charles VI) and Hildebrandt's Belvedere Palace (1700–24: for Prince Eugène of Savoy) are generally acknowledged to be their master-pieces. But while each of these buildings had its Roman Baroque parallel, no architect of quality, as late as this in the style's development, could have been ignorant of what was happening in France. Although born in Genoa and trained in Rome, Hildebrandt would nevertheless become the leading South German prophet of Rococo. And even the older Fischer was sufficiently aware of French building to be influenced by it. Fischer's three Salzburg churches – the Dreifaltigkeitskirche (1694–1702), the Kollegienkirche (1694–1707), and the Johannesspitalkirche (1699–1704) – all began with Borromini. But they had other roots also in the work of Jules Hardouin-Mansart (in Paris) and Jean-Baptiste Mathey (in Prague); while second only to Bernini as an inspiration for Fischer's palaces was Louis XIV's architect, Le Vau.

In Spain contemporaneously, the same Gallic fashions were beginning to arrive well before a Bourbon prince mounted the throne. And it would have needed a stronger will than the last Spanish Habsburg possessed to resist the cultural dominance of France. Charles II (1665–1700), unlike his father Philip IV, had no interest in the arts, nor the smallest claim to connoisseurship. He had

inherited as a minor and was cradle-sick from birth, so that at twenty-five, reported the papal nuncio:

> The king is short rather than tall; frail, not badly formed; his face on the whole is ugly; he has a long neck, a broad face and chin, with the typical Habsburg lower lip . . . He has a melancholic and faintly surprised look . . . He is as weak in body as in mind. Now and then he gives signs of intelligence, memory and a certain liveliness, but not at present; usually he shows himself slow and indifferent, torpid and indolent, and seems to be stupefied. One can do with him what one wishes because he lacks his own will.[44]

On one of his better days, Charles II and his Court were to be portrayed together, kneeling in adoration of the Sacred Host relic in the newly rebuilt Sacristy of the Escorial. However, the occasion was no triumph of Habsburg monarchy, as Claudio Coello's *Sagrada Forma* (1690) might suggest, but a healing reconciliation of the king and his critics, and a record of Charles's feebleness of purpose.

With the king's mind deranged and no firm leadership at Court, central patronage of the arts withered in Habsburg Spain. And in no time at all, from being the West's most important market for fine paintings outside Rome, Madrid lost that lead – even in Spain itself – to regional capitals like Seville. Bartolomé Esteban Murillo (1617–82), the Sevillian religious painter, had been much influenced in his youth by Zurbarán. Nor would he ever entirely give up working in that Golden Age naturalism which Antonio Palomino ('the Spanish Vasari') would shortly afterwards declare to be his people's 'National Style'. But Murillo, in the 1670s, was not painting for the Court, but for Andalucia's religious houses and its rich collegiate clergy – for the Franciscans and Dominicans, for Seville's Hospital of Charity and its Hospital of Priests, for the Capucins and the nuns of San Leandro. It was for the unlettered congregations of those champions of Catholicism, both in the Old World and the New, that Murillo created his escapist *estilo vaporoso*, which 'charms

by sweetness and attractive beauty', while exploiting 'the great seductive power of colour for winning popular favour' among the ignorant.[45]

So well suited was Murillo's style to the Church's populist mission in the Americas that it attracted immediate imitation in the work, for example, of the Colombian religious painter, Gregorio Vázquez de Arce y Ceballos (1638–1711), or of Miguel de Santiago (1626–1706), in Ecuador.[46] At home in Spain, its appeal was no less powerful to a crisis-prone society, perpetually on the verge of collapse. The 'grand climacteric' of Charles II's reign, in Henry Kamen's apt description, came in 1680: a year of plague and famine, of torrential rains and earthquake, and of a devaluation so severe that it 'has totally destroyed trade and private fortunes. No one (today) uses money . . . poverty has become fashionable . . . Everywhere there is poverty and bankruptcy'.[47] And it was circumstances like these, endured over a long period, that caused realism to yield to fantasy in the arts. Murillo, once a naturalistic painter in the mould of Zurbarán, was to become in later life the fabricator of illusions: the creator of what ordinary Sevillians most wanted to believe. And in much the same way, the Churriguera sculptors of a still prosperous Catalonia pandered to the religious longings of Central Spain. In the convent church of San Esteban, in Salamanca, the huge barley-sugar (Solomonic) columns of José Benito Churriguera's *retablo major* of 1690–2 had some instructional value in recalling the lost Temple of Jerusalem. However, a better-understood reference was to the fabled Gates of Paradise; and Churrigueresque over-ornament – widely copied in Spanish America – chiefly functioned as an opiate for the wretched. When prosperity returned, a more sober taste in art came back with the wealthy Madrid collector and connoisseur. But while some of the earliest elements in that recovery had already been put in place soon after 1680, a monetary crisis so severe as to bring about significant reforms in Spain's conservative economy was certain to leave casualties in its wake. One of those was independence in the arts. Between Murillo and Goya – for almost a century – the

best work in Spain was done by foreigners: by Giordano and Tie-
polo, by Juvarra and Sacchetti, by Ranc and Houasse, by Giaquinto,
Mengs and Van Loo. In the weakness of a dying dynasty and the
Gallomania of the next, Spain's Golden Age expired without sequel.

Enlightened Absolutism

'Superstition sets the whole world in flames', wrote the essayist Voltaire (1694–1778); 'philosophy quenches them.' And the overt scepticism of Voltaire and his fellow Encyclopedists (*philosophes*) undoubtedly contributed to the calming of religious tensions in their century. Prosperity returned with the peace. But just as sectarian violence had never been the sole cause of Europe's 'general crisis' in the seventeenth century, so religion's declining role in Voltaire's generation was only one of many factors in the boom. More significant in the longer term was a population surge which, beginning in the 1750s, had advanced beyond recovery to real growth. In England, for example, the population rose by some 70 per cent in the eighteenth century alone. And whereas France achieved a growth of less than half that size, the average across the Continent was much higher. Growth, moreover, was accelerating. In some industrializing nations – among them Britain and Germany, the Low Countries and Scandinavia – annual growth rates rose to 1.5 per cent in the next century. Through nineteenth-century Europe as a whole, the population is thought to have doubled.[1]

One cause of the recovery was the disappearance of plague, of which the last major visitations were in London in 1665–6, in Scandinavia and Germany in 1708–12, and in France in 1720–2. Another was famine avoidance, state-directed for the first time; a third was younger marriages; a fourth was declining infant

mortality; and a fifth, the lengthening life-spans of the elderly.[2] For fully a century from 1750, there was no European mortality crisis of more than regional significance, whether famine or plague related; and only pessimists anticipated an early death. While rising populations, by making labour cheap, may sometimes discourage new investment, the fact that the growth was natural (i.e. not wholly dependent on migration), and that much of it was focused on Europe's multiplying cities, created wealth on an unprecedented scale. In the first century of rising numbers before 1850, North–West Europe's estimated 160 cities rose to 552, more than doubling the proportion of urban to rural dwellers (from 7 to 17 per cent) and hugely increasing the number of townspeople (from 4.4 to over 20 million).[3] Plainly, it was not just on an expanding workforce that the industrial West was built, but on the concentration of skills and labour in the towns.

Whereas it was on the towns that the post-1700 recovery was largely centred, another major stimulus was its geographical spread, from the Urals across to the Atlantic. In eighteenth-century Europe, the most considerable population increase was achieved not in France (already well populated in 1700) but in Imperial Russia, where numbers had been rising steadily since the 1650s. Between Russia's first official census in 1719–23 and the sixth in 1811, its core population rose by as much as 250 per cent.[4] And if that followed in part from territorial expansion, it also reflected the modernizing culture introduced by Peter the Great (1689–1725). It was Russia's annexation of Sweden's Baltic Provinces – Livonia and Estonia, Ingria and East Karelia – following the Treaty of Nystad on 10 September 1721, that secured the future of the Tsar's new capital at St Petersburg: that 'great window lately opened in the North, through which Russia looks into Europe'.[5] Although still deeply unpopular with the great majority of his subjects – 'The Tsar pushes uphill with a dozen supporters; millions pull downhill', said a friend[6] – Peter I's Westernizing policies were nevertheless gaining ground, and were in practice irreversible from that date.

In 1703, when work there began, only its founder saw beauty in St Petersburg. Sited pestilentially on marshes by the sea, the new St Petersburg was 'a city built on bones', cordially hated by the Muscovite aristocracy. 'On one side the sea, on the other sorrow, on the third moss, on the fourth a sigh', was how one of Peter's own court jesters would describe it.[7] Yet 'it is surprising', wrote Friedrich Christian Weber in 1716, 'to see with what Resignation and Patience those People, both high and low, submit to such Hardships'.[8] And Russia's modernization was accepted the more readily because it promised such huge profits to the nobility. It was primarily as a consequence of the opening-up of Baltic trade that the West's long-standing price revolution at last came to Russia. In just a century from 1700, the price of agricultural products in Russia soared by some 550 per cent. And if the cost of manufactured goods was to rise less sharply, that too would be of benefit to a landowning aristocracy well positioned to buy cheaply and sell dear. Russia's noble families, furthermore, had another source of wealth less open to their cousins in the West. In the first quarter of the eighteenth century, when the bulk of industrial production was still located in the towns, only 5 per cent of Russia's larger manufacturing enterprises belonged to noblemen. Yet before the end of that century, the nobility's share of Russia's industry was to rise disproportionately to almost 50 per cent, as new industrial ventures started up on the estates, attracted by abundant capital and cheap serf labour. The same was true of commerce. In the grain trade, in particular – Russia's major export to the West – the larger transactions increasingly by-passed the towns, to be concluded directly between the greater landowners' agents and foreign merchants. What followed was the emasculation of the Russian bourgeoisie, with disastrous long-term consequences for democracy. Yet it was precisely those exceptional circumstances, unparalleled in the West, that enabled Russia's monopolistic noblemen to accumulate great fortunes, to travel extensively and to shop abroad for luxuries, to build competitively, and to furnish their huge new palaces with art: for 'one man,

out of affluence, will spend many thousands of roubles in building houses, gardens and summer-houses for his comfort and pleasure; a second does the same out of ostentation, and a third, following this pernicious example, does the same in order not to fall behind the others, and spends beyond his means.'[9]

Reviewing what had been achieved by Peter the Great's reforms, Prince Mikhail Shcherbatov (d.1790), a critic of the New Russia but a follower of Voltaire, saw both good and bad in what resulted:

> Through the labours and solicitude of this monarch (Peter I), Russia acquired fame in Europe and influence in affairs. Her troops were organized in a proper fashion, and her fleets covered the White Sea and the Baltic; with these forces she overcame her old enemies and former conquerors, the Poles and the Swedes, and acquired important provinces and sea-ports. Sciences, arts and crafts began to flourish there, trade began to enrich her, and the Russians were transformed – from bearded men to clean-shaven men, from long-robed men to short-coated men; they became more sociable, and polite spectacles became known to them.
>
> But at the same time, true attachment to the faith began to disappear, sacraments began to fall into disrepute, resoluteness diminished, yielding place to brazen, aspiring flattery; luxury and voluptuousness laid the foundation of their power, and hence avarice was also aroused, and, to the ruin of the laws and the detriment of the citizens, began to penetrate the law-courts.[10]

Westernization, as Peter first saw it, was to have been the beginning of a longer process of change, enabling Russia's new identity to emerge. 'We need Europe for a few decades; then we can turn our back on her', he once claimed.[11] However, Russia never did turn its back on Western ways, and what followed was surrender to foreign fashions. Gallomania, as elsewhere, would eventually triumph at Peter's Court. But the young Tsar's first introduction to

the West, in his Grand Embassy of 1697–8, had been to Branden-
burg and Hanover, Holland, England and Vienna. And the memory
of that journey remained with him throughout his life, even after
he had been to Paris two decades later. 'I myself have been to
France', Peter subsequently told the aspiring architect, Ivan Koro-
bov, when sending him abroad to learn new skills, '(and) I have
heard a fair bit about Italy . . . (but) Holland is more similar (to
St Petersburg and its environs) and therefore you should live in
Holland . . . and learn the manner of Dutch architecture . . . also
learn how to measure the proportions of gardens and to decorate
them with trees and figures, which none in the world are so fine
as in Holland . . . and also the building of sluices, which is very
vital here. Put all else aside and study (only) those things.'[12]

In 'Petrine Baroque', that most pragmatic of architectures, ideas
would be borrowed from every source. In 1716, shortly before
his Paris visit, Peter had commissioned a French architect, Jean-
Baptiste-Alexandre Le Blond (d.1719), to build his country palaces
at Peterhof and Strelna, of which Versailles (inevitably) would be
the model. And it was Le Blond who brought to Russia the Italian
portrait-sculptor, Carlo Bartolomeo Rastrelli (d.1744), whose archi-
tect son, Bartolomeo Francesco, would be the greatest Rococo
builder of the mid-century. Only half-finished on Le Blond's death,
Strelna would be given in 1719 to the visiting Italian architect, Niccolò
Michetti (d.1758), a former pupil of Carlo Fontana, to complete in
Roman Baroque. Before that, in 1703, Domenico Trezzini (d.1734),
the Swiss-Italian engineer, had been summoned from Copenhagen
(where he had been working on Frederick IV's palace) to take
charge of the development of St Petersburg. Dutch gardeners laid
out the grounds of Trezzini's Summer Palace (1710–14). And
German Baroque architects – Andreas Schlüter, Johann Friedrich
Braunstein, and Gottfried Schädel – took a prominent part in the
construction of the city's public buildings and private palaces.
Most influential of those palaces was Schädel's enormous Oranien-
baum (1713–25), on the Baltic shore, built for Prince Alexander

Menshikov, the Tsar's minister. At Menshikov's equally imposing townhouse on the Vasilievsky Island, the façade was Italian but the roofs were Dutch; the gardens were Dutch also and so too were the tiled interiors; the mirrored Grand Hall, used by the Tsar himself for state occasions, was modelled on Versailles's Galerie des Glaces.[13]

Fashions move on, so that by 1772 'the English have replaced the French', wrote Nikolay Novikov (*A Walk in the English Style*); 'nowadays women and men are falling over themselves to imitate anything English; everything English now seems to us good and admirable and fills us full of enthusiasm.'[14] Novikov, the satirist and critic of his times, overstated the change; and the fashion for things French was far from over. Yet the 'addiction to things foreign' which Novikov rightly characterized as his fellow countrymen's vice had already critically undermined their native culture. Nowhere was this more obvious than in Orthodox devotional painting, where very little had been allowed to change since the Conversion. As late as 1551, Ivan IV's Council of the Hundred Chapters had instructed all Russian religious painters to 'reproduce (only) the ancient models, those of the Greek icon-painters, of Andrey Rublev and other famous painters ... In nothing will the painters follow their own fancy.'[15] And the best of those earlier artists – notably Theophanes the Greek (d.1405) and Rublev (d.1430) himself – had indeed approached perfection in their work. However, the desire to embrace change was growing fast. Among Peter I's purchases in Paris in 1717 had been the big New Testament 'histories' – a *Raising of Lazarus*, a *Miraculous Draught of Fishes*, an *Expulsion from the Temple* etc. – of the fashionable French religious painter, Jean Jouvenet (1644–1717). Nothing could have been more remote from the native tradition of icon-painting, and Jouvenet's Baroque fantasies were not at first well received by the devout. Yet as the wealthiest patrons, both in Court and Church, turned increasingly to the support of Western artists, even the best of the old-style icon-painters found themselves passed over, neglected by the growing army of

Russian collector-connoisseurs, and forced to make their living in communities of Old Believers, where new talent and invention were snuffed out.

Peter the Great, characteristically, had led the way in favouring Western subjects in works of art. In 1694, even before his Grand Embassy, Peter had chosen to furnish his private apartments with battle paintings 'after the German model'. And a typical bulk order of 1711, placed with his Dutch agent for the new palaces of St Petersburg, would be for 'about four dozen pictures of good workmanship, on which are depicted sea battles and seafaring vessels of various kinds, perspectives of Dutch towns and villages with canals and boats'.[16] Five years later, it was Iury Kologrivov, Peter's agent in Italy, who made the first proposals for the setting-up of a new academy where Russia's artists might be trained 'first how to mix paints, at which our painters are very bad; secondly, to paint battles and assaults on towns for the eternal glory of Russia . . . in the third (to) learn history and fable, which is most useful in their profession for thinking up new subjects and the proper depiction of persons in action, in order not to paint a cavalryman as an infantryman' etc.[17] However, Kologrivov's plan was for an academy based in Rome. And it was not until the reign of Peter the Great's daughter, Elizabeth (1741–61), founder in 1758 of the St Petersburg Academy of Fine Arts, that the best native artists – among them the history-painter, Anton Losenko (d.1773), and the talented court portraitist, Dmitry Levitsky (d.1822) – could expect to make a decent living in their own country.

Elizabeth Petrovna, unlike her father, had a genuine affection for all things Russian. But she adored France too, with a passion hardly less than that of Ivan Shuvalov, her counsellor and intimate, of whom it would be said that 'he loved France and everything that came from France almost to madness'.[18] For the Empress and her circle, what attracted them especially to the Bourbon Court was the self-indulgent life-style of its familiars. 'Everything that is now called the good life', wrote Andrei Bolotov, the memorialist, 'was only just

coming into existence then, as well as a keen popular taste for it all.'[19] It was at Elizabeth's sybaritic Court that Louis Tocqué (d.1772), the celebrated Parisian portraitist, spent two fruitful years in the mid-1750s. And it was there that the great architect-decorator, Bartolomeo Francesco Rastrelli (d.1771), who had trained in Paris under the French king's premier architecte, Robert de Cotte (d.1735), was given a free hand to create his Rococo masterpieces at Tsarskoe Selo (1749–52) and at the rebuilt Winter Palace (1754–62) in St Petersburg. 'Count Rastrelli, by birth an Italian, in Russia a dexterous architect', wrote an early enthusiast for his work, 'is not so proficient in practice as he is inventive in his drawings. His designs are marvellously decorative and that which he has built gladdens the eye.'[20] At Tsarskoe Selo, Rastrelli's garden façade is a hugely complex composition of pilasters and engaged columns, of garlands, of broken pediments and caryatids. It was Rastrelli who used the priceless amber panels, given to Peter the Great by Frederick I of Prussia, to clad Elizabeth's Amber Hall at Tsarskoe Selo. And it was Rastrelli whose exemplary use of colours – Tsarskoe Selo was painted yellow, the Winter Palace turquoise blue – set new standards for his country of adoption.[21]

Only in contemporary Portugal, on the remote Atlantic rim, was there an architecture of comparable flamboyance. And while there was no direct link between the arts of the two countries, what both kingdoms shared was a fertile blend of unfettered royal absolutism and sudden wealth. Portugal's Golden Age, like its Manueline boom two centuries before, was commerce-based. But while the riches of Manuel the Fortunate (1495–1521) had come from Portugal's first colonial empire in Africa and the East, the extraordinary wealth of John V (1707–50), of Joseph I (1750–77), and of Joseph's all-powerful minister, the Marquis of Pombal (d.1782), originated in their territories in Brazil. In the mid-1690s, the discovery of significant quantities of alluvial gold in Minas Gerais, in the Brazilian Highlands south-west of the old capital at São Salvador (Bahia), began a gold rush which, almost at once, hugely increased the public revenues

of the mother-country. 'The great Glory of Portugal', wrote Adam Anderson, the historian of commerce, in 1740, 'at present centres in her very extensive and immensely rich Colony of Brazil in South America; from whence she has her vast Treasures of Gold and Diamonds, besides immense Quantities of excellent sugars, hides, drugs, tobacco, fine red-wood, etc.'[22] Much of that new wealth found its way untaxed into the pockets of the original prospectors; it was smuggled out of the country, or was syphoned away by over-privileged British merchants, still protected by century-old treaties. Nevertheless, the Portuguese Crown's revenues continued to rise steadily throughout the eighteenth century, very nearly quadrupling in the first half-century alone, before doubling again in the second. It was riches of that order, enabling Portugal's Braganza kings to govern without their Parliament (*Cortes*), that freed them to rule absolutely.

One consequence of that absolutism – in Portugal as in Russia – was the launching of huge programmes of royal building. It was a Bavarian goldsmith-turned-architect, João Frederico Ludovice (d.1752), trained in Rome, who built John V's Convent-Palace at Mafra, north of Lisbon: 'a second Escorial', wrote the French physician, Charles-Frédéric Merveilleux, in 1726, '(where) three-quarters of the king's treasure and the gold brought by the fleets from Brazil have been metamorphosed into stone'. Four years later, as Mafra's great church and conventual buildings approached completion, Lord Tyrawly, the British envoy, reported home:

> For some months past, the whole business of Portugal has stood quite still, and this wholly upon account of a church and convent that the king is building six leagues from Lisbon . . . the king will not hear of anything else . . . To raise money for this immense expense, the king has taxed all sorts of provisions, some twenty, some thirty, some fifty per cent . . . But the greatest misfortune is that neither the king nor the secretary of state are to be spoke about any business, because that His Majesty is busy about Mafra.[23]

John V's Mafra brought together many strands – from Spain (the Escorial), from Italy (the courtyard arcades), from France (the corner pavilions), and so on. And the salient characteristic of Joanine Rococo – as of Petrine Baroque – was its eclecticism. John could afford to shop anywhere for his art. He bought his tablewares in London and from Thomas Germain (d.1748) of Paris, the best Rococo silver-smith of the day. His ecclesiastical plate was made in Rome, as was the sumptuous prefabricated Chapel of St John the Baptist (for São Roque, Lisbon), and state coaches of exemplary magnificence. John got his silks from China; imported his diamonds from Brazil and had them cut in Amsterdam; shipped his ivory from Africa and his sapphires from Ceylon; and went to France and England again for palace furniture.[24] Joanine architecture, reverting to the excesses of the Manueline boom and in stark contrast to the 'plain style' of the seventeenth-century recession, was richly detailed and ostentatiously extravagant. In two Franciscan churches, for example – one in Oporto (Northern Portugal), the other in São Salvador (Brazil) – the native wood-carvers and gilders took Rococo ornamentation as far as it would go, leaving no surface unembellished by volutes and cartouches, pilasters and engaged columns, shells and garlands, draperies and lambrequins, putti, caryatids, and their like. What resulted were interiors of pure folly but great theatre: like 'gilded stalactite caves'.[25]

Lisbon and Oporto – 'the two eyes of Portugal' – were where 'the whole riches of the country' were located.[26] And each city developed an architecture of its own. Lisbon's new buildings – under the sobering hand of the Office of Royal Architects – were the simpler; Oporto's the more extravagantly Baroque. To both, John V's legendary riches drew scholars and bibliophiles, doctors and musicians, mathematicians, and every kind of artist. One of those artists was the *fêtes galantes* painter, Pierre-Antoine Quillard, a dis-ciple of Watteau; another, the Savoyard portraitist, Giorgio Dom-enico Duprà; a third, the Genoese religious painter, Giulio Cesare di Femine. There was the Roman sculptor, Alessandro Giusti; the

Turin architect, Filippo Juvarra; the French engravers, Guilherme Debrie and Pierre Massar de Rochefort; and many more. Some of that talent stayed in Portugal only briefly. However, Claude Laprade, the French Baroque sculptor, had been working there already for more than a decade when commissioned by John V to build his Royal Library (1716–28) at the University of Coimbra. And other long-serving foreigners included the Tuscan, Niccolò Nasoni (d.1773), and the Hungarian, Carlos Mardel (d.1763): the builders respectively of the extraordinary oval church of São Pedro dos Clérigos (Oporto) and of the Oeiras Palace of the Marquis of Pombal.[27]

In the many new churches of John V's Portugal, and in the country houses (*solares*) of his nobility, one style merged seamlessly with another. At Queluz, near Lisbon, built for the royal family in 1747–60, the cascading garden staircase is typically Portuguese, as are the heavily garlanded windows of the principal façade, and the colourful *azulejos* (painted tiles) of the canal. Yet Queluz's hipped roofs are Central European: probably by Mardel, who used them also at Oeiras. And if Queluz's first architect, the Ludovice-trained Mateus Vicente de Oliveira (d.1786), was Portuguese-born, its second, a decade later, would be a Frenchman. In the 1760s, when Jean-Baptiste Robillon added his two *jardins à la française* to the gardens at Queluz and built the west pavilion at the palace, some of the sparkle had already gone out of Portuguese architecture. In part, that was the result of a slowing-down of growth, as the receipts of Brazil slackened off. And the retreat was less apparent in that far-away economy, where the expert stone- and wood-carvings of the mulatto sculptor-architect, Antônio Francisco Lisboa (known as 'Aleijadinho' [little cripple], 1738–1814), kept Rococo alive and vigorous in Minas Gerais well into the following century. However, a more immediate curb on the free-spending of the Crown was the catastrophic Lisbon Earthquake of All Saints Day (1 November) 1755, flattening many churches in which the citizens were at Mass, and resulting in a death-toll which, on the most conservative

estimate, could hardly have been less than ten thousand. In the fire that followed, what was left of the Baixa – 'the part of the town towards the water where was the Royal Palace, the public tribunals, the Customs House, India House, and where most of the merchants dwelt for the convenience of transacting their business'[28] – was totally destroyed, along with collections of fine paintings and libraries of books, and the lavish furnishings of the houses of the nobility.

Lisbon's reduction to a 'heap of rubbish' was described by many in apocalyptical terms, as a punishment for Joanine excess. But its rebuilding was a triumph of the Enlightenment. The immediate need was to restore, as soon as possible, the commercial and administrative functions of the capital. And to this end, the new grid-plan city – designed and completed under Pombal's direction by the engineer-architects Manuel de Maia, Eugénio dos Santos and Carlos Mardel – focused on an enlarged and re-named Praça do Comercio (Commerce Square): a huge arcaded waterfront space with a big triumphal arch and equestrian statue of the king, the Pombaline equivalent of a place royale. In the grid of streets behind, standard road-widths were laid down, and house façades were required to 'maintain the same symmetries in doors, windows, and elevations'.[29] Such parade-ground order, in Lisbon as in St Petersburg, sacrificed beauty to utility. Yet what was created in Pombaline Lisbon was a working capital city of three-storey apartment-blocks – earthquake-proofed by the *gaiola* (a form of timber framing): exactly suited to the bourgeois life-style of a middle-class community of which commerce was the principal occupation.

For better or worse, it was in the rebuilding of Central Lisbon that Portugal became the personal fiefdom of Sebastião José de Carvalho e Melo, created Count of Oeiras (1759) and Marquis of Pombal (1769). And there is no better illustration of Enlightened Absolutism at work – of the clear duty of the state to intervene for the general good – than Pombal's ruthless setting aside of individual property rights in Lisbon's Baixa in what he believed to be the

national interest.[30] Not everybody shared that perception, and Pombal made many enemies during the almost three decades of his personal rule, from his recall from Vienna in 1749 to the death of Joseph I (1777). 'He wanted to civilize the nation and at the same time to enslave it', wrote António Ribeiro dos Santos, a former associate of the chief minister, shortly after his fall; 'He wanted to spread the light of philosophical sciences and at the same time elevate the royal power of despotism.'[31] But as Frederick the Great of Prussia (d.1786) was once heard to say: 'Drive out prejudices through the door, and they will return through the window.' And it was precisely to combat the entrenched prejudices of Portugal's ancient closed nobility (the *puritanos*: 'pure in blood') and of the more conservative branches of its ultramontane Church (the Inquisition and the Jesuits), that Pombal turned to that other familiar strategy of progressive rulers of the Enlightenment: the promotion of a state-educated elite. In Pombal's belief, his secularization of the educational system – following the expulsion of Jesuit teachers from both Portugal and Brazil – would prove to be his most significant reform. And it is undoubtedly the case that his wide-ranging reorganization of the University of Coimbra in 1772 came close to the *philosophes'* ideal of the secular university 'as a body at the heart of the state, which through its scholars creates and diffuses the enlightenment of wisdom to all parts of the monarchy, to animate and revitalize all branches of the public administration, and to promote the happiness of man.'[32] In Coimbra's great reform, the old faculties (theology, law and medicine) were modernized, and new faculties of mathematics and philosophy were set up; chemistry and physics were given their own purpose-built laboratories; a botanical garden and an observatory were both provided. Pombaline Coimbra's Neoclassical architecture – by Colonel William Elsden, the English military engineer – was as modern and universal as its curriculum.

Among Elsden's most important buildings was the Chemistry Laboratory. And mid-century Portugal, in this and other ways, was

deeply indebted to the English. While on a diplomatic mission to London in 1739–43, Pombal had moved in scientific circles. And it was his early introduction to the Royal Society and to the best of English science that caused him to look to London again, some thirty years later, for the instruments he needed for his laboratories. At Coimbra, with English help, Portugal's Catholic youth would be introduced to the natural sciences: to learn (*pace* the Lisbon Earthquake) that 'results were caused not by miracles but through the effects of nature'.[33] However, those four London years had also convinced Pombal of the harm done to his own country by the 'pernicious transfer of gold' and by the unfair bias of the alliance in England's favour. The Methuen Treaty of 1703 had exchanged preferential tariffs on Portuguese wines and olive oil for the unobstructed entry to Portugal and its possessions of English woollen cloths and manufactures. And whereas that agreement had led almost at once to a huge increase in export sales – Portuguese wines capturing as much as 70 per cent of the English market by 1750 – the value of Portugal's imports always exceeded what it sold, creating a trade gap which, when the gold ran out, could no longer be bridged by money payments. Pombal, like other statesmen of his day, was a mercantilist. And he made it his business, as soon as he came to power, to rebuild Portugal's industrial base, eroded by easy money and long neglect. Many years later, when the chief minister's 'tyranny' had been forgotten, Jacome Ratton, the Franco-Portuguese entrepreneur, would remember Pombal, in his *Recordações* of 1810, as 'that great man, known as such by the middle and thinking class of his nation'.[34] Ratton himself belonged to that class. And he spoke for a merchant oligarchy, largely created by Pombal, whose growing taxable wealth had more than compensated the Crown for the evanescent profits of Brazil.

Pombal's reforms helped keep Portugal solvent for the rest of its 'long' eighteenth century. And Portugal's economic decline began only with the French invasion of 1807 and the resulting flight of the royal family to Brazil. In 1820 the Portuguese Revolution broke

out; and Brazil won its independence two years later. But whereas, when it arrived, Portugal's collapse was total, there had never been a time, even in the Joanine Golden Age, when its future was entirely secure. Portugal's unsought prominence in the long Atlantic power struggle between England and France had cost successive governments new concessions. And as the English won control of the Atlantic trading system, they captured an increasing share of the South American trade, while simultaneously developing exclusive markets of their own in the North American colonies and the Caribbean. Much of that new activity, both on the Atlantic and in the Orient, was London-based. And London grew spectacularly as a result. From a population in 1600 of about 200,000 – just half the size of Paris – London had already overtaken the French capital well before 1700, to become in the next century, as Paris stagnated, by far the greatest city in the West.

That unprecedented growth was central to English art: on the threshold of its own Golden Age. High Baroque in England, in the churches and palaces of Sir Christopher Wren and Sir John Vanbrugh, had achieved international recognition. But neither in architecture nor in painting had there yet developed the distinctive 'English Style' which would later become the fashion in Nikolay Novikov's Moscow and would travel with Colonel Elsden to Pombal's Coimbra. London provided the key. By 1750, one in every ten Britons lived in London; in Paris, the proportion of Frenchmen was nearer one in forty.[35] And in that extraordinary concentration of humanity – totalling some 900,000 by 1800 – every profession, craft and trade was represented. Like other major continental capitals – Madrid or Berlin, Vienna or St Petersburg – London was the focus of government and Court ceremony. But it was also an innovatory banking centre and the West's greatest port: the permanent home-by-choice of an aldermanic elite, for whom commerce and industry, the military and the professions, were all socially acceptable destinations.[36]

In the absence of other stimuli, London's 'big bourgeoisie' would

probably never have become patrons of the arts. However, they were to be joined in the capital regularly by a well-travelled aristocracy, educated abroad in the Picturesque and the Antique, and greatly enriched by the Agricultural Revolution.[37] Painting the portraits of that aristocracy had made substantial fortunes for talented immigrant artists: for the Dutch Sir Peter Lely (d.1680), Principal Painter to Charles II, and for the German-born royal portraitist, Sir Godfrey Kneller (d.1723). In the next generation, as late as 1766, the gifted Swiss portraitist and decorative painter, Angelica Kauffmann (d.1807), was to establish herself in London for the same reason. 'No nation in the World delights so much in having their own, or Friends' or Relations' Pictures', had said a contemporary critic in 1712, '(for) what the Antique statues and Bas-reliefs which Italy enjoys are to the History-Painters, the beautiful and noble Faces with which England is confessed to abound, are to Face-Painters'.[38] True, those 'beautiful and noble Faces', reproduced in Kneller's studio, could look very much alike: 'some have their heads turned to the left, others to the right; and this is the most sensible difference to be observed between them', complained a Frenchman.[39] Nevertheless the painting of portraits, for all their perceived inferiority to works of the imagination – in particular to 'histories' – remained 'the chief branch by which a man can promise himself a tolerable livelihood (in England) and the only one by which a money-lover (can) get a fortune'.[40] And William Hogarth (1697–1764), who grumbled thus, was one of the finest portraitists of his century. Hogarth's affectionate study of his friend *Captain Thomas Coram* (1740), the great London philanthropist, ranks with the best 'grand manner' portraits on the Continent. And it was in the consistently undervalued art of society portrait-painting that Hogarth and his contemporaries, Francis Hayman (d.1776) and Joseph Highmore (d.1780), acquired the necessary confidence to experiment. Thus it was Hogarth who invented a new kind of warning fable – *A Harlot's Progress* (1731), *A Rake's Progress* (1735), and *Marriage à la Mode* (1743) – engraved for public sale in inexpensive sets, and purchased

by every household of Middle England. More even than in the success of his fashionable portraits and 'conversations', Hogarth's anecdotal moralities paved the way for a much wider recognition of British artists.

Heading those artists in the next generation was Sir Joshua Reynolds (1723–92), doyen of British art from the mid-century. Reynolds was the first President of the Royal Academy of Arts, founded in 1768; he was knighted the following year. And it was the continuing interest of George III (1760–1820) in the Academy and its affairs that raised the status and visibility of London's artists. Nobody knew the problem better than Reynolds. It was Reynolds who once wrote, even of the would-be enlightened George III, that 'the place which I have the honour of holding, of the King's principal painter, is a place of not so much profit and of near equal dignity with his Majesty's rat-catcher'.[41] And as Reynolds and his fellow academicians could see for themselves, the low standing of their profession in post-Reformation England had everything to do with the long-term indifference of just those patrons – the Crown and the Church – which more usually took the lead in Catholic countries. 'It is a circumstance to be regretted, by painters at least', wrote Reynolds on a visit to the divided Netherlands in 1781, 'that the Protestant countries have thought proper to exclude pictures from their churches . . . (so that) nothing of the kind being seen, historical paintings are not thought of, and go out of fashion.' Yet the potential for something better was already present, Reynolds thought; and only 'let there be buyers, who are the true Maecenases, and we shall soon see sellers, vying with each other in the variety and excellence of their works.'[42]

Reynolds was right, of course. But willing buyers had been gathering for some decades before he wrote: in Grand Tour noblemen and wealthy merchants, in retired planters from the West Indies and nabobs from India, in prize-rich admirals, successful lawyers and gentlemen-bishops. Most of those new patrons still wanted portraits. And it was to meet that huge demand that the specialist portrait

painters – Allan Ramsay (1713–84), George Romney (1734–1802), and Joshua Reynolds himself – continued to work mainly in that mode. But when, much earlier in the century, Roman-style frescoes had gone out of fashion, even the least tutored country gentleman had learnt to clothe his empty walls with the landscapes and battle-pieces, histories and fables, which were still largely imported from the Continent. Daniel Defoe tells the story (plausible enough) of a wealthy Hampshire landowner – 'of a great estate and of a mighty ancient family' – who was furnishing his new house in the 1720s. Sir A.B. (as Defoe calls him) had brought in a travelled friend who 'had lived abroad (and) seen abundance of the fine palaces in France, in Italy, (and) in Germany'. 'You want (lack) some good paintings', his visitor advised: 'Pictures are a noble ornament to a house. Nothing can set it off more.' But Sir A.B. had sent to London for the many indifferent pictures with which the walls of his grand staircase were already 'tolerably full', and had 'some more a-coming down' for the hall. 'I love a good story in a picture, and a battle or a sea-piece', the rich booby confessed, 'but as for the performance, the painting, I have no notion of it; anybody may impose upon me' – as they had.[43]

Forty years on, such ignorance was less excusable, for British art had come out of the closet. It was in the spring of 1760 that the first public exhibition of modern British paintings was held in London, in the Great Room of the Incorporated Society of Artists. The show was free and was very well attended, as were the Society's later exhibitions over the next two decades, and the regular shows (from 1769) of the Royal Academy. 'It may be safely asserted', claimed an anonymous reviewer in 1767, 'that even from the *first*, and that but a few years ago, down to the *Present Exhibition*, the *Painting Art* has been brought forward half a century, in comparison with its wonted crawling progress, before that animating Era.'[44] That progress was particularly rapid in the choice of subject matter, where British artists were becoming more adventurous. Every major painter, in the Academy's early years, had made his name originally

as a portraitist. But while the Academy's second President, Benjamin West (1728–1820), and his fellow-American, John Singleton Copley (1738–1815), started as portraitists as well, they were to be the pioneers also of histories in modern dress, of which West's *The Death of Wolfe* (1770) and Copley's *Brook Watson and the Shark* (1778) are two of the earlier examples. Both painters moved to London in mid-career: West (from New York) in 1763, Copley (from Boston) in 1775. And it was in that much larger market that they found new patrons, while benefiting from the competition of such major native artists as Thomas Gainsborough (1727–88), the great society portraitist who would rather have painted landscapes, George Stubbs (1724–88), the self-taught anatomist and horse-painter extraordinary, and Joseph Wright 'of Derby' (1743–97), the candle-light painter, whose special interest was in industry and science.

Only Gainsborough, of those artists, never studied in Italy. For, as Reynolds told the Academy shortly after the painter's death, Gainsborough had no need, 'in the style and department of art which (he) chose, and in which he so much excelled . . . to go out of his own country for the objects of his study; they were everywhere about him; he found them in the streets, and in the fields; and from the models thus accidentally found, he selected with great judgement such as suited his purpose.'[45] If Reynolds had little instinctive feeling for the bosky Suffolk landscapes and 'fancy' pictures of rural life that Gainsborough most enjoyed painting, he could nevertheless recognize the merit in that work, correctly prophesying that 'if ever this nation should produce genius sufficient to acquire to us the honourable distinction of an English School, the name of Gains-borough will be transmitted to posterity, in the history of the Art, among the very first of that rising name.'[46]

In practice, it would be some while yet before *le style anglais* in painting – in the work of William Blake (1757–1827), of John Constable (1776–1837), and of J.M.W. Turner (1775–1851) – won admiring attention on the Continent. English architecture was in a different league altogether. Already in the 1720s, there had been

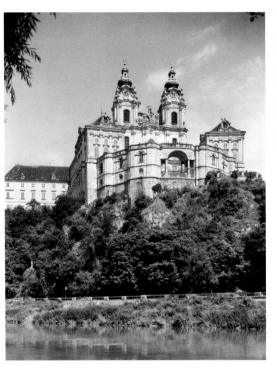

The Benedictines of Melk Abbey, on the Danube, were among the landowers emboldened to build again after the Ottoman threat had been lifted. At Melk, the catalyst was an energetic building abbot, Berthold Dietmayr, encouraging an architect of genius, Jakob Prandtauer, to do his best.

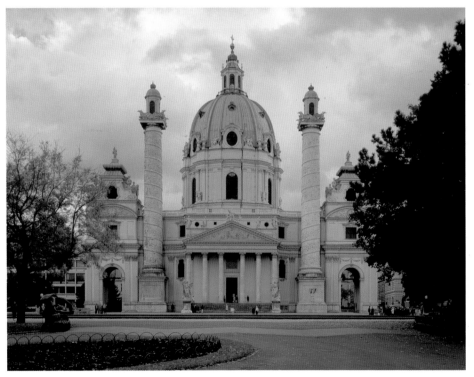

The temple front and triumphal columns of Charles VI's *Karlskirche* (1716–37) in Vienna show Fischer von Erlach's debt to Antiquity. But other contemporary sources for this extraordinary building include French Classicism and Roman Baroque.

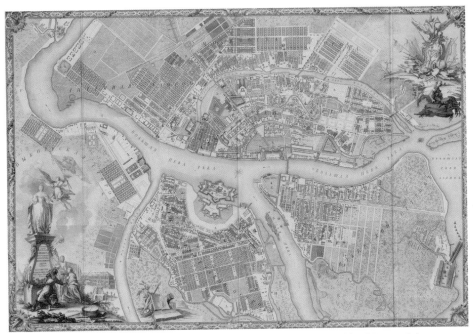

Peter the Great's great new capital at St Petersburg, mapped by Mikhail Ivanovich Makhaev in 1753, had risen from the Neva Marshes in just half a century, centering on the Peter and Paul Fortress.

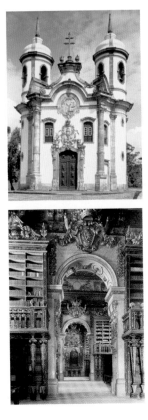

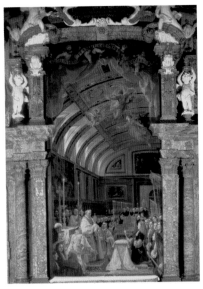

LEFT The Royal Library (1716–28) at Coimbra University, built by Claude Laprade for John V, combines Rococo and Baroque in the lavish Joanine Style of gold-rich Portugal.

FAR LEFT Aleijadinho's Church of São Francisco de Assis (1766–94) in Ouro Prêto is a masterpiece of Brazilian Rococo.

LEFT In Claudio Coello's *Sagrada Forma* (1685–90), the feeble-minded Charles II (d.1700), is shown kneeling at the head of his factious noblemen, as if reconciled with the conspirators who had exiled his mother's favourite, Valenzuela.

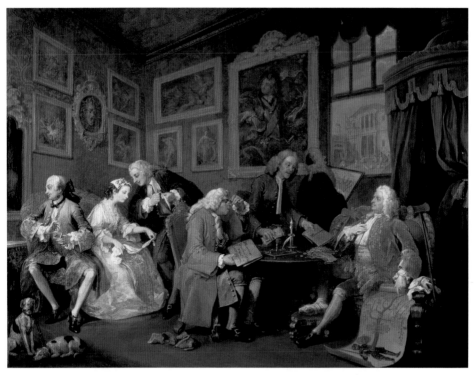

William Hogarth's *The Marriage Contract* (1743), painted specifically for engraving and general sale, was a scene from the popular 'comic history' which the painter named *Marriage à la Mode*. Hogarth's *Marriage*, along with his earlier *Progresses* of 1731 and 1735, released him from dependency on individual wealthy patrons and helped establish a new professionalism in British art.

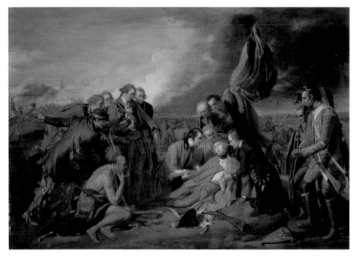

Modern-dress histories reached huge British audiences in the work of two North American painters, Benjamin West and John Singleton Copley, who settled in London in 1763 and 1775 respectively. West's *Death of Wolfe* (1771), shown above, caused a sensation when first exhibited, as did Copley's *Death of Major Peirson* in 1784, both being reproduced many times in bestselling editions of engravings.

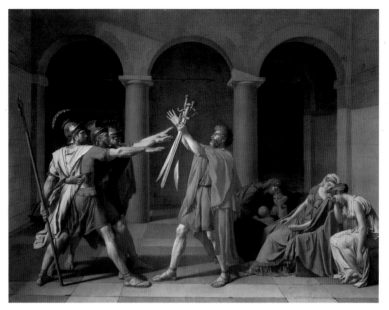

'I founded a brilliant school', wrote the Neoclassical history-painter, Jacques-Louis David (1748–1825): 'I painted pictures that the whole of Europe came to study'. And from the first showing of David's *Oath of the Horatii* at the Academy's *Salon* in 1785, he did just that, leading the taste of an entire generation.

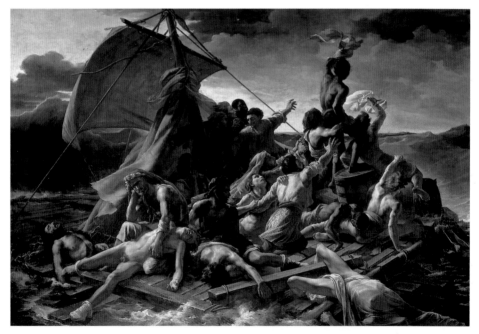

Setting aside Academy teaching, Theodore Géricault learnt his art by studying the old masters assembled by Napoleon at the Louvre. His *Raft of the Medusa* (1819), probably the most famous of all Romantic paintings, was interpreted widely as a critical comment on the inefficiency and venality of the restored Bourbon government, under attack by both liberals and imperialists

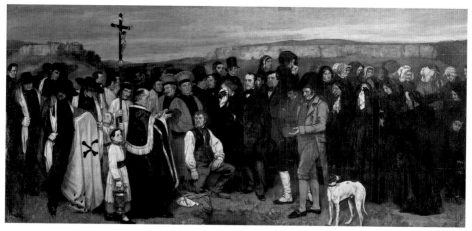

Gustave Courbet's iconic *Burial at Ornans* (1850), marking a radical new departure in mid-century French art, is often seen as the first Modernist work and as the birth of Realism in painting. Courbet himself spoke of his huge picture as 'the burial of Romanticism', and saw Realism as an 'essentially democratic art', where his depiction of peasant mourners in their *bourgeois* Sunday-best overtly challenged the elitism of city folk.

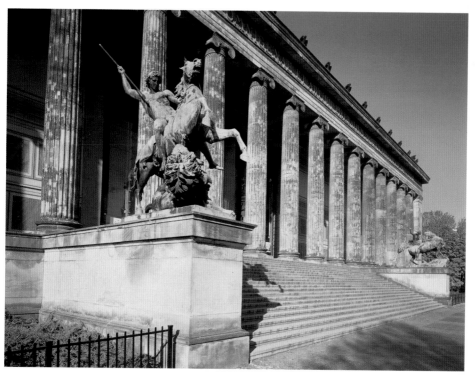

Berlin's post-Napoleonic Wars status as the capital of Greater Prussia was in part established by a major programme of public building. Of this, Karl Friedrich Schinkel's *Altes Museum* (begun in 1823) was his Greek Revival masterpiece, built to house the royal collections of paintings and sculptures only recently returned to Prussia following the stripping of the *Musée Napoléon* at the Louvre.

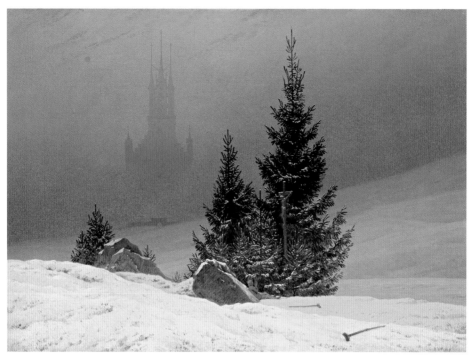

The Gothic cathedral rising through the mist in Friedrich's *Winter Landscape* (1811) symbolises the strength and continuity of German nationhood. In Germany, as in France, the wars gave impetus to the Romantic Movement, of which the landscapists Philipp Otto Runge (d.1810) and Caspar David Friedrich (d.1840) were pioneers.

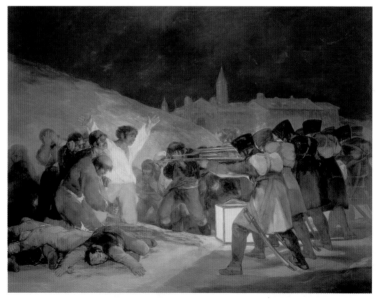

Goya's unforgettable image of wartime barbarity, *The Third of May 1808*, records the execution of Spanish patriots following the Madrid Rising of that spring against the French. Painted in 1814, Goya's brutally honest *tableau* showed war for the first time in its true tragic colours, without sentiment or glory of any kind.

nothing unusual in Sir A.B.'s investment – one of many at this date – in a dignified new mansion: 'a charming house [writes Defoe] and a seat fit for a man of his quality'.[47] And it is a significant pointer to the architectural priorities of the Hanoverian aristocracy that the sharply-lit townscapes of the Venetian view-painter, Giovanni Antonio Canal (better known as Canaletto, 1697–1768), were more sought-after in England than in any other country, causing him to work there for almost a decade. Canaletto's speciality was urban topography. But he also painted country houses, from the picturesque Gothic fortresses of Warwick and Alnwick, to the Duke of Beaufort's stately pile at Badminton House, which William Kent (1685–1748) was in the course of re-modelling. Kent, a committed Neo-Palladian, had trained in Rome – 'a magazine for all that is excellent in painting Sculpture & Architecture (and) undoubtedly the fittest place in Europe for our profession'.[48] And just as Inigo Jones (d.1652) had been the prophet of the First Palladian Revival, so Colen Campbell (1676–1729), Richard Boyle, Earl of Burlington (1694–1753), and William Kent himself headed the Second.

It was in 1715 – when Baroque was still the fashion and Sir Christopher Wren (d.1723), Sir John Vanbrugh (d.1726), Nicholas Hawksmoor (d.1736), Thomas Archer (d.1743) and James Gibbs (d.1754) continued building – that Colen Campbell published the first volume of his *Vitruvius Britannicus*. Campbell's purpose was to show plans and elevations of the best classical architecture in Britain, to which those 'learned and ingenious Gentlemen' had contributed. However, he was critical of the 'affected and licentious ornament' of High Baroque, politically damaged by its association with Tory governments. And he used his book instead to call for a return to the more 'correct' style of building of Bramante, of Palladio, and of Inigo Jones, which he was resurrecting himself at Wanstead House (1713–20). Wanstead was the out-of-town villa of Sir Richard Child, heir to a great East Indian fortune. And it was big City money, along with the rising rents and political emoluments of the Whig ruling class, that provided the funds for Neo-Palladianism.

Colen Campbell's Mereworth Castle (1723), one of the earliest of the new buildings, was too obviously a clone of Palladio's Villa Rotonda. However, the Second Palladian Revival was to find a voice, soon enough, in the 'antique simplicity' of another Palladian look-alike: Lord Burlington's Thames-side villa at Chiswick House (1725–8). 'Too small to inhabit, and too large to hang on one's watch', Burlington's costly whim was nevertheless so successful in re-assembling the different elements of the classical tradition as to create a style that was wholly its own.[49]

With the French wars over and the South Sea Bubble (1720) burst, almost everybody of any substance had started building. Typical of those new builders was Henry Hoare, successor to the pioneering banker, Sir Richard Hoare (d.1718), who engaged Colen Campbell in the early 1720s to build him a villa at Stourhead (Wiltshire) which – with its full-height columned portico and its absence of superfluous ornament – was already the signature 'cubic house' of the Revival. And it was Henry's younger brother Benjamin, also of Hoare's Bank, who commissioned Edward Shepherd (d.1747), the London architect-developer, to build him a Palladian house at Boreham (Essex), rather than modernize the historic Tudor mansion he already owned. As seen by Edward Harley, Earl of Oxford, on 29 December 1737, New Hall was 'all uncovered, the floors taken up and sold; all the chimney pieces gone . . . Mr Ben Hoare, who has bought this estate, has built a house three quarters of a mile from the old house, near the road, and has placed it so that he has no benefit of the fine avenue (of limes), nor of the noble fir grove, the finest I ever saw. *Such is the fine taste of a banker in Fleet Street.* He has laid out above twelve thousand pounds, and when he bought it first, had he laid out six or eight thousand pounds he had enjoyed one of the best houses in England.'[50]

Harley was a committed Tory, the son of a former Treasurer; and he loved neither the Whigs nor their architecture. Yet on that same tour of the eastern counties, a few days later, Harley was to be made most welcome – 'with all the civility, good nature, freedom,

ease, and cheerfulness as I ever saw' – by Sir Robert Walpole, the Whig Prime Minister, who was putting the finishing touches to Houghton Hall. Harley had been to Houghton once before, on 19 September 1732. And on that occasion he had described the Prime Minister's Norfolk estate as poorly equipped and badly sited, 'with neither wood, water, nor prospect that any place has that is worthy to be called a seat'. As for the house itself – an unfortunate blend of Neo-Palladian (by Colen Campbell) and Baroque (by James Gibbs) – 'some admire it because it belongs to the first Minister; others envy it because it is his, and consequently rail at it . . . (But) I think it is neither magnificent nor beautiful, there is a very great expense without either judgement or taste'.[51] Five years later, Harley had probably not changed his mind, for while he praised Walpole's collections – including the paintings subsequently sold to Catherine the Great of Russia – he said very little about the house. In contrast, what had been achieved on the estate, even in that short time, was very remarkable. Sir Robert's new stables were 'extremely handsome and convenient, beyond what I have seen'; his lake was 'very fine and holds (water) well'; and his 'vast' plantations, all sown from seed, were also 'very fine and thrive extremely well, and in a very few years, for example five, will make a very amazing appearance'.[52]

It was Walpole himself, reported Lord Hervey in 1731, who had insisted on the French-style corner-domes at Houghton: 'obstinately raised by the master, and covered with stones in defiance of all the virtuosi who ever gave their opinions about it'.[53] And all such Francophile references were to be banished before long from Britain's Neo-Palladian 'houses of parade': from Lord Leicester's Holkham Hall (by Lord Burlington and William Kent), from Lord Malton's Wentworth Woodhouse (by Henry Flitcroft), from Admiral Byng's Wrotham Park (by Isaac Ware), from Lord Arundell's Wardour Castle (by James Paine), and many more. Such colossal building enterprises, unparalleled in the West, could hardly fail to attract attention outside Britain. Thus it was that the porticoed cube – the Neo-Palladian stereotype – had reached Prussia already by

1740, to be re-used in the designs of the great soldier-architect, Georg Wenzeslaus von Knobelsdorff (1699–1753), for Frederick II's new Opera House in Berlin. In Louis XV's France, the cubic house likewise found a place in the *Recueil élémentaire d'architecture* (1757–68) of François de Neufforge (d.1791), one of the original defining texts of Neoclassicism. In the thirteen North American colonies, beneficiaries of Britain's primacy in the Atlantic trading system, Neo-Palladianism became the fashion of the century.

In colonial America, as in Britain itself, the context of Neo-Palladianism was a 'consumer revolution', accelerating in the 1740s and assisted by easy access to cheap credit. What eventually paid the bills was a rapid rise in exports: tobacco from Virginia, rice and indigo from Carolina, wheat and maize from the Middle Colonies (New York, New Jersey and Pennsylvania), and timber, fish and whale products from New England. Conversely, imports soared but at an even faster rate, for population was climbing steeply – much more quickly than in the homeland – from some 265,000 in 1700 to well over 2,000,000 by 1770.[54] 'In proportion to the Increase of the Colonies', wrote Benjamin Franklin in 1751, 'a vast Demand is growing for British Manufactures, a glorious Market wholly in the Power of Britain, in which Foreigners cannot interfere, which will increase in a short Time even beyond her Power of supplying'.[55] When Franklin wrote his treatise on *The Increase of Mankind*, he was living in booming Philadelphia. And there at the mid-century, reported a German visitor, 'it is already really possible to obtain all the things one can get in Europe, since so many merchant ships arrive there every year.'[56] Of course, 'Phyladelphia with all its Trade, and Wealth, and Regularity is not Boston', claimed John Adams: 'The Morals of our People are much better, their Manners are more polite and agreable – they are purer English. Our Language is better, our Persons are handsomer, our Spirit is greater, our Laws are wiser, our Religion is superior, our Education is better.' But even Adams had to admit that the Philadelphia he was visiting in 1774, while inferior to Boston in every other way, ranked higher than

his own city 'in a Markett and in charitable public foundations'.[57]

The greater part of that market was in manufactured goods, and much of the new spending was on buildings and their furnishings, whether out on the plantations or in the towns. It had once been the case, at the beginning of the century, that 'scarce a house (in Annapolis) will keep out rain'. Yet it would be no time at all before the Annapolis elite – its politicians, lawyers, and men of affairs – were in open competition to spend thousands of pounds on their townhouses.[58] Crown glass for windows, in demand for the new buildings, was to be one of the fastest growing colonial imports of the third quarter of the century; while heading the long list of contemporary objects of desire were the high-quality textiles (silks, velvets and damasks), the Turkey carpets and fine porcelains, and the many other 'superfluities' of upholstery and haberdashery on which wealthy Americans, in the third quarter of the century, were spending as much as 10 per cent of their incomes.[59] 'The quick importation of fashions from the mother country is really astonishing', wrote William Eddis from Annapolis in the early 1770s: 'I am almost inclined to believe that a new fashion is adopted earlier by the polished and affluent American than by many opulent persons in the great metropolis (London).'[60] And so it must have seemed to John Adams also, dining in Boston with his chums:

> Dined at Mr Nick Boylstones [16 January 1766], with the two Mr Boylstones, two Mr Smiths, Mr Hallowel, and the Ladies. An elegant Dinner indeed! Went over the House to view the Furniture, which alone cost a thousand Pounds sterling. A Seat it is for a noble Man, a Prince. The Turkey Carpets, the painted Hangings, the Marble Tables, the rich Beds with crimson Damask Curtains and Counterpins, the beautiful Chimny Clock, the Spacious Garden, are the most magnificent of any Thing I have ever seen.[61]

Two decades later, Thomas Jefferson (1743–1826), the planter-statesman, continued to believe that his own native Virginia was a

land over which 'the genius of architecture seems to have shed its maledictions'.[62] But whereas the bulk of colonial architecture had indeed been amateur, aspiring virtuosi – among them Jefferson himself and his plantation-owning friends – were just a library away from high fashion. The same was true of craftsmen in eighteenth-century America. Thus the great cabinet-making dynasties of Newport (Rhode Island) – the Townsends and the Goddards – had access almost immediately to the best contemporary taste (and to all the latest crazes from Rococo to Chinoiserie) in Thomas Chippendale's encyclopedic *The Gentleman and Cabinet Maker's Director* (1754; with new editions in 1755 and 1762). And the interested gentleman-builder, including Jefferson at Monticello, could pick and mix façades from Colen Campbell's *Vitruvius Britannicus* (1715), from William Kent's *Designs of Inigo Jones* (1727), from James Gibbs's *A Book of Architecture* (1728), from recent new editions of Palladio's *Quattro Libri*, and from the many contemporary handbooks of London designers and theoreticians: of Robert Morris and William Halfpenny, of Batty Langley and Abraham Swann.[63] It was William Kent's *Designs of Inigo Jones* that gave Peter Harrison (d.1776) the idea for the severely classical temple-front of his Redwood Library (1749), at Newport. And Palladio's open loggias and shaded porticoes, so well suited to hot weather, were to be welcomed especially in the slave-dependent South where, though the winters are 'very fine and pleasant', the 'long & hot summers enervate & unbrace the whole System'.[64] Dating to 1738–42, Drayton Hall (South Carolina) is a representative big plantation-house of the Carolinian rice boom of the 1730s and 1740s, when slave imports were rising at an exceptionally rapid rate, by as many as six times in just two decades. At this substantial colonial villa, built (as was still unusual in North America) of costly brick, the main entrance is shaded by the same two-storeyed columned portico which Palladio had once used, among other places, at his Villa Pisani (1552–5) in Montagnana.[65]

It was Jefferson again who once confessed: 'Architecture is my

delight, and putting up and pulling down one of my favourite amusements.'[66] And the addiction stayed with him all his life. In 1768, in his first plans for Monticello, Jefferson had chosen a Neo-Palladian façade from the popular *Select Architecture* (1755) of Robert Morris. Yet some twenty years later he was to change his mind, declaring English architecture to be 'in the most wretched stile I ever saw, not meaning to except America where it is bad, nor even Virginia where it is worse than in any other part of America, which I have seen.'[67] What had caused him to change his mind was the American War of Independence (1775–83), won with the support of the French. And Jefferson was in Paris in the mid-1780s, representing his emergent republic at the court of a monarchy threatened by imminent collapse. 'I find the general fate of humanity here most deplorable', he wrote home from Paris on 29 September 1785, less than four years before the Sack of the Bastille (14 July 1789); 'The truth of Voltaire's observation offers itself perpetually, that every man here must be either the hammer or the anvil.' However, Jefferson was persuaded that his fellow Americans, while domestically more content, still had much to learn from the French about polite behaviour ('to make all those little sacrifices of self which really render European manners amiable'), about the pleasures of the table (in which 'they are far before us'), and about the arts (where 'were I to proceed to tell you how much I enjoy their architecture, sculpture, painting, music, I should want words. It is in these arts [that] they shine.').[68]

They shone in literature also, in that great *siècle des lumières*. And it was the writings of the Encyclopedists – Diderot's *Pensées* (1754), Rousseau's *Du contrat social* (1772), Voltaire's *Candide* (1759), and much else – that attracted a large readership, laying the theoretical groundwork for Revolution. 'But', said Candide at the end of Voltaire's fable, 'we must attend to our own affairs (*il faut cultiver notre jardin*).' And another major factor in the growing demand for social change was ascending levels of consumerism. France, in the eighteenth century, was to fall behind its neighbours. Its population grew

more slowly – by only a third overall; it benefited hardly at all from the Agricultural Revolution; and its industry got off to a slow start.[69] Nevertheless, all the essentials of recovery were already in place during Philip of Orleans's Regency (1715–23), following Louis XIV's death. And with peace restored at Utrecht (1713) and only lesser wars ahead – the Quadruple Alliance against Spain (1718–20), the War of the Polish Succession (1733–8), the War of the Austrian Succession (1741–8) – the bourgeoisie of France prospered and multiplied as never before, to be three times more numerous in 1789 than they had been at the beginning of the century.[70] 'Ever since people have begun to get rich rapidly from finance and trade', wrote a bourgeois of Montpellier in 1768, 'the Second Estate has won new respect. Its spending and luxury have made it the envy of the First. Inevitably the two have merged, and today there are no more differences in the way they run their households, give dinner parties, and dress.'[71]

Life-styles converged at many levels. It was that same Montpellier citizen who complained of the Third Estate (servants and artisans) that:

> Nothing is more impertinent than to see a cook or a valet don an outfit trimmed with braid or lace, strap on a sword, and insinuate himself amongst the finest company in promenades; or to see a chambermaid as artfully dressed as her mistress; or to find domestic servants of any kind decked out like gentle people. All that is revolting.[72]

And in Paris in the 1780s – a crowded city (wrote Arthur Young) of 'coffee-houses on the boulevards, music, noise, and *filles* without end'[73] – such was the demand for cheap imitations of one-time luxuries – for painted fans and snuff boxes, for muffs and stockings, for pocket watches, parasols and umbrellas – that 'wenches with umbrellas and workmen with muffs' were a regular part of the street scene.[74] When the century began, it was not the old nobility but a new *noblesse d'affaires* – tax farmers, bankers and wealthy

commerçants – who commissioned the big *hôtels particuliers* of the Faubourg Saint-Germain. And it was those elegant courtyard houses, built less for parade than for comfort and convenience, that taught the nobility in turn how to live. Neither Louis XV (1715–74) nor Louis XVI (1774–93) were enthusiastic builders. Consequently, it was left to successful financiers and to a court-weary aristocracy to lead the way in architecture from the pomp of Baroque (best suited to royal palaces), through the froth of Rococo (ideal for *hôtel* interiors), to the understated elegance of Neoclassicism.

The three styles coincided for a while. Thus when at the mid-century public building began again – in the euphoria of Marshal Saxe's victories and of the Peace of Aix-la-Chapelle (18 October 1748) – Baroque's established place in palace architecture caused it to be chosen by Louis XV and his advisers for the new École Militaire (begun in 1750), for Perrault's Louvre extension (still only half-complete), and for the Place Louis XV (with equestrian statue of the king), which would subsequently be re-christened the Place de la Révolution and is now the Place de la Concorde. All three commissions were given to the talented royal architect, Ange-Jacques Gabriel (1698–1782), who was to demonstrate his versatility both in the *style rocaille* interiors of Versailles and Fontainebleau and in the fine Palladian villa which he built for Madame de Pompadour, the royal favourite. Unlike many in his profession, Gabriel had never been to Rome. Yet soon after the Rome-trained Jacques-Germain Soufflot (1713–80) started work on the huge Neoclassical basilica of Ste-Geneviève (now the Panthéon) in Paris, Gabriel himself began building with deliberate classical austerity at Versailles. Madame de Pompadour (d.1764) and her capable placeman brother, the Marquis of Marigny, Directeur Général des Bâtiments (1751–73), encouraged and directed both enterprises. And it was the Pompadour's influence at Louis XV's Court, along with growing public interest in the on-going excavations at Herculaneum and Pompeii, that promoted Neoclassicism from the 1750s. Soufflot's big Church of Ste-Geneviève, begun in 1757, was challengingly stark

and under-ornamented. But so also, in its fashion, was Gabriel's Petit Trianon (1761–4): an elegant cubic house in the English Palladian taste, in which straight lines and clean right-angles had replaced Baroque curves, and where only the interiors (completed after his patron's death) carried any lingering flavour of Rococo.[75]

By the 1760s, when both buildings were in progress, the French economy was in serious trouble. The Seven Years War (1756–63) – the fourth and last dynastic conflict of the post-Louis XIV era – had ended in national humiliation. At the Peace of Paris (10 February 1763) France lost much of its colonial empire, including Canada, to Britain. And never had the Bourbon monarchy been in more urgent need of amnesic programmes of public works than when Pierre Patte, the architect and critic, published his *Monuments érigés en France à la gloire de Louis XV* (1765). In Paris itself, major building projects of the second half of the eighteenth century included the Hôtel des Monnaies (Royal Mint), the Halle au Blé (Corn Market), and the unpopular *Barrières*: a 'whole string of custom-house palaces', wrote William Beckford, the English eccentric and connoisseur, 'which from their massive, sepulchral character look more like the entrances of a necropolis, a city of the dead, than of a city so damnably alive as this confounded capital.'[76] Very few of the *Barrières*, designed by the leading Neoclassicist, Claude-Nicolas Ledoux (1736–1806), survived the Revolution. Nevertheless, it was Ledoux and his associates, through three disordered decades, who created between them a new rationalist architecture of spheres and cubes, as close to engineering as to art.[77] 'By far the finest thing I have yet seen at Paris', reported Arthur Young, the agriculturist, in 1787, 'is the Halle aux bleds, or corn market: it is a vast rotunda; the roof entirely of wood, upon a new principle of carpentry . . . the gallery is 150 yards round . . . it is as light as if suspended by the fairies. In the grand area, wheat, pease, beans, lentils, are stored and sold. In the surrounding divisions, flour on wooden stands. You pass by staircases doubly winding within each other to spacious apartments for rye, barley, oats, etc. The whole is so well planned

and so admirably executed that I know of no public building that exceeds it in either France or England.'[78]

Programmes of national awakening – '*propres à ranimer la vertu et les sentiments patriotiques*' – were especially prominent in all branches of the arts while the Comte d'Angiviller was Louis XVI's Directeur Général des Bâtiments (1774–91). It was d'Angiviller who devised the *grands hommes* scheme – 'the last, the most elaborate, and perhaps the most intelligent act of *ancien régime* patronage'[79] – where the commissioning of life-size statues of the 'great men' of France resulted in such masterpieces as Pierre Julien's *La Fontaine* and Clodion's noble figure, *Montesquieu*. Before d'Angiviller's directorship, neither Julien nor Clodion could have hoped for commissions on that scale. For while important state projects earlier in the century had included Edmé Bouchardon's equestrian statue of Louis XV for the eponymous *Place* in Paris, Jean-Baptiste Pigalle's tomb of Marshal Saxe (d.1750) in Saint-Thomas (Strasbourg), and Guillaume Coustou's monument to the Dauphin, Louis de France (d.1765), at Sens Cathedral, the more ambitious sculptors of eighteenth-century France might have to travel far for new commissions. 'I shall soon be fifty', Étienne-Maurice Falconet (1716–91) told the Marquis of Marigny in 1763, 'and I have still done nothing which merits a name.' Three years later, he was to leave Paris for Russia, to work in St Petersburg for more than a decade – '*au milieu des glaces du Nord*', said his friend Diderot – on the equestrian statue of Peter the Great which would indeed be the masterpiece he craved.[80]

The sought-after challenge of another equestrian monument was what persuaded Jean-Antoine Houdon (1741–1828) – reputed, said Jefferson, to be 'the finest statuary of the world' – to make the long sea voyage to Virginia in 1785 to model George Washington at Mount Vernon. Houdon (as Jefferson had told the retired general the previous December) was 'so enthusiastically fond of being the executor of this work that he offers to go himself to America for the purpose of forming your bust from the life, leaving all his

business here in the mean time.'[81] And while a full-sized equestrian bronze, so soon after the Revolution, was too expensive for Virginia's assemblymen, Houdon's statue, *George Washington* (1788), in the Capitol at Richmond, remains one of his more significant achievements. More remarkable still is the same sculptor's alert and impish *Voltaire Seated* (1781), at the Comédie Française in Paris. And further proof of the growing financial pressure on the *ancien régime* was its unprecedented neglect of a sculptor of Houdon's genius: starved of the more challenging commissions. Houdon's reputation rests, accordingly, not – as he might have wished – on great public monuments, but on an extraordinarily complete series of portrait busts of famous men – on his *Diderot* (1771) and his *Gluck* (1775), his *Franklin* (1778) and his *Jefferson* (1789), his *Necker* (1790) and his *Mirabeau* (1791); and on the warmth, humour and intelligence of his beautiful women – on his *Madame Adélaïde* and his *Comtesse de Jaucourt* (1777), his *Comtesse de Sabran* (1785) and his *Madame Houdon* (1787), the artist's wife.

Among Houdon's distinguished royal sitters was Catherine the Great of Russia (1773). He lived long enough to be the sculptor of Napoleon (1806). However, most of his subjects were middle-class. In the previous generation, Madame de Pompadour had been raised in that class. And what the Pompadour liked in sculpture – Falconet's *Cupid* (1757), Pigalle's *Mercury* (1744) or his *L'Enfant à la cage* (1750) – was very much what appealed also to those *salonniers* of Paris who would become in due course the purchasers of Houdon's busts and who continued to be admirers, right up to the Revolution, of the classicizing terracotta groups of Clodion (1738–1814). It was for that middle market chiefly – of wealthy financiers, civil servants, and pleasure-loving noblemen – that most French artists worked throughout the century: that Jean-Antoine Watteau (1684–1721), the Rococo painter, created his pioneering *fêtes galantes*; that Jean-Baptiste-Siméon Chardin (1699–1799) painted his bourgeois house-interiors and his meticulous 'Dutch' still-lifes; and that Jean-Honoré Fragonard (1732–1806), the last of the great masters of

amorous dalliance, put together his garden charades. Only François Boucher (1703–70), of that gifted company, painted principally for the Court. But even in the large-scale entertainments he devised for that audience, Boucher was never as successful as a history-painter as in his extraordinary mastery of the flesh-tints of naked nymphs; while the overtly erotic treatment of his *Odalisque on a Sofa* (1752) or his *Venus and Vulcan* (1753) appealed principally to the cabinet collector. When, in 1749, the ambitious young Comte de Stainville, later Duc de Choiseul, was ready to begin collecting in his own right, he wrote to his friend Nivernais, then ambassador in Rome: 'I should very much like you to be able to unhook me some beautiful Guido, Titian, Albani, Forti, Barocci, Carracci, even Correggio or Raphael if necessary'. What he required, Stainville explained, was four large pictures for his study:

> I could lay out a thousand Ecus this year, if you could get me for that or thereabouts two beautiful pictures, agreeable above all, really pure, really original and by a fine name, for names count a lot in these parts ... I could perhaps devote a similar sum to it again next year, and gradually build up an Italian collection, that is to say of Italian pictures for the upper walls, for I believe that this is what we must go for.[82]

Highly-regarded though they were by Madame de Pompadour and her circle, Boucher's diversions lacked seriousness of purpose.

Frederick II of Prussia (1740–86), called 'the Great', similarly recognized the private quality of that art. At his castle at Rheinsberg, when still Crown Prince, Frederick had been an assiduous collector of French Rococo: 'There are two rooms full of pictures', Frederick wrote to Wilhelmina, his sister, in 1739; 'most of my pictures are by Watteau or Lancret'. And likewise in Berlin, in the early 1740s, the *fête galante* pastorals of Nicolas Lancret (1690–1743) continued firm favourites with the king. Yet just a few years later, when offered ten more Lancrets for his proposed Gallery at Sanssouci, Frederick turned them down without apparent regret: 'For the time

being I am happy to buy Rubens and Van Dyck, in a word, pictures by the great painters of the Flemish or French schools', he wrote to Claude Etienne Darget in 1754. And it was of old masters chiefly – 'paintings which were known or famous among connoisseurs' – that Frederick's Sanssouci collections came subsequently to be assembled: thirty-eight paintings by Rubens, fifteen by Van Dyck, a Tintoretto, a Michelangelo, two Veroneses, three Leonardos, nine Correggios, a Poussin and so on.[83]

That unadventurous choice of paintings, many of which were wrongly attributed, no doubt reflected the king's own growing conservatism: in the visual arts, it has been said – as in architecture, literature and music (including opera) – Frederick's taste 'changed only by going backwards'.[84] But there were reasons of state for his conversion. For Sanssouci again, in the privacy of his Supper Room, Frederick had commissioned a picture by the court painter, Antoine Pesne (d.1757), on a theme suggested by himself. 'It was a beautiful bawdy painting', recalled Voltaire, who had seen it many times as Frederick's guest; 'There were men embracing women, nymphs under satyrs, cupids playing games of Tag and Blind Man's Buff, a number of people swooning with pleasure at the sight of these romps, cooing turtle doves, billy-goats mounting nanny-goats, and rams mounting ewes.'[85] Yet Frederick's Picture Gallery, in contrast, was a public space, and its paintings had been collected with that in mind. Dutch masters filled the west wing, Italian the east; the hanging was formal, the setting palatial, the decorations of marble and gilt.

The Gallery at Sanssouci was finished in 1763, shortly after the treaties of Paris and Hubertusburg (10 and 15 February) had brought an end to the Seven Years War. And it was in that year also that Frederick, flush with money, began building his huge New Palace (Neues Palais): his Potsdam answer to the glories of Versailles. Like every would-be autocrat of the eighteenth-century West, Frederick cherished the image of Louis XIV who, 'greedy for every kind of glory, wanted to make his nation as supreme in matters of taste

and literature as it was already in power, conquests, politics and commerce'. Louis had been successful (Frederick believed) because he fought his wars abroad, keeping his enemies out of France: 'so it was entirely natural that the muses transferred to his kingdom, for peace and abundance are their natural habitat.'[86] And it became Frederick's clear ambition to work the same miracle for his own capital in Berlin, behind the shield of a professional army. 'Our age', wrote Immanuel Kant (1724–1804), the East Prussian philosopher, 'is the age of enlightenment, the century of Frederick'. But Kant, who lived in Königsberg (now Kaliningrad) all his life, had experienced Russian occupation in the Seven Years War, and knew that freedom of conscience had its price: 'only a ruler who is himself enlightened and has no fear of phantoms, yet who likewise has on hand a well-disciplined and numerous army to guarantee public security, may say what no republic would dare to say: Argue as much as you like and about what you like, but obey!'[87]

Paradoxically, while it was Frederick's opportunist occupation of the rich Austrian province of Silesia that began the wars again, his own kingdom of Prussia was at war for fewer years than any other continental power of the mid-century. Prussia was also the only major combatant – apart from off-shore Britain – to come out of the Seven Years War with a profit. Silesia (which Prussia retained at Hubertusburg) continued to furnish as much as a quarter of Frederick's state revenues. And it was efficient tax-collecting, along with substantial British subsidies and the plunder of occupied territories – Mecklenburg, Saxony, and Swedish Pomerania – that enabled Frederick, while keeping a huge army of 190,000 men in the field, to accumulate a peace-chest which, in 1763, totalled 14.4 million *Reichstaler*.[88] He was to quadruple that surplus over the next two decades. And while the greater part of the new money was concentrated in Berlin, it also helped regenerate the provinces. 'The gradual improvement of the country is visible to the most careless observer', reported an English visitor to Prussia in 1799; 'Roads, plantations, neat cottages, pleasant country estates, well built towns

and good inns, take the place of the appearance of poverty and depopulation.'[89]

In Central Europe's 'vital revolution', beginning in the 1740s, population growth was not limited to Prussia. 'Factories have increased', was said of Austria in the 1780s, under the reforming Joseph II; 'In the villages wooden hovels are disappearing and many brick houses are taking their place. The roads are improved, and there are schools even in small places.'[90] But Prussia's annual growth rate, averaging 0.86 per cent, was higher than most; and Berlin grew even more rapidly. In the last decades of the seventeenth century, when other German cities were only just recovering from the Thirty Years War, Berlin had already doubled in size; it doubled again in the next half-century, and was to add another two-thirds after 1750, to reach a population in 1800 of some 150,000, second only in Central Europe to Vienna.[91] Both Frederick the Great's grandfather (Frederick I, d.1713) and his father (Frederick William, d.1740) invested heavily in their new capital. And Frederick's first intention was to live there himself, in the range he added to Charlottenburg. His Berlin Opera House, too, was another early initiative, launched in the first year of his reign. However, the city had grown too quickly, and it was not long before Frederick – like Louis XIV at Versailles – began to distance his Court from the tumult of the capital by removing it to neighbouring Potsdam. That city, he later claimed, 'was a poky little provincial town in my father's day. He would not recognize the place now, I have made it so beautiful.' And while the credit for Potsdam's transformation belonged chiefly to Frederick's architect, Georg Wenzeslaus von Knobelsdorff (d.1753), it was the king nevertheless who set the pace. 'I love building and decorating', Frederick told Jean le Rond d'Alembert, the Encyclopedist, while the works were in progress; 'I should be ashamed to tell you how much Sanssouci is costing me.'[92] Yet he went on to finish it regardless.

Frederick's pocket-palace at Sanssouci ('without a care') was a personal extravagance: a *palais à l'italienne* in a landscaped 'English'

garden, featuring an Obelisk Gateway, a Mount of Ruins, a Neptune Grotto, a Marble Colonnade, a Chinese Pavilion, and so on. And his public architecture likewise – sensitive to place – re-used whatever style he thought appropriate. Thus while Frederick's Berlin Opera House was Anglo-Palladian, his palace interiors – at Rheinsberg and Charlottenburg, at the Stadtschloss (Potsdam) and Sanssouci – were Rococo; and while his grand Neues Palais was High Baroque, its service wing (the Communs) was Neoclassical. Jean-Laurent Legeay (1710–86), architect of the Communs, had trained at the French Academy in Rome. And it was Legeay who, as early as 1747–8, first brought Neoclassicism to Germany in the designs he prepared (with Knobelsdorff, the royal architect) for the new Catholic Cathedral of St Hedwig in Berlin. That confusion of styles, more prevalent in Germany than in any other Western country, resulted in large part from the serendipitous eclecticism of Grand Tour princes. But politics were almost equally to blame. 'These troops are our Peru', said William VIII, Landgrave of Hesse-Kassel (1730–60), of the 6000 Hessian auxiliaries he sent to fight for Britain in the War of the Austrian Succession; 'In losing them we would forfeit all our resources.' And it was William's estranged heir, Frederick II (1760–85) – of whom it would be said in 1766 that 'the landgrave's most ardent passion is the military, and the real driving force for this enthusiasm is the love of money and profit' – who most successfully exploited this lucrative traffic in German soldiery (*Soldatenhandel*), while using his resulting wealth to rebuild Kassel as a model Anglo-Palladian city of the Enlightenment.[93]

After his army, reported Count Pergen (the Austrian envoy), building was the Landgrave's favourite extravagance. He had travelled widely in his youth, as had his Huguenot-born architect, Simon Louis du Ry (1726–99). And together they made of Kassel (as Frederick had promised) 'one of the most beautiful cities in all Germany'. On the Friedrichsplatz – the largest of three squares and Germany's biggest at the time – the temple-fronted Museum

Fridericianum (the first of its kind) allowed public access to Frederick's library and his collections. And it was in 1776, the year that his Museum opened, that Frederick negotiated the most rewarding mercenary contract of his reign. As agreed with Britain on 31 January, a Hessian force of 12,000 men was to cross the Atlantic to help suppress the rebel colonists in North America. In anticipation of a short war, the terms were exceptionally favourable to Hesse. But the rebels held out, more troops were sent (rising to 19,000 by the end), and the Landgrave's profits continued to accumulate. By 1783, while the war was lost and his paymasters had been soundly beaten, Frederick had more than doubled his money. Moreover, by investing his surplus capital in foreign stocks, Frederick had added as much as 30 per cent to the normal tax revenues of his state.[94]

With so much to spend, Frederick had begun planning, in the year of his death, a comprehensive rebuilding on the grandest of scales of his palace in the country outside Kassel. As subsequently completed and re-named by his successor, William IX (1785–1821), Schloss Wilhelmshöhe (1786–92) stood in the direct line of descent from the great Anglo-Palladian mansions of the 1730s: Nostell Priory, Wentworth Woodhouse, and Prior Park.[95] And that again was the style chosen by Prince Franz of Anhalt-Dessau for the fine 'English' country villa – modelled on Colen Campbell's Wanstead – which he built at Schloss Wörlitz (1769–73), in northern Saxony. Before starting work on Schloss Wörlitz, the Prince and his architect, Friedrich Wilhelm von Erdmannsdorff (d.1800), had visited England, and had studied in both Italy and France. And it was while they were in Rome that they made the acquaintance of the expatriate Prussian classicist, Johann Joachim Winckelmann (1717–68), prophet of what would become the Greek Revival. 'During the six months I spent in Rome with our prince in 1766', recalled Erdmannsdorff subsequently, 'I saw Winckelmann every day. He used to come to us at about nine o'clock in the morning to accompany the prince on the tours which we made of the art collections in Rome. We would do this until three or four of the afternoon

when Winckelmann would dine with us or the three of us would dine with the Prince of Mecklenbourg where the conversation would often be a repetition of the lessons of the morning. Winckelmann's energy was indefatigable.'[96]

It was Winckelmann's thesis, which he developed influentially in two important books – *Reflections on the Imitation of Greek Art in Painting and Sculpture* (Dresden, 1755) and *A History of Ancient Art* (Rome, 1764) – that 'the only way for us to be great, and if at all possible, immortal, is by imitating the ancients'. High Baroque, by that measure, decisively failed the test. And Winckelmann's forthright condemnation of Italian Baroque – as of Rococo, its French derivative – was taken up enthusiastically by other German theorists, among them the Saxon architect, Friedrich August Krubsacius (d.1789), whose Dresden Landhaus (1770–6) and two big city churches – the Kreuskirche and the Annenkirche (both begun in 1764) – brought Neoclassicism to the one-time capital of Augustus 'the Strong'. Dresden had been rebuilt for Frederick Augustus, Elector of Saxony (1694–1733) and twice King of Poland, by two gifted Baroque architects, Matthäus Daniel Pöppelman (d.1736) and Georg Bähr (d.1738). And Krubsacius, in that context, was to find it impossible to exclude Baroque entirely from his architecture. In practice, Baroque and the purer Classicism – whether from England or from France – co-existed in Germany for many years, for reasons both functional and aesthetic.

Both were represented, for example, in the Margravine Wilhelmina's new Bayreuth Theatre (1745–50), of which the outer shell was Palladian by the German court architect, Joseph Saint-Pierre (d.1754), whereas the interior was High Baroque by Giuseppe Galli-Bibiena (d.1756), of the North Italian dynasty of theatrical designers. The probable model for Wilhelmina's theatre was her brother's Anglo-Palladian Opera House in Berlin. Yet Frederick the Great himself had not continued in that tradition, returning to High Baroque as late as the 1770s when he chose a design by the Viennese architect, Joseph Emmanuel Fischer von Erlach (d.1742), for the

new Royal Library of his Forum Fridericianum in Berlin. Fischer's curved façade had been proposed originally for the rebuilding of Charles VI's Hofburg in Vienna. And Frederick II's appropriation of one of the Habsburgs' grander unrealized projects for his own Berlin capital – where his Royal Library (Baroque) would share the Forum with his Opera House (Anglo-Palladian) and the Church of St Hedwig (Neoclassical) – had a great deal to do with political point-scoring.[97] But there was a magnificence also and a spectacle in High Baroque which continued to recommend it to eighteenth-century building princes, while nobody understood better the devotional resonance of Rococo than the increasingly prosperous Catholic clergy of Southern Germany. Peter Thumb's great pilgrimage church at Birnau (Swabia) and Johann Michael Fischer's equally imposing Rott am Inn (Bavaria), both of the mid-century, rank among the most successful religious spaces ever created. And Fischer alone, as his Munich epitaph relates, built thirty-two churches and twenty-three monasteries, along with an undeclared number of country houses.[98]

It was during the working lifetimes of Johann Fischer and Peter Thumb – from the early 1740s to the mid-1760s – that an extraordinary economic turnaround took place in Germany, catching many foreign visitors by surprise. The Agricultural Revolution came late to Germany, beginning no earlier than the third quarter of the century. But two decades of peace after 1720, interrupted only by a comparatively minor war (the War of the Polish Succession, 1733–8), had enabled many German rulers to introduce new industries, while encouraging the growth of long-distance trade by investment in improved waterways and better roads. Some of that investment was almost immediately undone by the War of the Austrian Succession (1740–8). Even so, when David Hume, the Edinburgh philosopher, travelled south through Germany (from Cologne to Vienna) in the final months of that war, he was to change his mind entirely about the Germans. 'I had entertain'd no such advantageous Idea of Germany', Hume confessed, when he reached his journey's end.

However, his six weeks by road and water had been 'very agreeable'. And Germany, he concluded, 'is undoubtedly a very fine Country, full of industrious honest People, & were it united it would be the greatest Power that ever was in the World'.[99]

Some German cities had been left behind by the boom. Once mighty Cologne was a melancholy sight, 'where there are Marks of past Opulence & Grandeur, but such present Waste & Decay, as if it had lately escap'd a Pestilence or Famine'. Yet Hume and his party, on the next day of their journey, were to take time off to visit the 'extensive magnificent Building' of the Archbishop of Bonn: 'certainly the best lodg'd Prince in Europe except the King of France . . . (having) besides this Palace & a sort of Maison de Plaisance near it (the most elegant thing in the World) . . . also two Country Houses very magnificent.' At Koblenz ('a very thriving well built town'), the Archbishop of Trier had 'a pretty magnificent Palace'. And whereas Hume thought nothing of the Prince of Orange's Nassau ('but a Village, & one of the most indifferent I have seen in Germany'), he was more impressed by Frankfurt ('a very large Town, well built & of great Riches & Commerce)', while at neighbouring Hanau, the Landgrave of Hesse had a palace so commodious 'that (it) may lodge any King in Europe'. The Prince-Bishop's Würzburg was a particular revelation:

> What renders this Town chiefly remarkable is a Building [the *Residenz*] which surprized us all, because we had never before heard of it, & did not there expect to meet with such a thing. Tis a prodigious magnificent Palace of the Bishop, who is the Sovereign. Tis all of hewn Stone and of the richest Architecture. I do think the King of France has not such a House. If it be less than Versailles, tis more compleat & finish'd. What a surprizing thing it is, that these petty Princes can build such Palaces?[100]

So indeed it was, and there were princes in Germany with delusions of grandeur who should never have built as they did. However,

Hume's astonishment was the greater because – like most of his Protestant countrymen – he had continued to view the Germans in apocalyptic terms: as a benighted people, permanently at war and crippled by congenital sectarianism. The reality, of course, was very different. If Hume had come to Würzburg just three years later, he would have found the land at peace, with a new Prince-Bishop installed, and with the great Venetian frescoist, Giambattista Tiepolo (1696–1770) – 'the most excellent painter of our day, above all others' – at work on the episcopal Residenz. Tiepolo had been persuaded to come to Würzburg by a generous contract, promising a large fee and expenses. But the unprecedented scale of the task ahead had a particular appeal of its own. Never before had Tiepolo been offered such an enormous unbroken space as Balthasar Neumann's great Treppenhaus (staircase-hall) ceiling. He responded by painting his masterpiece.[101]

Johann Balthasar Neumann (1687–1753), architect-in-chief of the Würzburg Residenz, was still in office when Tiepolo arrived there. And Neumann's appointment, some thirty years before, had likewise followed the election of a new Prince-Bishop and the coming of general peace in 1720. Similar windows between the wars gave other German architects their opportunities. The rebuilding of Dresden, under Pöppelman and Bähr, had begun soon after Peter the Great's victory over the Swedes at Poltava (1709) had handed Poland back to the Elector. And even the building-averse Habsburgs were to start commissioning again from the early 1720s, when Charles VI employed the veteran Rome-trained architect, Johann Bernhard Fischer von Erlach, to build his Hofburg Library: 'the crowning achievement of Austrian Baroque'.[102] Back in the 1690s, Fischer von Erlach (a pupil of Carlo Fontana) had prepared a suitably magnificent Roman Baroque design for a huge Versailles-style palace at Schönbrunn. Yet some fifty years later, Schönbrunn was still unfinished; nor would it ever be completed as first intended.

One major reason why eighteenth-century Austria's Habsburg rulers – Charles VI (1711–40), Maria Theresa (1740–80), and Joseph II (1780–90) – built so little, was the enormous expense of main-

taining an army which, by 1780, had risen to some 250,000 men. Nevertheless, the population of Austria was growing fast – by as much as a third in Maria Theresa's reign alone; while the Empire's revenues, swollen by new taxes and by Prussian-style collection, rose by two and a half times in the same period.[103] Poverty, accordingly, was never the only cause of the Habsburgs' neglect of the arts. And what clearly moved them also was a politically-inspired reluctance to set aside those monuments – the medieval Hofburg in particular – which confirmed (in sharp contrast to the *arriviste* Hohenzollerns) the incontrovertible right of their ancient dynasty to rule.[104] Typically, neither Johann Lukas von Hildebrandt (1668–1745), the great Baroque architect, nor Franz Anton Maulbertsch (1724–96), Austria's foremost decorative painter, were recruited by Maria Theresa to complete the Schönbrunn Palace for her Court. And Austrian art was much the poorer for their exclusion.

Joseph II (co-regent with Maria Theresa from 1765) showed more interest than his mother in public architecture. Yet even he was to see building chiefly during his last unfettered decade as just another instrument of the Enlightenment. 'You (Louis XVI) possess the most beautiful building in Europe', Joseph told his brother-in-law in 1777, meaning Jules Hardouin-Mansart's great Dôme des Invalides. But his overall verdict on French architecture was unforgiving: 'Everything is for show', Joseph concluded, as he left Paris that summer: 'a (mere) pretence of greatness'.[105] And the architecture of Josephism, the Emperor's radical church reform, would be notable for its austerity and its functionalism. In 1783, Joseph's choice of architect for his new medical buildings in Vienna – the Narrenturm (a hospital for the insane) and the Josephinum (an army medical school) – was the French Neoclassicist, Isidore Canevale (1730–86), builder of Hungary's monumental Vác Cathedral (1763–72). And Canevale's Narrenturm – of cylinder plan with a circular courtyard in the middle – was of the same stark geometry as the Rationalist engineering of Claude-Nicolas Ledoux, substituting utility for the architecture of princes.

Vienna – that 'small world in which the great world holds rehearsal'[106] – was the crucible in the 1780s of the most extraordinary social experiment of the Enlightenment. In less than a decade, Joseph II (the 'crowned revolutionary') forced through a reforming programme which included the abolition of censorship, the emancipation of the peasantry, a revised tax system, and a new legal code. He guaranteed religious freedom, suppressed the enclosed monasteries, secularized education, and reorganized the parochial system. But he had acted both too hastily and too late.

> Dined today [wrote Arthur Young from Paris on 17 October 1787] with a party whose conversation was entirely political . . . One opinion pervaded the whole company, that they are on the eve of some great revolution in government . . . a great ferment amongst all ranks of men, who are eager for some change, without knowing what to look to or to hope for: and a strong leaven of liberty, increasing every hour since the American revolution.[107]

Two years later, the Bastille fell; and what Joseph himself described as the 'delirium which reigns in France' had begun. With his armies committed to a purposeless Balkan war, and with no possibility of French assistance, Joseph lost control within months of the rich Austrian Netherlands (re-born precariously as Belgium). Hungary, likewise, was demanding self-government. And while the Emperor retained the sympathy of the intelligentsia in Vienna, almost everybody else had turned against him. Late in January 1790, with only weeks to live, Joseph abandoned his cherished policies and rescinded his more unpopular reforms. 'Here lies Joseph II', ran his own wry epitaph, 'who failed in everything he undertook.'[108] In Vienna, there was dancing in the streets.

CHAPTER NINE

Revolution

'There never was a good war or a bad peace', wrote Benjamin Franklin, just days after the Peace of Versailles (3 September 1783). And for the remainder of the 1780s, as the peace in Europe held, there were radicals and America-watchers in England and on the Continent who were at last convinced that 'the happiness for which they have sighed finally does in truth exist'.[1] One of Franklin's correspondents was the Welsh-born theologian, Richard Price, who professed to believe that the American states' ratification of a federal constitution in 1788 was the beginning of a time 'more favourable to human rights than any that has yet been known in this world'.[2] And it was that same Richard Price whose address to London's Society for Commemorating the (American) Revolution in Great Britain ignited the debate on what was currently happening in France. 'Behold kingdoms', Price urged his free-thinking friends on 4 November 1789, 'starting from sleep, breaking their fetters, and claiming justice from their oppressors! Behold the light . . . after setting America free, reflected to France, and there kindled into a blaze that lays despotism in ashes, and warms and illuminates Europe!'[3] Published immediately as *A Discourse on the Love of Our Country*, Dr Price's philippic ran to no fewer than six editions within the year. It was the trigger for Edmund Burke's conservative *Reflexions on the Revolution in France* of 1790, which in turn provoked Thomas Paine's *Rights of Man* (1791), the battle-cry of Anglophone republicans.

'I do not deny', Burke admitted, concerning the 1789 Assembly's first decrees, 'that among an infinite number of acts of violence and folly, some good may have been done. They who destroy every thing certainly will remove some grievance. They who make every thing new, have a chance that they may establish something beneficial.' But 'the improvements of the national assembly are superficial', he concluded: 'their errors fundamental'.[4] And the same could have been said, with even more reason, of the National Convention's later meddling with the arts. In the Revolution's early days, the more progressive academicians, led by the radical history-painter, Jacques-Louis David (1748–1825), had successfully campaigned for the admission of new talent to the Académie Royale de Peinture et de Sculpture. The result was to double the works on show at the Academy's first open *Salon* of 1791; there were 1000 works exhibited in 1793; and two years later, that number had risen to over 3000.[5] However, France was at war again from 1792: with Austria and Prussia (20 April and 8 July 1792), with Britain and Holland (1 February 1793), with Spain and the Holy Roman Empire (7 and 26 March 1793), and with Russia (28 September 1794). And French art was more exposed than it had ever been under the monarchy to the patriotic rhetoric of politicians. It was in 1794 (Year II of the Republic) that the Committee of Public Safety called upon 'all poets to celebrate the principal events of the French Revolution, to compose patriotic songs and poems, dramatic and republican plays; to make known the heroic actions of the soldiers of liberty, and the victories won by French armies'. Painters, too, were to 'multiply the engravings and caricatures which can awake the mind of the public and make them feel how ridiculous and atrocious the enemies of Freedom or of the Republic are'.[6] Approved populist images included *The Triumph of the People* and *The Siege of the Tuileries by the Brave Sans-Culottes*.[7] And much contemporary work was mediocre. Nevertheless, growing hostility abroad and radical patriotism at home had already combined to inspire such lasting totems of the Revolution as Rouget de Lisle's great battle-hymn,

the *Marseillaise* (1792), and the unfinished *Oath of the Jeu de Paume* (1791) by David. In one administration after another – during the Convention and the Directory, in Bonaparte's Consulate and his Empire – patriotic sentiments never failed to swell French breasts, with important long-term consequences for art.

It was David himself – the quintessential painter of the Revolution – who made the connection between the *Tennis Court Oath* and his earlier *Oath of the Horatii* (1784). It was a misleading association, for David's *Oath of the Horatii*, commissioned by d'Angiviller for the monarchy's ends, had nothing initially to do with reform. Yet the painting which had been the occasion for a revolution in the arts continued to be of service to politicians. All who saw the *Horatii*, claimed Thomé (David's first biographer) in 1826, 'paid tribute to the man who held the sceptre of the arts. They relinquished the old manner in order to subscribe to the new character which he had given to painting. Sculptors, engravers, and architects thought only of imitating his manner. Furniture, dress, decoration, textiles, all underwent a change in taste and style.'[8] That style was Neoclassical, ending the long reign of Court-led Rococo and putting painters like Fragonard out of business. And David himself remained wedded to that tradition, as did his one-time pupil, Jean-Auguste-Dominique Ingres (1780–1867), who remained a Neoclassicist to the end. 'Leaf through your Plutarch', David told another former pupil as late as 1820, '(for) a subject that everyone can understand'.[9] Even so, the seismic changes of the 1790s – to which, as a Deputy, David was committed – gave a new contemporary relevance to his art. David's *Death of Marat* (1793), a lamentation over his dead friend, was a work of stark simplicity and ruthless realism. Resembling nothing he had done before – or would ever paint again – *Marat assassiné* has since become the single most memorable image of the Terror.

Just a few years later, David's visceral patriotism and his admiration for Bonaparte's generalship brought another change of direction. Yet it was less David – the creator of such enormous imperial

set-pieces as *The Coronation of Josephine* (1804) and *The Distribution of the Eagle Standards* (1805) – who captured successfully the Napoleonic myth than Antoine-Jean Gros (1771–1835), the professional war-artist. In one big military canvas after another, Gros painted Napoleon visiting the sick in the *Pesthouse at Jaffa* (1804), Napoleon haranguing his troops before the *Battle of the Pyramids* (1808), Napoleon re-visiting the field after the *Battle of Eylau* (1808), the *Capture of Madrid* (1808), the *Battle of Wagram* (1810), and many other works of that description.[10] All Gros's Napoleonic canvases shared the same Romantic vision – fully endorsed by the Emperor – of the heroism and self-sacrifice of war. And in their rejection of actuality in favour of the dramatic gesture, they were to exert a powerful influence on Théodore Géricault (1791–1824) and Eugène Delacroix (1798–1863), the two leading Romantic painters of the post-war decades. 'The life of Napoleon', noted Delacroix in 1824, 'is teeming with suitable subjects . . . (it) is the epic theme of our century in all the arts'.[11] And so indeed it would continue to be in the art of a Second Empire military-painter like Émile-Jean-Horace Vernet (1789–1863), and in the affections of his middle-class patrons.

'The only advice I can give my successor', Napoleon told Marshal Ney on the eve of abdication, 'is to change nothing in this country save the sheets of my bed.'[12] What he meant was not to meddle with *la France profonde*: with the immutable routines of the French peasant farmer. However, in an economy reduced to ruin by revolution and war, it was not the peasants alone who were change-averse, but the restored Bourbons and their clerical supporters. While Bourbon kings with long memories remained on the throne, official policy remained unflinchingly conservative. And art itself would take sides in the fierce political battle between the royalists (Neoclassicists) and the out-of-office imperialists and liberals (Romantics). Gericault's pioneering *Raft of the Medusa* (1819), first exhibited at the Academy's *Salon* in 1819, was shown alongside the Neoclassical pieces commissioned by Louis XVIII (1814–24). And like the two other great Romantic masterpieces of Restoration

France – Delacroix's *Massacre of Chios* (1824) and his *Death of Sardanapalus* (1827) – Gericault's 'sublime' *Raft* attracted attention not just for its quality and its painterly ambition but for the political message it was believed to contain.[13]

That message was plain enough in Delacroix's rousing barricade-picture, *Liberty Leading the People* (1830–31): 'if I have not conquered for my country', he told his soldier-brother, 'at least I will paint for her'.[14] And so transparently did Delacroix's *Liberty* endorse the street violence that had brought down the government of the last Bourbon, Charles X (1824–30), that it had to be put away out of sight. Nevertheless, Romantic art was to be among the instruments chosen by the Orleanist monarchy of Louis-Philippe (1830–48) to promote national unity and reconciliation. Horace Vernet's triumphalist *Louis-Philippe and his Sons riding out from the Château of Versailles* (1847), all in the uniform of France, was too obviously propaganda for a fragile would-be dynasty, legitimized only through service.[15] However, a better-deserved tribute to the very real economic achievements of the Orleanist regime was Delacroix's fresco cycle at the Palais Bourbon, featuring Industry and Agriculture, Literature and Justice, Philosophy and Science; while under the benevolent eye of the 'Citizen King', even revolutionary nationalism found expression again in the works of the Romantic sculptor, François Rude (1784–1855), whose spirited *Marseillaise* (1836) on the Arc de Triomphe celebrated the heroism and self-sacrifice of the defenders of the Republic in the volunteer armies of 1792.[16] In an early decree, Louis-Philippe – self-styled *ordonnateur des beaux-arts* in his new kingdom – required the Academy to hold its *Salon* (formerly biennial) every year. And so successful was his administration in revivifying French art that Paris (said Alphonse de Lamartine in 1841) 'has become one vast artists' studio. Europe visits, admires, purchases, and exports our products everywhere . . . "Painted in Paris" is a title of honour for a work of art, a certificate of good taste, a guarantee of origin that is in itself a mark of the highest distinction.'[17]

It was while Louis-Philippe was on the throne that artists of the

stature of Horace Vernet, of Paul Delaroche (1797–1856), and of Jean-Baptiste Corot (1796–1875) – specializing in Napoleonic battle-pictures (Vernet), in oriental fantasies and romantic set-pieces from Shakespeare and Goethe (Delaroche), and in naturalistic landscapes (Corot) – first created the market that, by the century's end, had caused 'every rich family (to be) necessarily obliged to possess a gallery of pictures, and this for two compelling reasons: first, from a natural taste for modern luxury, and secondly, because *fortune oblige*.'[18] And vital to that market was the redistribution of wealth associated with the Industrial Revolution. '*Monsieurs, enrichissez-vous*', was the characteristically bourgeois advice of François Guizot (d.1874), historian and politician, when addressing his new cabinet for the first time. And while large-scale industrialization, riding the Railway Age, came to France only in the third quarter of the century, there were already many potential openings, even before 1848, for entrepreneurs to grow seriously wealthy.[19] With over a million visitors to the Academy's *Salon* of 1846, art-collecting became a middle-class pursuit. Yet so vigorous was the tradition of dissent in France that the embourgeoisement of culture under Louis-Philippe at once provoked a socialist reaction. Pierre-Joseph Proudhon's *Qu'est-ce que la propriété?* – to which his stark reply was 'Property is theft' – was published in 1840. And in the free-press cacophony of the Orleanists' dying years, the philosophies most debated in artistic circles on the Left were either cooperationist (Fourierist) or socialist (Saint-Simonian), in each case highly critical of the values of a monarchy which the brilliant caricaturist and lithographer, Honoré Daumier (1808–79), repeatedly lampooned as the self-serving regime of the 'Crowned Pear'. Within weeks of Louis-Philippe's abdication and of the proclamation of the Second Republic on 24 February 1848, there was a Communist rising in Paris. Rebellions broke out simultaneously in Austria and in Prussia, in Poland and in Italy. And while order was restored everywhere before very long, Revolution and Reaction on the scale of 1848–9 inevitably had an impact on the arts.

Revolution

It was in 1851 that social realism found a master in the Franche-Comté painter Gustave Courbet (1819–77): 'an engine of revolution' and 'the Proudhon of painting' to his critics.[20] Courbet showed nine paintings at the Academy's *Salon* of 1851 (the first major exhibition since Louis-Philippe's fall), of which one in particular, *A Burial at Ornans* (1850), attracted much hostile attention. 'This seriousness and this buffoonery, these tears, these grimaces, this Sunday-best mourning, in black coat, in smock, in beguine cap, all add up to a funeral from some carnival, ten yards long, an immense ballad in painting, where there is more to laugh at than to make you cry', wrote one of the more perceptive of Courbet's critics.[21] A major problem with the work was its lack of Christian reverence: the *Burial*, as Courbet painted it, was just another social occasion. But equally disturbing to many Parisians, whether on the Right or from the Left, was the prosperous actuality of Courbet's well-dressed country-folk (his bourgeois *campagnards*), for it challenged too abruptly the ancient urban myth of a rural underclass which, whether brutalized by privation or ennobled by labour, was at any rate different from themselves. Almost alone, the Fourierist critic, François Sabatier, could see further. 'M. Courbet', Sabatier wrote, 'has made a place for himself in the current French School in the manner of a cannon ball which lodges itself in a wall . . . Since the shipwreck of the *Medusa* nothing as strong in substance and in effect, especially nothing as original, has been made among us . . . *A Burial at Ornans* will be classed, I have no doubt at all, among the most remarkable works of our time.'[22]

Sabatier was right, of course; and Courbet's *Burial* has since been accepted as one of the founding icons of Modern Art. However, among the painting's many critics in 1851 had been another who likened Courbet's enormous work to 'a badly done daguerreotype'. And there were already those in Paris in Orleanist times who were predicting the end of portrait-painting in photography.[23] In 1849, only ten years after the publication of Louis Daguerre's photographic process, there were some 100,000 daguerreotype portraits made in

Paris alone. Édouard Manet (1832–83), along with other young painters, used photography in his work; and even established masters like Ingres and Corot are known to have experimented with the technique.[24] Simultaneously, improved materials, new technologies, and more adventurous patrons were causing fresh departures in French building. While Antoine Quatremère de Quincy continued in post as secrétaire perpétuel to the Academy (1816–39), public architecture remained committed to Neoclassicism. Even so, there were enterprising young architects – chief among them Pierre-François-Henri Labrouste (1801–75) and Jacques-Ignace Hittorff (1792–1867) – who were building for preference in iron and in glass, who worked with bright colours (arguing that the Greeks had done the same), and who repeatedly challenged and contravened the old orthodoxies. In his cast-iron columns and arches, his sky-lights, his guard-rails and iron-grating decks, Labrouste's Bibliothèque Ste-Geneviève (1838–50) and his Bibliothèque Nationale (from 1853) paid overt homage to the pragmatic industrial architecture of his day. And Rationalism in building – like Realism in painting – was either Fourierist or Saint-Simonian in inspiration.[25]

In the 1840s, the characteristically Fourierist belief in the power of architecture to do good was energetically championed by César-Denis Daly (d.1893), the founding editor in 1839 of the *Revue générale de l'architecture et des travaux publiques* – France's first illustrated architectural review. However, it was in their rediscovery of thirteenth-century Gothic as the true *architecture nationale* that the Orleanists made their most individual contribution to building practice. Jules Michelet's *Introduction à l'histoire universelle* and Victor Hugo's popular novel, *Notre-Dame de Paris*, both published within a year of the July Revolution, reminded liberal Frenchmen of their medieval past and furnished Gothic Revivalism with new texts. And it was François Guizot, already the author of a popular *Histoire de la Civilisation en France* (1829), who, as Minister of the Interior from 1830, appointed Ludovic Vitet as his inspector-general of historical monuments, before establishing the Commission des monuments

historiques (1837) of which Vitet became the first president. Vitet, a dedicated patriot, held the view that the Gothic style was rooted in French soil: *'elle seule est sortie de notre propre sève* (sap), *elle seule porte la marque de notre propre création'*.[26] And that was the position also of his successor as inspector-general, the dramatist Prosper Mérimée, who in 1840 introduced the great architect-restorer, Eugène-Emmanuel Viollet-le-Duc (1814–79), to public works. Viollet-le-Duc's restorations in the 1840s included the important churches of Ste-Madeleine (Vézelay), Notre-Dame (Paris), and St-Sernin (Toulouse); he began work in the same decade on Louis IX's Sainte-Chapelle and on the reconstruction of the walled city of Carcassonne; for Napoleon III (1852–70), he was to rebuild Louis d'Orleans's ducal fortress at Pierrefonds. But while nothing could be more devotionally uplifting than the huge pilgrimage basilica at Vézelay, nor more Romantic than the multi-towered *enceinte* of Carcassonne, Viollet-le-Duc chose to see himself rather as a Rationalist. It was that central argument – for the engineering logic of arches, vaults and buttresses, and against intuition and the Hand of God – that Viollet-le-Duc developed influentially in his *Dictionnaire raisonné de l'architecture française du Xle au XVIe siècle* (1854–68), from an increasingly socialist and anti-clerical perspective.

While architecture, inevitably, was the most politicized of the arts, neither painting nor sculpture in the 'long' nineteenth century escaped the interference of politicians. Back in 1796, Bonaparte had been told by his superiors in the Directory that 'the time has come for the reign (of the arts) to pass to France in order to uphold and embellish that of liberty'.[27] Just three years later, the general himself was in control. And it was as First Consul (1799–1804) and then Emperor (1804–15) that Napoleon – expertly assisted by Dominique Vivant Denon, director-general of the Louvre – filled his 'New Rome' with the cream of the Continent's collections. In 1815, following the Congress of Vienna and Napoleon's second exile, many of those masterpieces would be sent home again, for fear (wrote Lord Liverpool) of 'keeping up remembrance of their former conquests

and of cherishing the military spirit and vanity of the nation'. However, the process was unpopular and politically damaging to the Bourbons. And there is no better demonstration of the growing political resonance of public collections of fine art than the fury of the citizens of Allied-occupied Paris on seeing their captured treasures taken down. 'Upwards of 1800 pictures and other articles are said to have been removed from the Louvre', wrote the London *Courier*'s correspondent on 4 October 1815, reporting ugly scenes of protest in the streets. Two days earlier:

> The stripping of the Louvre is the chief cause of public irritation at present . . . The long gallery of the Museum presents the strongest possible image of desolation; here and there a few pictures giving greater effect to the disfigured nakedness of the walls. I have seen several French Ladies in passing along the galleries suddenly break into extravagant fits of rage and lamentation; they gather around the *Apollo* to take their last farewell . . . There is so much passion in their looks . . . that a person unacquainted with their character or accustomed to study the character of the fair sex in England, where feeling is controlled by perpetual discipline, would be disposed to pronounce them literally mad.[28]

The Vatican's *Apollo Belvedere*, so the rumour was put about, was to be packed off to England for the Prince Regent's collection in a covert bargain with Pope Pius VII. But London – never invaded – had lost no art; whereas the great art collections of Potsdam and Kassel, Vienna and Munich, Nuremberg and Salzburg had all been systematically looted. It was in Germany, accordingly, that the argument for repatriation was heard most strongly, not least because the value of fine art as political propaganda had been learnt from the French at the Louvre. Late in 1815, the return of Prussia's treasures was to revive the campaign for a National Museum in Berlin. Nor was art's contribution to political causes ever seriously questioned from that time. One increasingly important contemporary cause

was German unification, greatly advanced by the intervention of Napoleon; another, inherited from the Enlightenment, was personal freedom. 'If man is ever to solve the problem of politics in practice', advised the poet Friedrich Schiller (1759–1805) in 1795, 'he will have to approach it through the aesthetic, because it is only through Beauty that man makes his way to freedom'.[29] Five years later, with Napoleon in Italy and the Habsburg Empire near collapse, Schiller had to admit that: 'Freedom is only in the realm of dreams/And Beauty blooms only in song.' Yet it was Schiller again, in the last year of his life, who gave the German unionists a rousing rallying-call, picturing 'a single nation of brothers (*ein einzig Volk von Brüden*) standing together in any hour of need or danger' (*Wilhelm Tell*, 1804).

In practice, the comprehensive unification of 1871 was still a long way off. But with the end of the Holy Roman Empire in 1806, the process took a giant stride forward. In 1815, when the map of Central Europe was comprehensively re-drawn at the Congress of Vienna, the huge number of semi-autonomous territories which had characterized the former Empire re-emerged as forty-one sovereign states, while the conviction was growing among German patriots of all allegiances that the break with the past was now total. 'In the three generations alive today', reported Friedrich Perthes, a Thuringian publisher, in 1818, 'our own generation has, in fact, combined what cannot be combined. No sense of continuity informs the tremendous contrasts inherent in the years 1750, 1789 and 1815; to people alive now . . . they simply do not appear as a sequence of events.'[30] Those 'people alive now' included the great poet-dramatist Johann Wolfgang von Goethe (1749–1832) who had come to believe, like his friend the philosopher Johann Gottfried von Herder (1744–1803), in an individual German genius and in a race with more than language in common. Goethe and Herder had met for the first time at Strasbourg in 1770. And it was while Goethe was still a student there – 'my head filled with general notions of good taste . . . (and) a sworn enemy of the confused arbitrariness of Gothic

adornment' – that he first came under the spell of Strasbourg Cathedral's Gothic architecture, with its 'thousands of harmonizing details'. 'This is German architecture! Our architecture!', the young Goethe exclaimed with a neophyte's passion; 'the Italians cannot boast one of their own, much less the French.' (*On German Architecture*, 1772). And when, much later, he returned to that early essay in the context of Cologne, 'I was pleased to discover that I had no cause to be ashamed, for I had been intuitively aware of the inner proportions of the whole, (and) had grasped the natural evolvement of the ornamentations from this wholeetc.' (*On Gothic Architecture*, 1823).[31]

Much later again, the French *savant* Ernest Renan – orientalist, critic, and historian of religion – would remind a Sorbonne audience in 1882 that 'before French culture, German culture, Italian culture, there is human culture'. However, he spoke in the bitter aftermath of the Franco-Prussian War (1870–1). And no Frenchman still mourning the loss of Alsace-Lorraine – any more than a Prussian patriot after the Wars of Liberation (1813–15) – could easily have accepted such a message. The completion of Cologne Cathedral, begun in 1816 as a Francophobe gesture following the collapse of Jerome Bonaparte's kingdom of Westphalia, was to be one of the many post-war projects of the great architectural polymath, Karl Friedrich Schinkel (1781–1841), whose own career had been blighted by the wars. Starved of major architectural commissions for almost a decade between the Prussian defeat at Jena (1806) and the Allied victory at Waterloo (1815), Schinkel had turned instead to the painting of Gothic townscapes and to theatrical design, creating stage-sets for the Berlin Opera which drew on recent discoveries in Egypt and Meso-America, as well as on Gothic and Classical Antiquity. When peace returned, all those separate strands were brought together in buildings of astonishing virtuosity. Gothic, predictably, was Schinkel's choice for the huge Cathedral of the Liberation, conceived (but never built) as a monument to the Prussian Fallen in the Wars. His cast-iron Kreuzberg Memorial (1818–21)

was Gothic also, as was the Friedrich-Werder Kirche (1824–30), in brick and terracotta, for which he looked to English Perpendicular for his model. Another English influence was the industrial architecture – 'enormous factories . . . 7–8 storeys high, as long as the Palace in Berlin and equally wide' – which Schinkel studied at first hand on his English tour of 1826, when it was the cotton-mills of Lancashire that most impressed him.

> Since the war 400 new factories have been built in Lancastershire (sic); one sees buildings standing where three years ago there were still fields, but these buildings appear as blackened with smoke as if they had been in use for a hundred years. It makes a dreadful and dismal impression: monstrous shapeless buildings put up only by foremen without architecture, only the least that was necessary and out of red brick.[32]

Yet while critical at the time of such social devastation, Schinkel was well aware of the revolution he was witnessing, and would turn that knowledge to good account when he got home. One of Schinkel's excursions, during his tour, had been to see the Royal Pavilion in Brighton: an 'oriental' extravaganza recently remodelled for the Prince Regent by his architect, John Nash (1752–1835), in a mixture of 'Chinese' and 'Hindoo'. And it was probably Nash's 'Chinese' stairs at the Royal Pavilion – of which, Schinkel noted, 'the banisters are of cast iron in a delicate imitation of bamboo tracery' – that inspired the iron staircases of Prince Albrecht and Prince Karl in the palaces Schinkel built for them in Berlin. Likewise, it was red brick that Schinkel chose in 1831 for his own Bauakademie (School of Architecture) on the Wedersche Markt in Berlin: a great slab of a building, not unlike the behemoths of Manchester.

At the Crown Prince's Schloss Charlottenhof (Potsdam) and at the many other villas and garden-palaces of his increasingly wealthy post-war patrons, Schinkel continued to demonstrate his skills as a theatrical designer. However, it was Berlin itself that was his

principal stage-set. Prussia's critical contribution to the defeat of Napoleon had been rewarded in 1815 at the Congress of Vienna with new provinces in Northern Saxony and the Rhineland. And Berlin's enhanced role as the capital of Greater Prussia was to provide the occasion for another grand rebuilding in an 'architecture of state', paid for by economic recovery. Thus Schinkel's first post-war monument, started in 1816, was the comparatively modest unadorned block of the Neue Wache (New Guardhouse) on the Unter den Linden in Berlin, relieved only by a Greek Revival portico. His second, much larger building – temple-fronted like the first – was Berlin's great Schauspielhaus (Theatre) of 1818–21. His third major project was the massively colonnaded Altes Museum (1822–30) on the Lustgarten, built for the public exhibition of Prussia's royal collections and to house its repatriated treasures.[33]

Other contemporary German architects – among them Gottfried Semper (1803–79) in Dresden, Georg Ludwig Friedrich Laves (1788–1864) in Hanover, Leo von Klenze (1784–1864) in Munich, and Friedrich Weinbrenner (1766–1826) in Karlsruhe – were commissioned in the peace to rebuild the capital cities of their newly sovereign states, released from allegiance to the Empire. They were Neoclassicists to a man. But the style's firm association with aggressive French imperialism had cost it many friends, and it was beginning to look jaded and old-fashioned. While still usually selected for the most solemn commemorative monuments – for Ludwig of Bavaria's Walhalla (1830–42), near Regensburg, or his Munich Ruhmeshalle (Hall of Fame, 1843–54), both by Leo von Klenze – Neoclassicism's long reign as the automatic first choice for all public buildings of any substance was everywhere approaching its end. *'In welchem Stil sollen wir bauen? . . . In what style shall we build?'* was the question openly posed in 1828 by Heinrich Hübsch (1795–1863), state architect of Baden. Hübsch's own preference was for the *Rundbogenstil* (Round-Arch Style): an eclectic borrowing from Early Christian and Lombardic, Byzantine and Tuscan Romanesque.[34] However, many architects of his generation chose Gothic

instead, while others were more attracted by industrialized building, making use of prefabricated materials.

'I hate all the French without exception', wrote the literary patriot Ernst Moritz Arndt, 'in the name of God and my people.'[35] However, more constructive was Arndt's belief – shared (among others) by Johann Gottlieb Fichte (1762–1814), the philosopher – in Germany's unique cultural mission: 'Germans have not been bastardized [claimed Arndt] by foreign nations . . . they remain in their original purity and have been able to develop from this purity their own character and nature, slowly and in accord with eternal laws.'[36] By that measure, Gothic architecture (thought to be German) was pure and undefiled. And so also were the paintings of the *altdeutsch* masters, recalling the German Empire's glory days. It was on 10 July 1809, less than a week after Napoleon's crushing victory over the Austrians at Wagram, that six young painters at the Vienna Academy founded the archaizing Brotherhood of St Luke. Viscerally patriotic and strongly religious, the Nazarenes (as they came to be known from their biblical style of dress) left Vienna for Rome in 1810. With Franz Pforr (1788–1812) as their leader and Friedrich Overbeck (1789–1869) as their 'priest', they were joined there shortly afterwards by the talented decorative painter, Peter von Cornelius (1783–1867). And it was in Rome, under Cornelius's direction, that they practised the ancient art of wet-ground fresco-painting, which then brought them to the attention of Ludwig of Bavaria and of other leading patrons of Germany's Medieval Revival.[37]

Many German liberals, attracted by his reforms, refused to see Napoleon as the arch-enemy. Yet everything about the wars – defeat, occupation, and eventual victory over the French – contributed to the German sense of nationhood. Thus while the Nazarenes (in Rome) were reproducing medieval imagery, and Schinkel (in Berlin) decorated his historical townscapes with imaginary cathedrals, Caspar David Friedrich (1774–1840), the great Dresden Romantic painter, populated his canvases with 'German' Gothic buildings and with figures in traditional dress.[38] Even so, no major artist, whether

German or French, had ever tried to show the war as it really was. And it was left to a Spanish court painter, Francisco de Goya (1746–1828), to record for the first time the sufferings of the poor in a war of occupation and resistance. Goya's savage etchings, *The Disasters of War* (1810–14), too disturbing for public viewing, stayed unpublished until 1863. Yet 'no bloodier pamphlet against war and the spirit of conquest has ever been written', wrote a French critic at the time.[39] And that also had been the message, almost forty years before, of Goya's unforgettable masterpiece, *The Third of May 1808*, still the most powerful of anti-war images. One of a pair of paintings commissioned in 1814 by the restored monarchy of Ferdinand VII (1814–33), *The Third of May* commemorated the heroism of ordinary *madrileños* in an unsuccessful popular rising against the French. Yet in choosing for his subject a mass execution – arbitrary, anonymous, and totally without sentiment (there are no weeping bystanders or welcoming angels in the sky) – Goya stripped the revolt bare of every particle of glory, painting only its brutality and its failure.[40]

Unlike those younger contemporary artists who knew only Revolution, Goya was a creature of the Enlightenment. He was as instinctively liberal and anti-clerical as the Nazarenes and their like were congenitally conservative and religious. In an earlier set of etchings, the *Caprichos* (Caprices), published in 1799, Goya had pilloried the Spanish Church and Inquisition. However, when appointed First Court Painter in 1800 by the reactionary Charles IV (1788–1808), Goya had been working for many years as a society portraitist in Madrid. And if there had been no French invasion of Spain in 1808, he might never have discovered that other voice. Arguably, then, while he was already an important painter in pre-invasion times, it was the Peninsular War that unlocked Goya's genius. 'The light of Velázquez, the diabolical colours of El Greco', wrote Isidore Taylor, shortly after Goya's death, 'the manners and customs of bullfighters, *majas, manolas*, police, smugglers, thieves, gypsies, and finally witches – those Spanish witches, so much more Satanic than ours [in France]

– all these meet and die with Goya . . . the most unusual artist ever born in Spain'.[41]

Only one other major artist of the early nineteenth century was as 'unusual' as Goya. Yet his circumstances could hardly have been more different. J.M.W. Turner (1775–1851), England's greatest landscape-painter, never worked for the Crown. He aspired to do so, making unsuccessful bids to attract the patronage in turn of the Prince Regent (later George IV), of William IV, and of Prince Albert (Victoria's consort). But while the Prince Regent, in particular, might claim with some reason (at an Academy dinner of 1811) that nobody could 'exceed him in his love of the arts, or in wishes for their prosperity', he showed little real enthusiasm for the new. What the Prince bought instead were the accomplished but less challenging works of the fashionable London portraitist, Sir Thomas Lawrence (1769–1830), and of the Scottish anecdotal painter, Sir David Wilkie (1785–1841), which – together with the paintings of Reynolds and Gainsborough, Romney and Stubbs – were enough to persuade him that 'as this country had risen superior to all others in Arms, in military and naval prowess, so would it (also) in the Arts'.[42]

And so indeed it would in the pioneering landscapes of J.M.W. Turner and John Constable (1776–1837), neither of whom owed anything to the Hanoverians. Both the Prince and his father, George III (1760–1820), had prided themselves justifiably on connoisseurship. And the much-travelled nobility of eighteenth-century England had come to include some of the best-informed collectors of all time. But the downside of connoisseurship, as learnt on the Grand Tour, was an exaggerated regard for 'correct' taste. 'The Enquiry in England', grumbled William Blake (1757–1827), the poet-painter, 'is not whether a Man has Talents & Genius, but whether he is Passive & Polite & a Virtuous Ass & Obedient to Noblemen's Opinions in Art & Science. If he is, he is a Good Man. If Not, he must be Starved.'[43] And Blake's highly individual art, while admired by fellow professionals like the young painter John

Linnell (1792–1882), held few attractions for the wealthy grandee still in thrall to the Picturesque and the Antique. Sir George Beaumont (d.1827), for example, while an amateur painter of distinction and a collector of 'genius', had no time for Blake and heartily disliked Turner's art. True, he counted the independent-minded Constable among his artist friends. However, Beaumont's consuming passion was for old masters of long repute, his greatest collecting coup being the purchase in Rome in 1822 of Michelangelo's marble tondo, *The Virgin and Child with St John* – 'you may be sure I was made to pay for it', he told Lawrence. Among Beaumont's other important acquisitions were the two Rembrandts and a Rubens, a Poussin, a Canaletto, and four Claudes which he included in his founding Gift to the new National Gallery (1824) in London, of which he himself had been the principal proponent.[44] However, to collect paintings of that cost and quality, when every prince and magnate was under pressure to do the same, required both great wealth and an educated taste. And London's middle-class collectors were attracted instead to the more affordable work, both in watercolour and oils, of those contemporary British artists to whom they could more easily relate. Turner, furthermore, was one of them himself. He had friends in the aristocracy, most notably in George O'Brien Wyndham (d.1837), third Earl of Egremont and custodian of the huge collections at Petworth House. Yet he was to enjoy the 'proud pleasure', not long into his career, of turning down Beaumont's offer for his newly-completed *Fishing upon the Blythe-Sand* (1809). And what gave him that independence was the high prices he could obtain from lesser collectors of his work, while simultaneously accumulating a substantial fortune of his own through investments in property and the Funds.[45]

Constable likewise, having sufficient private means, was free in middle age to return to the Suffolk landscapes of his early apprenticeship, and to paint essentially what he liked. And there were important contemporary architects – among them William Wilkins (1778–1839), C.R. Cockerell (1788–1863), and Augustus Pugin

(1812–52) – whose comfortable family fortunes enabled them to pick and choose their commissions. Their context was wealth-creation on an unprecedented scale: the result of an Industrial Revolution which had begun in Britain at least a generation ahead of all competitors. 'For the last 50 years', wrote the visiting Prussian, Schinkel, in 1826, 'for as long as machines have been in operation, England has doubled, and in some places tripled and quadrupled, its population, and has become much improved.'[46] What Schinkel was witnessing was the Revolution's earliest phase, when Lancashire's machine-made calicos had already captured the global market in cheap cloth. 'England', claimed the cotton industry's first historian in 1835, 'is far more indebted for her triumphs to Arkwright [of the spinning-jenny] and Watt [of the steam-engine] than to Nelson and Welling-ton. No nation ever had a more universal commerce than this.'[47] Yet unnoticed by Schinkel – who had arrived in England just months after it happened – the opening of the Stockton and Darling-ton Railway on 27 September 1825 had launched a second Revo-lution far more general than the first: 'the great iron revolution of science'.[48]

By 1851 – the year of the Great Exhibition (in Hyde Park), of Joseph Cubitt's King's Cross Station (for the Great Northern Rail-way), and of Turner's death – there were already over 6000 miles of rail track in Britain: Russia, in contrast, had fewer than 700, while Spain and Italy had even less. Turner himself, rising to the challenge, had been the first to capture successfully, in his *Rain, Steam and Speed* (1844), the steam-train's headlong urgency and dash. And Constable too, as his big 'six-footers' began to sell, grew hopeful that 'I may yet make some impression with my "light" – my "dews" – my "breezes" – my *bloom* and my *freshness* – no one of which qualities has been perfected on the canvas of any painter in this world.'[49] The French, especially, were impressed. It was the supreme truthfulness to nature of Constable's *Hay-Wain* (1821) – its water, its trees, and its rain-laden clouds – that won it a gold medal at the Paris *Salon* of 1824. Likewise, Turner's experiments

with light and colour, while too daring for many Englishmen, found admirers in France from the beginning. 'No painter perhaps of any school', wrote the French critic, Théophile Thoré, some years after Turner's death, 'has painted the subtle and impalpable effects of light so marvellously. His craving for light made him conceive of colour combinations which the great colourists before him had never foreseen. His feeling for the infinity of nature made him reveal in his works the infinity of art, and thus demonstrate that there is still, and always will be, a new art after the masters of the past.'[50]

Among the many extraordinary paintings of Turner's last productive decades were his two views from life of *The Burning of the Houses of Lords and Commons, 16 October 1834*. Half London was there also to watch a catastrophe which, in no time at all, had been re-invented as a challenge and opportunity. The medieval Palace of Westminster had been a warren of ancient offices: 'notoriously imperfect, very crazy as buildings, and extremely incommodious in their local distribution'. And both Sir John Soane (1753–1837) and James Wyatt (1746–1813), the leading architects of their day, had been commissioned in the 1790s to prepare plans for a substantial rebuilding. But then the outbreak of war with France in 1793 had called a halt to all such projects, causing Soane's ambitious 'Grecian' proposals to be set aside. And Wyatt's cheapskate 'Gothick' substitute was a failure. 'Oh it was a glorious sight', wrote the young Pugin unabashed, 'to see his (Wyatt's) composition mullions and cement pinnacles and battlements flying and cracking, while his 2*s* 6*d* turrets were smoking like so many manufacturing chimneys till the heat shivered them into a thousand pieces.'[51] Wyatt's pasteboard Perpendicular was probably best forgotten. But any return to Soane's Grecian – too closely identified with revolutionary France and with the associated architecture of Ledoux – had likewise been ruled out by Francophobia. 'The Gothic mania, like the French Revolution, carries all before it', Soane himself had complained while the wars were still in progress; 'It destroys and sweeps away every principle of ancient architecture and every idea of correct taste.'[52] And whether

'correct' or not, nothing would now satisfy Westminster's patriotic legislators but Gothic again: 'eminently English . . . derived from our ancestors . . . adapted to the Gothic origin and time-worn buttresses of our constitution . . . (and) brought to the greatest perfection in this country'.[53]

There were those at the time, conscious of the identical claims of both the Germans and the French, who questioned the essential 'Englishness' of Gothic. Others saw Gothic as a reminder of feudal tyranny, arguing that Soane's Grecian, in contrast, was 'more expressive . . . of the character of the institutions of a free people'.[54] But for Pugin, partnering Sir Charles Barry (1795–1860) in the Houses of Parliament's reconstruction, only Gothic was 'warranted by religion, government, climate, and the wants of society . . . the perfect expression of all we should hold sacred, honourable and national'.[55] And few principled builders or their patrons in Pugin's day had any desire to turn the clock back to unadulterated Neoclassicism, let alone to Picturesque where 'the Turk and the Christian, the Egyptian and the Greek, the Swiss and the Hindoo march(ed) side by side' in the works of an architect like John Nash (1752–1835).[56] Even the Gothic Revivalists had their critics. 'Gothic', wrote John Henry Newman in 1848, 'is now like an old dress, which fitted a man well twenty years back but must be altered to fit him now . . . It was once the perfect expression of the Church's ritual . . . It is not the perfect expression now.' Newman, recently converted to Catholicism, had joined the Oratorians: a community once prominent in the Counter-Reformation. And he wrote from Baroque Rome, surrounded by an architecture – not least that of his own order – which 'Mr Pugin calls reproachfully *pagan*'.[57] While individually incensed by what he saw as Pugin's 'bigotry', Newman was not alone in appealing for a more flexible *living* architecture for his times. Nikolai Gogol (d.1852), for example, the Russian essayist and playwright, had already pictured his ideal city as a repository of all the styles: 'let there rise on one and the same street [Gogol wrote in 1835] something sombre and Gothic; something Eastern,

burdened under the luxury of ornament; something Egyptian, colossal; and something Greek, suffused with slender proportions . . . etc.'[58] And Gothic, while never a native style, would continue to find favour with Russia's liberal intelligentsia as alternative and antidote to the megalomaniac Neoclassicism of the Tsars.

Neoclassicism had begun well under Catherine the Great (1762–96) as an instrument of the Russian Enlightenment. Catherine loved building, representative works of her long reign being the Neoclassical Cathedral of the Alexander Nevsky Lavra by Ivan Yegorovich Starov (1743–1808), the Anglo-Palladian English Palace by Giacomo Quarenghi (1744–1817), and the Picturesque garden houses – '*J'aime à la folie les jardins à l'anglaise*', she once told Voltaire – by Charles Cameron (1745–1812) and others at Tsarskoe Selo.[59] In the same modernizing spirit, Catherine drew repeatedly on the West for every kind of art, assembling the huge collections – 4000 old masters, 10,000 prints and drawings, 38,000 books, 16,000 coins and medals, 10,000 antique intaglios – with which she furnished her Winter Palace at St Petersburg. 'The generosity of Catherine, the splendour of her reign, the magnificence of her Court, her institutions, her monuments, her wars, were precisely to Russia what the age of Louis XIV was to Europe', recalled Charles François Philibert Masson (d.1807), one-time diplomat of France and memorialist of Catherine's Court, who was also among the more perceptive of her critics. But then:

> The French Revolution, so unfriendly to sovereigns in general, was particularly so to Catherine. The blaze which suddenly emerged from the bosom of France as from the crater of a burning volcano, poured a stream of light upon Russia, vivid as that of lightning; and injustice, crimes and blood were seen where before all was grandeur, glory and virtue. Catherine trembled with fear and indignation.[60]

And Russia's brief Enlightenment, wounded by Revolution, expired in the Patriotic War.

That war began in earnest for Russia in 1805, when Catherine's grandson, Alexander I (1801–25), joined the Third Coalition against Napoleon. Alexander had come to the throne four years earlier as a social reformer, convinced of the irreversibility of change. But he then had a good war. And any plans he may have made for consti- tutional reform had largely been forgotten before its end. Napoleon's invasion of Russia, begun in June 1812 and abandoned within the year, had been the turning-point. And in 1814, with a million men under arms and his regiments in France, Alexander was widely hailed throughout the West as a popular hero: the 'Saviour of Europe' and the 'Christian Conqueror of Napoleon'. The adulation went to his head. When Alexander returned to Russia in 1815, he 'wanted to make Petersburg more beautiful than any of the Euro- pean capitals he had visited'.[61] To the neglect of reform and at huge cost to his people, he proceeded to do just that.

In contrast to Catherine, who had built mainly for her pleasure, the buildings of Alexander and of his brother, Nicholas I (1825–55), were provided principally for the Army and the State. Alexander began by completing his murdered father's huge Kazan Cathedral (1801–11) – a cross between St Peter's (Rome) and Soufflot's Pan- théon in Paris. He built the Grand Theatre (1802–5) and the Exchange (1801–16), the Horse Guards' Riding School (1804–7) and the Academy of Mines (1806–11), the Pavslovsky Barracks (1816–19) and the vast new headquarters of the General Staff (1819–29), which closed off the Winter Palace Square. Nicholas, in turn, built the Alexandrinsky Theatre (1827–32) and the Senate and Synod (1829–34), raised the mighty Alexander Column (1819) in memory of his brother, and celebrated victories of his own with a cast-iron triumphal arch, the Moscow Gate (1834–8).[62]

Nicholas's Alexander Column was the tallest in the world, and each fresh addition to Alexandrine St Petersburg was conceived on a similar scale. But the greater part of that new architecture was imported. And only at the New Admiralty (1806–23), rebuilt by Andreyan Dmitrievich Zakharov (1761–1811) on the site of Peter

the Great's shipyards, were there any substantial reminders of Old Russia. All Alexander's principal architects – Andrei Nikiforovich Voronikhin (1760–1814) of the Kazan Cathedral, Thomas de Thomon (1754–1813) of the Exchange, Vasily Petrovich Stasov (1769–1848) of the Pavslovsky Barracks, Karl Ivanovich Rossi (1775–1849) of the General Staff, and even Zakharov himself – had studied abroad. And while the Neoclassicism of France continued to be their model, they had all included Italy on their educational itineraries, not just for its antiquities but for what they could learn of modern architecture.

Again, much of that new architecture in Italy was French-inspired. It was Napoleon, crowned King of Italy in Milan Cathedral on 26 May 1805, who ordered the completion of the Gothic Duomo's west façade. And it was Napoleon again, ruler of Venice also from the end of that same year, who directed his architects to finish-off the closing range of the Piazza San Marco – 'the finest drawing-room in Europe'.[63] Left to govern Italy in Napoleon's absence, his generals remodelled their separate provinces in France's image. In Milan, for example, the city gates and toll-houses ordered by Eugène de Beauharnais, Napoleon's stepson, were clearly inspired by Ledoux's Barrières de Paris. And Luigi Cagnola (1762–1833), builder of the surviving Porta Ticinese in Milan, would also be the designer of Beauharnais's Arco del Sempione, modelled on Napoleon's Arc de Triomphe de l'Etoile. In other Italian cities, vigorous Neoclassical buildings in the manner of Ledoux included the Ponte Milvio (Rome) by Giuseppe Valadier (1762–1839) and the Teatro San Carlo (Naples) by Antonio Niccolini (1772–1850). Nor was French influence to disappear when peace returned, for nothing could be more austerely Franco-Grecian – the very antithesis of Baroque – than Selva's Tempio Canova (1819–33) at Possagno.[64]

Giovanni Antonio Selva (1753–1819), the designer of Canova's Tempio, had begun his career as a Palladian. He had then taken up Neoclassicism but, once a traveller in his youth, had urged that education on his pupil, Giuseppe Jappelli (1783–1852), whose

Paduan Caffè Pedrocchi (1816–31) – an eclectic mixture of many styles from Gothic to Egyptian – has been described as 'the handsomest nineteenth-century café in the world'.[65] With such talented architects as Jappelli in the next generation, Italy's reputation for building was secure. But the same could no longer be said for either its sculptors or its painters, only Antonio Canova (1757–1822) ranking indisputably as world class. 'Painting here [in Italy] is dead and buried', wrote the visiting Marie Henri Beyle (Stendhal) in 1817: 'Canova [the sculptor] has emerged quite by chance out of the sheer inertia which this warm climate has imposed. But, like Alfieri [the dramatist], he is a freak. Nobody else is in the least like him, and sculpture in Italy is as dead as the art of men like Correggio.'[66]

Others agreed. Nevertheless, Rome's standing in the arts remained intact, and it continued to attract foreign artists. Canova, a Venetian, was still a young man when he settled in Rome in 1781, one of his earliest major commissions being the monument of Pope Clement XIV (1769–74). And it was Canova's successful workshop in that city that persuaded his closest rival, the Danish sculptor Bertel Thorvaldsen (1770–1844), to stay in Rome himself for over forty years, resisting every pressure until 1838 to return to his native Copenhagen. Similarly, the English Classical sculptors, John Flaxman (1755–1826) and John Gibson (1790–1866), both stayed in Rome for long periods. And that would be the case also with Karl Briullov (1799–1852) and Alexander Ivanov (1806–58), working in Rome on the two enormous canvases – Briullov's *The Last Day of Pompeii* (1830–3) and Ivanov's *Christ's First Appearance to the People* (1837–57) – which brought the two Russians international recognition.[67]

One regular visitor to Italy when peace returned was the Englishman, J.M.W. Turner. In 1819, Turner had found art in Rome 'at the lowest ebb'.[68] But the clear light of Italy – and of Venice in particular – repeatedly drew him back; while it was to tread in Turner's footsteps that the self-taught American landscapist, Thomas Cole (1801–48), came to Florence in 1831. Cole's Tuscan landscapes were no match for Turner's. Yet it was on his first

European journey of 1829–33 that Cole learnt to paint the grand-manner 'histories' with which he dazzled his New York patrons on his return. While in London in 1829–31, Cole had become familiar with the disaster-paintings – very popular in their day – of John 'Pandemonium' Martin (1789–1854). He was in Rome when Karl Briullov was finishing his much-acclaimed *The Last Day of Pompeii*. Inspired by contemplation of Rome's monuments, Cole developed his own vision – highly attractive to American audiences – of Arcadia ruined by Vainglory. Cole's five-part series, *The Course of Empire* (1834–6), begins with *The Savage State*: an empty landscape closely resembling those he had painted of America. But for *The Arcadian or Pastoral State*, the second painting in Cole's cycle, the scene has already shifted to Early Bronze Age Europe. And Cole's three remaining works – *The Consummation of Empire* ('a great city girding the bay'), *The Destruction of Empire* ('a tempest, a battle, and the burning of the city'), and *Desolation* ('the funeral knell of departed greatness') – are all of the Roman Empire and its Decline.[69] Cole was a Federalist, favouring John Quincy Adams (1825–9), the former Secretary of State and ousted President. And the underlying message of *The Course of Empire* was political. What had happened to Imperial Rome (Cole suggests) could happen to America too under the populist presidency of 'Old Hickory' (Andrew Jackson, 1829–37), to be 'another mighty Empire overthrown'.[70]

CHAPTER TEN

The Gilded Age

When the young American history-painter, Benjamin West (1738–1820), studied in Rome in 1760–3, he was already comparing it unfavourably with the progressive colonial society he had just left. 'In America all was young, vigorous and growing – the spring of a nation, frugal, active, simple', recalled John Galt, West's biographer, shortly before the painter's death; 'In Rome all was old, infirm, and decaying – the autumn of a people who had gathered their glory, and were sinking under the disgraceful excesses of vintage.'[1] Yet Rome, while West was there, was still the training-ground and studio of major foreign artists and a place of pilgrimage for the scholar-connoisseur. Other residents in Rome in the early 1760s included Anton Raffael Mengs (1728–79), the German frescoist, and Johann Joachim Winckelmann (1717–68), the art historian; Gavin Hamilton (1723–98), the Scottish history-painter, was living there also, as was Hubert Robert (1733–1808), the French landscapist, and Giovanni Battista Piranesi (1720–78), the great Venetian archaeological fanta-sist and engraver. Two generations later, Rome's reputation remained intact – for Thorvaldsen, the Danish sculptor; for the expatriate Russian painters, Briullov and Ivanov; and for the Viennese Over-beck and his fellow Nazarenes. But revolutions and wars had left their mark. And so powerful had the myth of Free America become, that devotees of Thorvaldsen claimed American descent for their sculptor hero-figure, from the first Norseman born on those shores.[2]

Central to America's magnetism was personal freedom. Another strong attraction was its money. America's long-preserved neutrality in the Continental wars had served it well, bringing unprecedented growth to the carrying trades once dominated by European seafarers like the Dutch. Thus while North America's exports – chiefly of cotton to Lancashire – more than doubled in the decade after 1793, its re-export trades – in sugar, in coffee, and in manufactured goods – rose disproportionately in value from barely $500,000 in 1790 to almost $60,000,000 in 1807: an increase of 12,000 per cent.[3] For the well-placed merchants and shipowners of the North Atlantic Rim what resulted were extraordinary profits. But more significant in the long term for the nation as a whole was a doubling of the size of the Republic. Louisiana, formerly French, had been ceded to Spain at the Treaty of Paris in 1763. Yet so destabilized was the Spanish monarchy by the Revolutionary Wars that it was unable to prevent Napoleon raising money for his armies by selling Louisiana to the Americans. President Jefferson's Louisiana Purchase of 1803 – which included the port of New Orleans, at the mouth of the Mississippi, and the Great Plains west to the Rocky Mountains – realized an old aspiration. In 1786, soon after Independence, Jefferson had predicted that 'our confederacy must be viewed as the nest from which all America, North and South, is to be peopled . . . (But first) the navigation of the Mississippi we must have.'[4] And while, in practice, Anglo-Saxon colonization never extended south of the Mexican border, the Louisiana Purchase opened the Caribbean Islands and Latin America to northern trade; it freed the Great Plains for settlement from the East; and it contributed to a more-than-doubling of the Republic's population, from under four millions in 1790 to well over eight millions in 1814: a harbinger of greater things to come.

America's boom, already compromised five years earlier by the self-imposed Trade Embargo of 22 December 1807, ended abruptly in 1812 on the outbreak of the Anglo-American War. However, neither side emerged the victor at the Treaty of Ghent (24 December

1814). And what resulted more importantly was a shared determination to avoid open warfare in the future. Industrialized Britain needed American cotton for its mills and the trans-Atlantic market for its goods and manufactures. And the Americans for their part, having successfully defended their independence for a second time, brimmed over with new confidence, so that when 'after the termination of that war, it became the manifest destiny of the United States to surpass all the nations of the earth in Art as in everything else, they set about doing something to justify the boast they were so fond of proclaiming'.[5] Washington's public buildings – the President's House, the War Office, the Capitol, and the Treasury – had been torched by British raiders on 24 August 1814. It was the federal capital that rose anew in the post-raid generation as a model Neoclassical city.

Jefferson's architect at Washington before the war had been Benjamin Latrobe (1764–1820), appointed Surveyor of Public Buildings in 1803. Latrobe – by his own admission 'a bigoted Greek' – had practised independently in England for a number of years before taking ship for North America in 1796. And he brought with him the professionalism which even the most travelled Americans, including Jefferson himself, had characteristically lacked until that date. It was Jefferson and Latrobe, with Pierre Charles L'Enfant (1754–1825), the French military engineer, who first gave Washington its plan. And while much of their work was destroyed in the raid, there was never any question after 1814 of the style to be adopted in the rebuilding. 'I think', Jefferson had told Latrobe just before the war began, 'that the work [on the Capitol] when finished will be a durable and honourable monument to our infant republic, and will bear favourable comparison with the remains of the same kind of the ancient republics of Greece and Rome'. In Jefferson's rhetoric, the Capitol was to be 'the first temple dedicated to the sovereignty of the people, embellishing with Athenian taste the course of a nation (but) looking far beyond the range of Athenian destinies'.[6]

'An American', pronounced James Fergusson, the mid-Victorian London critic, 'has a great deal too much to do, and is always in too great a hurry to do it, ever to submit to the long patient study and discipline requisite to master any one style of Architecture completely.' But even Fergusson had to admit that Washington's new Capitol 'would be a respectable building anywhere', while obliged to acknowledge that its 'elegant Classical formality' – the continuing inspiration of public buildings throughout America – was 'far more appropriate to a city designed [like Washington] after the fashion of a chess-board' than the 'rude, irregular Medievalism' of the Smithsonian.[7] For Fergusson, the self-styled evangelist of 'common sense' in architecture, 'Copyism' was the principal enemy. Yet in 1862, when he published his *History of the Modern Styles of Architecture*, the Capitol was even then being finished off with an iron-framed dome of Roman Baroque design, for which the engineering had been borrowed from St Petersburg. Thomas Ustick Walter (1804–87), the architect of that dome, had earlier built in the Gothic, the Neo-Egyptian, and the Greek Revival styles. And in Walter's time, such eclecticism was rather the rule than the exception. But, argued Fergusson, 'whatever faults we (Europeans) have committed in this respect, the Americans have exaggerated them, and the disappointing part is that they do not evince the least tendency to shake off our errors in copying, which, in a new and free country, they might easily have done.'[8]

While perhaps true at the time, Fergusson's criticisms were soon overtaken by events. Walter finished his Capitol dome in 1865. And it was on 26 May that same year that the American Civil War (1861–5), in which over 600,000 men had lost their lives, ended on the surrender of the last Confederate army near New Orleans. Reconstruction in the South took more than a decade. Yet America's Industrial Revolution, already under way before the war began, was again proceeding briskly by the late 1870s, led by a second railroad boom. In 1861, there had been some 35,000 miles of rail track in North America. Four decades later, that total had risen to 193,000

– or more than the whole of Western Europe put together. With a population exceeding 91 millions in 1910, North America was by far the largest market in the Western Hemisphere. And by 1914, not only had the United States overtaken the other major industrialized nations – Britain, France and Germany – in coal and steel production, but it was already the world leader in the manufacture of motor vehicles, in the supply of electricity, and in the extraction and refining of petroleum.

Much of the new wealth of *fin de siècle* America – the 'Billion Dollar Country' of the racketeering 1890s[9] – was in steel and its associated industries. In the 1850s, the invention of the Bessemer Converter Process had made large-scale steel manufacture economic for the first time. And steel production rose quickly after the Civil War, from just 77,000 tons in 1870 to well over 28,000,000 tons in 1910.[10] Initially, most of that steel was absorbed in railroad-building. But other customers entered the market as prices fell, among them the developers of city-centre sites, under pressure to make the most of their plots. 'The elevator doubled the height of the office building', wrote a contemporary critic in 1899, 'and the steel frame doubled it again.'[11] In 1851, it had been Elisha Otis's invention of the ratchet-controlled Otis Safety Elevator that started the revolution. Forty years later, it was the Chicago architect, Louis Henry Sullivan (1856–1924), who 'invented' the all-American steel-framed skyscraper. Sullivan himself tells the tale:

> Chicago activity in erecting high buildings finally attracted the attention of the local sales managers of Eastern rolling mills; and their engineers were set at work. The mills for some time past had been rolling those structural shapes that had long been in use for bridge work. Their own ground work thus was prepared. It was a matter of vision in salesmanship based upon engineering imagination and technique. Thus the idea of a steel frame which should carry all the load was tentatively presented to Chicago architects ... The need was there, the

capacity to satisfy was there . . . Then came the flash of imagination which saw the single thing. The trick was turned; and there swiftly came into being something new under the sun.[12]

Sullivan had already used the same prophetic imagery (cf. *Ecclesiastes* 1:9) in a mould-breaking essay on *The Tall Office Building Artistically Considered*, published in 1896. And it was there that he first coined the famous aphorism 'form follows function', which became a defining text of the Modernist Movement, and which dogged him for the rest of his life.[13] Functionalism and ornament are not usually compatible. Yet Sullivan believed in them both. He had written in 1896 of the tall office building as 'a proud and soaring thing'; and he never lost sight of client hubris. In Sullivan's tall office building – as defined in that essay – the ground floor (over a service basement) housed shops and banks; the larger general offices (reached by stair) were situated on the first floor; above (served by elevator) were 'an indefinite number of stories of offices piled tier upon tier, one tier just like another tier, one office just like the other offices'.[14] In the 1890s, the first skyscrapers of that plan were incontestably American; they epitomized the confidence of a new imperial power; and they promised a memorial, dear to Sullivan's clients, to business ability and commercial success. Such projects commanded ample funds. And Sullivan's acknowledged masterpieces – his Wainwright Building (St Louis, 1890–1), his Guaranty Building (Buffalo, 1894–6), and even the minimalist Carson Pirie Scott Store (Chicago, 1898–1904) – were never less than works of art in their own right.

Sullivan was ahead of his time. In the next generation, his pupils Irving John Gill (1870–1936) and Frank Lloyd Wright (1869–1959) were to raise Modernism to a fashionable cause. However, Sullivan himself built little of importance after 1900. And the 'American Renaissance' of the 1890s and 1900s was led not by Modernists of the Chicago School but by a New York firm of architects, McKim, Mead & White, ready to build in whatever style the client chose. It was of architecture such as theirs that Louis Sullivan wrote

dismissively: 'We have Tudor for colleges and residences; Roman for banks and railway stations and libraries, or Greek if you like ... We have French, English and Italian Gothic, Classic and Renaissance for churches ... Residences we offer in Italian or Louis Quinze.' Yet few Americans shared Sullivan's loathing of the 'bogus antique', and fewer still could have agreed with the Chicago master's verdict that 'Architecture (in America) is dead'.[15] Quite the contrary, they would have argued, for while the major buildings of McKim, Mead & White made little claim to be original, they were as good as any in the West. Charles McKim (1847–1909), who had studied architecture in Paris at the École des Beaux-Arts, borrowed the design of his much-admired Boston Public Library (1887–95) from the Bibliothèque Ste-Geneviève (1838–50) of Henri Labrouste. With Stanford White (1853–1906) and William Mead (1846–1928), McKim designed New York's huge Pennsylvania Station (1902–11) in the Classical style; their University Club (1899–1900) was Florentine Renaissance; their New York Municipal Building (completed in 1908) was Classical again, as was their Knickerbocker Trust Building of 1904.

Prominent among the younger architects trained by the firm was Cass Gilbert (1859–1934), originally from St Paul (Minnesota). And it was in the foyers and staircase halls of such monumental projects as Gilbert's Woolworth Building (1911–13) in New York – a Neo-Gothic skyscraper taller than any other of its time – that fresh opportunities arose for public art. Murals of *Labour* and *Commerce*, by Carl Paul Jennewine (1890–1978), decorated the cathedral-like spaces of the Woolworth Building. At Gilbert's Beaux-Arts US Custom House (1899–1906), there were marble sculptures of *The Continents* by Daniel Chester French (1850–1931). French was the sculptor also of a big *Progress of the State* for the Minnesota State Capitol (1895–1903), another Gilbert building. And it was French again who created the bronze doors of McKim's Boston Library, to which other major American artists – among them the sculptor, Augustus Saint-Gaudens (1848–1907), and the painters, Edwin

Austin Abbey (1852–1911) and John Singer Sargent (1856–1925) – each contributed works of their own.

It was in 1893, as the Boston Library neared completion, that Charles McKim brought off the greatest artistic coup of his career. When first approached for a contribution to the Boston project two years earlier, Pierre-Cécile Puvis de Chavannes (1824–98), the Parisian decorative artist, had already begun his huge ceiling-painting of *Victor Hugo Offering his Lyre to the City of Paris* (1891–4) for the Staircase of Honour at the Hôtel de Ville. And it was Puvis's declared intention, when that ceiling was done, 'to enjoy a rest . . . enlivened by work on a number of (easel) pictures in which I can indulge my imagination'.[16] Those pictures, in the event, were never painted. McKim's proffered fee of 250,000 francs for the Boston panels was far higher than any other payment the artist had yet received, being almost three times as much as he had only recently accepted for *Victor Hugo Offering his Lyre*. The other terms were equally attractive. No deadline was imposed, and Puvis was free to handle as he liked the nine big paintings – of *History* and *Philosophy, Astronomy, Chemistry* and *Physics, Virgil, Aeschylus, Homer*, and *The Inspiring Muses* – designed for the main staircase hall. The Boston offer was irresistible, and Puvis signed.

McKim's pursuit of the famous Frenchman, whatever it might cost, is proof of the unease still felt by many Americans about parity between the Old World and the New. And America's foremost collectors – among them John Pierpont Morgan (d.1913), the banking and railroad mogul, and Isabella Stewart Gardner (d.1924), the Boston millionairess – quite commonly felt the same, relying on the advice of overseas experts (whether dealers, scholars, or practising artists), and making regular shopping trips abroad for Old Masters. However, even that hesitation was beginning to disappear before 1900, as American artists found customers in the boom. When James Bryce, the British historian and political scientist, first published his well-received study of *The American Commonwealth* in 1888, he could still take the view that Americans were too busy making

money to have time left over for the arts: 'life (in America) is that of the squirrel in his revolving cage, never still even when it does not seem to change'.[17] But just seventeen years later, in a characteristically perceptive essay on 'America Revisited – Changes of a Quarter Century' (*Outlook*, 1905), Bryce reported differently, noting that while 'industrial growth, swift thirty or forty years ago, advances (even) more swiftly now ... the love of poetry and the love of art are more widely diffused in America than ever before'. 'Business is king', Bryce continued, yet 'one finds a far greater number of good pictures in private houses than could have been seen thirty years ago, and the building up of public art galleries has occupied much of the thought and skill of leading citizens as well as required the expenditure of vast sums.'[18]

That metamorphosis was owed chiefly to the 'prodigious material development' of the North American economy, where 'every class seems rich compared with the corresponding class in the Old World', and where 'the huge fortunes, the fortunes of those whose income reaches or exceeds a million dollars a year, are far more numerous than in any other country'.[19] Followers of the arts had seen it happen. Henry Adams (1838–1918) – Washington-watcher, descendant of two Presidents, and author of the quirkily autobiographical *The Education of Henry Adams* (1907) – belonged to what he called 'the generation of 1870'. And it was Adams's belief that the American artists of his day, in contrast to their fathers of 'the generation of 1840', had begun to make 'more figure, not in proportion to public wealth or in the census, but in their own self-assertion'. Of his immediate contemporaries and personal friends, the novelist Henry James (1843–1916), the late architect Henry Hobson Richardson (1838–82), and the painter John La Farge (1835–1910) had each been outstandingly successful. And 'from their school had sprung others, like Augustus St Gaudens, (Charles) McKim, Stanford White, and scores born in the forties, who counted as force even in the mental inertia of sixty or eighty million people'.[20]

It was the soaring aspirations of the Industrial Revolution's

'Robber Barons' – of Morgan and Carnegie, Rockefeller and Guggenheim, Huntington, Vanderbilt and Frick – that turned America into a nation of collectors. 'The American', complained Adams of his profligate countrymen, 'wasted money [in the 1890s] more recklessly than anyone ever did before; he spent more to less purpose than any extravagant court aristocracy; he had no sense of relative values, and knew not what to do with his money when he got it, except use it to make more, or throw it away.'[21] But what resulted was a revolution in the arts. Until that time, good quality art had been rare in America. And ambitious young painters – among them Mary Cassatt (1844–1926), the talented Pennsylvanian – had had to go abroad for inspiration. Yet the art galleries of America were to fill to overflowing in Cassatt's own lifetime with the *in memoriam* benefactions of millionaires. Unencumbered by the dynastic baggage of Old World aristocracies, America's super-rich were free to dedicate their great collections to the education of their countrymen and the public good. 'All the pictures privately bought by rich Americans', predicted Mary Cassatt in 1911, 'will eventually find their way into public collections and (will) enrich the nation and the national taste'.[22] And that was already beginning to happen as she wrote.

Cassatt had left Philadelphia for France in 1865. She had lived four years in Paris, and had then continued her studies in Italy, Spain and the Netherlands, before returning to Paris in 1874 to make it her permanent home. Befriended by Edgar Degas, Cassatt exhibited with the Impressionists from 1879. But while clearly influenced by their style, Cassatt (the rich *Américaine*) gave at least as much back to her Impressionist friends by introducing their work to American collectors, long before its full acceptance in their homeland. 'It has been one of the chief pleasures of my life', Cassatt told a wealthy Boston collector in 1909, 'to help fine things across the Atlantic'. Other millionaire collectors she had advised were the Popes and the Whittemores (in iron), the Sears and the Palmers (in real estate), the Stillmans (in banking), and the Havemeyers (in

sugar). And it was chiefly due to her endorsement – and to that of the Paris and New York dealer, Paul Durand-Ruel – that the work of the Impressionists sold so briskly to rich Americans. On 16 January 1894 in a single buying spree, Cassatt's close friends the Havemeyers (Louisine and Henry) bought three Degases and three Monets, a Manet and a Sisley, a Corot, a Delacroix and a colour print by Cassatt herself: all from Durand-Ruel. And it was following another American shopping trip later that same year that Camille Pissarro re-told the tale of a wealthy Cleveland iron magnate – also Cassatt's friend – who had come to Paris specifically for a Manet:

> I met Vollard [the dealer] in Paris; he told me the story of this American [Alfred Pope] who came to Paris to find a beautiful Manet and was willing to pay any price if the painting met his expectations. All the dealers were exhausted from continual searching in every corner for the pearl. Finally this nabob purchased the *Woman with Guitar* from Durand-Ruel for 75,000 francs [$12,000]. Amazement far and wide![23]

That 'amazement', in Pissarro's case, owed something at least to jealousy. However, Pissarro's own Paris cityscapes were beginning to sell much better. And so quickly were prices rising in *Belle Époque* France that Louisine Havemeyer had to pay the extraordinary sum of 478,000 francs – a record price for the work of a living artist – for Degas's *Dancers Practising at the Bar*, which she bought in 1912 in Henry's memory. By that time, many of the best Impressionist paintings had already crossed the Atlantic, and the Havemeyers' collection of modern French art would have been difficult to match anywhere in Europe. Between them, they had collected sixty-five Degases, twenty-five Manets, thirty Monets, and six Pissarros; they had bought forty-one Courbets, twenty-five Corots, and thirteen Cézannes, along with some important Old Masters.[24] Yet in 1929, when the H.O. Havemeyer Collection came to the Metropolitan Museum of Art on Louisine's death, it was far from the first such benefaction. Half-a-century earlier, at the opening in 1880 of the

Metropolitan's new galleries in Central Park (New York), the developer Joseph Choate, one of the Museum's founders, had spelled out its populist mission. Fine art, Choate predicted, 'would tend directly to humanize, to educate, and refine a practical and laborious people'.[25] To that end, New York's assembled *glitterati* and Choate's fellow millionaires were urged to 'convert pork into porcelain, grain and produce into priceless pottery, the rude ores of commerce into sculptured marble, and railroad shares and mining stocks ... into the glorified canvases of the world's masters, that shall adorn these walls for centuries'.[26] And many of them followed Choate's advice.

In 1880, when he made that appeal, American art was still low on Choate's agenda. And it was not until early in the next century that the Metropolitan's trustees took their own native artists sufficiently seriously to dedicate an entire gallery to their work. But the painters themselves shared the blame. Thomas Eakins (1844–1916) and Winslow Homer (1836–1910), America's most talented Realists, had both studied in Paris as young men. And when Homer in mid-career felt the need for inspiration, he left America for England in 1881, to live among the artists and fisherfolk of Cullercoats.[27] Twenty months later, on returning to New York, Homer's style had moved closer to mainstream European art. And neither artists nor collectors in *fin-de-siècle* America were yet ready to take positions of their own. It was Mary Cassatt, heartened by the more enthusiastic reception of her colour prints in Paris, who remarked in 1891: 'Of course, it is more flattering from an Art point of view than if they sold in America'. Even so, she admitted, 'I am still very much disappointed that my compatriots have so little liking for any of my work.'[28] And it remained difficult for an American – even for one as well-travelled as the patrician Henry Adams – to see the two continents on equal terms. In February 1891, when Adams crossed the Atlantic on the *Teutonic* ('an ocean steamer of the new type'), he found the whole experience a revelation: 'the *Teutonic* was a marvel. That he (Adams) should be able to eat his dinner through a week of howling winter gales was a miracle. That he

should have a deck stateroom, with fresh air, and read all night, if he chose, by electric light, was matter for more wonder than life had yet supplied, in its old forms.' Most of all, however, Adams had welcomed the company of the great Anglo-Indian writer, Rudyard Kipling (d.1936), to whom he had secured an introduction from Henry James. 'Fate was kind on that voyage', Adams remembered a decade later, for Kipling was in sparkling form – an 'exuberant fountain of gaiety and wit'. However, Adams could not avoid the feeling that

> Somehow, somewhere, Kipling [the Englishman] and the American [himself] were not one, but two, and could not be glued together . . . Whatever the defect might be, it was American; it belonged to the type; it lived in the blood . . . All through life one had seen the American on his literary knees to the European; and all through many lives back for some two centuries, one had seen the European snub or patronize the American . . . Kipling neither snubbed nor patronized; he was all gaiety and good-nature; but he would have been first to feel what one meant.[29]

It was Matthew Arnold (d.1888), poet and sage, who had earlier formed the view, while on a lecture tour of North America in 1883–4, that it was because of the absence in their own country of what was 'really beautiful in the arts' that 'American artists live chiefly in Europe' and that 'all Americans of cultivation and wealth visit Europe more and more constantly'. Arnold, the Englishman, clearly placed little value on the great unpeopled landscapes which had inspired successive generations of the Hudson River School: from Thomas Cole (d.1848) to Asher B. Durand (d.1886) and Frederic Church (d.1900). And he was equally unimpressed by the public architecture of America, remarking dismissively that the only American 'architect of genius' was Henry Hobson Richardson, and that 'where the Americans succeed best in their architecture . . . is in their [Shingle Style] villa cottages in wood'.[30] Yet in one regard

at least he was correct. James McNeill Whistler (1834–1903), the most original of the young painters of Adams's 'generation of 1840', left America for good in 1855, to divide his time subsequently between London and Paris. And other major American artists – the sculptor St Gaudens; the painters La Farge and Abbey, Sargent and Cassatt – either crossed to Europe regularly or chose to live there all the time, usually starting off with a year or more in Paris.

Belle Époque Paris – the city that Haussmann built and that the Impressionists painted – owed its peculiar magnetism in the last years of the nineteenth century to two episodes of exceptional prosperity. The first of those booms, beginning at the mid-century, underwrote the boulevard years of Napoleon III's Second Empire (1852–70). The second – coinciding with *Art Nouveau* and shared equally by other Western cities from Brussels to Barcelona, Budapest to Buenos Aires, Vienna to Moscow and Berlin – began no earlier than the mid-1890s and lasted until 1914. In between, there were early signs of recession even before Napoleon III's fall, brought on by excessive government spending and political unrest. The slump had then deepened in the economic downturn following the Franco-Prussian War (1870–1), and continued through a quarter-century of agricultural depression, especially damaging to a nation of peasant farmers. In addition, long-term weaknesses in the French economy, aggravated by an exceptionally slow rate of population growth, continued to frustrate large-scale industrialization, setting the French apart from their neighbours. 'Our habits are economical, prudent, perhaps timid', wrote Victor Cousin (d.1867), the Orleanist philosopher of the *juste milieu*; 'we like to grow moderately rich by small profits, small expenditures, and constant accumulation.'[31] And while such sentiments helped keep the peace by protecting the vested interests (*intérêts acquis*) of the political class, the traditional French model of under-mechanized craft-based workshops and cash-starved family businesses was deeply discouraging to capital investment on the scale that the new industries required. Thus it was only as late as the 1960s that a major restructuring of the Lyonese textile industry

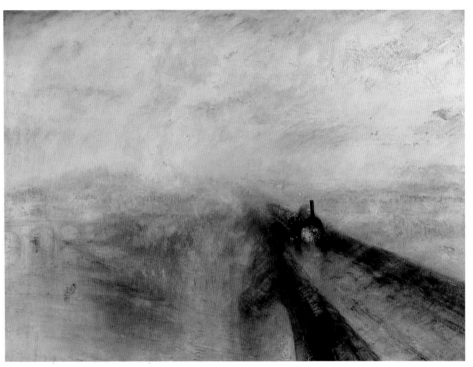

It was the railways that revolutionised transport and made Victorian Britain a land of unprecedented opportunity. While some saw the steam locomotive as a 'new-fangled absurdity', others including Turner felt the romance of the iron road, the old colourist's *Rain, Steam and Speed* (1844) being one of his most powerful and immediate images.

In Karl Ivanovich Rossi (d.1849), Alexander I found a visionary architect skilled in city-planning on a megalomaniacal scale and capable of realising the Tsar's grand design 'to make Petersburg more beautiful than any of the European capitals he had visited'. Rossi's Neoclassical *General Staff Headquarters* (1819–29), with its sweeping concave facade and great central arch, was proof in stone of the might of Russia's armies.

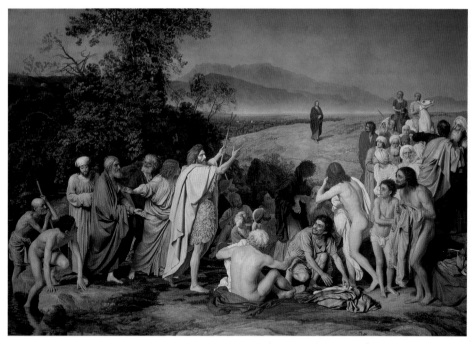

It took Alexander Ivanov twenty years to complete his huge *Christ's First Appearance to the People* (1837–57): a Messianic work which he painted in Rome and then brought to Russia in 1858 to prepare for a spiritual renewal. While not initially well received in his native St Petersburg, the raw religious conviction and radical sympathies of Ivanov's masterpiece have attracted admiration ever since.

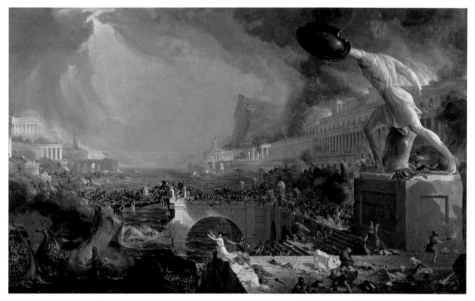

Thomas Cole's *The Destruction of Empire* was the fourth work of his ambitious cycle, *The Course of Empire* (1834–6), painted in warning to his fellow-Americans of the corruption of riches and of the *Desolation* (the title of Cole's fifth painting) into which New York, like Rome itself, would be plunged.

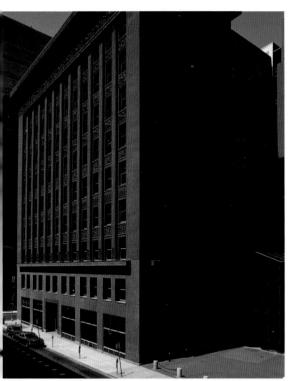

Louis Sullivan's steel-framed Wainwright Building (St Louis, 1890–1) was his first 'tall office building', with services in the basement, shops and banks on the ground floor, general offices on the next, and tiers of individual offices (reached by Otis elevator) above.

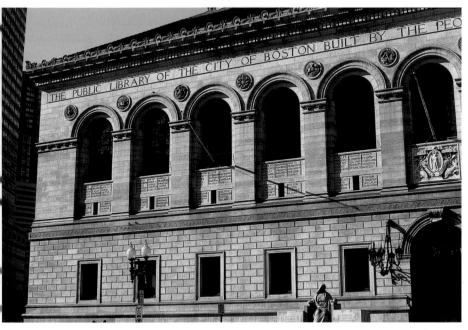

The eclectic architecture of Golden Age America is seen at its 'Roman' best in Charles McKim's Boston Public Library (1887–95), for which Labrouste's *Bibliotèque Ste-Geneviève* (Paris, 1850) was the model. American artists persuaded by McKim to contribute work to the Library included the painters Abbey and Sargent, and the sculptors Saint-Gaudens and French.

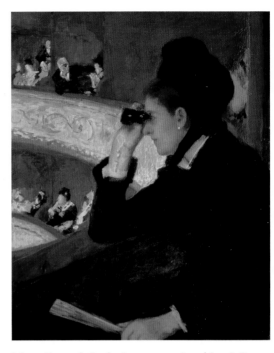

Physics is one of the nine big canvases McKim commissioned from the French muralist Puvis de Chavannes (d. 1898) for the staircase hall of the Boston Public Library.

Mary Cassatt's *In the Loge* was painted in 1878, the year before she began exhibiting with the Impressionists. Cassatt – 'the most eminent of all living American women painters' (1909) – was resident in Paris throughout the *Belle Époque*.

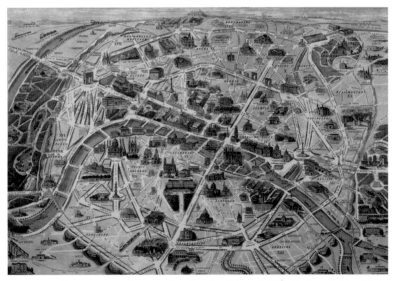

Baron Haussmann's master-stroke was the circular *Place de l'Étoile* (top left) with its radiating boulevards, mapped here while the rebuilding of Paris was in progress. Another important objective of the planners was to link Paris's major railway terminals, as France's state-subsidised rail network, initially slow to spread, developed at a furious pace.

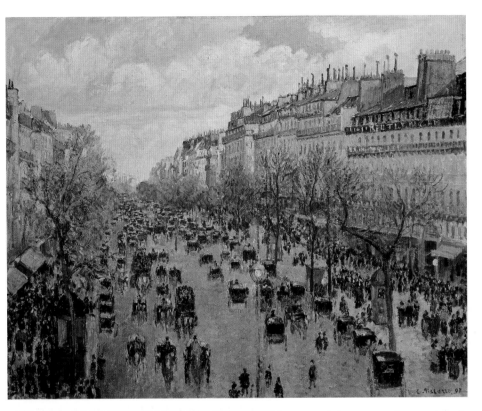

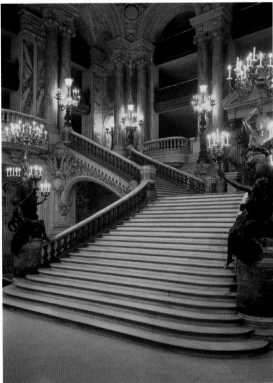

ABOVE 'I have started my series of *Boulevards*', wrote Camille Pissarro early in 1897. And his *Boulevard Montmartre* was one of many Impressionist street-life paintings, capturing the busy regularity of *fin-de-siècle* Paris as Haussmann had always intended it.

LEFT Garnier's Grand Staircase at the *Opéra* (Paris, 1861–75) exemplifies his *Beaux-Arts* style, also known as '*le style Napoléon III*'. Taking its name from the *École des Beaux-Arts*, the style drew on the eclectic scholarship of prize-winning architects who had travelled widely in Italy and Greece.

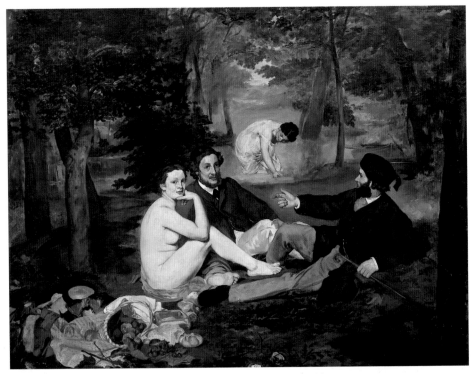

Manet's *Le Déjeuner sur l'herbe*, when shown at Napoleon III's *Salon des Refusés* in 1863, caused an instant sensation, both on account of its innovative technique (Manet's flat colours and distinctive brushwork) and of its controversial politics – a re-working in modern dress, thought to be critical of Second Empire morals, of Titian's *Fête Champêtre* at the Louvre.

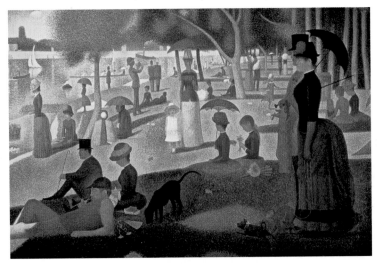

While similarly criticised for its radical social commentary, Georges Seurat's pointillist *Un Dimanche à la Grand-Jatte*, shown at the last Impressionist Exhibition in 1886, had many admirers among his peers, giving him temporary leadership of the Parisian *avant-garde* until challenged by the Synthetism of Gauguin.

Engravings of John Everett Millais's *The North-West Passage* (1874) – picturing 'a brave old sea-dog … stranded on the sands of life' – sold in their thousands in Victorian Britain, helping to bring this fashionable painter (a leading Pre-Raphaelite in his youth) a considerable and ever-growing fortune.

Painted long after the event, Anton von Werner's *A Billet outside Paris 1870* (1894) is a re-working of an episode in the Franco-Prussian War which he had witnessed himself on campaign. While such patriotic subjects continued to be popular in *fin-de-siècle* Germany, Werner lived to see his painstaking Realism come under Modernist attack, and died embittered by the success of the Expressionists.

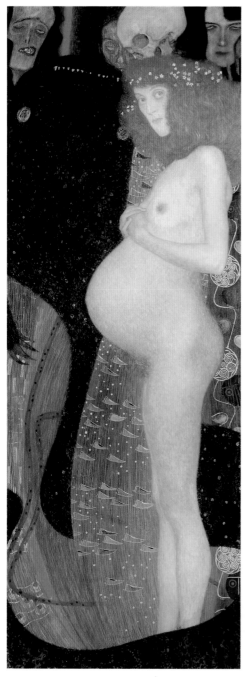

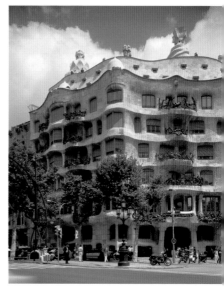

The curvilinear *Modernisme* of Gaudí's *Casa Milà* (Barcelona, 1906–10) was the architect's personal response to the stimulus of the Catalan *Renaixença*.

Gustav Klimt, first president of the Vienna Secession from 1897, painted his *Hope I* (1903) after his conversion to Symbolism.

In *Cain* (1917), Lovis Corinth painted the fratricidal rivalry of the First World War, evoking the anguish – 'What hast thou done?' (Genesis iv:10) – of the Lord.

enabled it to compete globally in the market for fine silks. And it was characteristic of commercial attitudes throughout the nineteenth century that even a huge new department store like the Bon Marché in Paris, founded in 1869, functioned less as a distributor of mass-produced goods – as was soon to be the case with its American equivalents – than as a central sales outlet for the high-quality craft products of the *fabriques collectives*: the silk weavers of Lyon, the ribbon-makers of Saint-Étienne, and so on.[32]

'The Napoleonic idea', wrote the young Louis Napoleon Bonaparte in 1839, 'is not an idea of war, but a social, industrial, commercial and humanitarian idea'.[33] And it was that more acceptable face of Bonapartism that Louis Napoleon began to show from December 1848, when elected President of the Second Republic. Four years later, Napoleon III's proclamation as Emperor in 1852 enabled him to throw the whole weight of his office behind modernization, starting with expansion of the railways. France's railway system, following years of indecision by the Orleanist regime, grew rapidly under Louis Napoleon from just 3000 kilometres in 1850 to almost 18,000 kilometres in 1870. And it was Paris, as the central hub of the entire French railway network, that gained the most benefit from that expansion. Right from the start, as Charles Merruau remembered:

> Individuals who had access to him [Louis Napoleon] often found him pencilling lines on a map of Paris. He paid special attention to the railway terminals as points of departure for what he planned; he saw them as the real approaches to the city instead of the old *barrières* which, though they led to the national highways, would in his opinion eventually become secondary lines of communication. That is why it was of major importance to him to link these new terminals in such a way that the traffic flow between individual stations and hence between the various regions of France could proceed promptly and efficiently through their common centre. It also seemed

indispensable to him that broad arteries should lead from these
terminals directly to the centre of the metropolis.[34]

Merruau, General Secretary of the Seine Prefecture during the Prince-
President's term, left office in 1852. And when Baron Haussmann
(1809–91) took the oath as Prefect on 29 June 1853, the Emperor
had a working map of Paris already spread before him, on which
he had 'marked in blue, red, or green, depending on their priority,
the various new streets whose construction he suggested'.[35] Louis
Napoleon's first ambition had been to complete his uncle's Rue de
Rivoli (1849–56): the east-west axis begun by Napoleon I. However,
it was in the creation of a new north-south axis – *'le projet du
Boulevard de Sébastopol'* (1855–8) – that the Emperor and his Prefect
made their most significant contribution to the modernization of
the city, driving a broad thoroughfare through the heart of Old
Paris to link the northern railway terminals (Gare de l'Est, Gare
du Nord and Gare St-Lazare) with the three mainline stations to
the south and east (Gare Montparnasse, Gare d'Austerlitz and Gare
de Lyon) in what came to be known as 'la Grande Croisée de
Paris'.[36]

Much later, Haussmann would argue that it was the coming of
the railways that had been the 'principal and effective cause' of
Paris's mid-century expansion.[37] And it is probably true that had it
not been for the superior economy and speed of the new transport
system, Haussmann's larger ambitions for the transformation of the
capital would have foundered on political opposition. As it was,
critics gathered on every side. With France's population barely ris-
ing, Paris's more than 40 per cent increase in the two decades of
the Empire was so at odds with the condition of other parts of the
country that it was widely perceived as a threat. 'The extraordinary
stimulus given to building by the creation of immense projects in
the centre of Paris has depopulated the countryside', wrote a worried
sub-prefect of Seine-et-Marne as early as 1853.[38] And Paris in 1870
would be a city of two millions: bigger and more beautiful than it

had ever been before, but also more socially divided. 'The trans-
formation of Paris', wrote Anthime Corbon in 1863, 'has evicted
the working population from the centre to the periphery, so that two
cities have developed within the capital: one rich, the other poor;
the one encircling the other'.[39] And that diaspora had begun more
than a decade before: when loans were cheap, when the army was
sent back to its barracks again, and when 'troops of masons, carpen-
ters, and other artisans rushed to various building sites' in the city:

> Eventually [wrote Merruau] we witnessed the important period
> in which large projects were carried out under the adminis-
> tration of M. Haussmann, which transformed the capital and
> made it healthier and bigger. But if one asks what was the
> cost of all these good deeds, the answer is that the nation
> sacrificed its freedom and accepted Caesarism.[40]

And so indeed it had. But the next and larger costs, following
Haussmann's dismissal and Napoleon III's fall, were the Siege of
Paris, the Prussian Occupation, and the internecine blood-bath of
the Commune (18 March–28 May 1871).

'It must be said', wrote another of the Prefect's critics in 1865, 'that
what are called the embellishments of Paris are basically nothing
but a general system of offensive and defensive armament against
uprising, a precaution taken against future revolutions'.[41] And
Haussmann's ample boulevards and die-straight avenues (Avenue
des Champs-Élysées, Boulevard Magenta, Boulevard Diderot etc.),
feeding strategically into his *places rayonnantes* (Place de l'Étoile,
Place de la République, Place de la Nation), were indeed better
suited to control by artillery – to Carlyle's 'whiff of grapeshot' –
than the labyrinthine streets of Old Paris. Yet, wrote Haussmann
later, 'in putting in the boulevard de Strasbourg and extending it
to the Seine and beyond, I am certain that the Emperor did not
have its strategic usefulness in mind'.[42] And Louis Napoleon's fixed
determination 'to rebuild the capital of capitals' was always less
military than utopian. Included in the new works were modern

public services: street-lighting, underground sewers, and piped water. Pavements were levelled; obtrusive signs were taken down; houses were repaired and their façades were cleaned; 100,000 trees were planted; and the new boulevards were furnished with benches and kiosks, and with the ubiquitous street urinals (*vespasiennes*).[43] While in exile in London in 1846–8, Louis Napoleon had learnt to love its spreading parks and shaded squares. And London would be his model for a new and healthier Paris: for the city-centre's public gardens (Jardin du Luxembourg, Jardin des Tuileries, Jardins du Trocadéro, Jardin des Champs Élysées etc.), and for the lakes and recreational woodlands (Bois de Boulogne, Bois de Vincennes) on the periphery.[44]

Haussmann liked to describe himself as an *artiste démolisseur*. He favoured regularity in building – in street façades especially; but otherwise showed little feeling for the finer points of architecture, his background being in finance and the law. Second Empire Paris, in consequence, would have much less to offer in the way of memorable public buildings than the *Art Nouveau* designer capital of Héctor Guimard (1867–1942) and Jules Lavirotte (1864–1924), of Frantz Jourdain (1847–1935), Frédéric Sauvage (1873–1932) and the Maison Bing. Yet there were two important projects – the Halles Centrales (Central Market) by Victor Baltard (1805–74) and the Paris Opéra of Charles Garnier (1825–1898) – which contemporaries immediately recognized as emblematic of the Empire, and to which Louis Napoleon gave a great deal of time. His interventions in each case were decisive. Thus it was because Haussmann knew the Emperor's mind that he was able to warn his old friend Victor Baltard – whose stone-built Market ('*le fort des Halles*') had been begun in 1851 but discontinued – that only 'Iron! iron! nothing but iron!' would now do for the three streets and ten pavilions of the new Halles Centrales (1853–66).[45] And Garnier's mighty Opéra (1861–75) – by far the largest of its day – became critically important, in the last imperial decade, to Louis Napoleon's *politique de grandeur*. Part-Classical, part-Renaissance, part-Baroque and part-Rococo, Garnier's eclectic

opera-house has since been seen as the apotheosis of '*le style Napoléon III*'. It also provided rich commissions for Garnier's artist friends: for Paul Baudry (1828–86), the academic painter, who had studied with Garnier in Italy in the early 1850s, and for Jean-Baptiste Carpeaux (1827–75), another close friend, whose voluptuous *La Danse*, one of four great sculptural groups on the façade, was condemned by the regime's opponents on first unveiling, as further evidence of moral turpitude and decline. Neither Baudry nor Carpeaux are much remembered today. And Garnier's Opéra, while copied many times, was criticized from the beginning for its extravagance. Haussmann's Paris, in contrast, was a masterpiece. '*L'art est là*', wrote the novelist, Emile Zola (1840–1902): '*Un art vivant . . . autour de nous.*'[46] And nobody has subsequently disagreed.

Zola's art-criticism was not always as reliable, for his agenda was too often political.[47] Nevertheless, as the close friend and former schoolfellow of Paul Cézanne (1839–1906), Zola met every major painter of the 1860s *avant-garde*: Camille Pissarro (1830–1903) and Édouard Manet (1832–83), Edgar Degas (1834–1917) and Alfred Sisley (1839–99), Claude Monet (1840–1926), Pierre-Auguste Renoir (1841–1919) and Frédéric Bazille (1841–70). The opportunities for young talent were exceptional. In 1863, by order of the Emperor, a new Salon des Refusés was established for works rejected by the jurors of the Académie des Beaux-Arts. And Zola and his associates took advantage of the times to introduce their fellow countrymen to other ways of looking at the arts. Manet and Pissarro, Whistler, Johann Jongkind (the Dutch Impressionist, 1819–91), and Henri Fantin-Latour (1836–1904), all showed paintings at the 1863 Salon des Refusés. And it was the critics' hostile reception of Manet's *Le déjeuner sur l'herbe* (1863) that provoked Zola to mount his own robust defence of his *avant-garde* friends, ridiculing in turn the tactile nudes and '*tout le bric-à-brac de l'historie et de la mythologie*' of popular academicians like Jean Leon Gérôme (1824–1904) and William-Adolphe Bouguereau (1825–1905), history-painters in the grand French tradition.

It was in the mid-1860s that Monet and Renoir, while still in their twenties, began to paint the ambitious canvases, including Monet's own huge version of *Le déjeuner sur l'herbe* (1866), with which they hoped to win public recognition.[48] And in the few years that remained of Louis Napoleon's Second Empire, nothing stood in their way. 'Despite the prejudices of the administration, despite the hostility of the École, despite the opposition of the juries, Naturalism has won out on all fronts. Religion is dead, History is dead, Mythology is dead!', trumpeted the radical Jules-Antoine Castagnary in 1867.[49] And even a prominent establishment figure like the highly-regarded poet-critic, Théophile Gautier (1811–72), President of the Société Nationale des Beaux-Arts, had begun to wonder, before the decade's end, whether 'one can truly understand anything in art other than the works of one's own generation, that is to say, those with whom one was twenty years old'. Writing in 1868, Gautier had conceded that 'it is probable that the pictures of Courbet, Manet, Monet, and *tutti quanti* contain beauties apparent to young people in short jackets and top hats, but which escape the rest of us, our old Romantic manes already streaked with threads of silver.'[50] But the public mood was hardening against experiment in the arts, and Gautier's concession was premature. When Gustave Courbet showed his work at Dijon in May 1870, his overtly erotic *The Woman with a Parrot* (1866) – later to be bought by the Havemeyers of New York – was interpreted by a local critic as a sign of the times: of *'la maladie de l'époque'* and *'la séduction du sensualisme et du luxe'*.[51]

Just months later, on 1 September 1870, the Second Empire collapsed at Sedan. And for a decade and more, the association of artistic licence with a discredited regime was deeply damaging to the genre and landscape painters – the Realists, the Impressionists, and the neophytes of Théodore Rousseau (1812–67) of the Barbizon School – who had come to dominate the final *Salons* of the Empire. 'What a ghastly time it was for painting!', reflected the dealer Paul Durand-Ruel in 1910, recalling the failure of an auction of

Impressionist works which he had held at the Hôtel Drouot in 1875: 'The insults which were hurled at us – especially Monet and Renoir! The public howled, and treated us as imbeciles, as people with no sense of decency. Works were sold for as little as 50 francs . . . Without America, I would have been ruined'.[52] But that recognition by American buyers was still a decade off. And until Durand-Ruel's successful New York exhibition in 1886, the Impressionists remained dependent on the support of the *bien-pensant bourgeoisie* – of a doctor and a pastrycook, a manufacturer, an opera-singer, and retired civil servant[53] – none of whom wanted works on the grand scale. Starved of state patronage throughout the 1870s, Monet and Renoir failed to experience the creative boost felt, for example, by the sculptor Auguste Rodin (1840–1917) when commissioned in 1880 to make the giant portal – his unfinished *Gates of Hell* (1880–1900) – for the proposed new Musée des Arts Décoratifs. And for as long as conservative governments of Moral Order stayed in power, official support of the arts continued to be reserved for 'monumental architecture, decorative painting, grand sculpture and classical engraving' (Blanc), where the only arts thought worth rewarding were heroic. 'The time has come', wrote Henri Delaborde *à propos du Salon de 1872*, 'to return to serious thoughts (in the arts), to a moral reform in proportion to our responsibilities and our sufferings'.[54] And that would be the argument also of the Marquis de Chennevières, Charles Blanc's ultra-clerical successor as Director of Fine Arts, throughout the presidency of Marshal Maurice de MacMahon (1873–9). In 1872, national rebirth was the inspiration of the two *Hope* paintings of the establishment artist, Pierre Puvis de Chavannes; Puvis's serene *Summer* (1873) celebrated 'social harmony regained'; his tripartite *The Childhood of Saint Geneviève* (1876–7), patron saint of Paris, hallowed 'the marvellous history of the Christian origins of France'.[55]

Puvis painted his *Saint Geneviève* for De Chennevières's redecoration of the Panthéon. But no monument of the Catholic Revival attracted more attention than the breast-beating Basilique du Sacré-Coeur (1875–1919). Sited spectacularly in the Commune's

Montmartre heartland, and designed in a showy Romano-Byzantine style by the leading cathedral-restorer and ecclesiologist, Paul Abadie (1812–84), the Sacré-Coeur was to be a symbol of Christian penance and renewal. 'The day when France will be solemnly consecrated to the Sacred Heart of Jesus will be for her a day of rebirth', promised the bishop of Constantine in 1873, less than three years after the Prussian victory at Sedan.[56] But a generation would come and go before the Sacré-Coeur was finished. And if one reason for that slow progress was the steadily mounting agricultural crisis in *la France profonde*, another was politicization of the arts. In 1879, the resignation of the monarchist President MacMahon put the republicans back into office. And the return to France soon afterwards of the exiled *communards* and their friends re-ignited the art-political debate. 'Perhaps never before has everyone talked about the fine arts in France as much as during the year 1881', wrote Victor Champier of *L'Année artistique 1881–1882*; 'The legislature, the press, even the public, everyone is preoccupied by the subject with an interest stimulated much less, it is true, by pure artistic sentiment than by political passions.'[57]

In the 1860s, while France still prospered, the association of radical art with left-wing politics was weak. But the Franco-Prussian War, the Monarchist Reaction, and the Great Depression of 1873–96 all helped propel the *avant-garde* into the centre of the political struggle. Camille Pissarro, always the most radical of the Impressionists, openly embraced Anarchism in the mid-1880s, to join such younger left-wing artists as the Neo-Impressionist painter, Paul Signac (1863–1935), whose *In the Time of Harmony* (1895) – an Arcadian vision of self-sufficiency and plenty – would gain currency as an Anarchist manifesto.[58] There is no evidence that Georges Seurat (1859–91), Signac's mentor, was an Anarchist himself. Nevertheless, the smoking factory chimneys behind Seurat's bathing workers in *Une Baignade à Asnières* (1883–4) convey his radical sympathies, while in his huge Pointillist masterpiece, *Un Dimanche à la Grande-Jatte* (1886), the social commentary is undisguised,

castigating the stiff hypocrisy of the *petite bourgeoisie* who promen-
ade with prostitutes on the river-bank.[59]

Seurat's *La Grande-Jatte* was the sensation of the eighth and last
Impressionist Exhibition of 1886. It brought temporary converts to
Pointillism in Pissarro and Signac, and raised Seurat immediately
to the leadership of the Parisian *avant-garde*. But consensus was
now out of the question. Shortly before Seurat's triumph, Gustave
Boulanger, a conservative professor at the École des Beaux-Arts,
had voiced his despair at the loss since the 1860s of a common
language of art, and 'the cult of originality at all costs':

> This so-called novelty crops up, year after year, under such
> pretentious and inappropriate names as naturalism, impression-
> ism, luminarism, intentionism and even *tachisme* – to use the
> slang by which incompetence and laziness are glorified.[60]

Boulanger knew his styles, but his list was already incomplete.
Before Paul Gauguin (1848–1903) left for Tahiti in 1891, he brought
Synthetism to Paris from his Brittany retreat. Paul Sérusier (1863–
1927), the Symbolist art-theorist and founder of the *Nabis* ('prophets'),
had met Gauguin at Pont-Aven and been converted to his views.
And Gauguin's uncompromising repudiation of naturalism, his
strong line, and his unbroken blocks of colour, would be a powerful
influence also on Henri Matisse (1869–1954) and Albert Marquet
(1875–1947), the leaders from 1905 of the *Fauves* ('wild beasts'),
whose other favoured models were late Cézanne (d.1906) and the
works of the great Dutch colourist, Vincent van Gogh (1853–90),
father of modern Expressionism. Both Matisse and Marquet had
been students at the École des Beaux-Arts of the ageing Symbolist
and mythological painter, Gustave Moreau (1826–98), who taught
there from 1892. 'Art', sighed Moreau, 'used to be such a simple
matter for those nurtured and ballasted by its great principles – so
clear to every true intelligence – the scale of originality and aptitude
took shape of its own accord, in proportion to each man's talent or
lack of it.' But what had happened since that time was 'a kind of

aesthetic deformity . . . a hankering after means and material effects that have nothing to do with art . . . (a) modern lunacy'.[61]

'France is now all decadence', pronounced George Moore, the Anglo-Irish critic, in 1893; 'In the Champ de Mars, as in the *Salon*, the man of the hour is he who has invented the last trick in subject or treatment.'[62] But nothing could keep the British away. Alexander Stanhope Forbes (1857–1947), founder of the Newlyn School of Cornish genre painters, learnt both his style and his technique from the sentimental *plein-air* Realist, Jules Bastien-Lepage (1848–84). Moore himself had lived in Paris through most of the 1870s, studying at the École under Boulanger among others, and mixing with the Impressionists at the Café de la Nouvelle-Athènes. And Walter Sickert (1860–1942), who first came to Paris in 1883 with an introduction to Degas, later settled for long periods in Dieppe. Philip Wilson Steer (1860–1942), Sickert's friend and exact contemporary, also trained in Paris in the early 1880s. And the New English Art Club, founded in 1886 as a counterblast to the Royal Academy, was the creation of Paris-trained artists. Three years later, in December 1889, the London Impressionists – led by Sickert and Steer – held their first (and only) exhibition at the Goupil Gallery, in New Bond Street. Degas and Monet were their heroes at the time, and George Moore was one of their supporters. But Paris was moving too fast for them. In the mid-1890s, Steer deserted his French models, returning to Gainsborough, Constable and Turner for inspiration.[63] And Sickert's departure for Dieppe in 1898 left London's would-be radicals without a leader. The New English Art Club had been divided from the beginning between the adherents of Degas and of Bastien-Lepage. And by the time Sickert came back to London in 1905, to head the Camden Town Group just before the Great War, there were other powerful influences to absorb. Paintings by Gauguin, Cézanne and Van Gogh dominated Roger Fry's first Post-Impressionist exhibition of 1910. Matisse was shown in London in 1908; the next year, it was the turn of Wassily Kandinsky (1866–1944), the Russian abstract painter. Simultaneously, Londoners had

the opportunity to see works by the Polish sculptor, Elie Nadelman (1882–1946), and the Paris-based Romanian, Constantin Brancusi (1876–1957), pioneers of Modernism on the Continent.

London's exposure to Modernism, brief though it was, inspired the Vorticist Wyndham Lewis (1882–1957), the Camden Town Group's Spencer Gore (1878–1914), and Bloomsbury's Roger Fry (1866–1934), Duncan Grant (1885–1978) and Vanessa Bell (1879–1961). However, it failed to survive the First World War (1914–18). In part, that was a consequence of the inter-war recession. But as important was the resilience of the so-called 'English School' in painting, highly regarded for its independence and eclecticism. 'In countries where the State and Church have been tyrants over life, property, and thought', claimed a reviewer of the Royal Academy's 1865 Exhibition, 'the arts have been marked by uniformity, even monotony . . . But in lands such as England, where each person has the privilege of thinking as he likes, the artist will naturally paint as he pleases . . . (hence) the English School is as remarkable for its variety as for its vigour.'[64] That individual voice had been acknowledged by French critics since the *Salon* of 1824, when they first discovered Constable as a cloud-painter. At the Paris International Exhibition of 1855, both the medievalizing Pre-Raphaelites (followers of the Nazarenes) and Britain's naturalistic animal-painters – notably Sir Edwin Landseer (1803–73) – attracted general interest and admiration. Nor was it to be expected that mid-Victorian Britain, leading the world in technology and design, would settle easily for second-best in the arts. In 1850, half the world's iron was made in Britain; *per capita* productivity was over 50 per cent higher than in Germany or France; there was three times as much capacity in the cotton-mills of Britain as in all the rest of Western Europe put together.[65] In London at the mid-century, the 'Great Exhibition of the Works of Industry of All Nations' opened on May Day 1851: 'the first morning', boasted *The Times*, 'since the creation of the world that all peoples have assembled from all parts of the world and done a common act'. And 'nothing (was) too stupendous, too

rare, too costly . . . nothing too minute or apparently too insignifi-
cant' to be shown in Sir Joseph Paxton's Crystal Palace.[66] A quarter-
century of prosperity lay ahead.

Among the more popular exhibits at the Crystal Palace in Hyde
Park was the Great Western's thousand-horsepower locomotive,
Lord of the Isles.[67] And steam-power was to be the key to the 'Great
Victorian Boom' in transport, communications, and heavy industry.
Coal output doubled between 1850 and 1875; industrial production
increased by 72 per cent; overseas investment more than trebled;
and global exports rose substantially on free trade.[68] Even agriculture
in Britain – widely predicted to face ruin following the repeal of
the Corn Laws in 1846 – experienced, on the contrary, a last Golden
Age, temporarily saved from foreign competition by wars in the
Crimea (1854–6) and North America (1861–5).[69] Then the whole
process went suddenly into reverse. 'Just as there had been no pre-
vious example of so great an expansion', wrote the economist Robert
Griffin shortly after the Great Crash of 1875, 'there has not since
the free trade period [in the 1840s] been such a decline in our foreign
trade'.[70] Yet for those with the good fortune to have coincided with
the boom, new patterns of wealth-holding had been established.
Personal wealth grew hugely after 1850, there being more million-
aires in London and the provinces than the economy had ever
previously supported.[71] And it was those rich financiers and industri-
alists who, in the building and furnishing of their substantial new
houses, created the demand for modern art. Frederic Stephens
(1828–1907) had been a founder-member of the Pre-Raphaelite
Brotherhood in 1848. And while he gave up painting for art journal-
ism a decade later, Stephens was unusually well-placed to witness
for himself the unfolding of the Pre-Raphaelite phenomenon. 'The
so-called middle-class of England has been that which has done
the most for English art', Stephens told the readers of *The Portfolio*
in 1871; 'While its social superiors "*praised*" Pietro Perugino, neg-
lected Turner, let Wilson starve, and gave as much for a Gaspard
Poussin [pupil of Nicholas] as for a Raphael; the merchant princes

bought of Turner, William Hunt, Holman Hunt, and Rossetti.'[72]

The new men were more comfortable with modern pictures. Earlier in the century, James Morrison (1789–1857), the most successful businessman of his day, had started his collection with the works of living painters – of Wilkie, Constable and Turner. Then he had taken his family on the Grand Tour in 1826–7, and had switched to Old Masters soon afterwards. Morrison died a multi-millionaire. But his first 'brown varnish' painting – *The Rape of Europa* by Claude Lorrain – had cost him a thousand guineas in 1831.[73] And few of the new rich, whether of Morrison's generation or the next, had either the wealth or the connoisseurship to risk such large sums in a market notorious for fakes. Contemporary paintings, of reliable attribution and established market value, offered a more acceptable alternative. 'Nothing is easier', suggested Philip Hamerton in his *Thoughts about Art* (1862), 'than to buy the works of living painters; you go to their own studios, you see them personally, you have ascertained the current prices of their works, and you give them commissions, having settled the three questions of size, and price, and subject. There is little chance of your being deceived . . . But when you lay out money in old masters, no such certainty is possible.'[74] And for the middle-class collector, seeing art as an investment, such common-sense arguments prevailed. 'Almost every day', wrote the Anglo-American history-painter, Charles Leslie (1794–1859), in 1851, 'I hear of some man of fortune, whose name is unknown to me, who is forming a collection of the works of living painters; and they are all either men of business, or who have made fortunes in business and retired.'[75] Just the year before, 'railroad speculators, iron mine men, and grinders from Sheffield, &c., Liverpool and Manchester merchants and traders' had been listed by Thomas Uwins (1782–1857), Keeper of the National Gallery from 1847, as the patrons of modern art, now that 'the old nobility and land proprietors are gone out.'[76]

Prices went on rising. It was already clear, for example, at the great Northwick Sale of 1859 that the late Lord Northwick's finest

Old Masters had sold for little more than his best modern works –
two Maclises, a Mulready, a Leslie and a Webster.[77] And it was the
luck of the Pre-Raphaelites – of William Holman Hunt (1827–1910),
of Dante Gabriel Rossetti (1828–82), and of John Everett Millais
(1829–96) – to make their *début* as aspiring young painters at the
beginning of a quarter-century of rising prices. Equally well-situated
were the mid-Victorian Realists – William Powell Frith (1819–1909),
George Elgar Hicks (1824–1914), and Augustus Egg (1816–63) –
whose faithful representations of middle-class pursuits anticipated
even those of the French. As Philip Hamerton noted in the second
edition of his *Thoughts* (1873):

> During the last twelve years the appreciation of modern pic-
> tures has become so firmly established that even a living artist
> may sell his works for prices equal to those given for old
> canvases of the same quality ... any picture of importance by
> an artist whose name is in repute is worth a thousand pounds,
> whilst exceptionally fine examples of great men easily rise to
> twice or three times that figure.[78]

Back in 1852, Holman Hunt's *The Hireling Shepherd* had sold for
just £315. Yet only eight years later, Ernest Gambart, the London
dealer, was to pay £5,500 for Hunt's *The Finding of the Saviour in
the Temple*; while his *Shadow of Death* would be sold to William
Agnew in 1873 for an unprecedented £11,000.[79]

London's entrepreneurial dealers could risk such large sums on
modern art because of the high anticipated returns on single-picture
exhibitions and on the sale of engravings to the public. Thus when
Louis Flatow commissioned Frith's *The Railway Station* for £4,500
in 1862, he had already seen the popular success of the same painter's
Life at the Seaside (1854) and *Derby Day* (1858), and rightly believed
that he would recoup his investment many times. But while both
the painters and their dealers grew rich on such transactions, it was
the millionaires who had created the market. David Price, a London

wool-merchant, was the buyer of the original version of *The Railway Station*, from which Flatow took the engraving. And there would be copies of Frith's big painting in the collections of a rich Middlesbrough iron-master (Sir Isaac Lowthian Bell) and of a London sherry-importer (Frederick Cosens). In forming such collections, a Newcastle industrialist (James Leathart), a Birkenhead banker (George Rae), and a Liverpool shipowner (Frederick Leyland) were the earliest supporters of the Pre-Raphaelites. Then, after John Ruskin's influential endorsement of the Brotherhood in 1851, other wealthy businessmen invested in their art, attracted especially by the sentimental piety and gorgeous female models of Dante Gabriel Rossetti and Edward Burne-Jones (1833–98), the leaders of Pre-Raphaelitism's second phase.[80]

The move into Aestheticism, in which Rossetti and Burne-Jones were associated with the Arts and Crafts ideology of the designer, William Morris (1834–96), and with the *japonisme* of the expatriate American painter, James McNeill Whistler (d.1903), took them through to the end of the century. And the continuing strength of the London art market after the Great Crash of 1875 is one of many signs of a comparatively soft landing in the Recession. True, cereal prices fell sharply as imports rose; Britain's industrial investment, as a percentage of national expenditure, was only half that of its main competitors in Germany and France; and heavy industry suffered a collapse. Arguably, too, the entrepreneurial drive of Britain's comfortably-off middle classes – in particular of those who had inherited family businesses – had faded well before 1900. Yet agriculture, in an increasingly urbanized society, had long ceased to be the only – or even the principal – employer. And if Britain's manufacturing growth undoubtedly slowed-down in the last quarter of the century, its 'steam intellect culture' remained as vigorous as before, while both personal incomes and standards of living went on rising. Even the British Empire, over-extended though it had become, brought more profit to the homeland than it cost.[81] 'Remember that you are English', insisted Cecil Rhodes (d.1902) at the

century's end, 'and have therefore drawn first prize in the Lottery of Life.' And the great imperialist was not speaking in jest.

Pioneering industrialization had its price. Great industrial conglomerates were rare in Britain, and many family businesses were both inadequately equipped and too small for economies of scale. It is a significant fact, critically important to the arts, that no new fortune in late-Victorian Britain ever approached that of a dollar billionaire.[82] Yet with boom-rich industrialists having capital to protect, the art market remained very solid. Millais's iconic *The North-West Passage* (1874), which had sold for £4,930 to a Middlesbrough iron-master just before the Great Crash, was 'perhaps the most popular of all (his) paintings at the time, not only for its intrinsic merit, but as an expression more eloquent than words of the manly enterprise of the nation'.[83] And fourteen years later, at the well-attended London auction of Henry Bolckow's big collection, a 'huge cheer' went up when Henry Tate, the wealthy sugar-refiner and subsequent benefactor of the arts, bid four thousand guineas for the same painting.[84] 'In spite of the depression of trade, of the Royal Commission thereon, and of all the other signs of the times, the production and dispersion of works of art still goes on', noted *The Times* on 1 April 1886; 'Men are no longer making fortunes, they say; but pictures are painted in greater abundance than ever, and if they are good ones they are bought. Never were artists so multitudinous; never were exhibitions so constant or so rapid in their succession.'[85] The arts community had never been as rich.

Proof of that prosperity was the purpose-built studio-house: a phenomenon unique to the period. Needing a larger London studio, Millais moved in 1878 to 2 Palace Gate (Kensington): 'a great plain square house', designed for him by Philip Hardwick (1822–92) of the architectural dynasty, but 'characteristic of the man', of which 'the ornamental details are Renaissance of a rather severe type, the few columns introduced being Roman, Doric, and Ionic'.[86] Frederic Leighton (1830–96), the history-painter, lived a

few streets away at 2 Holland Park Road, in an even grander mansion in the Italianate style, built for him in the mid-1860s by George Aitchison (1825–1910), who had studied abroad with William Burges (1827–81). Burges's own extraordinary Gothic Revival house – 'massive, learned, glittering, amazing'[87] – was at 3 Melbury Road, just round the corner. And there were other artists' houses clustered in Holland Park, including the 'country parsonage' of Val Prinsep by the Arts and Crafts architect Philip Webb (1831–1915), and the studio-houses of Luke Fildes and Marcus Stone by Richard Norman Shaw (1831–1912).[88] 'You choose the style of your house', wrote Robert Kerr in *The Gentleman's House* (1864), 'just as you choose the build of your hat; – you can have *Classical*, columnar or non-columnar, arcuated or trabeated, rural or civil or indeed palatial; you can have *Elizabethan* in equal variety; *Renaissance* ditto; or, not to notice minor modes, *Medieval* in any one of many periods and many phases, – old English, French, German, Belgian, Italian, and more.'[89]

Whether in government, municipal, or country-house building, the safe choice was usually Classical.[90] And there were talented contemporary architects, of whom Glasgow's Alexander 'Greek' Thomson (1817–75) was probably the most gifted, who continued to build in little else. Others, among them the prolific church-builder, George Edmund Street (1824–81), were more content with Gothic. However, the most successful metropolitan partnerships were those best prepared to build in whatever style the client chose. Thus whereas George Gilbert Scott (1811–78) had originally proposed Flemish Gothic elevations – later re-styled as Byzantine – for the New Foreign Office (1862–73) in Whitehall, the monumental office-building he eventually completed ('a triumph of romantic classicism') was Italianate.[91] G.E. Street, in the meantime, had won the competition for the New Law Courts (1873–82) in the Strand with a striking Gothic design. But when Alfred Waterhouse (1830–1905), the Gothic Revival architect of Manchester Town Hall (1869–77), had submitted proposals in 1868 for the Natural History

Museum in Kensington, his choice had fallen instead on the *rund-bogenstil* (round-arched style) of South German Romanesque, thought to 'afford both the grandeur and simplicity which should characterize a building of this description'.[92]

Paradoxically, Arts and Crafts – Victorian Britain's most important contribution to the canon of Western architecture – was only exceptionally the choice for public building. As first conceived for the country-loving London commuters of the Railway Age, the 'Old English Style' of Philip Webb, of Norman Shaw, and of the young Edwin Lutyens (1869–1944), was also used successfully at such cost-no-object country-houses as Webb's 'Queen Anne Revival' Clouds (1881–6) for the 'old money' Percy Wyndham, and Shaw's fortress-like Cragside (1869–85) for the wealthy armaments manufacturer, Sir William Armstrong. At both great houses, frequent use was made of the papers, glass and furnishings of Morris, Marshall, Faulkner & Co., of which Webb himself, along with the Pre-Raphaelites Rossetti and Burne-Jones, had been a founder-partner back in 1861. Two decades later, 'our business is pretty good considering the bad state of trade throughout the country', William Morris was able to say in 1884.[93] And six years on again, when reviewing the third show of London's Arts and Crafts Exhibition Society (founded in 1886), the poet W.B. Yeats had no hesitation in naming its first source of inspiration:

> But for these 'arts and crafts' exhibitions [Yeats claimed in 1890] the outer public would hardly be able to judge of the immense change that is going on in all kinds of decorative art and how completely it is dominated by one man of genius [William Morris] . . . Only a small part of the exhibits are from Morris & Co., and yet all . . . are under the same spell.[94]

By the end of the century, the work of Britain's Arts and Crafts designers, among them Charles Rennie Mackintosh (1868–1928) of the Glasgow School, was becoming better known in Central Europe: in Vienna, in Munich and Berlin. And no Western designer with the

smallest interest in Arts and Crafts could have remained unaware of the movement's origins and principal beliefs. 'Our aim', wrote the Austrian Secessionist architect Joseph Hoffmann (1870–1956), founder of the Wiener Werkstätte in 1903, 'is to create an island of tranquillity in our country, which, amid the joyful hum of arts and crafts, would be welcome to anyone who professes faith in Ruskin and Morris.'[95] And for Germany's *altdeutsch* designers, looking back to the Northern Renaissance (*Dürerzeit*) for an uncorrupted native style, Morris's axioms retained a powerful attraction. However, they were not prepared to follow him in everything. 'What business have we with art unless all can share it?', Morris had asked rhetorically in 1883, after reading Marx's *Das Kapital* for the first time.[96] And that perception of art's relevance to all spheres of human life was shared by the great Belgian *Art Nouveau* designer, Henry van de Velde (1863–1957), who, after moving to Germany at the beginning of the century, was the co-founder with Hermann Muthesius (1861–1927) in 1907 of the Deutscher Werkbund in Munich. In reality, however, the strict handicrafts ethic of Morris's Arts and Crafts had limited its products to the rich. And it was left to German industrial designers of the first two decades of the new century to broaden the movement's appeal. Muthesius, a close friend of the Mackintoshes (Charles Rennie and Margaret), had introduced their work – a stylish combination of Arts and Crafts and *Art Nouveau* – to rich Berlin patrons. And it was Muthesius again, in his *Das Englische Haus* (1904), who brought the 'English Style' to suburban Germany before the War. Yet even as Arts and Crafts caught on in Germany as the preferred bourgeois style, Muthesius and his associates were simultaneously experimenting with large-scale mass-production and with a new industrial architecture – as at the AEG works by Peter Behrens and the Fagus-Werk by Walter Gropius – which combined functionalism with the use of new materials (concrete and glass) and good design. Whether in their garden-city factories in Berlin's more affluent neighbourhoods, or in the contemporary *Werkstätten* (Workshops) of Munich, Dresden

or Vienna, Morris's Central European neophytes could no more embrace the master's categorical rejection of factory-based production than the 'moral realism' of his socialist philosophy.

One reason for that reluctance to go the whole way with William Morris was the comparatively late arrival of industrialization in Central Europe, still too novel for disenchantment to have set in. The other reason – unification – was political. Otto von Bismarck's 'founding of the Reich' in 1871, closely following Prussian victories over Denmark (1864), Austria (1866) and France (1870–1), remained a cherished memory in *fin-de-siècle* Germany. And to the knee-jerk patriotism of the German-speaking *Volk* was now added the fresh stimulus of a 'new economic order': of the *Zollverein* (General Customs Union) of 1833, of the Central European railway boom of 1850–73, and of the simultaneous development of the *Kreditbanken* (investment banks) as capital-providers for heavy industry. In the event, the initial commercial optimism of the *Gründerzeit* (Founders' Age) was to be punctured almost immediately by the Great Crash of 1873. But Germany – like Britain, where the Crash came two years later – suffered less damage in the Recession than its primarily agricultural neighbours, while its recovery from the mid-1890s was more complete. Supporting that recovery was an exceptionally mobile labour force, recruited internally from the fecund farming communities of East Prussia. Berlin, already a great city in 1871, would more than double in size by 1910. But more impressive still was the startlingly rapid growth of the Rhine-Ruhr conurbations, where new high-tech industries – in chemicals, optics and electrical engineering – were brought together into ever larger and more powerful corporations. In less than a generation, Wilhelmine Germany – 'the Cinderella of European history, ridiculed by all nations'[97] – had become a world leader: the new industrial colossus of the West.[98]

It was the leading Modernist architect Peter Behrens (1868–1940) – for whom Walter Gropius (1883–1969), Mies van der Rohe (1886–1969) and Le Corbusier (1887–1965) all worked before the War –

who told an influential audience of Düsseldorf's good and great that the 'new tasks' imposed on architecture by Germany's commercial growth could be tackled only 'in the spirit of industry and big business'. For, said he:

> The evolution of monumental art has always been an expression of the concentration of power: if one can speak of the art of the Church in the Middle Ages; in the Baroque era of the art of Kings; of bourgeois art in the styles around 1800; then I believe that today [1912] our flourishing industry again forms a concentration of power which cannot remain without influence on the development of culture.[99]

And in Wilhelmine Germany, in the early years of the new century, there would indeed be a shift in patronage and connoisseurship to big business and the millionaire collector. For a while, industry and the State had worked together. Thus it was Prussia's high-speed industrialization that would be the subject, for example, of *The Iron-Rolling Mill* by Adolf Menzel (1815–1905), painted in 1872–5. And when Menzel's patron, Adolph von Liebermann (the Berlin banker), ran into financial difficulties as a result of the Great Crash, the Nationalgalerie had agreed to buy the painting.[100] In post-unification Germany, for almost thirty years, wealthy businessmen-collectors – Bethel Henry Strousberg (the railway magnate), Eduard Behrens (the banker), Thomas Knorr (the publisher), Maximilian von Heyl (the industrialist) – competed with public galleries and departments of State to commission new work from native artists.[101] History-painters and portraitists, genre-painters and landscapists, had never known better times, as Francophobia added to the bonanza. 'Now that we have established our relationship with the French thoroughly and, let us hope, finally in the field of politics and war', wrote the art historian Wilhelm Lübke in 1872, 'the task of measuring our culture with that of France faces us all the more urgently.'[102] But there was little chance of a German challenge in the arts. Paris remained the Mecca of German artists for the remainder

of the century: for Max Liebermann (1847–1935), the Berlin Impressionist, who lived and worked in Paris from 1874 to 1878; for the Munich painter, Lovis Corinth (1858–1925), who studied there under Bouguereau in 1884–7; and for Max Slevogt (1868–1932), also from Munich, who was a student at the Académie Julian two years later. Then, from early in the next century, Munich's *Blaue Reiter* Expressionists – Alexei von Jawlensky (1864–1941), Wassily Kandinsky (1866–1944), Franz Marc (1880–1916), and Paul Klee (1879–1940) – and the principal architect-designers of Germany's *Jugendstil* (*Art Nouveau*) all likewise looked to Paris for direction. Yet periodic mutual sabre-rattling throughout the inter-war years – from the Peace of Frankfurt (10 May 1871) to Germany's declaration of war on France (3 August 1914) – kept tensions high, and furnished many German artists with a living. Anton von Werner (1843–1915), the tutor and Court-painter of the Emperor William II (1888–1918), had accompanied the Prussian army to France in 1870. His *General Moltke with his Staff outside Paris* (1873), *The Proclamation of the German Empire at Versailles* (1877), and *The Battle of Sedan* (1883) were big set-pieces from that time. However, popular demand remained high for Werner's lesser vignettes of army life. And he would return to his campaign sketch-books for *A Billet outside Paris* (1894) – a sharply-realized celebration of Prussian *kameradschaft* and *kultur* – in which the Kaiser's intrepid soldiers, nearing the end of their campaign, sing Schumann at the piano with their boots on.[103]

The paint was barely dry on Werner's *Billet outside Paris* when it was bought by the Nationalgalerie for the State. Yet just two years later, Hugo von Tschudi (d.1911), the Nationalgalerie's new Director (1896–1909), was to buy his first French Impressionist (Manet's *In the Conservatory*, 1879); and Werner never sold another major painting to the Gallery. The next year, Tschudi followed his Manet purchase with a middle-period Cézanne (*The Mill on the Couleuvre at Pontoise*, 1881), and subsequently with other modern French paintings by Monet and Degas, Pissarro and Renoir, acquired with the help of rich Berliners.[104] It was Tschudi's candid

opinion, increasingly shared by other German directors of his day, that 'France [has been] the classic soil for the painting of the nineteenth century. There is scarcely a problem of modern art that was not addressed and brought to its ultimate solution in France. A wealth of stimuli flows from there to all civilized countries [including Germany].'[105] Yet in 1909, when Tschudi proposed buying Post-Impressionist paintings for the Nationalgalerie by Gauguin and Van Gogh, the Emperor intervened to block the purchase. 'The Kaiser', wrote Paul Seidel in *Der Kaiser und die Kunst* (1907), 'has often spoken most clearly about his relationship with the so-called "modern" trends and movements in art. He is against artists who want to ignore the whole evolution of our culture – and the laws of beauty and harmony which have come from it – and who instead claim, or at least give the impression of believing that they have only just rediscovered true art.'[106] The proper role of the German artist, the Kaiser had declared in a widely-publicized address, was not to 'represent misery as even more horrible than it is . . . as is often the case at present', but to nurture 'the great ideals . . . more or less lost to other peoples . . . (which) have become lasting possessions of the German people'.[107] The occasion was the opening on 18 December 1901 of the Siegesallee (Avenue of Victory) in Berlin, being just one of many costly imperial projects – another was Paul Wallot's Baroque Reichstag (Parliament Building) of 1884–94, and a third Julius Karl Raschdorff's new Lutheran Cathedral of 1890–1905 – on which the architects, painters and sculptors of Wilhelmine Germany were kept profitably employed between the wars.

'What an inspiration and awakening of ambition it must be for all concerned', Seidel suggested in 1907, '(to be) aware that every design of importance, whether it is for a church, a station, a post office or a monument, is first laid in front of the Ruler to undergo a thorough examination.'[108] Yet for Germany's restless dissidents, more confident by the hour of the support of the super-rich, the Kaiser's stubborn historicism and his constant meddling with the arts provided just the stimulus they needed for opposition. It was

Adolf Behne (1885–1948), a leading Modernist critic, who dismissed the Kaiser, shortly before the First World War, as 'a defiant reactionary eclecticist and an undistinguished decadent'.[109] And it was in confrontational Berlin, rather than in liberal Munich (home of the first Secession), that many dissidents chose to gather before the War. Both Ernest Kirchner (1880–1938) and Erich Heckel (1883–1970), of the Expressionist *Die Brücke*, left Dresden for Berlin in 1911. And Munich's leading Impressionists, Lovis Corinth and Max Slevogt, had already moved there ten years earlier, to join Max Liebermann in the Berlin Secession. 'I became an authority', Corinth remembered in his post-war *Autobiography*; 'And how could it be otherwise, as commercial activities in Berlin were excellent, the dealers were intelligent and eager to acquire new art, and furthermore the young Emperor had an aversion to everything new, so that we [the modernizers] were also surrounded by the radiance of a martyr's crown.'[110]

From Munich (1892) to Vienna (1897) and then Berlin (1898), the Secessionists rejected the teaching of the Academies. They showed contemporary French paintings – 'gutter art', the Kaiser called them – at their annual exhibitions; they championed the right of individual artists to paint as they pleased; and they encouraged the formation of like-minded groups in other German cities – at Leipzig and Dresden, Weimar, Düsseldorf and Karlsruhe – as well as at Budapest, Cracow and Prague. Freed by the Secessions from their earlier inhibitions, even well-established artists were to change their styles, exploring new territory in the process. It was the Vienna Secession, Hans Teitze recalled shortly after the painter's death, that revealed the *real* Gustav Klimt (1862–1918) in the early years of the century: 'it tore him from the direction in which it seemed he would travel for ever, destroyed or awakened his innermost being, and created the man and the artist Klimt whom we now know'.[111] Likewise, Edvard Munch (1863–1944), the one-time Oslo portraitist, found the context he needed in *fin-de-siècle* Berlin to pursue his bleak personal vision. Munch showed his work regularly in Paris. How-

ever, nothing would do more for public awareness of his art than the peremptory closing in 1892 of his first Berlin exhibition, within less than a week of its opening. It was the 'Munch Affair', reported Lovis Corinth, that made the Norwegian painter 'the most famous man in the whole German Empire'.[112] And Munch was still living in Berlin in 1902, when he exhibited his extraordinary *Frieze of Life* at the Secession:

> It went right round the walls of the great entrance hall [Munch wrote] . . . There were grey-green, sad shades in the colours of the room where someone died – there were ominous screams – blood-red skies, and a glaring patch of red, luminous red and yellow and green. It was like a symphony – it attracted a great deal of attention – a lot of hostility – and acclaim.[113]

Three years later, at the Salon d'Automne of 1905, a very similar commotion greeted the earliest Paris showing of Fauvist work. But when Matisse was taken up almost immediately by American collectors – first by the Steins (Leo and Gertrude) and then by the Cone sisters (Etta and Claribel) of Baltimore – millionaire doors began opening in Germany as well, as its industrialists bought into Modernism. 'Freedom of life and of movement against the long-established older forces' was the central demand of Ernest Kirchner's *Die Brücke* manifesto of 1905.[114] And as disenchantment grew with the Kaiser and all his works, overtly dissident groups like *Die Brücke* (The Bridge, 1905–13) and *Der Blaue Reiter* (The Blue Rider, 1911–14) found the audience growing for their art. 'It's incredible how blind and crazy one can be!', reflected Middle Germany's favourite Realist, Anton von Werner, embittered by the Expressionists' success. And in 1913, when Werner wrote his memoirs, boldly-coloured works by the *Blaue Reiter*'s Kandinsky, Jawlensky and Marc had already 'crossed the museum threshold' and were commanding high prices from collectors.[115]

Modernism's sudden flowering in the last decade before the Great War had much to do with rapid industrialization, with the steady

haemorrhage of rural populations to the big urban centres, with growing extremes of wealth and poverty, and with the consequent rise in social tensions. In 1900, the New York art establishment had still been highly conservative. Yet in just ten years, the painters of the *Stieglitz Group* (Hartley, Weber, Dove and Walkowitz) had begun their first experiments with abstract art, and Realism (as in Germany) was in retreat. In pre-war Paris, there were the Cubists (Picasso, Bracque and Gris) and the Orphists (Léger, Delaunay, Picabia and Duchamp); in London, the Vorticists (Lewis and Bomberg, Roberts and Nevinson); in Vienna, the Expressionists (Gerstl, Schiele and Kokoshka); in Budapest, the Eight (Berény, Czigány, Czóbel, Kernstok, Márffy, Orbán, Pór and Tihanyi); in Cracow, the Post-Impressionists (Wyspianski and Witkiewicz); in Italy, the Futurists (Boccioni, Balla and Sant'Elia, Carrà, Russolo and Severini); in Sweden, the Young Ones (Engström and Grünewald); in Finland, the Group of Seven and the November Group (Enckell, Thesleff, Rissanen, Sallinen, Cawén and others); in Russia, the Constructivists (Tatlin, Pevsner and Gabo); in Holland, the Neo-Plasticists (Mondrian and Van Doesburg) of *De Stijl*. A good number of those artists were designers also. Thus in Cracow, Stanislaw Wyspianski (1869–1907) designed both *Zakopane* (Polish Arts and Crafts) furniture and *Secesja* (*Art Nouveau*) glass and textiles, while continuing to paint in the style of the Post-Impressionists, which he had learnt while studying in Paris.[116] And when Henry van de Velde, the Belgian doyen of *Art Nouveau*, built himself a new villa in the country outside Brussels, both Bloemenwerf (1895) and its contents were of his own design, handling the minor and major arts with equal ease.[117]

'My garden is my library', wrote the *Art Nouveau* cabinet-maker, Louis Majorelle (1859–1926). And in the generous climate of the 1900s boom, *Art Nouveau* spread like convolvulus through the West. Known as the *Style Moderne* in Belgium, *Art Nouveau* had many names in France: *Style 1900, Style Métro, Art fin de siècle, Style Jules Verne, Art belle époque* etc. In Germany, it was the *Jugendstil*; in

Austria, the *Sezessionstil*; in Poland, *Secesja*; in Bohemia, *Secese*; in Hungary, *Szecesszió*; in Italy, *Arte Nuova* or *Stile Liberty*; in Catalonia, *Modernisme*; in Holland, the *Nieuwe Kunst*, and so on. Arts and Crafts had developed slowly as a rich man's style, stunted by the Crash and Great Depression. In contrast, *Art Nouveau* – 'this strange decorative disease' (Walter Crane) – coincided with two decades of high-living. In 1898, when Hermann Bahr called on Vienna's artists to 'Swathe our people in Austrian beauty!', the city had only recently emerged from the Recession.[118] And it was then that Otto Wagner (1841–1918) broke with the staid historicism of his Vienna Stadtbahn (City Railway, 1894–1901) to build the blithe Majolikahaus (1898–9) on the Linke Wienzeile, with its tile-clad floral façade.[119]

Wagner designed his Majolikahaus for the Viennese middle class. And *Art Nouveau* everywhere was a *bourgeois* style, instantly recognizable in objects of daily use, and embraced by the middle classes as their own. Thus Giuseppe Sommaruga (1867–1917), the builder of *Stile Liberty* villas for Milan's *nouveaux riches*, owed his well-off clientèle to Italy's post-*Risorgimento* industrialization and the sudden wealth of the 'Age of Giolitti' (1896–1914).[120] A few years earlier, Brussels's entrepreneurial bankers and *commerçants* – grown rich on Third World lending to Mexico, China and the Congo – had begun commissioning *Style Moderne* villas from Paul Hankar (1859–1901) and Victor Horta (1861–1947).[121] They were also lending money to Imperial Russia during its Second Railway Age (1890–1901), when that huge empire was opened to big industry. And one consequence of industrialization in Russia itself was the growing passion of wealthy Muscovites for international design, the lush vegetal interiors of the Stepan Riabushinskii House (1900–2), designed by Fedor Shekhtel (1859–1926) for the rich banker of that name, being the equal of any in the West.[122]

Both Arts and Crafts and *Art Nouveau* were cosmopolitan styles. But they might also be put to use by mutinous subject peoples as propaganda in the war against absolutism. In Poland's Cracow

heartland, annexed by the Habsburgs in 1847, the folklorist architecture of Stanislaw Witkiewicz (1851–1915) was a token of resistance by patriots like himself to the Austro-Hungarian occupation of Polish territory. And it was anti-Tsarist sentiment in Russian-controlled Finland that similarly inspired the individual blend of log-cabin medievalism with Arts and Crafts and *Art Nouveau* that characterized the work of Lars Sonck (1870–1956) and Eliel Saarinen (1873–1950), the patriotic architects of Helsinki's 'Golden Age'. In Hungary likewise, following the creation of the Dual Monarchy in 1867, first Ödön Lechner (1845–1914) and then Károly Kós (1883–1977) led the search for a national style. As Hungary industrialized, Lechner began to ask: 'Why should a new direction not be born in our time, a flourishing Hungarian style?' And in the anachronistic tent-roofs and battlements of Budapest's Museum of Applied Arts (1892–6), its Geological Institute (1898–9), and its Postal Savings Bank (1899–1901), he found his answer.[123] 'In my modest opinion', wrote the young Károly Kós in 1910, 'the Middle Ages must be one of the two parents of our emerging national style. No other artistic trend but one which builds on existing traditions can be healthy ... Our folk art is based on the art of the Middle Ages, and our national art is based on our folk art.'[124] So much for the classical tradition.

If National Romanticism made sense in Budapest, the same was true of rapidly-growing Barcelona, as its native-born architects – Lluís Domènech i Montaner (1850–1923), Antonio Gaudí y Cornet (1852–1926) and Josep Puig i Cadafalch (1867–1957) – filled the city's new *Eixample* (extension) with buildings of Moorish or Gothic derivation. Barcelona, specializing in cotton textiles, was still Spain's most important industrial city. And it was the coincidence of solid commercial wealth with an intellectual *Renaixença* and the flowering of Catalan separatism, that gave Gaudí the context for his art. Spain's last-remaining colonial markets – in Cuba and Puerto Rico, Guam and the Philippines – had been lost to the United States in the Spanish-American War of 1898. But the consequent slump in

Barcelona's exports had yet to dent its prosperity; and wealthy Catalan businessmen, enjoying the humiliation of the central government in Madrid, looked everywhere but Spain itself for inspiration. Gaudí's mature architecture – the surreal façades of his Casa Batlló and Casa Milà (both of the 1900s), and the mushrooming towers of the Sagrada Familia (begun in 1883) – had neither precedent in Catalonia nor successor. It could not have happened at any other time.[125]

It was in 1923 that Eliel Saarinen, the surprise runner-up in the 1922 competition for the Chicago Tribune Tower, left his successful Helsinki practice to open a new office in Ann Arbor (Michigan). Finland had won its freedom from Bolshevik Russia at the Treaty of Brest-Litovsk (March 1918). But four years of total war had so impoverished Europe that a talent as big as Saarinen's had no place there. The War had touched the Arts in other ways. It had inspired a temporary return in wartime Paris to French Neo-Classicism. 'We don't need German influence', Rodin was quoted as saying of Berlin Expressionism in 1917, 'but rather that of our most beautiful classic traditions.'[126] It had also cut a swathe through the Modernists of both sides, many of call-up age when it began. August Macke (b.1887), of the *Blaue Reiter*, was the first to die, reported missing on 12 October 1914 at Perthes-les-Hurlus. Then the young French sculptor, Henri Gaudier-Brzeska, aged only twenty-three, was killed at Neuville St Vaast on 5 June 1915: 'We have lost the best of the young sculptors', wrote Ezra Pound; 'The arts will incur no worse loss from the war than this is.'[127] But the carnage went on for three more years. Italian Futurism lost two of its finest in 1916, on the deaths of Umberto Boccioni and Antonio Sant'Elia. And while Oskar Kokoshka, the Viennese Expressionist, survived being wounded and left for dead on the Russian front (29 August 1915), his return to active service the following year ended within weeks in a breakdown.[128] Other artists in the trenches – Christopher Nevinson (the English Futurist), Max Beckmann (the Impressionist), Ernest Kirchner (of *Die Brücke*), George Grosz (the social satirist)

– collapsed that way, the anguish entering their art. 'I have half-finished work to be done', wrote the thirty-six-year-old Franz Marc, one of the pioneers of abstract painting; 'The *whole purpose of my life* lies hidden in my unpainted pictures'. Yet two weeks later Marc was dead, killed on 4 March 1916 at Verdun.[129]

Among those whose alienation grew as the slaughter continued were Max Slevogt and Lovis Corinth, the Impressionists. Neither saw military service. Yet Slevogt's wartime *Visions* (1917) were among the strongest things he did; while Corinth's choice of battle image in the fratricidal *Cain* (1917) – 'What hast thou done? [said the Lord] the voice of thy brother's blood crieth unto me from the ground. And now art thou cursed from the earth.' (*Genesis*, 4:10–11) – was the clearest possible statement of how he felt.[130] Corinth, when Peace returned, remembered pre-war Berlin with huge nostalgia. But the fighting had changed everything. And he was not the only survivor of the Great War's long Inferno to look back on that Gilded Age as Eldorado. John Maynard Keynes (1883–1946), the Cambridge economist, was another:

> What an extraordinary episode in the economic progress of man that age was which came to an end in August 1914! The greater part of the population, it is true, worked hard and lived at a low standard of comfort . . . But escape was possible, for any man of capacity or character at all exceeding the average, into the middle and upper classes, for whom life offered, at a low cost and with the least trouble, conveniences, comforts, and amenities beyond the compass of the richest and most powerful monarchs of other ages. The inhabitant of London could order by telephone, sipping his morning tea in bed, the various products of the whole earth . . . He could at the same moment and by the same means adventure his wealth in the natural resources and new enterprises of any quarter of the world . . . He could secure forthwith, if he wished it, cheap and comfortable means of transit to any country or climate

without passport or other formality . . . But most important of all, he regarded this state of affairs as normal, certain, and permanent.[131]

Permanent it was not. And Keynes could already see, in the punitive terms of the Peace Settlement at Versailles, the shadow of a Second World War. 'If we aim deliberately at the impoverishment of Central Europe', Keynes wrote in 1919, 'vengeance, I dare predict, will not limp.'[132] After the Inferno, the Holocaust.

Notes

Introduction

1 Philip Gilbert Hamerton, *Thoughts about Art* (London, Macmillan, 1873), p.125 (my italics).

2 As seen in *Homes & Gardens* (November 2000), advertising Bang & Olufsen's *BeoVision Avant*.

3 Adam Smith, *An Inquiry into the Nature and Causes of the Wealth of Nations*, ed. Edwin Cannan (London, Methuen, 1925), p.173.

4 As quoted by Peter J. Lucas, *From Author to Audience: John Capgrave and medieval publication* (Dublin, University College Dublin Press, 1997), pp.270–1 (I owe this reference to my friend and one-time student, David Freemantle). Humphrey of Lancaster (d.1447), Duke of Gloucester and Earl of Pembroke, was Henry IV's youngest son. John Capgrave (1393–1464), an Austin friar at King's Lynn, wrote thus in the dedication of his *Commentarius in Exodum* (1439–40), of which the original presentation copy is preserved in Duke Humphrey's Library at the Bodleian (Oxford).

5 Charles Burney, *A General History of Music from the Earliest Ages to the Present Period (1789)*, ed. Frank Mercer (London, G.T. Foulis, 1935), i:807 (author's italics); and see Michael North (ed.), *Economic History and the Arts* (Cologne, Böhlau Verlag, 1996), p.1.

6 Erika Rummel (ed.), *The Erasmus Reader* (Toronto, University of Toronto Press, 1990), pp.292, 299 (from 'A Complaint of Peace/ *Querela pacis*').

7 As quoted by John Michael Montias, 'Works of art in a random sample of Amsterdam inventories', in North, *Economic History and*

the Arts, p.67; and see also Chapter 6 (Markets and Collectors) to
 follow.
8 Francis Frascina and Charles Harrison (eds), *Modern Art and
 Modernism: a critical anthology* (London, Harper & Rowe, 1982),
 pp.79–87.
9 Philip Novak (ed.), *The Vision of Nietzsche* (Rockport [Mass.],
 Element Books, 1996), pp.56–7.
10 Herschel B. Chipp (ed.), *Theories of Modern Art. A source book by
 artists and critics* (Berkeley, University of California Press, 1968), p.66.
11 *Ibid.*, p.32 (to Emile Bernard, April 1888).
12 *Ibid.*, p.144.
13 Frascina and Harrison, *Modern Art and Modernism*, pp.89–91.
14 *Ibid.*, pp.205–7.
15 W.P. Frith, *My Autobiography and Reminiscences* (London, Richard
 Bentley, 1890), p.220.
16 Frascina and Harrison, *Modern Art and Modernism*, p.71; Clive
 Bell's 'The Aesthetic Hypothesis' was first published in 1914.
17 Frith, *My Autobiography*, p.489.
18 Robin Lenman, *Artists and Society in Germany 1850–1914*
 (Manchester, Manchester University Press, 1997), p.61.
19 Frith, *My Autobiography*, p.221.
20 James Steele, *Architecture Today* (London and New York, Phaidon,
 1997), pp.164–5.
21 For these figures, see Diane Coyle, 'Special Report: "Winner takes
 all" markets', *Prospect*, August–September 1998, p.64 (quoting
 Peter Drucker).
22 Jacob Burckhardt, *The Civilization of the Renaissance in Italy*
 (London, Penguin Classics, 1990), p.19.

CHAPTER ONE **A White Mantle of Churches**
1 John France (ed. and trans.), *Rodulfus Glaber. The Five Books of the
 Histories* (Oxford, Clarendon Press, 1989), pp.114–7.
2 *Ibid.*, pp.185–93.
3 *Ibid.*, pp.194–5.
4 *Ibid.*, pp.196–7.
5 T.N. Bisson, 'The "feudal revolution"', *Past & Present*, 142(1994),
 pp.6–42; the arguments against are presented by Dominique
 Barthélemy and Stephen D. White (*ibid.*, 152(1996), pp.196–223).

6 Kenneth John Conant, *Carolingian and Romanesque Architecture 800 to 1200* (Harmondsworth, Penguin Books, 1966), *passim*.

7 Peter Spufford, *Money and its Use in Medieval Europe* (Cambridge, Cambridge University Press, 1988), p.77.

8 *Ibid.*, p.83; and see also Simon Franklin and Jonathan Shepard, *The Emergence of Rus 750–1200* (London, Longman, 1996), pp.167–8.

9 George Heard Hamilton, *The Art and Architecture of Russia* (Harmondsworth, Penguin Books, 1975), pp.11, 15; Franklin and Shepard, *The Emergence of Rus*, pp.210–14.

10 As quoted by Peter Brown, *The Rise of Western Christendom. Triumph and diversity AD 200–1000* (Oxford, Blackwell Publishers, 1996), p.300.

11 As quoted by Robert Bartlett. *The Making of Europe. Conquest, colonization and cultural change 950–1350* (London, Penguin Books, 1994), p.172.

12 Susan Reynolds, *Kingdoms and Communities in Western Europe, 900–1300* (Oxford, Clarendon Press, 1984), p.217.

13 Antonia Gransden, *Historical Writing in England c.550–c.1307* (London, Routledge & Kegan Paul, 1974), pp.153, 158–9 (n.177): for Orderic's neighbours at Saint-Evroult, see Marjorie Chibnall, *The World of Orderic Vitalis* (Oxford, Clarendon Press, 1984), pp.20–8.

14 For some recent work on pre-Conquest English prosperity, see Pamela Nightingale. 'The evolution of weight standards and the creation of new monetary and commercial links in Northern Europe from the tenth century to the twelfth century'. *Economic History Review*, 38(1985), pp.192–209; also S.R.H. Jones, 'Devaluation and the balance of payments in eleventh-century England: an exercise in dark age economics', *ibid.*, 44(1991), pp.594–607; and the same author's 'Transaction costs, institutional change, and the emergence of a market economy in later Anglo-Saxon England', *ibid.*, 46(1993), pp.658–78.

15 David C. Douglas, *The Norman Achievement 1050–1100* (London, Eyre & Spottiswoode, 1969), p.198.

16 David Abulafia, 'The end of Muslim Sicily', in his *Commerce and Conquest in the Mediterranean 1100–1500* (Aldershot, Variorum, 1993), chapter 3.

17 Donald Matthew, *The Norman Kingdom of Sicily* (Cambridge, Cambridge University Press, 1992), pp.197–206 (Mosaics and the Monarchy).

18 For the most recent study of the *Winchester Bible*, dating it to the 1160s under Bishop Henry's patronage, see Claire Donovan, *The Winchester Bible* (London, The British Library, 1993); the paintings (dated to 1175–85) are discussed by David Park, 'The wall paintings of the Holy Sepulchre Chapel', in T.A. Heslop and V.A. Sekules (eds), *Medieval Art and Architecture at Winchester Cathedral* (London, British Archaeological Association, 1983), pp.38–62; for Byzantine influences in Western manuscripts generally, and for the *Winchester Psalter* in particular, see C.M. Kauffmann, *Romanesque Manuscripts 1066–1190* (London, Harvey Miller, 1975), pp.27–8 and 105–6.

19 As quoted by Herbert Bloch, 'The new fascination with Ancient Rome', in Robert L. Benson and Giles Constable (eds), *Renaissance and Renewal in the Twelfth Century* (Oxford, Clarendon Press, 1982), p.618.

20 Ernst Kitzinger, 'The arts as aspects of a Renaissance. Rome and Italy', in Benson and Constable, *Renaissance and Renewal*, p.639 and *passim*.

21 For the entire passage, which includes Bernard's famous denunciation of Cluniac sculptures, see Wolfgang Braunfels, *Monasteries of Western Europe. The architecture of the orders* (London, Thames & Hudson, 1972), pp.241–2.

22 Marjorie Chibnall (trans. and ed.), *The Ecclesiastical History of Orderic Vitalis. Volume IV, Books VII and VIII* (Oxford, Clarendon Press, 1973), pp.311–13, 327.

23 Taken from the *Vita Prima* of William of St Thierry (Pauline Matarasso (trans. and ed.), *The Cistercian World. Monastic writings of the twelfth century* (London, Penguin Books, 1993), p.38).

24 Quoted by Giles Constable, 'Renewal and reform in religious life: concepts and realities', in Benson and Constable, *Renaissance and Renewal*, p.43.

25 *Ibid.*, p.42 (the italics are mine).

26 Giles Constable, *Monastic Tithes from their Origins to the Twelfth Century* (Cambridge, Cambridge University Press, 1964), p.86.

27 Dorothy M. Owen, *Church and Society in Medieval Lincolnshire* (Lincoln, Lincolnshire Local History Society, 1971), p.5.

28 Bartlett Jere Whiting, *Proverbs, Sentences, and Proverbial Phrases from English Writings mainly before 1500* (Cambridge (Mass.), Harvard University Press, 1968), pp.368–9.

29 Braunfels, *Monasteries of Western Europe*, p.243.

30 David C. Douglas and George W. Greenaway (eds), *English Historical Documents 1042–1189* (London, Eyre & Spottiswoode, 1953), p.697 (the judgement is William of Malmesbury's).

31 Matarasso, *The Cistercian World*, p.31.

32 *Ibid.*, pp.287–92.

33 Constable, 'Renewal and reform in religious life', p.50.

34 Matarasso, *The Cistercian World*, pp.159–60.

35 *Ibid.*, pp.253–4.

36 Isabel Alfonso, 'Cistercians and feudalism', *Past & Present*, 133(1991), pp.3–30; and see my own *The Monastic Grange in Medieval England. A reassessment* (London, Macmillan, 1969), *passim*.

37 As said of Grandmont in the 1180s by Gérard Ithier, its seventh prior; quoted by Carole A. Hutchinson, *The Hermit Monks of Grandmont* (Kalamazoo, Cistercian Publications, 1989), pp.52–3.

38 As quoted by Colin Morris, *The Papal Monarchy. The Western Church from 1050 to 1250* (Oxford, Clarendon Press, 1989), p.292.

39 While properly scornful of many such claims, Guibert de Nogent's lengthy attack on relics was probably little known at the time, for there is only one surviving contemporary manuscript of his *De sanctis et eorum pigneribus* (Of saints and their relics), a new edition of which is included in R.B.C. Huygens's recent *Guibert de Nogent*, Corpus Christianorum, Continuatio Mediaevalis CXXVII, 1993, pp.79–175.

40 Elizabeth G. Holt (ed.), *A Documentary History of Art. Volume I. The High Middle Ages and the Renaissance* (New York, Doubleday & Company, 1957), pp.49–51.

41 For a firm rejection of the poor's participation to any significant degree in cathedral-financing, see Alain Erlande-Brandenburg, *The Cathedral. The social and architectural dynamics of construction* (Cambridge, Cambridge University Press, 1994), chapter 5 (Men, finance and administration).

42 Spufford, *Money and its Use in Medieval Europe*, pp.109–13, 138–40.

43 As quoted, among others, by Wim Swaan, *The Gothic Cathedral* (London, Paul Elek, 1969), p.282.

CHAPTER TWO **Commercial Revolution**

1 Guy Bois, *The Transformation of the Year One Thousand. The village of Lournand from antiquity to feudalism* (Manchester, Manchester University Press, 1992), pp.92–3.

2 As quoted by Alain Erlande-Brandenburg, *The Cathedral. The social and architectural dynamics of construction* (Cambridge, Cambridge University Press, 1994), p.238. For the circumstances of Suger's works, see Sumner McKnight Crosby, *The Royal Abbey of Saint-Denis from its Beginnings to the Death of Suger, 475–1151* (New Haven and London, Yale University Press, 1987), pp.105–20.

3 Richard Vaughan (trans. and ed.), *Chronicles of Matthew Paris* (Gloucester, Alan Sutton, 1986), p.275.

4 Victor Mortet and Paul Deschamps (eds), *Recueil des textes relatifs a l'histoire de l'architecture et la condition des architects en France, au Moyen Age* (Paris, Editions Auguste Picard, 1929), pp.246–7; and see also Rosalind B. Brooke, *The Coming of the Friars* (London, George Allen & Unwin, 1975), p.199.

5 Wolfgang Braunfels, *Monasteries of Western Europe. The architecture of the orders* (London, Thames & Hudson, 1972), p.246.

6 M.R.B. Shaw (trans. and ed.), *Joinville & Villehardouin. Chronicles of the Crusades* (Harmondsworth, Penguin Books, 1963), p.344; and see also William Chester Jordan, *Louis IX and the Challenge of the Crusade. A study in rulership* (Princeton, Princeton University Press, 1979), pp.232–5 (Appendix 2. Mendicant foundations under Louis IX). For the building, at first excessively grandly, of the Minorite friary at Valenciennes, see Mortet & Deschamps, *Recueil des textes*, pp.235–41.

7 As quoted by C.H. Lawrence, *The Friars. The impact of the early Mendicant movement on western society* (London, Longman, 1994), p.167.

8 Shaw, *Joinville & Villehardouin*, p.343.

9 Lester K. Little, 'Saint Louis' involvement with the friars', *Church History*, 33(1964), pp.129–30 and *passim*.

10 H.M. Colvin (ed.), *Building Accounts of King Henry III* (Oxford, Clarendon Press, 1971), pp.192–3. For the most recent description

of Henry's ambitious works at Westminster, see Paul Binski, *Westminster Abbey and the Plantagenets. Kingship and the representation of power 1200–1400* (New Haven and London, Yale University Press, 1995), passim.

11 Shaw, *Joinville & Villehardouin*, p.343.

12 As quoted by D.L. D'Avray, *Death and the Prince. Memorial preaching before 1350* (Oxford, Clarendon Press, 1994), pp.147–8.

13 Alison Brown (trans. and ed.), *Guicciardini. Dialogue on the Government of Florence* (Cambridge, Cambridge University Press, 1994), p.92.

14 As quoted by John F. McGovern, 'The rise of new economic attitudes – economic humanism, economic nationalism during the Later Middle Ages and the Renaissance, A.D. 1200–1550', *Traditio*, 26(1970), p.230 (my italics); and see also Barbara H. Rosenwein and Lester K. Little, 'Social meaning in the monastic and mendicant spiritualities', *Past & Present*, 63(1974), pp.29–31.

15 D.L. D'Avray, 'Sermons to the upper bourgeoisie by a thirteenth-century Franciscan', *Studies in Church History* 16, 1979, pp.187–99; and see also the same author's *The Preaching of the Friars. Sermons diffused from Paris before 1300* (Oxford, Clarendon Press, 1985), pp.204–16 (Echoes of the market economy).

16 Daniel Waley, *The Italian City-Republics* (London, Longman, 1988), p.21.

17 For the figures, see Avner Greif, 'On the political foundations of the late-medieval Commercial Revolution: Genoa during the twelfth and thirteenth centuries', *Journal of Economic History*, 54(1994), p.284; also David Nicholas, *The Growth of the Medieval City from Late Antiquity to the Early Fourteenth Century* (London, Longman, 1997), p.184 and *passim*.

18 Peter Spufford, *Money and its Use in Medieval Europe* (Cambridge, Cambridge University Press, 1988), p.261.

19 For these quotes, see Waley, *The Italian City-Republics*, pp.106–9.

20 Stephen Murray, *Beauvais Cathedral. Architecture of Transcendence* (Princeton, Princeton University Press, 1989), p.3.

21 As translated and reproduced by L.F. Salzman, *Building in England down to 1540, A documentary history* (Oxford, Clarendon Press, 1967), p.376.

22 Diana Greenway and Jane Sayers (trans. and eds), *Jocelin of*

Notes

Brakelond, Chronicle of the Abbey of Bury St Edmunds (Oxford, Oxford University Press, 1989), pp.36–7.

23 *Ibid.*, p.27.

24 Mavis Mate, 'The indebtedness of Canterbury Cathedral Priory 1215–95', *Economic History Review*, 26(1973), pp.183–97.

25 William Urry, *Canterbury under the Angevin Kings* (London, Athlone Press, 1967), pp.249–63 (Rental D); also quoted by M.T. Clanchy, *From Memory to Written Record. England 1066–1307* (London, Edward Arnold, 1987), p.73.

26 Christopher Dyer, *Standards of Living in the Later Middle Ages. Social change in England c.1200–1520* (Cambridge, Cambridge University Press, 1989), p.36 (Table 2).

27 For this general shift, see my own *The Architecture of Medieval Britain. A social history* (New Haven and London, Yale University Press, 1990), pp.127–8 and *passim*.

28 For these dates, confirmed by recent work, see R.H. Britnell, *The Commercialisation of English Society 1000–1500* (Cambridge, Cambridge University Press, 1993), p.127 and *passim*.

29 Jacques Le Goff, *Medieval Civilization 400–1500* (Oxford, Basil Blackwell, 1988), p.229.

30 James L. Goldsmith, 'The crisis of the Late Middle Ages: the case of France', *French History*, 9(1995), p.449. For the identical case of England, see Bruce Campbell's 'Land, labour, livestock, and productivity trends in English seignorial agriculture, 1208–1450', in Bruce M.S. Campbell and Mark Overton (eds), *Land, Labour and Livestock: historical studies in European agricultural productivity* (Manchester, Manchester University Press, 1991), p.173 and *passim*; and see also Bruce Campbell's *Before the Black Death. Studies in the 'crisis' of the early fourteenth century* (Manchester, Manchester University Press, 1991), with relevant contributions by Barbara Harvey, Richard Smith and Mavis Mate.

31 Platt, *The Architecture of Medieval Britain*, p.80.

32 *Ibid.*, p. 125.

33 Robert C. Stacey, 'Agricultural investment and the management of the royal demesne manors, 1236–1240', *Journal of Economic History*, 46(1986), pp.919–34.

34 Nikolaus Pevsner and Priscilla Metcalf, *The Cathedrals of England. Southern England* (Harmondsworth, Viking, 1985), p.118; for this

and other important contemporary English work, see also Nicola Coldstream, *The Decorated Style. Architecture and ornament 1240–1360* (London, British Museum Press, 1994), p.46 and *passim*.

35 For these and other examples of superior quality both in the arts and in the crafts, see Platt, *The Architecture of Medieval Britain*, pp.138–42.

36 Richard Marks, *Stained Glass in England during the Middle Ages* (London, Routledge, 1993), p.158.

37 As cited by Thomas Curtis van Cleve, *The Emperor Frederick II of Hohenstaufen. Immutator Mundi* (Oxford, Clarendon Press, 1972), p.304; for a more critical assessment of Frederick's achievements, in the arts as in all else, see David Abulafia, *Frederick II. A medieval emperor* (London, Allen Lane, The Penguin Press, 1988), *passim*.

38 As quoted by Waley, *The Italian City-Republics*, p.147.

39 Van Cleve, *The Emperor Frederick II*, p.304.

40 George Bull (trans. and ed.), *Giorgio Vasari. Lives of the Artists* (London, Penguin Books, 1987), i:57–8, ii:1.

41 John White, *Art and Architecture in Italy, 1250 to 1400* (Harmondsworth, Penguin Books, 1966), pp.204–17 (The Arena Chapel at Padua).

42 Bull, *Giorgio Vasari*, ii:9; White, *Art and Architecture in Italy*, pp.50–3. The inscription reads: *Boni Johannis est sculptor huius operis*.

43 As quoted by Waley, *The Italian City-Republics*, p.117.

44 As quoted by White, *Art and Architecture in Italy*, p.234; and also, in a slightly different version, by Alastair Smart, *The Dawn of Italian Painting 1250–1400* (Oxford, Phaidon, 1978), p.89.

45 Bartlett Jere Whiting, *Proverbs, Sentences, and Proverbial Phrases from English Writings* (Cambridge (Mass.), Harvard University Press, 1968), p.278.

CHAPTER THREE **Recession and Renaissance**

1 As quoted by Michael W. Dols, *The Black Death in the Middle East* (Princeton, Princeton University Press, 1979), p.67.

2 Mahmood Mamdani, *The Myth of Population Control. Family, caste, and class in an Indian village* (New York, Monthly Review Press, 1972), p.14.

3 Alan Macfarlane, *Marriage and Love in England. Modes of reproduction 1300–1840* (Oxford, Basil Blackwell, 1986), p.64.

4 As quoted by David Herlihy, 'Deaths, marriages, births, and the Tuscan economy (*ca*.1300–1550)', in Ronald Demos Lee (ed.), *Population Patterns in the Past* (New York, Academic Press, 1977), p.145.

5 David Herlihy, *Medieval and Renaissance Pistoia. The social history of an Italian town, 1200–1430* (New Haven and London, Yale University Press, 1967), pp.68, 75; also the same author's 'Population, plague and social change in rural Pistoia, 1201–1430', *Economic History Review*, 18(1965), pp.225–44.

6 Guy Bois, *The Crisis of Feudalism. Economy and society in Eastern Normandy c.1300–1550* (Cambridge, Cambridge University Press, 1984), pp.55, 57.

7 Julio Valdeón *et al.*, *Feudalismo y Consolidación de los Pueblos Hispánicos (Siglos XI–XV)* (Madrid, Editorial Labor, 1980), pp.100–101.

8 Angus MacKay, *Money, Prices and Politics in Fifteenth-Century Castile* (London, Royal Historical Society, 1981), pp.23–41.

9 Quoted by Peter Spufford, *Money and its Use in Medieval Europe* (Cambridge, Cambridge University Press, 1988), p.312.

10 Le Soterel's advice to his king was given in *c*.1340 (Spufford, *Money and its Use*, p.306).

11 *Ibid.*, pp.314–5.

12 *Ibid.*, pp.356–7.

13 *Ibid.*, pp.358, 360, and Raymond de Roover, *The Rise and Decline of the Medici Bank 1397–1494* (Cambridge, Harvard University Press, 1963), pp.359–60.

14 John H. Munro, 'Monetary contraction and industrial change in the late-medieval Low Countries, 1335–1500', in N.J. Mayhew (ed.), *Coinage in the Low Countries (880–1500)*, British Archaeological Reports, International Series 54, 1979, pp.95–183.

15 Walter Prevenier and Wim Blockmans, *The Burgundian Netherlands* (Cambridge, Cambridge University Press, 1986), p.95.

16 Pamela Nightingale, 'Monetary contraction and mercantile credit in later medieval England', *Economic History Review*, 43(1990), pp.560–75; also the same author's *A Medieval Mercantile Community. The Grocers' Company, and the Politics and Trade of*

London 1000–1485 (New Haven and London, Yale University Press, 1995), especially chapters XVII (The struggle to compete, 1430–1445) and XVIII (Recession and opportunity, 1445–61).

17 Colin Richmond, *John Hopton. A fifteenth-century Suffolk gentleman* (Cambridge, Cambridge University Press, 1981), p.30 and *passim*.

18 The judgement is Albrecht Dürer's (J.-A. Goris and G. Marlier (eds), *Albrecht Dürer. Diary of his Journey to the Netherlands 1520–1521* (London, Lund Humphries, 1971), p.87).

19 Richard A. Goldthwaite, *Wealth and the Demand for Art in Italy 1300–1600* (Baltimore and London, The Johns Hopkins University Press, 1993), p.47.

20 *Ibid.*, pp.57–8.

21 George Bull (trans.), *Giorgio Vasari. Lives of the Artists* (London, Penguin Books, 1987), i:127.

22 Pamela M. King, 'The cadaver tomb in England: novel manifestations of an old idea', *Church Monuments*, 5(1990), p.32 and *passim*; Paul Binski, *Medieval Death. Ritual and representation* (London, British Museum Press, 1996), pp.139–52 (Transi tombs).

23 Marta Powell Harley, *A Revelation of Purgatory by an Unknown Fifteenth-Century Woman Visionary* (Lewiston/Queenston, The Edwin Mellen Press, 1985), pp.123, 134–5.

24 For this and the John Barton of Holme inscriptions, see my own *King Death. The Black Death and its aftermath in late-medieval England* (London, UCL Press, 1996), pp.154, 164.

25 P.S. Lewis, *Later Medieval France. The polity* (London, Macmillan, 1968), pp.203–4.

26 Howard Colvin, *Architecture and the After-Life* (New Haven and London, Yale University Press, 1991), chapter IX (Chantries and funerary churches in medieval Europe).

27 Although usually identified as Cardinal Niccolò Albergati (d.1443), Jan van Eyck's sitter for this portrait is more likely to have been Cardinal Beaufort (Malcolm Vale, 'Cardinal Henry Beaufort and the "Albergati" portrait', *English Historical Review*, 105(1990), pp.337–54).

28 G.L. Harriss, *Cardinal Beaufort. A study of Lancastrian ascendancy and decline* (Oxford, Clarendon Press, 1988), especially chapter 19 (Last will, and final judgement); also K.B. McFarlane, *England in the Fifteenth Century: collected essays* (London, The Hambledon

Press, 1981), especially chapter 6 (At the deathbed of Cardinal Beaufort).

29 For both quotes, see my own *The Architecture of Medieval Britain. A social history* (New Haven and London, Yale University Press, 1990), pp.222–3, 280.

30 Vespasiano, *Renaissance Princes, Popes, and Prelates. The Vespasiano Memoirs. Lives of Illustrious Men of the XVth Century* (New York, Harper & Row, 1963), pp.351–2.

31 Jenny Stratford, *The Bedford Inventories. The worldly goods of John, Duke of Bedford, Regent of France (1389–1435)* (London, Society of Antiquaries, 1993), pp.319–25.

32 D.S. Chambers, *A Renaissance Cardinal and his Worldly Goods: the will and inventory of Francesco Gonzaga (1444–1483)* (London, The Warburg Institute, 1992), p.63 and *passim*.

33 Charles G. Nauert, *Humanism and the Culture of Renaissance Europe* (Cambridge, Cambridge University Press, 1995), chapter 3 (Crossing the Alps); Vespasiano, *Renaissance Princes*, pp.351–3.

34 Charlotte Augusta Sneyd (trans. & ed.), *A Relation, or rather a True Account, of the Island of England*, Camden Society 37, 1847, pp.20–22, 28, 41.

35 R.S. Lopez and H.A. Miskimin, 'The economic depression of the Renaissance', *Economic History Review*, 14(1962), pp.408–26; and see also the criticism of Carlo M. Cipolla, 'Economic depression of the Renaissance?', *ibid.*, 16(1964), pp.519–24, and the instant replies in the same journal of Professors Lopez and Miskimin (pp.525–9). Miskimin subsequently gave more substance to the case for economic depression in two books: *The Economy of Early Renaissance Europe 1300–1460* (Englewood Cliffs, Prentice-Hall, 1969) and *The Economy of Later Renaissance Europe 1460–1600* (Cambridge, Cambridge University Press, 1977). The same argument, in its application to the arts, was raised also by the monetarist historian John H. Munro in his 'Economic depression and the arts in the fifteenth-century Low Countries', recently reprinted in his *Textiles, Towns and Trade. Essays in the economic history of late-medieval England and the Low Countries* (London, Variorum Reprints, 1994), paper XI.

36 For this well-defined break in the building of new farmhouses in Kent, see Sarah Pearson, *The Medieval Houses of Kent: an historical*

analysis (London, Royal Commission on the Historical Monuments of England, 1994), pp.140–3.

37 P.J. Jones, 'The end of Malatesta rule in Rimini', in E.F. Jacob (ed.), *Italian Renaissance Studies* (London, Faber and Faber, 1960), p.236.

38 Vespasiano, *Renaissance Princes*, p.84.

39 *Ibid.*, pp.100–101.

40 *Ibid.*, p.106.

41 As quoted by Denys Hay and John Law, *Italy in the Age of the Renaissance 1380–1530* (London, Longman, 1989), p.326. The italics are mine.

CHAPTER FOUR **Expectations Raised and Dashed**

1 Peter Spufford, *Money and its Use in Medieval Europe* (Cambridge, Cambridge University Press, 1988), Chapter 16 (Money on the Eve of the Price Revolution).

2 Oliver Volckart, 'Early beginnings of the quantity theory of money and their context in Polish and Prussian monetary policies, *c.*1520–1550', *Economic History Review*, 50(1997), p.434 and *passim*.

3 *Ibid.*, p.434.

4 As quoted by F.J. Fisher, 'Influenza and inflation in Tudor England', *Economic History Review*, 18(1965), p.121.

5 *Ibid.*, p.127.

6 Volckart, 'Early beginnings of the quantity theory of money', p.433.

7 Mary Dewar (ed.), *A Discourse of the Commonweal of this Realm of England, attributed to Sir Thomas Smith* (Charlottesville, University Press of Virginia, 1969), pp.63–4.

8 Harry A. Miskimin, 'Silver, not sterling: a comment on Mayhew's velocity', *Economic History Review*, 49(1996), p.359; Eric Kerridge, *Trade and Banking in Early Modern England* (Manchester, Manchester University Press, 1988), p.99; Douglas Fisher, 'The price revolution: a monetary interpretation', *Journal of Economic History*, 41(1989), pp.883–902.

9 W.H.D. Rouse (ed.), *The Book of the Courtier by Count Baldassare Castiglione, done into English by Sir Thomas Hoby. Anno 1561* (London, Everyman, 1928), p.20.

10 Peter Burke, *The Fortunes of the Courtier. The European reception of Castiglione's Cortegiano* (Cambridge, Polity Press, 1995), pp.48, 142.

11 Betty Radice and A.H.T. Levi (trans. and eds), *Praise of Folly and Letter to Maarten van Dorp 1515. Erasmus of Rotterdam* (London, Penguin Books, 1993), p.110.

12 Peter Partner, *Renaissance Rome 1500–1559. A portrait of a society* (Berkeley, University of California Press, 1976), Chapter 6 (The Face of Rome) and *passim*.

13 For papal finances throughout this period, see Peter Partner, 'Papal financial policy in the Renaissance and Counter-Reformation', *Past & Present*, 88(1980), pp.17–62; and see also John A.F. Thomson, *Popes and Princes, 1417–1517* (London, George Allen & Unwin, 1980), Chapter 4 (The Financial Problems of the Papacy).

14 Radice and Levi, *Praise of Folly*, pp.110–111.

15 Andrew Pettegree, 'The early Reformation in Europe: a German affair or an international movement?', in the same author's edited volume *The Early Reformation in Europe* (Cambridge, Cambridge University Press, 1992), p.10; for the epithets commonly applied by Protestant reformers to the Roman Church, see Alastair Duke, 'The Netherlands', *ibid.*, p.154.

16 George Bull (trans. and ed.), *Giorgio Vasari. Lives of the Artists* (London, Penguin Books, 1987), i:270, 306, 418.

17 As quoted by R.J. Knecht, *Renaissance Warrior and Patron: the reign of Francis I* (Cambridge, Cambridge University Press, 1994), p.408.

18 Bull, *Giorgio Vasari*, i:266–7.

19 *Ibid.*, ii:169.

20 *Ibid.*, ii:184.

21 George Bull (trans. and ed.), *The Autobiography of Benvenuto Cellini* (Harmondsworth, Penguin Books, 1956), pp.268–72.

22 As quoted by Knecht, *Renaissance Warrior and Patron*, p.457.

23 *Ibid.*, pp.419, 531. The second commentator was also Venetian.

24 As quoted by Howell A. Lloyd, *The State, France and the Sixteenth Century* (George Allen & Unwin, London, 1983), p.84.

25 As quoted by Markus Fierz, *Girolamo Cardano 1501–1576. Physician, natural philosopher, mathematician, astrologer, and interpreter of dreams* (Basel, Birkhäuser, 1983), p.12.

26 *Ibid.*, p.15.

27 Knecht, *Renaissance Warrior and Patron*, pp.58–60; also the same author's *The Rise and Fall of Renaissance France* (London, Fontana, 1996), pp.227–9.

28 For these, see Simon Thurley, *The Royal Palaces of Tudor England. Architecture and Court Life 1460–1547* (New Haven and London, Yale University Press, 1993), pp.102–111.

29 David Howarth, *Images of Rule. Art and Politics in the English Renaissance, 1485–1649* (London, Macmillan, 1997), p.15.

30 Fierz, *Girolamo Cardano*, p.19.

31 For specie shortages as a factor in England's Great Debasement of 1544–51, see J.R. Wordie, 'Deflationary factors in the Tudor price rise', *Past & Present*, 154(1997), pp.59–61 and *passim*.

32 Described as a 'typical Spanish formula' and quoted by M.J. Rodríguez-Salgado, *The Changing Face of Empire. Charles V, Philip II and Habsburg Authority, 1551–1559* (Cambridge, Cambridge University Press, 1988), p.33. But the point is also made there that the inheritance belonged to Juana: 'she was the *reina propietaria*, literally, the proprietary monarch of these lands' (p.34).

33 As said by the Florentine historian, Francesco Guicciardini, and quoted (together with the formula above) by Richard Mackenney, *Sixteenth-Century Europe. Expansion and Conflict* (London, Macmillan, 1993), pp.59–60.

34 Francis Bacon, *Novum Organum* (1620), Book One: cxxix.

35 As quoted by John Hale, *The Civilization of Europe in the Renaissance* (London, HarperCollins, 1993), p.589.

36 J.-A. Goris and G. Marlier (eds), *Albrecht Dürer. Diary of his Journey to the Netherlands 1520–1521* (London, Lund Humphries, 1971), pp.57, 59–60, 96.

37 *Ibid.*, pp.86–8.

38 Walter S. Gibson, *Hieronymus Bosch* (London, Thames & Hudson, 1973), pp.162–3.

39 As quoted by Hale, *The Civilization of Europe*, p.306; but compare the quite different views of the Haarlem painter and biographer Karel van Mander (d.1606) who saw artistic influences in the sixteenth century moving south rather than north, and, in correcting Vasari on the travels of Lucas van Leyden (d.1533), wrote: 'He never travelled outside the Netherlands to learn his art, whatever Vasari writes to the contrary, in the belief that all our admired masters have perforce acquired their art from Italy and learnt from the Italians; he errs in this as in many other things about which he is misinformed.' (Walter S. Melion, *Shaping the*

Netherlandish Canon. Karel van Mander's Schilder-Boeck [Chicago and London, University of Chicago Press, 1991], pp.157–8).

40 I am here combining two different translations of the original *inopem me copia fecit* in Ovid's *Metamorphoses*, Book III (Narcissus and Echo), the second and later being A.D. Melville's version for the World's Classics edition (Oxford, Oxford University Press, 1987), p.65.

41 Bull, *Giorgio Vasari*, i:456; for the non-payment of Titian's pension, made up immediately by Philip II as an act of conscience following his father's death, see Harold E. Wethey, *The Paintings of Titian* (London, Phaidon, 1971), ii:5.

42 As described by Karl Brandi, *The Emperor Charles V. The growth and destiny of a man and of a world-empire* (London, Jonathan Cape, 1939), pp.633–4.

43 As quoted by James Hutton, *Themes of Peace in Renaissance Poetry* (Ithaca and London, Cornell University Press, 1984), pp.129–31; and see also Hale, *The Civilization of Europe*, pp.6–7.

CHAPTER FIVE **Religious Wars and Catholic Renewal**

1 Niccolò Machiavelli, *The Prince and The Discourses* (New York, Random House, 1950), Chapter 3 (Of Mixed Monarchies).

2 As quoted by J.H. Elliott, 'A Europe of composite monarchies', *Past & Present*, 137(1992), p.59.

3 As quoted by Henry Kamen, *Philip of Spain* (New Haven and London, Yale University Press, 1997), p.180.

4 As quoted by M.J. Rodríguez-Salgado, 'The Court of Philip II of Spain', in Ronald G. Asch and Adolf M. Birke (eds), *Princes, Patronage, and the Nobility. The Court at the Beginning of the Modern Age c.1450–1650* (Oxford, Oxford University Press, 1991), p.214.

5 Kamen, *Philip of Spain*, pp.183–4.

6 As quoted by Geoffrey Parker, *Philip II* (Boston and Toronto, Little, Brown & Company, 1978), p.43.

7 Kamen, *Philip of Spain*, p.183.

8 Catherine Wilkinson-Zerner, *Juan de Herrera. Architect to Philip II of Spain* (New Haven and London, Yale University Press, 1993), p.85.

9 As quoted by A.A. Parker, 'An Age of Gold. Expansion and

scholarship in Spain', in Denys Hay (ed.), *The Age of the Renaissance* (London, Thames & Hudson, 1967), p.229; and see Wilkinson-Zerner, *Juan de Herrera*, p.115.

10 As quoted by Henry Kamen, *Spain 1469–1714. A society in conflict* (London, Longman, 1991), p.120.

11 Rosemarie Mulcahy, *The Decoration of the Royal Basilica of El Escorial* (Cambridge, Cambridge University Press, 1994), p.156 (quoting José de Sigüenza's account of the incident in full); and see also p.65.

12 *Ibid.*, p.64.

13 Anthony Blunt, *Artistic Theory in Italy, 1450–1600* (Oxford, Clarendon Press, 1956), Chapter 8 (The Council of Trent and Religious Art), in particular pp.107–8 and p.110.

14 As quoted by Mulcahy, *The Decoration of the Royal Basilica of El Escorial*, p.64. For the full text, see Evelyn Carole Voelker, *Charles Borromeo's Instructiones Fabricae et Supellectilis Ecclesiasticae, 1577. A translation with commentary and analysis* (Ann Arbor, University Microfilms International, 1982: reproduced from Dr Voelker's Syracuse University 1977 Ph.D.), pp.228–30.

15 Mulcahy, *The Decoration of the Royal Basilica of El Escorial*, p.57; the comment is Sigüenza's again.

16 Harold E. Wethey, *The Paintings of Titian. III. The Mythological and Historical Paintings* (London, Phaidon, 1975), pp.161–2; and see also pp.78–84 (The *Poesie* and the Spanish Royal Palaces).

17 George Bull (trans. and ed.), *Giorgio Vasari. Lives of the Artists* (London, Penguin Books, 1987), i:461; also Wethey, *The Paintings of Titian. I. The Religious Paintings* (London, Phaidon, 1969), *passim.*

18 Wethey, *The Paintings of Titian. I*, p.124 and plate 196.

19 As quoted by James Hutton, *Themes of Peace in Renaissance Poetry* (Ithaca and London, Cornell University Press, 1984), pp.137–8.

20 Anthony Blunt, *Art and Architecture in France, 1500 to 1700* (London, Penguin Books, 1953), p.54.

21 I am combining two essays and two translations here: John Florio's *The Essayes of Michael Lord of Montaigne* (London, Routledge, 1885), p.409, and Peter Burke's new version in 'Montaigne', *Renaissance Thinkers* (Oxford, Oxford University Press, 1993), pp.306, 360–1.

22 Burke, 'Montaigne', p.359.

23 Blunt, *Art and Architecture in France*, p.97.

24 As quoted by R.J.W. Evans, *Rudolf II and his World. A study in intellectual history 1576–1612* (Oxford, Clarendon Press, 1973), p.162; and see also Eliska Fucikova *et al.* (eds), *Rudolf II and Prague. The Court and the City* (London, Thames and Hudson, 1997), pp.16–26 and *passim*.

25 Hessel Miedema (ed.), *Karel van Mander. The Lives of the Illustrious Netherlandish and German Painters* (Doornspijk, Davaco, 1994), pp.350–1; for Rudolf's eccentric ways and probable depressive illness, see H.C. Erik Midelfort, *Mad Princes of Renaissance Germany* (Charlottesville and London, University Press of Virginia, 1994), Chapter 5 (A Melancholy Emperor and his Mad Son).

26 For the art of Rudolf's Court, see Evans, *Rudolf II and his World*, Chapter 5 (Rudolf and the Fine Arts); and for the context of Arcimboldo's portraits, see the same author's 'The Imperial Court in the time of Arcimboldo', in *The Arcimboldo Effect. Transformations of the face from the sixteenth to the twentieth century* (London, Thames & Hudson, 1987), pp.35–54.

27 As quoted by Walter S. Melion, *Shaping the Netherlandish Canon. Karel van Mander's Schilder-Boeck* (Chicago and London, University of Chicago Press, 1991), pp.64, 181.

28 *Ibid.*, p.64; and see Margaret A. Sullivan, *Bruegel's Peasants. Art and audience in the Northern Renaissance* (Cambridge, Cambridge University Press, 1994), *passim*.

29 Geoffrey Parker, 'Success and failure during the first century of the Reformation', *Past & Present*, 136(1992), pp.79–80.

30 Evans, *Rudolf II and his World*, p.84.

31 Peter Humfrey, *Painting in Renaissance Venice* (New Haven and London, Yale University Press, 1995), pp.232–6.

32 As quoted by Paul Holberton, *Palladio's Villas. Life in the Renaissance Countryside* (London, John Murray, 1990), p.133.

33 As quoted by Eric Cochrane, *Italy 1530–1630* (London, Longman, 1988), p.178.

34 As quoted by Bruce Boucher, *Andrea Palladio. The architect in his time* (New York, Abbeville Press, 1994), p.146.

35 As quoted by Manfred Wundram and Thomas Pape, *Andrea Palladio 1508–1580. Architect between the Renaissance and Baroque* (Cologne, Benedikt Taschen, 1992), p.190.

36 Voelker, *Charles Borromeo's Instructiones*, pp.51–2.

37 Ludwig H. Heydenreich and Wolfgang Lotz, *Architecture in Italy 1400 to 1600* (Harmondsworth, Penguin Books, 1974), p.275.

38 As quoted by John W. O'Malley, *The First Jesuits* (Cambridge (Mass.) and London, Harvard University Press, 1993), pp.97–8, 357.

39 Heydenreich and Lotz, *Architecture in Italy 1400 to 1600*, p.278; for the popes' finances, see Peter Partner, 'Papal financial policy in the Renaissance and Counter-Reformation', *Past & Present*, 88(1980), p.49 and *passim*.

40 Rudolf Wittkower, *Art and Architecture in Italy 1600 to 1750* (Harmondsworth, Penguin Books, 1973), pp.6–9 (The 'Style Sixtus V' and its Transformation).

41 As quoted by Jean Delumeau, 'Rome: political and administrative centralization in the Papal State in the sixteenth century', in Eric Cochrane (ed.), *The Late Italian Renaissance 1525–1630* (London, Macmillan, 1970), p.292.

42 J.H.M. Salmon, *Society in Crisis. France in the sixteenth century* (London, Ernest Benn, 1975), p.212.

43 *Ibid.*, p.284; and see also Henry Heller, *Iron and Blood. Civil wars in sixteenth-century France* (Montreal and Kingston, McGill-Queen's University Press, 1991), Chapter 6 (The Croquants' Revolt).

44 Heller, *Iron and Blood*, p.136.

45 As quoted by Richard Bonney, *The King's Debts. Finance and politics in France 1589–1661* (Oxford, Clarendon Press, 1981), p.54.

46 For the re-planning of Paris and for the arts generally in Henry IV's reign, see André Chastel, *French Art. The Renaissance 1430–1620* (Paris and New York, Flammarion, 1995), pp.270–305.

47 Edmund H. Dickerman and Anita M. Walker, 'Monuments of his own magnificence: Henrichemont and the archaeology of Sully's mind', *French History*, 6(1992), pp.159–84.

48 As quoted by Felicity Heal, *Hospitality in Early Modern England* (Oxford, Clarendon Press, 1990), p.101.

49 Howard Colvin and John Newman (eds), *Of Building. Roger North's writings on architecture* (Oxford, Clarendon Press, 1981), pp.25–6.

Notes

CHAPTER SIX **Markets and Collectors**

1 Michael North, *Art and Commerce in the Dutch Golden Age* (New Haven and London, Yale University Press, 1997), p.82.

2 Ad van der Woude, 'The volume and value of paintings in Holland at the time of the Dutch Republic', in David Freedberg and Jan de Vries (eds), *Art in History: History in Art. Studies in seventeenth-century Dutch culture* (Santa Monica, Getty Center for the History of Art and the Humanities, 1991), p.314.

3 *Ibid.*, p.299; and see John Michael Montias, *Artists and Artisans in Delft. A socio-economic study of the seventeenth century* (Princeton, Princeton University Press, 1982), p.129.

4 Simon Schama, *The Embarrassment of Riches. An interpretation of Dutch culture in the Golden Age* (London, Collins, 1987), p.319.

5 Arthur K. Wheelock, *Johannes Vermeer* (New Haven and London, Yale University Press, 1995), pp.22–3.

6 *Ibid.*, p.15; also Donalk Haks and Marie Christine van der Sman, *Dutch Society in the Age of Vermeer* (Zwolle, Waanders Publishers, 1996), pp.15, 61.

7 Montias, *Artists and Artisans in Delft*, pp.134–5.

8 Wheelock, *Vermeer*, p.16 (as said by Catharina Bolnes, Vermeer's widow).

9 As quoted by Schama, *The Embarrassment of Riches*, pp.300–301.

10 *Ibid.*, p.303.

11 North, *Art and Commerce*, pp.118–28, 132–8.

12 *Ibid.*, p.137.

13 Svetlana Alpers, *Rembrandt's Enterprise. The Studio and the Market* (Chicago, University of Chicago Press, 1988), p.88 (quoting Descamps).

14 Christopher Brown *et al.*, *Rembrandt: the Master and his Workshop. Paintings* (New Haven and London, Yale University Press, 1991), p.57; North, *Art and Commerce*, pp.121–7.

15 As quoted by Peter Thornton, *Seventeenth-Century Interior Decoration in England, France and Holland* (New Haven and London, Yale University Press, 1978), p.40; for Sir William Brereton's travels, see John Stoye, *English Travellers Abroad 1604–1667* (New Haven and London, Yale University Press, 1989), pp.174–6.

16 As reported by Jean Muret shortly after Philip's death and quoted

by Jonathan Brown, *Kings & Connoisseurs. Collecting art in seventeenth-century Europe* (New Haven and London, Yale University Press, 1995), p.145.

17 Jonathan Brown, *Velázquez. Painter and Courtier* (New Haven and London, Yale University Press, 1986), pp.67–8.

18 For the argument, see Henry Kamen, 'The decline of Spain: a historical myth?', *Past & Present*, 81(1978), pp.24–50.

19 *Ibid.*, p.40.

20 J.H. Elliott, 'Art and decline in seventeenth-century Spain', in the same author's *Spain and its World 1500–1700. Selected Essays* (New Haven and London, Yale University Press, 1989), p.285.

21 Valerie Fraser, *The Architecture of Conquest. Building in the Viceroyalty of Peru 1535–1635* (Cambridge, Cambridge University Press, 1990), p.21 (my italics).

22 *Ibid.*, p.46.

23 I am conflating two quotes here: Henry Kamen, *Spain 1469–1714* (London, Longman, 1991), p.218, and Brown, *Kings & Connoisseurs*, p.141.

24 As quoted by R.A. Stradling, *Philip IV and the Government of Spain 1621–1665* (Cambridge, Cambridge University Press, 1988), p.xv.

25 J.H. Elliott, *The Count-Duke of Olivares. The statesman in an Age of Decline* (New Haven and London, Yale University Press, 1986), p.611.

26 Jonathan Brown and J.H. Elliott, *A Palace for a King. The Buen Retiro and the Court of Philip IV* (New Haven and London, Yale University Press, 1980), p.27.

27 *Ibid.*, p.87.

28 *Ibid.*, p.105.

29 Elliott, 'Art and decline in seventeenth-century Spain', p.280.

30 Brown, *Velázquez. Painter and Courtier*, pp.107–23.

31 Brown and Elliott, *A Palace for a King*, p.115.

32 Brown, *Kings & Connoisseurs*, p.139.

33 *Ibid.*, p.143.

34 As quoted by J.H. Elliott, 'Philip IV of Spain. Prisoner of ceremony', in A.G. Dickens (ed.), *The Courts of Europe. Politics, patronage and royalty, 1400–1800* (London, Thames & Hudson, 1977), p.180; for the Buen Retiro's building costs, see Brown and Elliott, *A Palace for a King*, pp.96–104.

35 Elliott, *The Count-Duke of Olivares*, p.42; J.H. Elliott, *Richelieu and Olivares* (Cambridge, Cambridge University Press, 1984), p.18.

36 Elliott, *Richelieu and Olivares*, p.29.

37 Anthony Blunt, *Art and Architecture in France 1500 to 1700* (London, Penguin Books, 1953), pp.138–42.

38 Edric Caldicott, 'Richelieu and the arts', in Joseph Bergin and Laurence Brockliss (eds), *Richelieu and his Age* (Oxford, Clarendon Press, 1992), pp.203–35; Brown, *Kings & Connoisseurs*, pp.191–200.

39 Blunt, *Art and Architecture in France*, p.143.

40 Brown, *Kings & Connoisseurs*, pp.187–8 (I have again conflated two quotes here).

41 W. Noel Sainsbury (ed.), *Original Unpublished Papers Illustrative of the Life of Sir Peter Paul Rubens* (London, Bradbury & Evans, 1859), p.326; quoted by Graham Parry, *The Golden Age Restor'd. The culture of the Stuart Court 1603–42* (Manchester, Manchester University Press, 1981), pp.215–6.

42 As quoted by R. Malcolm Smuts, 'Art and the material culture of majesty in early Stuart England', in the same author's *The Stuart Court and Europe. Essays in politics and cultural change* (Cambridge, Cambridge University Press, 1996), p.103.

43 The words are Sir John Eliot's, quoted by David Howarth, *Images of Rule. Art and politics in the English Renaissance, 1485–1649* (London, Macmillan, 1997), p.270.

44 Ruth Saunders Magurn (trans. and ed.), *The Letters of Peter Paul Rubens* (Evanston, Northwestern University Press, 1991), p.314.

45 As said by Sir Thomas Palmer to Prince Henry and quoted by John Stoye, *English Travellers Abroad 1604–1667* (New Haven and London, Yale University Press, 1989), p.6.

46 Magurn, *Letters of Peter Paul Rubens*, p.322.

47 As quoted by Parry, *The Golden Age Restor'd*, p.158.

48 John Peacock, *The Stage Designs of Inigo Jones. The European context* (Cambridge, Cambridge University Press, 1995), pp.82, 91–2.

49 As quoted by Ronald G. Asch, *The Thirty Years War. The Holy Roman Empire and Europe, 1618–1648* (London, Macmillan, 1997), p.1; the references are to *Matthew* 27:33 and *Acts* 1:19.

50 As quoted by Hugh Trevor-Roper, *The Plunder of the Arts in the Seventeenth Century* (London, Thames and Hudson, 1970), p.45.

51 As quoted by Francis Haskell, 'Charles I's collection of pictures', in Arthur MacGregor (ed.), *The Late King's Goods. Collections, possessions and patronage of Charles I in the light of the Commonwealth Sale inventories* (London and Oxford, Alistair McAlpine and Oxford University Press, 1989), p.217.

52 *Ibid.*, pp.226–7; for these and other valuations of comparable interest, see Oliver Millar (ed.), *The Inventories and Valuations of the King's Goods 1649–1651*, Walpole Society 43, 1972, p.195 and *passim*.

53 Millar, *Inventories and Valuations*, pp.74, 79, 117.

54 *Ibid.*, pp.1–3, 7, 12–13, 29–30, 32, 40 and *passim*; for Boulton's art purchases, see pp.130, 142 and 206.

55 Brown, *Kings & Connoisseurs*, pp.71, 87–8.

56 *Ibid.*, p.92.

57 *Ibid.*, pp.172–3.

58 *Ibid.*, pp.241, 244.

CHAPTER SEVEN **Bernini's Century**

1 Hessel Miedema (ed.), *Karel van Mander. The Lives of the Illustrious Netherlandish and German Painters* (Doornspijk, Davaco, 1994), pp.46–7, 52–3.

2 Charles Avery, *Bernini. Genius of the Baroque* (London, Thames and Hudson, 1997), p.273 (as said of Bernini by the Jesuit Cardinal Pietro Sforza Pallavicino).

3 As quoted by Francis Haskell, *Patrons and Painters. Art and society in Baroque Italy* (New Haven and London, Yale University Press, 1980), p.121.

4 Catherine Enggass (trans.), *The Life of Bernini by Filippo Baldinucci* (Philadephia and London, The Pennsylvania State University Press, 1966), p.13.

5 *Ibid.*, p.21.

6 As quoted by Haskell, *Patrons and Painters*, pp.59, 146.

7 Enggass, *Life of Bernini*, p.42.

8 Haskell, *Patrons and Painters*, p.152.

9 Robert S. Duplessis, *Transitions to Capitalism in Early Modern Europe* (Cambridge, Cambridge University Press, 1997), pp.95–123 and *passim*.

10 Haskell, *Patrons and Painters*, Chapter 8 (The Provincial Scene).

11 Cecil Gould, *Bernini in France. An episode in seventeenth-century history* (London, Weidenfeld and Nicolson, 1981), pp.33–4.

12 Enggass, *Life of Bernini*, p.52.

13 Orest and Patricia Ranum (eds), *The Century of Louis XIV* (USA, Walker and Company, 1972), p.198.

14 Jonathan Brown, *Kings & Connoisseurs* (New Haven and London, Yale University Press, 1995), p.214.

15 Francis Haskell, 'The market for Italian art in the 17th century', *Past & Present*, 15(1959), pp.52–3 and *passim*; and see also the same author's *Patrons and Painters*, pp.187–9.

16 As quoted by Haskell, *Patrons and Painters*, p.187.

17 Robert W. Berger, *A Royal Passion. Louis XIV as patron of architecture* (Cambridge, Cambridge University Press, 1994), p.33.

18 *Ibid.*, p.6.

19 The description is Christopher Wren's (Ranum, *The Century of Louis XIV*, p.198).

20 Gould, *Bernini in France*, pp.87–8.

21 Peter Burke, *The Fabrication of Louis XIV* (New Haven and London, Yale University Press, 1992), Chapter XII (Louis in Perspective) and *passim*; also Robert W. Berger, *In the Garden of the Sun King. Studies on the Park of Versailles under Louis XIV* (Washington, Dumbarton Oaks Research Library and Collection, 1985), for 'The Apollo Theme in the Petit Parc', 'The Apollo Theme in the Château', and *passim*.

22 Burke, *The Fabrication of Louis XIV*, p.122.

23 As quoted by William Doyle, *The Old European Order 1660–1800* (Oxford, Oxford University Press, 1992), p.269.

24 Ranum, *The Century of Louis XIV*, p.118.

25 *Ibid.*, p.113.

26 *Ibid.*, p.197.

27 *Ibid.*, p.135 (my italics).

28 *Ibid.*, pp.197–8.

29 Anthony Blunt, *Art and Architecture in France 1500 to 1700* (London, Penguin Books, 1953), p.161.

30 As quoted by Peter Thornton, *Seventeenth-Century Interior Decoration in England, France and Holland* (New Haven and London, Yale University Press, 1978), p.10.

31 David Kirby, *Northern Europe in the Early Modern Period. The Baltic World 1492–1772* (London, Longman, 1990), p.193.

32 As quoted by Michael Roberts, *Essays in Swedish History* (London, Weidenfeld and Nicolson, 1967), p.260.

33 As quoted by Berger, *A Royal Passion*, p.177.

34 Francis Haskell and Nicholas Penny, *Taste and the Antique. The lure of classical sculpture 1500–1900* (New Haven and London, Yale University Press, 1982), p.41.

35 As said by Wren's son and quoted by Paul Jeffery, *The City Churches of Sir Christopher Wren* (London, The Hambledon Press, 1996), pp.18–19. 'On the 13 (September)', the diarist John Evelyn recorded, 'I presented his Majestie with a Survey of the ruines, and a Plot for a new Citty, with a discourse on it, whereupon, after dinner his Majestie sent for me into the Queenes Bed-chamber, her Majestie and the Duke (of York) onely present, where they examind each particular, and discoursd upon them for neere a full houre, seeming to be extreamly pleasd with what I had so early thought on'. (E.S. De Beer (ed.), *The Diary of John Evelyn* [London, Oxford University Press, 1959], p.500).

36 De Beer, *Diary of John Evelyn*, pp.756–7.

37 Montague Summers (ed.), *The Complete Works of Thomas Shadwell* (London, The Fortune Press, 1927), i:193–4.

38 *Ibid.*, ii:17. I owe these references to Steven A. Pincus, 'From butterboxes to wooden shoes; the shift in English popular sentiment from anti-Dutch to anti-French in the 1670s', *Historical Journal*, 38(1995), p.358.

39 De Beer, *Diary of John Evelyn*, p.757.

40 Ellis Waterhouse, *Painting in England 1530 to 1790* (New Haven and London, Yale University Press, 1994), pp.128–9.

41 As quoted by Warren C. Scoville, *The Persecution of Huguenots and French Economic Development 1680–1720* (Berkeley and Los Angeles, University of California Press, 1960), pp.334–5 (from the report of Jean Anisson and Archbishop Fénelon of Cambrai).

42 *Ibid.*, pp.129–30, 138–9.

43 *Ibid.*, pp.322–3.

44 As quoted by Henry Kamen, *Spain in the Later Seventeenth Century, 1665–1700* (London, Longman, 1980), p.21.

45 As quoted from Antonio Palomino's *Museo Pictórico y Escala*

Notes

Optica (1724) by John F. Moffitt, *The Arts in Spain* (London, Thames and Hudson, 1999), p.164.

46 George Kubler and Martin Soria, *Art and Architecture in Spain and Portugal and their American Dominions 1500 to 1800* (Harmondsworth, Penguin Books, 1959), pp.319–20.

47 Kamen, *Spain in the Later Seventeenth Century*, p.92; and for the quotation from Antonio de Solís, see p.365.

CHAPTER EIGHT **Enlightened Absolutism**

1 For these figures, see Michael W. Flinn, *The European Demographic System 1500–1820* (Baltimore, The Johns Hopkins University Press, 1985), pp.80–1.

2 For introductions to the literature on population change and the disappearance of plague, see Andrew B. Appleby, 'The disappearance of plague: a continuing puzzle', *Economic History Review*, 33(1980), pp.161–73; Paul Slack, 'The disappearance of plague: an alternative view', *ibid.*, 34(1981), pp.469–76; Flinn, *The European Demographic System, passim*; and Michael Anderson, 'Population change in north-western Europe, 1750–1850', in Michael Anderson (ed.), *British Population History from the Black Death to the Present Day* (Cambridge, Cambridge University Press, 1996), pp.191–279.

3 Anderson, *British Population History*, p.214.

4 For these estimates, see Janet M. Hartley, *A Social History of the Russian Empire 1650–1825* (London, Longman, 1999), pp.9–10.

5 George Heard Hamilton, *The Art and Architecture of Russia* (Harmondsworth, Penguin Books, 1975), p.175 (quoting Count Francesco Algarotti in 1739).

6 As quoted by A. Lentin, *Russia in the Eighteenth Century* (London, Heinemann, 1973), p.41.

7 As quoted by Christopher Marsden, *Palmyra of the North. The first days of St Petersburg* (London, Faber & Faber, 1942), p.51.

8 As quoted by Lindsey Hughes, *Russia in the Age of Peter the Great* (New Haven and London, Yale University Press, 1998), p.215.

9 Boris N. Mironov, 'Consequences of the price revolution in eighteenth-century Russia', *Economic History Review*, 45(1992), pp.457–78; Basil Dmytryshyn (ed.), *Modernization of Russia under*

Peter I and Catherine II (New York, John Wiley & Sons, 1974), p.119.

10 Dmytryshyn, *Modernization of Russia*, pp.54–5.

11 Lentin, *Russia in the Eighteenth Century*, p.41.

12 As quoted by Hughes, *Russia in the Age of Peter the Great*, p.226.

13 *Ibid.*, pp.224–8; Hamilton, *Art and Architecture of Russia*, pp.181–7.

14 As quoted by Anthony G. Gross, 'The British in Catherine's Russia: a preliminary survey', in J.G. Garrard (ed.), *The Eighteenth Century in Russia* (Oxford, Clarendon Press, 1973), p.233.

15 Hamilton, *Art and Architecture of Russia*, p.109.

16 Hughes, *Russia in the Age of Peter the Great*, pp.19, 237.

17 *Ibid.*, p.238.

18 Tamara Talbot Rice, *Elizabeth, Empress of Russia* (London, Weidenfeld and Nicolson, 1970), p.154.

19 As quoted by Paul Dukes, *The Making of Russian Absolutism 1613–1801* (London, Longman, 1990), p.141.

20 Talbot Rice, *Elizabeth*, p.178.

21 Hamilton, *Art and Architecture of Russia*, pp.191–6.

22 As quoted by Kenneth Maxwell, *Pombal. Paradox of the Enlightenment* (Cambridge, Cambridge University Press, 1995), p.37.

23 As quoted by Hellmut Wohl, 'Portuguese Baroque architecture', in Jay A. Levenson (ed.), *The Age of Baroque in Portugal* (New Haven and London, Yale University Press, 1993), p.141.

24 A.J.R. Russell-Wood, 'Portugal and the World in the age of Dom Joao V', in Levenson, *The Age of Baroque*, pp.16–18.

25 Wohl, 'Portuguese Baroque architecture', p.145 and fig.6.

26 The writer was Arthur Costigan in the 1780s (Maxwell, *Pombal*, p.40).

27 Russell-Wood, 'Portugal and the World', pp.17–18.

28 As quoted by Maxwell, *Pombal*, p.23.

29 As quoted by José Augusto França, 'Lisbon, the Enlightened City of the Marquês de Pombal', in Levenson, *The Age of Baroque*, pp.135–6.

30 Kenneth R. Maxwell, 'Eighteenth-century Portugal. Faith and reason, tradition and innovation during a Golden Age', in Levenson, *The Age of Baroque*, p.116.

31 As quoted by Maxwell, *Pombal*, p.2.

32 *Ibid.*, p.105 (quoting Pombal's co-reformer, Francisco de Lemos).

33 *Ibid.*, p.106 (quoting the contemporary educator, António Nunes Ribeiro Sanches).

34 *Ibid.*, p.131.

35 For these figures, see E.A. Wrigley, 'A simple model of London's importance in changing English society and economy 1650–1750', *Past & Present*, 35 (1967), pp.44–5.

36 Nicholas Rogers, 'Money, land and lineage: the big bourgeoisie of Hanoverian London', reprinted (with a commentary) in Peter Borsay (ed.), *The Eighteenth-Century Town. A reader in English urban history 1688–1820* (London, Longman, 1990), pp.268–91.

37 For the continuing debate on the nature and timing of this Revolution, see Mark Overton, *Agricultural Revolution in England. The transformation of the agrarian economy 1500–1850* (Cambridge, Cambridge University Press, 1996), and the same author's 'Re-establishing the English Agricultural Revolution', *Agricultural History Review*, 44(1996), pp.1–20. For the case for an earlier main period (i.e. before 1750), see Robert C. Allen, 'Tracking the agricultural revolution in England', *Economic History Review*, 52(1999), pp.209–35.

38 As quoted by Shearer West, 'Patronage and power: the role of the portrait in eighteenth-century England', in Jeremy Black and Jeremy Gregory (eds), *Culture, Politics and Society in Britain, 1660–1800* (Manchester, Manchester University Press, 1990), pp.131–2.

39 *Ibid.*, p.132.

40 *Ibid.*, p.131.

41 As quoted by Iain Pears, *The Discovery of Painting. The growth of interest in the arts in England, 1680–1768* (New Haven and London, Yale University Press, 1988), p.137.

42 Harry Mount (ed.), *Sir Joshua Reynolds. A journey to Flanders and Holland* (Cambridge, Cambridge University Press, 1996), pp.82–3.

43 Karl D. Bülbring (ed.), *The Compleat English Gentleman by Daniel Defoe* (London, David Nutt, 1890), pp.124–5 (Defoe's satire was published in 1728–9).

44 As quoted by David H. Solkin, *Painting for Money. The visual arts and the public sphere in eighteenth-century England* (New Haven and

London, Yale University Press, 1993), p.247; for rising attendance figures at these exhibitions, see John Brewer, *The Pleasures of the Imagination. English culture in the eighteenth century* (London, HarperCollins, 1997), p.237.

45 Robert R. Wark (ed.), *Sir Joshua Reynolds. Discourses on Art* (New Haven and London, Yale University Press, 1975), pp.252–3; Reynolds's fourteenth *discourse* to the Royal Academy, devoted to Gainsborough's art, was delivered on 10 December 1788.

46 *Ibid.*, p.248.

47 For this emphasis, see R.G. Wilson and A.L. Mackley, 'How much did the English country house cost to build, 1660–1880?', *Economic History Review*, 52(1999), pp.436–68 (especially p.466).

48 As written from Rome in 1761 by the Scottish draughtsman, George Richardson, and quoted by Damie Stillman, *English Neo-Classical Architecture* (London, A. Zwemmer, 1988), i:28.

49 John Harris, *The Palladian Revival. Lord Burlington, his villa and garden at Chiswick* (New Haven and London, Yale University Press, 1994), p.107 (quoting Lord John Hervey).

50 As quoted by Wilson and Mackley, 'How much did the English country house cost to build?', p.439; for a more complete text, see Historical Manuscripts Commission, *Report on the Manuscripts of his Grace the Duke of Portland, K.G., preserved at Welbeck Abbey* (London, HMSO, 1901), vi:65, 169 (my italics).

51 HMC, *Portland MSS*, vi:160–1; for the overlap of architects at Houghton, see John Harris, 'The architecture of the house', in Andrew Moore (ed.), *Houghton Hall. The Prime Minister, the Empress and the Heritage* (London, Philip Wilson, 1996), pp.20–4.

52 *Ibid.*, pp.170–1; and see also Tom Williamson, 'The planting of the park', in Moore, *Houghton Hall*, pp.41–7.

53 As quoted by Terry Friedman, *James Gibbs* (New Haven and London, Yale University Press, 1984), p.107.

54 John J. McCusker and Russell R. Menard, *The Economy of British America 1607–1789* (Chapel Hill and London, University of North Carolina Press, 1991), pp.53–4 and *passim*.

55 Leonard W. Labaree (ed.), *The Papers of Benjamin Franklin* (New Haven, Yale University Press, 1961), iv:228–9.

56 As quoted by T.H. Breen, 'An Empire of Goods: the Anglicization of Colonial America, 1690–1776', *Journal of British Studies*,

25(1986), p.489 (I have slightly amended the wording here); and see also the same author's 'Baubles of Britain: the American and Consumer Revolutions of the eighteenth century', *Past & Present*, 119(1988), pp.73–104. For a notably more cautious view of this 'consumer revolution', measured against population increases, see Carole Shammas, 'Changes in English and Anglo-American consumption from 1550 to 1800', in John Brewer and Roy Porter (eds), *Consumption and the World of Goods* (London and New York, Routledge, 1993), pp.177–205.

57 L.H. Butterfield (ed.), *Diary and Autobiography of John Adams* (Cambridge, Mass., Harvard University Press, 1961), p.150.

58 Aubrey C. Land, *Colonial Maryland. A history* (White Plains, NY, KTO Press, 1981), pp.135, 184.

59 Carole Shammas, *The Pre-Industrial Consumer in England and America* (Oxford, Clarendon Press, 1990), p.65; and see also S.D. Smith, 'The market for manufactures in the thirteen continental colonies, 1698–1776', *Economic History Review*, 51(1998), pp.676–708.

60 Breen, 'Baubles of Britain', p.85.

61 Butterfield, *Diary of John Adams*, i:294.

62 William Peden (ed.), *Notes on the State of Virginia by Thomas Jefferson* (Chapel Hill, University of North Carolina Press, 1955), p.153.

63 John Summerson, *Architecture in Britain 1530–1830* (New Haven and London, Yale University Press, 1993), pp.338–40 (Books and the Palladian Movement).

64 H. Roy Merrens and George D. Terry, 'Dying in Paradise: perception and reality in Colonial South Carolina', in Karen Ordahl Kupperman (ed.), *Major Problems in American Colonial History* (Lexington, D.C., Heath and Company, 1993), p.333 (quoting Eliza Lucas Pinckney and the physician Alexander Garden).

65 Robert Tavernor, *Palladio and Palladianism* (London, Thames & Hudson, 1991), pp.86–7, 185; for the rising prosperity of the Carolinian planters, see R.C. Nash, 'South Carolina and the Atlantic economy in the late seventeenth and eighteenth centuries', *Economic History Review*, 45(1992), pp.677–702.

66 As quoted by Giles Worsley, *Classical Architecture in Britain. The*

Heroic Age (New Haven and London, Yale University Press, 1995), p.285.

67 Julian P. Boyd (ed.), *The Papers of Thomas Jefferson* (Princeton, Princeton University Press, 1954), ix:445.

68 *Ibid.*, viii:568–9.

69 L.M. Cullen, 'History, economic crises, and revolution: understanding eighteenth-century France', *Economic History Review*, 46(1993), pp.635–57; Patrick Karl O'Brien, 'Path dependency, or why Britain became an industrialized and urbanized economy long before France', *ibid.*, 49(1996), pp.213–49.

70 John A. Lynn, *The Wars of Louis XIV 1667–1714* (London, Longman, 1999), pp.362–7 (Limited War); Hilton L. Root, 'Institutions, interest groups and authority in *Ancien Régime* France', *French History*, 6(1992), p.424 and *passim.*

71 As quoted by Robert Darnton, *The Great Cat Massacre and other Episodes in French Cultural History* (London, Penguin Books, 1991), p.133.

72 *Ibid.*, p.133.

73 Arthur Young, *Travels in France and Italy* (London, Dent, 1976), p.83.

74 Cissie Fairchilds, 'The production and marketing of populuxe goods in eighteenth-century Paris', in Brewer and Porter, *Consumption and the World of Goods*, pp.228–48.

75 Wend Graf Kalnein and Michael Levey, *Art and Architecture of the Eighteenth Century in France* (Harmondsworth, Penguin Books, 1972), pp.307, 324; Allan Braham, *The Architecture of the French Enlightenment* (London, Thames & Hudson, 1980), p.42.

76 As quoted by Braham, *The Architecture of the French Enlightenment*, pp.193–4.

77 Antoine Picon, *French Architects and Engineers in the Age of Enlightenment* (Cambridge, Cambridge University Press, 1992), *passim.*

78 Young, *Travels in France and Italy*, p.77.

79 Michael Levey, *Painting and Sculpture in France 1700–1789* (New Haven and London, Yale University Press, 1993), p.236.

80 *Ibid.*, pp.135–7.

81 As quoted by H.H. Arnason, *The Sculptures of Houdon* (London,

Phaidon, 1975), pp.73–4; and see Boyd, *Papers of Thomas Jefferson*, vii:566–7.

82 As quoted by Rohan Butler, *Choiseul. Volume I. Father and Son 1719–1754* (Oxford, Clarendon Press, 1980), pp.797–8. Choiseul's most-favoured painters included Bartolomeo Guidobono (1654–1709), Francesco Albani (1578–1660), Luca Forte (1615–70), and Federico Barocci (1535–1612).

83 As quoted by Giles MacDonogh, *Frederick the Great. A life in deeds and letters* (London, Weidenfeld & Nicolson, 1999), pp.108, 236–7.

84 T.C.W. Blanning, 'Frederick the Great and German culture', in Robert Oresko *et al.* (eds), *Royal and Republican Sovereignty in Early Modern Europe. Essays in memory of Ragnhild Hatton* (Cambridge, Cambridge University Press, 1997), p.536.

85 As quoted by Gert Streidt and Klaus Frahm, *Potsdam. Palaces and gardens of the Hohenzollern* (Cologne, Könemann, 1996), pp.39, 41.

86 Blanning, 'Frederick the Great and German culture', pp.527–8.

87 As quoted by James J. Sheehan, *German History 1770–1866* (Oxford, Clarendon Press, 1989), pp.66–7, 202–3; or as Frederick himself is alleged to have said: 'My people and I have come to an agreement which satisfies us both. They are to say what they please, and I am to do what I please.'

88 Richard Bonney (ed.), *Economic Systems and State Finance* (Oxford, Clarendon Press [for the European Science Foundation], 1995), pp.333–5, 361.

89 As quoted by David Watkin and Tilman Mellinghoff, *German Architecture and the Classical Ideal 1740–1840* (London, Thames & Hudson, 1987), p.10.

90 As quoted by Saul K. Padover, *The Revolutionary Emperor: Joseph II of Austria* (London, Eyre & Spottiswoode, 1967), p.209.

91 Sheehan, *German History 1770–1866*, pp.116–7.

92 As quoted by Eberhard Hempel, *Baroque Art and Architecture in Central Europe* (Harmondsworth, Penguin Books, 1965), p.270.

93 Charles W. Ingrao, *The Hessian Mercenary State. Ideas, institutions, and reform under Frederick II, 1760–1785* (Cambridge, Cambridge University Press, 1987), pp.127, 129; but for these quotes again and for another view on the German princes' motives for engaging in the trade – arguably more political than economic – see Peter H.

Wilson, 'The German "Soldier Trade" of the seventeenth and eighteenth centuries: a reassessment', *International History Review*, 18(1996), p.764 and *passim*.

94 Ingrao, *The Hessian Mercenary State*, pp.145–6.

95 Watkin and Mellinghoff, *German Architecture*, pp.44–9.

96 *Ibid.*, p.29.

97 Hellmut Lorenz, 'The Imperial Hofburg. The theory and practice of architectural representation in Baroque Vienna', in Charles W. Ingrao (ed.), *State and Society in Early Modern Austria* (West Lafayette, Purdue University Press, 1994), p.103.

98 Hempel, *Baroque Art and Architecture*, p.233.

99 G.Y.T. Greig (ed.), *The Letters of David Hume* (Oxford, Clarendon Press, 1932), i:126.

100 *Ibid.*, i:124; also quoted by Svetlana Alpers and Michael Baxandall, *Tiepolo and the Pictorial Intelligence* (New Haven and London, Yale University Press, 1994), p.101.

101 Michael Levey, *Giambattista Tiepolo. His life and art* (New Haven and London, Yale University Press, 1986), Chapter 8 (The Years at Würzburg).

102 Hempel, *Baroque Art and Architecture*, p.94.

103 P.G.M. Dickson, *Finance and Government under Maria Theresa 1740–1780* (Oxford, Clarendon Press, 1987), ii:87.

104 Lorenz, 'The Imperial Hofburg', *passim*.

105 Padover, *The Revolutionary Emperor*, pp.77, 82.

106 As said of the Habsburg capital by the nineteenth-century dramatist, Friedrich Hebbel (1813–63).

107 Young, *Travels in France and Italy*, p.80.

108 As quoted by Charles Ingrao, *The Habsburg Monarchy 1618–1815* (Cambridge, Cambridge University Press, 1994), p.209; for a recent revisionary account of Joseph's reign and policies, see T.C.W. Blanning's *Joseph II* (London, Longman, 1994), *passim*.

CHAPTER NINE **Revolution**

1 William Doyle, *The Oxford History of the French Revolution* (Oxford, Clarendon Press, 1989), p.64 (quoting Jacques-Pierre Brissot).

2 As quoted by D.O. Thomas, *The Honest Mind. The thought and work of Richard Price* (Oxford, Clarendon Press, 1977), p.283.

Notes

3 Richard Price, *A Discourse on the Love of our Country 1789* (Oxford, Woodstock Books, 1992), p.50.

4 Conor Cruise O'Brien (ed.), *Edmund Burke. Reflections on the Revolution in France* (Harmondsworth, Penguin Books, 1969), pp.374–5.

5 Serge Bianchi, *La révolution culturelle de l'an II. Élites et peuple 1789–1799* (Paris, Aubier, 1982), p.190.

6 As quoted by René Pillorget, 'The cultural programmes of the 1789 Revolution', *History*, 70(1985), pp.390–1.

7 Bianchi, *La révolution culturelle*, p.190.

8 Anita Brookner, *Jacques-Louis David* (London, Chatto & Windus, 1980), p.79 (quoting A. Thomé de Gamond, *Vie de David*, 1826).

9 *Ibid.*, p.182 (his correspondent was the battle-painter, Baron Gros).

10 Christopher Prendergast, *Napoleon and History Painting. Antoine-Jean Gros's* La Bataille d'Eylau (Oxford, Clarendon Press, 1997), pp.148–9 and *passim*.

11 Hubert Wellington (ed.), *The Journal of Eugène Delacroix* (Oxford, Phaidon, 1980), pp.38–9.

12 As quoted by Gregor Dallas, *The Imperfect Peasant Economy. The Loire Country, 1800–1914* (Cambridge, Cambridge University Press, 1982), p.280 (the occasion was Napoleon's abdication in 1814 at Fontainebleau).

13 The adjective is Delacroix's, 1 April 1824 (Wellington, *Journal of Delacroix*, p.27).

14 As quoted by William Vaughan, *Romantic Art* (London, Thames and Hudson, 1991), p.250.

15 Jo Burr Margadant, 'Gender, vice, and the political imaginary in post-revolutionary France: reinterpreting the failure of the July monarchy, 1830–1848', *American Historical Review*, 104(1999), pp.1485–6; and see also Christopher M. Greene, 'Romanticism, cultural nationalism and politics in the July Monarchy: the contribution of Ludovic Vitet', *French History*, 4(1990), pp.487–509.

16 F.W.J. Hemmings, *Culture and Society in France 1789–1848* (Leicester, Leicester University Press, 1987), pp.303–5.

17 *Ibid.*, p.297

18 Theodore Zeldin, *France 1848–1945. Volume Two. Intellect, Taste and Anxiety* (Oxford, Clarendon Press, 1977), p.459 (quoting Georges de Sonneville on Bordeaux's collectors in 1893).

19 For France's Industrial Revolution starting only with the Railway Age, see Clive Trebilcock, *The Industrialization of the Continental Powers 1780–1914* (London, Longman, 1981), pp.139–55; but for a more positive view of the 1840s in France, see David H. Pinkney, *Decisive Years in France 1840–1847* (Princeton, Princeton University Press, 1986), Chapter 2 (Industrial Takeoff); and see also Tom Kemp, *Industrialization in Nineteenth-Century Europe* (London, Longman, 1985), pp.60–1.

20 T.J. Clark, *Image of the People. Gustave Courbet and the 1848 Revolution* (London, Thames and Hudson, 1973), p.134.

21 *Ibid.*, p.138.

22 As quoted by Sarah Faunce and Linda Nochlin, *Courbet Reconsidered* (New Haven and London, Yale University Press, 1988), p.5.

23 *Ibid.*, p.4.

24 Zeldin, *France 1847–1945*, ii:455–6.

25 Robin Middleton and David Watkin, *Neoclassical and 19th Century Architecture* (New York, Harry N. Abrams, 1980), pp.229–32.

26 As quoted by Greene, 'Romanticism, cultural nationalism and politics in the July monarchy', p.505.

27 Stuart Woolf, 'French civilization and ethnicity in the Napoleonic Empire', *Past & Present*, 124(1989), p.108.

28 Dorothy Mackay Quinn, 'The art confiscations of the Napoleonic wars', *American Historical Review*, 50(1945), pp.447, 454–5; I owe these references to Hemmings, *Culture and Society in France*, pp.82–3.

29 As quoted by James J. Sheehan, *German History 1770–1866* (Oxford, Clarendon Press, 1989), p.329.

30 As quoted by Joachim Whaley, 'The German lands before 1815', in Mary Fulbrook (ed.), *German History since 1800* (London, Arnold, 1997), p.15.

31 John Geary (ed.), *Johann Wolfgang von Goethe. Essays on Art and Literature* (Princeton, Princeton University Press, 1994), pp.5, 8, 14.

32 David Bindman and Gottfried Riemann (eds), *Karl Friedrich Schinkel, 'The English Journey'. Journal of a visit to France and Britain in 1826* (New Haven and London, Yale University Press, 1993), p.175; and see also David Watkin and Tilman Mellinghoff,

German Architecture and the Classical Ideal 1740–1840 (London, Thames and Hudson, 1987), pp.110–12.

33 Gottfried Riemann, 'Schinkel's buildings and plans for Berlin', in Michael Snodin (ed.), *Karl Friedrich Schinkel: a universal man* (New Haven and London, Yale University Press, 1991), pp.16–25.

34 Watkin and Mellinghoff, *German Architecture and the Classical Ideal*, pp.177–8.

35 As quoted by David Blackbourn, *The Fontana History of Germany 1780–1918. The Long Nineteenth Century* (London, Fontana, 1997), p.89.

36 As quoted by Sheehan, *German History 1770–1866*, p.381.

37 William Vaughan, 'Longing for the South', in Keith Hartley *et al.* (eds), *The Romantic Spirit in German Art 1790–1990* (London, Hayward Gallery, 1994), pp.301–2.

38 Brigitte Buberl, 'The craving for identity and liberty', in Hartley, *The Romantic Spirit*, pp.289–300.

39 Nigel Glendinning, *Goya and his Critics* (New Haven and London, Yale University Press, 1977), p.95 (quoting Charles Yriarte).

40 Hugh Thomas, *Goya: The Third of May 1808* (New York, The Viking Press, 1973), *passim*.

41 As quoted by Glendinning, *Goya and his Critics*, p.76; Taylor's *majas* and *manolas* are alternative names for the young Madrid women, showy of dress and cheeky in manner, who came from the poorer areas of the city.

42 E.A. Smith, *George IV* (New Haven and London, Yale University Press, 1999), p.263 (quoting the diarist Joseph Farington).

43 As quoted by Ann Pullan, 'Public goods or private interests? The British Institution in the early nineteenth century', in Andrew Hemingway and William Vaughan (eds), *Art in Bourgeois Society, 1790–1850* (Cambridge, Cambridge University Press, 1998), p.35.

44 Felicity Owen and David Blayney Brown, *Collector of Genius. A life of Sir George Beaumont* (New Haven and London, Yale University Press, 1988), pp.166, 205, 234.

45 John Gage, *J.M.W. Turner. 'A wonderful range of mind'* (New Haven and London, Yale University Press, 1987), p.171.

46 Bindman and Riemann, *Karl Friedrich Schinkel. 'The English Journey'*, p.180.

47 As quoted by D.A. Farnie, *The English Cotton Industry and the*

World Market 1815–1896 (Oxford, Clarendon Press, 1979), pp.36–7, 82.

48 Michael Freeman, *Railways and the Victorian Imagination* (New Haven and London, Yale University Press, 1999), p.25 (quoting John Francis, *History of the English Railway*, 1851).

49 As quoted by Michael Rosenthal, *Constable. The painter and his landscape* (New Haven and London, Yale University Press, 1983), p.226.

50 As quoted by Gage, *J.M.W. Turner*, p.11.

51 M.H. Port (ed.), *The Houses of Parliament* (New Haven and London, Yale University Press, 1976), pp.5, 54–5.

52 As quoted by David Watkin, *Sir John Soane. Enlightenment thought and the Royal Academy Lectures* (Cambridge, Cambridge University Press, 1996), p.391.

53 Port, *Houses of Parliament*, pp.28–32 (The Competition).

54 *Ibid.*, p.31.

55 As quoted by J. Mordaunt Crook, *The Dilemma of Style. Architectural ideas from the Picturesque to the Post-Modern* (London, John Murray, 1987), p.49.

56 *Ibid.*, p.46.

57 As quoted by Nikolaus Pevsner, *Some Architectural Writers of the Nineteenth Century* (Oxford, Clarendon Press, 1972), pp.118–9.

58 As quoted by William Craft Brumfield, *A History of Russian Architecture* (Cambridge, Cambridge University Press, 1993), pp.393–4.

59 George Heard Hamilton, *The Art and Architecture of Russia* (Harmondsworth, Penguin Books, 1975), pp.197–216.

60 As quoted by Basil Dmytryshyn (ed.), *Modernization of Russia under Peter I and Catherine II* (New York and London, John Wiley & Sons, 1974), pp.125, 128.

61 Hamilton, *Art and Architecture of Russia*, p.218 (quoting the historian, F.F. Vigel [d.1856]).

62 *Ibid.*, Chapter 12 (The Alexandrian Empire: 1796–1850); also Brumfield, *Russian Architecture*, Chapter 12 (The Early Nineteenth Century: Alexandrine Neoclassicism).

63 Carroll L.V. Meeks, *Italian Architecture 1750–1914* (New Haven and London, Yale University Press, 1966), p.106 (the words are Napoleon's own).

64 *Ibid.*, pp.97–190 (The Triumph of Neoclassicism 1795–1840).
65 Henry-Russell Hitchcock, *Architecture. Nineteenth and Twentieth Centuries* (Harmondsworth, Penguin Books, 1968), p.56.
66 As quoted by Matthew Craske, *Art in Europe 1700–1830* (Oxford, Oxford University Press, 1997), p.257.
67 *Ibid.*, p.141; Hamilton, *Art and Architecture of Russia*, pp.253–5.
68 Gage, *J.M.W. Turner*, p.60.
69 John Wilmerding, *American Art* (Harmondsworth, Penguin Books, 1976), pp.79–80 (quoting Cole's proposals for his paintings).
70 'Another year! – another deadly blow! Another mighty Empire overthrown!' (William Wordsworth, *Another Year!*, 1807).

CHAPTER TEN **The Gilded Age**

1 As quoted, from Galt's *Life and Studies of Benjamin West* (1816), by Matthew Craske, *Art in Europe 1700–1830* (Oxford, Oxford University Press, 1997), p.252.
2 *Ibid.*, pp.245–6.
3 The figures are given by Reginald Horsman, *The New Republic. The United States of America 1789–1815* (London, Longman, 2000), p.93.
4 As quoted by Merrill D. Peterson, *Thomas Jefferson and the New Nation. A Biography* (New York, Oxford University Press, 1970), pp.745–6.
5 James Fergusson, *History of the Modern Styles of Architecture* (London, John Murray, 1862), p.436.
6 Peterson, *Thomas Jefferson*, p.743.
7 Fergusson, *History of the Modern Styles*, pp.437–43 (Washington); and see also Nikolaus Pevsner, *Some Architectural Writers of the Nineteenth Century* (Oxford, Clarendon Press, 1972), Chapter 23 (James Fergusson).
8 Fergusson, *History of the Modern Styles*, pp.443, 445.
9 The description of North America as 'a Billion-Dollar Country' is Thomas Reed's of 1892. Mark Twain's satire, *The Gilded Age*, had been published in 1873.
10 The figures are from Tom Kemp, *The Climax of Capitalism. The U.S. economy in the twentieth century* (London, Longman, 1990), p.10.
11 As said by Montgomery Schuyler and quoted by Kenneth

Frampton, *Modern Architecture: a critical history* (London, Thames and Hudson, 1992), p.52.

12 Louis H. Sullivan, *The Autobiography of an Idea* (New York, Dover Publications, 1956), pp.312–13.

13 Louis H. Sullivan, *Kindergarten Chats (revised 1918) and Other Writings* (New York, George Wittenborn, 1947), p.208. What Sullivan actually wrote was: 'It is the pervading law of all things organic, and inorganic, of all things physical and metaphysical, of all things human and all things superhuman, of all true manifestations of the head, of the heart, of the soul, that the life is recognizable in its expressions, that form ever follows function. This is the law.'

14 *Ibid.*, p.203.

15 Sullivan, *Autobiography of an Idea*, pp.325–6.

16 As quoted by Brian Petrie, *Puvis de Chavannes* (Aldershot, Ashgate, 1997), p.145.

17 James Bryce, *The American Commonwealth* (New York and London, The Macmillan Company, 1899: 3rd edit.), ii:771, and Chapter III (Creative Intellectual Power), *passim*.

18 Quoted from James Bryce's essay, 'America revisited – changes of a quarter century', in Allan Nevins (ed.), *America through British Eyes* (New York, Oxford University Press, 1948), pp.384, 386, 391.

19 *Ibid.*, p.384.

20 Ernest Samuels (ed.), *The Education of Henry Adams* (Boston, Houghton Mifflin Company, 1973), p.315.

21 *Ibid.*, p.328.

22 As quoted by Erica E. Hirshler, 'Helping "fine things across the Atlantic": Mary Cassatt and art collecting in the United States', in Judith A. Barter (ed.), *Mary Cassatt: modern woman* (Chicago, The Art Institute of Chicago, 1998), p.181; and see also Griselda Pollock, *Mary Cassatt. Painter of Modern Women* (London, Thames and Hudson, 1998), *passim*.

23 Hirshler, 'Helping "fine things across the Atlantic"', p.196.

24 *Ibid.*, pp.190–1.

25 *Ibid.*, p.178.

26 As quoted by Lawrence W. Levine, *Highbrow/Lowbrow. The emergence of cultural hierarchy in America* (Cambridge [Mass.], Harvard University Press, 1988), p.201.

27 Helen A. Cooper, *Winslow Homer Watercolours* (New Haven and London, Yale University Press, 1986), pp.92–123 (Cullercoats, 1881–1882).

28 As quoted by Kevin Sharp, 'How Mary Cassatt became an American artist', in Barter, *Mary Cassatt*, p.147.

29 Samuels, *The Education of Henry Adams*, pp.318–20.

30 Nevins, *America through British Eyes*, p.365.

31 As quoted by Robert Tombs, *France 1814–1914* (London, Longman, 1996), p.149; for Cousin's common-sense philosophy, see also Theodore Zeldin, *France 1848–1945* (Oxford, Clarendon Press, 1977), ii:408–11.

32 Charles Sabel and Jonathan Zeitlin, 'Historical alternatives to mass production: politics, markets and technology in nineteenth-century industrialization', *Past & Present*, 108(1985), pp.133–76; and see also, for the garment industry, Nancy L. Green, 'Art and industry: the language of modernization in the production of fashion', *French Historical Studies*, 18(1994), pp.722–48, and Michael B. Miller, *The Bon Marché. Bourgeois culture and the department store, 1869–1920* (London, George Allen & Unwin, 1981), *passim*.

33 As quoted by Zeldin, *France 1848–1945*, i:552.

34 As quoted from Merruau's *Souvenirs de l'Hôtel de Ville de Paris 1848–1852* (1875) by Johannes Willms, *Paris. Capital of Europe. From the Revolution to the Belle Époque* (New York, Holmes and Meier, 1997), p.263.

35 *Ibid.*, p.262.

36 Patrice de Moncan and Christian Mahout, *Le Paris du Baron Haussmann* (Paris, Editions SEESAM-RCI, 1991), pp.42–3.

37 David H. Pinkney, *Napoleon III and the Rebuilding of Paris* (Princeton, Princeton University Press, 1972), p.155.

38 *Ibid.*, p.162.

39 As quoted by Willms, *Paris. Capital of Europe*, p.271.

40 *Ibid.*, p.261; and see also Ann-Louise Shapiro, 'Housing reform in Paris: social space and social control', *French Historical Studies*, 12(1981–2), pp.486–507, and Victoria E. Thompson, 'Urban renovation, moral regeneration: domesticating the *Halles* in Second-Empire Paris', *ibid.*, 20(1997), pp.87–109.

41 As quoted by T.J. Clark, *The Painting of Modern Life. Paris in the art of Manet and his followers* (London, Thames and Hudson, 1985), p.40.

42 Willms, *Paris. Capital of Europe*, p.266.

43 Pinkney, *Napoleon III and the Rebuilding of Paris, passim.*

44 David Van Zanten, *Building Paris. Architectural institutions and the transformation of the French capital, 1830–1870* (Cambridge, Cambridge University Press, 1994), Chapter 6 (Haussmann, Baltard, and Municipal Architecture).

45 As quoted by Pinkney, *Napoleon III and the Rebuilding of Paris*, p.78.

46 As quoted by Marie-Claire Bancquart, *Images littéraires du Paris 'fin-de-siécle'* (Paris, Éditions de la Différence, 1979), p.71; and for the artists, see the useful entries in William E. Echard, *Historical Dictionary of the French Second Empire 1852–1870* (London, Aldwych Press, 1985), pp.42 (Baudry) and 72–4 (Carpeaux).

47 Lilian R. Furst, 'Zola's art criticism', in Ulriche Fichte (ed.), *French 19th Century Painting and Literature* (Manchester, Manchester University Press, 1972), pp.164–81.

48 Steven Adams, *The Barbizon School and the Origins of Impressionism* (London, Phaidon, 1994), pp.197–209.

49 As quoted by Patricia Mainardi, *Art and Politics of the Second Empire. The Universal Expositions of 1855 and 1867* (New Haven and London, Yale University Press, 1987), p.138.

50 *Ibid.*, pp.188–9.

51 Paul B. Crapo, 'Art and politics in the Côte-D'Or: Gustave Courbet's Dijon Exhibition of May 1870', *French History*, 9(1995), p.322.

52 Bernard Denvir (ed.), *The Impressionists at First Hand* (London, Thames and Hudson, 1987), p.90.

53 John House, *Landscapes of France. Impressionism and its rivals* (London, Hayward Gallery, 1995), p.29.

54 As quoted by Patricia Mainardi, *The End of the Salon. Art and the State in the early Third Republic* (Cambridge, Cambridge University Press, 1993), p.37.

55 House, *Landscapes of France*, p.49.

56 As quoted by Raymond A. Jonas, 'Monument as Ex-voto, Monument as Historiosophy: the Basilica of Sacré-Coeur', *French Historical Studies*, 18(1993), p.490.

57 Mainardi, *The End of the Salon*, p.57.

58 John House, 'The legacy of Impressionism in France', in

Post-Impressionism. Cross-currents in European painting (London, Royal Academy of Arts, 1979), p.16.

59 For Seurat's politics, see Paul Smith, *Seurat and the Avant-Garde* (New Haven and London, Yale University Press, 1997), pp.97–104 (The Political Ideal).

60 As quoted by Albert Boime, *The Academy and French Painting in the Nineteenth Century* (London, Phaidon, 1971), p.184.

61 *Ibid.*, p.220 (note 89).

62 George Moore, *Modern Painting* (London, Walter Scott, 1893), p.96 (concluding his chapter on 'Monet, Sisley, Pissarro, and the Decadence').

63 Kenneth McConkey, *Impressionism in Britain* (New Haven and London, Yale University Press, 1995), p.89.

64 As quoted by Laurel Bradley, 'The "Englishness" of Pre-Raphaelite painting: a critical review', in Margaretta Frederick Watson (ed.), *Collecting the Pre-Raphaelites. The Anglo-American Enchantment* (Aldershot, Ashgate, 1997), p.203.

65 Roger Lloyd-Jones and M.J. Lewis, *British Industrial Capitalism since the Industrial Revolution* (London, UCL Press, 1998), pp.67–8.

66 As quoted by Jeffrey A. Auerbach, *The Great Exhibition of 1851. A nation on display* (New Haven and London, Yale University Press, 1999), pp.1, 91.

67 Michael Freeman, *Railways and the Victorian Imagination* (New Haven and London, Yale University Press, 1999), p.64.

68 Lloyd-Jones and Lewis, *British Industrial Capitalism*, pp.67–81.

69 E.L. Jones, *The Development of English Agriculture, 1815–1873* (London, Macmillan, 1968), pp.17–25 (The Basis of the 'Golden Age').

70 W.H.B. Court (ed.), *British Economic History 1870–1914. Commentary and Documents* (Cambridge, Cambridge University Press, 1965), pp.16–17.

71 W.D. Rubinstein, *Men of Property. The very wealthy in Britain since the Industrial Revolution* (London, Croom Helm, 1981), p.38 and *passim*; and see also the same author's 'The Victorian middle classes: wealth, occupation, and geography', *Economic History Review*, 30(1977), pp.602–23.

72 As quoted by Diane Sachko Macleod, *Art and the Victorian Middle*

Class. Money and the making of cultural identity (Cambridge, Cambridge University Press, 1996), p.211.

73 Richard Gatty, *Portrait of a Merchant Prince. James Morrison 1789–1857* (Northallerton, privately printed and undated), Chapter 22 (The Collector).

74 Philip Gilbert Hamerton, *Thoughts about Art* (London, Macmillan, 1873: revised edition, originally published in 1862), pp.130–1.

75 Tom Taylor (ed.), *Autobiographical Recollections of Charles Robert Leslie, R.A.* (London, John Murray, 1860; reprinted in 1978 by E P Publishing Limited, Wakefield), p.303.

76 Sarah Uwins, *A Memoir of Thomas Uwins, R.A.* (London, Longman, 1858; reprinted in 1978 by E P Publishing Limited, Wakefield), p.125.

77 David Robertson, *Sir Charles Eastlake and the Victorian Art World* (Princeton, Princeton University Press, 1978), pp.189–90.

78 Hamerton, *Thoughts about Art*, p.139 (from a note added in 1873).

79 For Gambart's calculations, see Bernard Denvir, *The Late Victorians. Art, design and society 1852–1910* (London, Longman, 1986), pp.120–1; and see also Macleod, *Art and the Victorian Middle Class*, pp.237–8.

80 Macleod, *Art and the Victorian Middle Class*, Chapter 3 (Pre-Raphaelitism: progressive or regressive?) and Appendix (Major Victorian Collectors), *passim*.

81 S.B. Saul, *The Myth of the Great Depression, 1873–1896* (London, Macmillan, 1969), *passim*, and Keith Burgess, 'Did the Late Victorian economy fail?', in T.R. Gourvish and Alan O'Day (eds), *Later Victorian Britain, 1867–1900* (London, Macmillan, 1988), pp.251–70. And see also Stephen J. Nicholas, 'The overseas marketing performance of British Industry, 1870–1914', *Economic History Review*, 37(1984), pp.489–506; Patrick K. O'Brien, 'The costs and benefits of British imperialism 1846–1914', *Past & Present*, 120(1988), pp.163–200; Paul Kennedy and Patrick K. O'Brien, 'Debate: the costs and benefits of British Imperialism 1846–1914', *ibid.*, 125(1989), pp.186–99; Avner Offer, 'The British Empire, 1870–1914: a waste of money?', *Economic History Review*, 46(1993), pp.215–38; Raymond E. Dumett (ed.), *Gentlemanly Capitalism and British Imperialism. The new debate on Empire* (Longman, London, 1999), *passim*; Tom Nicholas, 'Cogs to clogs in three generations?

Explaining entrepreneurial performance in Britain since 1850',
Journal of Economic History, 59(1999), pp.688–713; Ian Inkster *et al.*
(eds), *The Golden Age. Essays in British Social and Economic History,
1850–1870* (Aldershot, Ashgate, 2000), *passim*; and Peter Marsh,
*Bargaining on Europe: Britain and the First Common Market,
1860–1892* (New Haven and London, Yale University Press, 2001),
passim.

82 W.D. Rubinstein, 'New men of wealth and the purchase of land in
 nineteenth-century Britain', *Past & Present*, 92(1981), p.138.
83 John Guille Millais, *The Life and Letters of Sir John Everett Millais,
 President of the Royal Academy* (London, Methuen, 1899), ii:48.
84 Macleod, *Art and the Victorian Middle Class*, pp.231, 395–6, 477–8.
85 As quoted by Denvir, *The Late Victorians*, p.112.
86 Millais, *The Life and Letters*, ii:93–4.
87 Caroline Dakers, *The Holland Park Circle. Artists and Victorian
 Society* (New Haven and London, Yale University Press, 1999),
 p.178 (quoting W.R. Lethaby).
88 *Ibid.*, pp.49–50, 157–70.
89 As quoted by Roger Dixon and Stefan Muthesius, *Victorian
 Architecture* (London, Thames and Hudson, 1985), p.33.
90 For examples, see M.H. Port, *Imperial London. Civil government
 building in London 1850–1915* (New Haven and London, Yale
 University Press, 1995), *passim*, and J. Mordaunt Crook, *The Rise of
 the Nouveaux Riches. Style and status in Victorian and Edwardian
 architecture* (London, John Murray, 1999), Chapter 2 (The Style of
 Millionaires).
91 Port, *Imperial London*, Chapter 13 (The Battle of the Styles).
92 As quoted in the *Survey of London, Volume XXXVIII: The
 Museums Area of South Kensington and Westminster* (London,
 Athlone Press, 1975), p.206.
93 As quoted by Charles Harvey and Jon Press, *William Morris.
 Design and enterprise in Victorian Britain* (Manchester, Manchester
 University Press, 1991), p.182.
94 *Ibid.*, p.187.
95 As quoted by Elizabeth Cumming and Wendy Kaplan, *The Arts
 and Crafts Movement* (London, Thames and Hudson, 1991), p.198.
96 Harvey and Press, *William Morris*, p.161 (quoting from a letter to
 the editor of the *Manchester Examiner*: 14 March 1883).

97 As quoted by Robin Lenman, *Artists and Society in Germany 1850–1914* (Manchester, Manchester University Press, 1997), p.2 (from Wilhem Lübke's *Die moderne französische kunst* [1872]).

98 For good general surveys, see Clive Trebilcock, *The Industrialization of the Continental Powers 1870–1914* (London, Longman, 1981), Chapter 2 (Germany); Tom Kemp, *Industrialization in Nineteenth-Century Europe* (London, Longman, 1985 [2nd edit.]), Chapter 4 (The Rise of Industrial Germany); Alan S. Milward and S.B. Saul, *The Development of the Economies of Continental Europe 1850–1914* (London, George Allen & Unwin, 1977), Chapter 1 (The Economic Development of Germany, 1870–1914).

99 As quoted by Matthew Jefferies, *Politics and Culture in Wilhelmine Germany. The case of industrial architecture* (Oxford and Washington DC, Berg Publishers, 1995), p.22.

100 Françoise Forster-Hahn *et al., Spirit of an Age. Nineteenth-century paintings from the Nationalgalerie, Berlin* (London, National Gallery Company, 2001), pp.132–4.

101 Lenman, *Artists and Society*, pp.153–4; and see also the same author's 'Painters, patronage and the art market in Germany 1850–1914', *Past & Present*, 123(1989), pp.109–40.

102 As quoted by Lenman, *Artists and Society*, p.51.

103 Forster-Hahn, *Spirit of an Age*, pp.30, 140–1.

104 *Ibid.*, pp.166–75.

105 As quoted by Lenman, *Artists and Society*, p.57.

106 As quoted by Jefferies, *Politics and Culture*, p.49.

107 As quoted in Forster-Hahn, *Spirit of an Age*, p.128.

108 As quoted by Jefferies, *Politics and Culture*, p.48.

109 *Ibid.*, p.50.

110 As quoted in Forster-Hahn, *Spirit of an Age*, p.176.

111 Written in 1919 and quoted by Frank Whitford, *Klimt* (London, Thames and Hudson, 1990), p.80.

112 As quoted by Reinhold Heller, *Munch. His life and work* (London, Jonathan Murray, 1984), p.101.

113 As quoted by Ulrich Bischoff, *Edvard Munch 1863–1944* (Cologne and London, Taschen, 2000), p.34.

114 As quoted by George Heard Hamilton, *Painting and Sculpture in Europe 1880 to 1940* (Harmondsworth, Penguin Books, 1967), p.126.

Notes

115 Lenman, *Artists and Society*, pp.61, 176–84 (Selling the Blue Rider).
116 Stefan Muthesius, *Art, Architecture and Design in Poland 966–1990. An introduction* (Königstein im Taunus, Verlag Langewiesche Nachf., 1994), pp.73–80.
117 Klaus-Jürgen Sembach, *Henry van de Velde* (London, Thames and Hudson, 1989), pp.36–7.
118 As quoted by Gabrielle Fahr-Becker, *Art Nouveau* (Cologne, Könemann, 1997), p.335; for a recent comment on the Austrian economy, arguing for a revival no later than the early 1890s, see Max-Stephan Schulze, 'The machine-building industry and Austria's great depression after 1873', *Economic History Review*, 50(1997), pp.282–304.
119 Franco Borsi and Ezio Godoli, *Vienna 1900. Architecture and design* (London, Lund Humphries, 1986), Chapter 1 (Otto Wagner).
120 Carroll L.V. Meeks, *Italian Architecture 1750–1914* (New Haven and London, Yale University Press, 1966), pp.434–8; Gianni Toniolo, *An Economic History of Liberal Italy 1850–1918* (London, Routledge, 1990), Chapter 10 (The 'Age of Giolitti').
121 Franco Borsi and Hans Wieser, *Bruxelles. Capitale de l'Art Nouveau* (Brussels, Mark Vokar, 1992), *passim*.
122 William Craft Brumfield, *A History of Russian Architecture* (Cambridge, Cambridge University Press, 1993), pp.426–37; and see also Peter Gatrell, *The Tsarist Economy 1850–1917* (London, Batsford, 1986), Chapter 5 (The Manufacturing Sector).
123 Akos Moravánszky, *Competing Visions. Aesthetic invention and social imagination in Central European architecture, 1867–1918* (Cambridge [Mass.] and London, The MIT Press, 1998), pp.223–33.
124 As quoted by Dora Wiebenson and Jozsef Sisa (eds), *The Architecture of Historic Hungary* (Cambridge [Mass.] and London, The MIT Press, 1998), p.237.
125 Josep Maria Montaner, *Barcelona. A city and its architecture* (Cologne, Taschen, 1997), Chapter 3 (The Heyday of Modernismo).
126 As quoted by Richard Cork, *A Bitter Truth. Avant-Garde Art and the Great War* (New Haven and London, Yale University Press, 1994), p.147.
127 *Ibid.*, p.79.
128 *Ibid.*, pp.82–4, 116–20.
129 *Ibid.*, p.112.

130 *Ibid.*, pp.178–9.
131 John Maynard Keynes, *The Economic Consequences of the Peace* (London, Macmillan, 1919), pp.9–10.
132 *Ibid.*, p.251.

Index

Index

Index

Quillard, Pierre-Antoine xiii, 163
Quinel, Peter, Bishop of Exeter 34

Rae, George 251
railways 215, 226, 237
Rainaldi, Carlo 136
Rambaldoni da Feltre, Vittorino 61
Rammelsberg mines 4
Ramsay, Allan 171
Raphael (Rafaello Sanzio) 72, 117, 128
Rastrelli, Bartolomeo Francesco 158, 161
Rastrelli, Carlo Bartolomeo 158
Ratgeb, Jorg 80
record-keeping 30
Reimenschneider, Tilmann 80
religious communities 32–3
Rembrandt van Rijn 107, 109, 110–11, 127
Reni, Guido 117, 119, 121
Renoir, Pierre-Auguste 241, 243
Reuchlin, Johann 80
Reynolds, Sir Joshua xiv, 170, 171
Rheims 20
Ribera, José de 117
Ricci, Sebastiano 135
Richard of Aversa 7
Richardson, Henry Hobson 231, 235
Richelieu, Armand-Jean du Plessis, Duc de (Cardinal) 118, 136
Rievaulx Abbey 16
Riga 5–6
Robert, Hubert 223
Robillon, Jean-Baptiste xiii, 164
Rodin, Auguste 243
Roger II of Sicily and Apulia 8
Romanelli, Giovanni Francesco 120, 133, 140
Rome 70, 99, 100–2, 131–4, 221, 223
Romney, George xiv, 171

Rossetti, Dante Gabriel 250, 251
Rossi, Karl Ivanovich 220
Rosso Fiorentino 73–4
Rouen 76
Rousseau, Jacques 146
Rousseau, Théodore 242
Royal Academy of Arts, London 170, 171
Royal Gold Cup 57–8
Royal Naval Hospital, Greenwich 144
Rubens, Peter Paul 109, 111, 112, 119, 122, 123–4
Rublev, Andrei 159
Rude, François 201
Rudolf II, Holy Roman Emperor 94–5, 96
Ruijven, Pieter Claesz van 107
Russell, Francis, Earl of Bedford 126
Russia
 10th-11th century 4–5
 18th century 155–61
 19th century 218–19, 263
 20th century 262–3
Ry, Simon Louis du 189

Saarinen, Eliel 264, 265
Saint-Pierre, Joseph 191
sale of offices 75
Salisbury Cathedral 34
Samson, Abbot of Bury 29–30
Sangallo, Antonio da 71
Sant'Elia, Antonio 265
Santiago, Miguel de 152
Santos, Eugénio dos 165
Sargent, John Singer 230, 236
Sauvage, Frédéric 240
Savery, Roelandt 109
Schädel, Gottfried 158
Schiller, Friedrich 207

327